THE HUMAN FIGURE IN MOTION

THE HUMAN

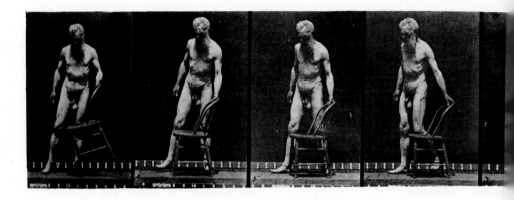

Introduction by Professor Robert Taft, University of Kansas

FIGURE IN MOTION

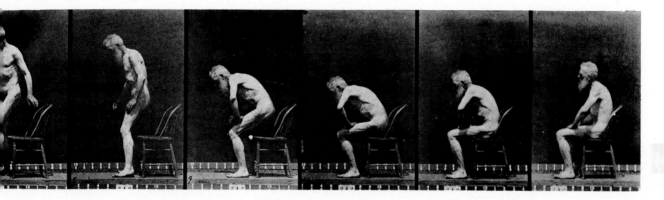

EADWEARD MUYBRIDGE

DOVER PUBLICATIONS, INC., NEW YORK

COPYRIGHT © 1955 BY DOVER PUBLICATIONS, INC.

All rights reserved under Pan American
and International Copyright Conventions.

Published in Canada by
General Publishing Company, Ltd.,
30 Lesmill Road, Don Mills, Toronto, Ontario.
Published in the United Kingdom by
Constable and Company, Ltd.,
10 Orange Street, London WC 2.

International Standard Book Number: 0-486-20204-6

Library of Congress Catalog Card Number: 55-13973

Manufactured in the United States of America

DOVER PUBLICATIONS, INC.
180 Varick Street
New York, N. Y. 10014

This Dover edition, first published in 1955, contains a new selection of plates from the eleven-volume work, *Animal Locomotion*, published in 1887. Almost all of the illustrations are reproduced the same size as in the original work. The selection of plates was made by Alex Domonkos, Head of the Instruction Department of the Famous Artists School of Westport, Connecticut, and Dr. Wallace Green, Diplomate of the American Board of Orthopedic Surgery. The introduction was especially written for this new edition by Professor Robert Taft, University of Kansas.

The publisher is grateful to Mr. E. Weyhe of Weyhe Galleries for permission to use illustrations from the original set owned by the Weyhe Bookshop. Without the use of this complete set, it is doubtful that a new edition could have been published.

AN INTRODUCTION
EADWEARD MUYBRIDGE
AND HIS WORK

Late in 1881, Jean Meissonier, a popular French artist, entertained in his Paris home a group of fellow artists such as had seldom been "found within the walls of one room," as a contemporary account stated. Among the guests were such celebrated artists as Gérôme, Léon Bonnat, Detaille, DeNeuville, Jules Goupil, Jalabert, Cabonel, Ridgway Knight, Steinheil, and others. Also present were members from other professions, including the well-known writer and dramatist, Alexander Dumas.

The small paintings of Meissonier depicting life in the Napoleonic era and of the period contemporary with the artist were noted for their draftsmanship and exactitude in reproducing detail. Some of these paintings represented extensive study of the problem of correctly portraying animals in motion—a problem which seems to have perplexed Meissonier for years.

The year before the gathering in Meissonier's home, Leland Stanford of California, while visiting Paris, had shown Meissonier photographs of horses in action taken by Eadweard Muybridge. Thus when the California photographer himself reached Paris, he found that Meissonier had arranged for the group of celebrities to meet him and view his work. Muybridge had by this time sufficiently improved his equipment to permit the projection of transparencies made from

his photographs of animals in motion. The projected image produced in his audience an illusion "as if the living animal itself were moving."

There can be little doubt that Muybridge's exhibition produced a tremendous impression on his audience, and "the magnificent entertainment" he provided became a principal topic of conversation among many Parisians. Muybridge showed not only his photographs of the horse in motion but also "the attitudes of men in the art of wrestling, running, jumping, and other exercises." "These, though few in number," the report reads, "were most admirably represented, and the warmest applause came from those whose greatest works on the canvas or in marble are those of the human figure."[1]

The Paris showing was by no means the first exhibition of the "moving" Muybridge photographs, for by late 1881, Muybridge had achieved an international reputation that has continued to this day. In the seventy odd years that have elapsed since the original showing of these photographs, they have continued to produce remarkable impressions and to exert an influence in many fields. A modern student has stated, "His pictures startled artists, physiologists, and many others, for they showed that the conventional representations of motion such as a horse running, a man walking, or an athlete

vaulting were composites on the brain of the observer . . ." The conventional method of portraying the gallop of a horse by artists ("the rocking horse gallop") underwent a marked change after the appearance of the Muybridge photographs. As I have shown elsewhere, for example, Frederic Remington, one of the most celebrated of the depicters of the horse, soon adopted a mode of representing a horse in motion that bore a remarkable resemblance to a Muybridge photograph.[2]

The originator of these studies of animals in motion was born in England on April 9, 1830, and was christened Edward James Muggeridge. Apparently an eccentric throughout his life, he early changed his name to Edward Muybridge (which later became Eadweard Muybridge) and left home. He arrived in America in the early 1850's, and by the 1860's, he was established as a well-known photographer on the Pacific Coast.[3] Where and how he acquired his training as a photographer is not known.

By 1872, Leland Stanford, one of the builders of the Central Pacific Railroad and a former governor of California, had become greatly interested in horse breeding and had acquired a large ranch, Palo Alto, on part of which Stanford University now stands. Legend has it that as a trotting horse passed before a group at his farm, Stanford became involved in an argument over the position of the feet, Stanford maintaining that the horse at times had all of its feet off the ground. The argument, apparently, led Stanford to wager $25,000. Stanford's biographer, George T. Clark, believes that this story is apocryphal, for Stanford was not in the habit of betting, and further, the individual with whom Stanford was supposed to have made the friendly wager, Frederick MacCrellish, was his bitter enemy. The only contemporary information available, two newspaper accounts of 1878, seem to support the view advanced by Clark that Stanford was interested in the most scientific method of training a race horse and employed Muybridge to photograph various phases of the gait for this purpose.[4] Because of the very slow speed of the wet plate, the results obtained in 1872 by Muybridge were not satisfactory. Further work was not resumed until 1877 when

Muybridge, as a result of some experiments on a ship at sea, felt that improvement in both materials and method warranted his taking the matter to Stanford again.[5] The photographs obtained during the summer of 1877 were so successful that larger scale experiments were tried the following year. The method employed by Muybridge, backed by the extensive bank account of Stanford, can be described briefly: an intensely white background, brilliant California sunshine, large camera aperture, drop shutters actuated by springs and rubber bands, wet plates of greatly increased sensitivity for exposures of 2/1000 of a second, a battery of 24 cameras at right angles to the race track and line of motion. The horse broke a thread that tripped the shutter in each camera as it passed before the lens. If the horse were pulling a racing cart, the iron rim of the wheels completed an electric circuit which activated the shutter of each camera as the cameras were successively passed. So successful were the horse pictures, that Stanford commissioned Muybridge to photograph other animals, including man, in motion. By 1879 these photographs of animals in motion were known throughout the civilized world, and lectures by Muybridge based on his photographs began in California. Muybridge went East where he attracted wide attention, then abroad to England, France, and Germany, where he created still greater sensations as the gathering at Messonier's home clearly shows.[6]

The first lectures of Muybridge (1878) were illustrated by means of "the stereoptecon and oxy-calcium light"; that is, the illustrations were still pictures projected and enlarged by the familiar projection lantern.[7] However, on May 5, 1880 an important step in projection of animals in motion was reported by San Francisco newspapers.[8] The evening before, Muybridge had illustrated his lecture by the use of an instrument which one newspaper called a "zoögyroscope" and another the "zoetrope." The zoetrope had long been known as a novel toy. In such a device, a series of figures on the inside of a revolving cylinder was viewed through slits in the cylinder—the individual figures appearing as a single animated figure. Muybridge modified this device by mounting transparencies made from

a series of his photographs on a circular glass plate. By rotating the plate, the individual transparencies could be projected by a projection lantern in the usual manner. A major refinement of the toy consisted of a second plate, this one of metal mounted parallel to the glass plate on a concentric axis but turning in the opposite direction. The metal plate was slit at appropriate intervals. When the two plates revolved, the metal plate served as a shutter. The persistence of vision between each slit gave the viewer the illusion of motion as each individual picture in the series was projected. As many as two hundred transparencies could be mounted on a single plate and, once started, the wheels or plates could be revolved endlessly, or for, as Muybridge stated, "a period limited only by the patience of the spectators."[9] The significance of the first showing of pictures by the Muybridge "zoöpraxiscope," a word invented by Muybridge, was not overlooked at the time, for the San Francisco *Alta California* on May 5, 1880, stated: Mr. Muybridge has laid the foundation of a new method of entertaining the people and we predict that his instantaneous photographic, magic lantern zoetrope will make the round of the civilized world." There has been long and extended controversy about the actual origin of the motion picture, but this need not concern us here.[10] The fact remains that Muybridge was certainly the first to bring the moving picture international attention and to use it as a method of instruction.[11]

The Muybridge work in California, sponsored by Stanford, was terminated in 1879, and Muybridge spent the next five years lecturing. In 1882 Stanford published a large volume based on a study of the Muybridge photographs. *The Horse in Motion*.[12] The text of this handsome book was written by J. D. B. Stillman, M.D., whose name appears on the title page. The book includes seven chapters on the theory of animal locomotion and 107 plates, many of the plates being reproductions of the Muybridge photographs. In the preface written by Stanford, Muybridge is mentioned by name as "a very skillful photographer," and an appendix describes the methods employed by Muybridge in securing the photographs. The book appeared in 1882, and

although it attracted considerable attention, it had little sale. Apparently Muybridge felt that he did not receive sufficient credit in this volume for his part in the venture; he brought suit against Stanford for $50,000. The suit was not pressed and may have been dropped. Perhaps the wide acclaim accorded Muybridge in the early 1880's convinced Muybridge that he was solely responsible for his results. He had copyrighted his photographs of horses in motion in his own name before the book was published, and in his suit he claimed that he originated the idea of taking the photographs. Actually Stanford had originated the idea, supplied the money (stated at times to be about $40,000), and supplied very considerable technical assistance from his railroad engineering staff. Even Muybridge, in a letter written in 1879, had stated: "He [Stanford] originally suggested the idea, and his persistency and liberal expenditure has accomplished the trifling success we have met with."[13] At any rate, the disagreement brought an end to any possible future arrangements between the two men.

Some of the photographs at Palo Alto had portrayed human beings. Athletes were shown in various positions, and in one lecture, it was reported that "a man was made to walk, run, jump a hurdle, and turn a somersault." The problem of human motion, however, had scarcely been touched in these early photographs. This was a phase which interested Muybridge greatly and which, no doubt, had been frequently discussed with him by artists in his travels around the world. The greatest American painter of the 19th century, Thomas Eakins of Philadelphia, had become interested in the work of Muybridge and had corresponded with him as early as 1879. More important, however, than such interests was the fact that in the interval between 1879, when the California experiments ended, and 1884, when Muybridge began his photographic work anew, the gelatin dry plate, of far greater sensitivity than the wet plate used by Muybridge in California, became commercially available. Its introduction opened greater possibilities in stopping motion of all kinds, and Muybridge was quick to realize it.[14] Because of the break with Stanford, it was obvious that

Muybridge could no longer expect aid from California; and it must have been with relief and pleasure that Muybridge received the news late in 1883 that the University of Pennsylvania was willing to underwrite an ambitious new program of photographic research on animals in motion and, in particular, on human motion.

Elaborate equipment was provided by the university. Two chief assistants were employed, L. F. Rondinella, an electrical expert, and Henry Bell, in charge of the photographic developing room. Special housing on the West Philadelphia campus was built. Funds for the venture were originally supplied in great part by the Philadelphia publisher, J. D. Lippincott, although other men made additional contributions which in total amounted to something over $30,-000 during Muybridge's stay at the university. Dr. William Pepper, Provost of the University, and Charles C. Harrison, Samuel Dickson, and Thomas Hockley, in addition to Lippincott, were the moving spirits in securing the services of Muybridge for the university. They provided that the work be supervised by a commission appointed by Dr. Pepper and consisting largely of members of the university staff in fine arts and medicine. The commission included Dr. Joseph Leidy, Dr. George F. Barker, Dr. R. S. Huidekopper, Dr. Harrison Allen, and Professors W. D. Marks, L. M. Haupt, and E. H. Coates of the university staff and Thomas Eakins of the Philadelphia Academy of Fine Arts.[15]

The animal subjects used by Muybridge in studying animal motion came from the Philadelphia Zoological Gardens. The men and women who performed before his battery of cameras were, in part, connected with the university. The "professor of physical culture," "the champion runner," "instructors at the Fencing and Sparring Club" and "a well-known pugilist" were among the male performers. The women were chiefly—since many of them appeared nude—professional artists' models, but the *première danseuse* of one of the Philadelphia theatres also danced before the 48 cameras on the university campus.[16]

The method that Muybridge employed at the university was an elaboration of his Palo Alto procedure. The performers usually passed before a whitened background some 120 feet in length. This background was marked horizontally and vertically into spaces five centimeters square, every tenth line being heavier. For some trials, portable backgrounds were employed, sometimes white, sometimes black. Opposite the fixed background was a battery of 24 cameras arranged parallel to the line of motion, the lenses about six inches apart and about 49 feet from the background.

In addition to the 24 fixed cameras, two portable batteries of 12 cameras each were employed at times. One of the batteries could be moved behind the subject once he was under way, and "rear views" could be taken. Sometimes the battery of cameras was arranged vertically. In such cases, the sixth camera lens was at the same level as the lenses of the fixed battery. The second movable battery of cameras usually photographed the subject as he approached at an angle of 60° from the fixed background. The results of such exposures Muybridge called "rear foreshortenings" and "front foreshortenings," and those at right angles to the line of motion, "laterals."

All three batteries could be in use at once, the simultaneous exposures being taken by means of an ingenious electrical system. Cameras number one in each battery, for example, could be "fired," at the same instant, then all three number two's, etc. As a result, for twelve exposures at least, three sets of photographs could be secured, one set at right angles to the line of motion, a second set from the rear in the line of motion (that is, at right angles to the fixed background and its opposite main battery of cameras), and a third set of photographs depicting the subject at a 60° angle as he approached this remaining battery.

To secure and time these simultaneous exposures, a motor-driven metallic contact (technically "a brush") passing over a disc-like but segmented commutator was used. The speed of the brush was adjustable (thus varying the interval between exposures), and as the brush came into contact with each segment of the commutator, an electric current was completed which actuated a magnetic device releasing one, two, or three shutters simultaneously, depending

upon how many were connected to the system. An electrically operated tuning fork, vibrating at 100 times per second was also connected into the circuit. As each exposure was made, the movement of the fork was exaggerated and left its record on a sheet of blackened paper. From the number of vibrations recorded, the length of each exposure and the time between each exposure could be calculated. Muybridge estimated that his most rapid exposure at Pennsylvania approximated one six thousandth of a second, an exposure that was rarely needed. As a matter of fact, in the published results, Muybridge usually records not the exposure but the time interval between exposures, which could be varied at the will of the operator. The range of intervals employed were stated to lie between "one-sixtieth part of a second, to several seconds." Where the time interval between exposures is recorded, the elapsed time for a subject to complete a given movement can readily be determined by multiplying the number of exposures shown in the completion of the movement by the time interval which is recorded in thousandths of a second. As Muybridge said, however, the calculation of such intervals in hundredths or even tenths of a second "may be found sufficiently accurate." Tests were made on the accuracy of the time intervals between exposures by photographing a white spot painted on a black disc revolving at a known speed. Two cameras were used simultaneously for this purpose, and a university committee after studying the results decided that the intervals between exposures were equal "except in two cases, where they differed by a few ten-thousandths of a second." The chronograph (the record of the tuning fork) too, it was concluded, agreed exactly with the results of the tests in giving the correct time interval between exposures.

The 24 "fixed" cameras (those placed opposite the long runway and background at right angles to the line of motion) used glass negatives 4 x 5 inches in size. The portable batteries of 12 cameras used smaller negatives, although each small battery was essentially one camera with partitions dividing the area covered by each lens. The shutters used were roll shutters operating in front of each lens. The endless roll of each

shutter possessed two equal sized openings. When the shutter was tripped by a magnetic device, the roll was put into motion by springs or rubber bands, and the two openings passed each other. The openings were so spaced that their simultaneous passage occurred in front of the lens, thus making the exposure. The tension actuating the roll shutter could be adjusted, thus changing the speed of the shutter opening.

Photography began on the university campus in the spring of 1884 and concluded in the fall of the following year. On a good day, five or six hundred negatives would be exposed, and on one record breaking day, 750 photographs were taken. Altogether some 100,000 negatives were secured.[17]

The next several years were apparently spent by Muybridge in selecting and preparing prints for publication, and in 1887, the university issued 781 plates, each plate containing reproductions of 12 to 36 of the Muybridge photographs. The copper plates for reproduction were prepared by the New York Photo Gravure Company, and they were printed on heavy linen paper sheets 19 x 24 inches in size. The printing surface of the individual plates varied from 6 x 18 inches to 9 x 12 inches. The individual plates sometimes showed a subject taken by the battery of 24 cameras at right angles to the line of motion, sometimes by two of the camera batteries previously described, sometimes by all three. The illustrations in the present volume are reproductions from these Muybridge plates first published in 1887.

The plates were issued in several forms. All 781 plates could be secured unbound and packaged in leather portfolios or bound into 11 volumes with each plate hinged. The advertised prices of these two forms were $500.00 and $550.00 respectively. It was also possible to secure selections of 100 unbound plates in a leather portfolio for $100.00. Or a prospective purchaser could, if he bought the 100 plates, secure any or all of the additional plates for $1.00 each. A complete catalog of the plates was published separately. It may be useful to summarize the various classes of plates, for the list may be of value to the present-day student.[18]

The 14 classes as published by Muybridge

included:

Class	No. of Plates
1. Men, draped	6
2. Men, pelvis cloth	72
3. Men, nude	133
4. Women, draped	60
5. Women, transparent drapery and semi-nude	63
6. Women, nude	180
7. Children, draped	1
8. Children, nude	15
9. Movements of a man's hand	5
10. Abnormal movements, men and women, nude and semi-nude	27
11. Horses, walking, trotting, galloping, jumping, etc.	95
12. Mules, oxen, dogs, cats, goats, and other domestic animals	40
13. Lions, elephants, buffaloes, camels, deer, and other wild animals	57
14. Pigeons, vultures, ostriches, eagles, cranes, and other birds	27
Total	781

The tenth group, "Abnormal movements," is of particular note. Presumably Muybridge's interest in making these photographs was aroused by Dr. Francis X. Dercum, a neurologist on the staff of the University of Pennsylvania Medical School. Certainly one of the earliest, if not the earliest, publication in medical literature to be illustrated by photographs of abnormal motion was Dercum's paper, "A Study of Some Normal and Abnormal Movements," which was illustrated by Muybridge photographs of various types of tremors.[19]

The great bulk and high cost of the complete Muybridge work prevented any extensive sale.

To meet the demand for a less expensive compilation of his plates, Muybridge subsequently published two abridgments of the original work. The first of these, *Animals in Motion,* was copyrighted in 1899 and apparently went through several printings. It was illustrated by about 100 plates reproduced in halftone. Considerable reduction of the plates from the original printing was made as the individual pages of this volume measure approximately 9½ by 12 inches. The printing surface of the plates was considerably smaller than the page size. It is still a most useful work, however, for Muybridge reviewed and discussed his work in more detail here than in the previous collection. This volume was followed by one of approximately the same size, *The Human Figure in Motion,* (containing about 125 plates) which was copyrighted in 1901 and also issued in various printings. (I have seen a "Third Impression" dated 1907.) As the title indicates, the plates were restricted to those depicting human motion, although a few such plates had been included in the earlier *Animals in Motion.*

The Human Figure in Motion appears to be Muybridge's last publication. After severing his connection with the University of Pennsylvania, he lived for a time in this country and for a time in England. Finally in 1900, he returned to Kingston-on-Thames, his birthplace, where he continued to live until his death on May 8, 1904. His remaining materials on animal locomotion were bequeathed to the Kingston Public Library.[20]

August, 1954

ROBERT TAFT
University of Kansas
Lawrence

NOTES

These notes have been provided for anyone seeking further information on Muybridge and his work. The bibliography on Muybridge material is in a badly confused state, especially that which was published under Muybridge's name. Not all such material is included here, but the more important items have been. A number of entries under Muybridge can be found in the Library of Congress CATALOG OF PRINTED CARDS.

[1] The account of the exhibit at Meissonier's home was published originally in the *Paris American Register;* reprinted in *Anthony's Photographic Bulletin,* Jan., 1882, and *Scientific American Supplement,* Jan. 28, 1882, v. 13, p. 5058.

[2] The quotation of the "modern student" is from Henry Leffman, "The Invention of the Motion Picture," *Journal of the Franklin Institute,* v. 207, p. 826 (1929).

My discussion of the Remington depiction of the horse and the Muybridge photographs is in PHOTOGRAPHY AND THE AMERICAN SCENE (N. Y., 1938), pp. 410-415.

[3] For biographical accounts see: THE DICTIONARY OF NATIONAL BIOGRAPHY, Second Supplement, v. 2; THE NATIONAL CYCLOPEDIA OF AMERICAN BIOGRAPHY, v. 19; THE DICTIONARY OF AMERICAN BIOGRAPHY, v. 13. One of these accounts states that Muybridge arrived in the U.S. about 1852, and a passing comment in Muybridge's ANIMALS IN MOTION (London, 1902) refers to a southern tour of the U.S. "early in the fifties." I have described his large views of Yosemite made in the late sixties in my PHOTOGRAPHY AND THE AMERICAN SCENE, p. 405. A number of these were used in John S. Hittell's YOSEMITE: ITS WONDERS AND ITS BEAUTIES (San Francisco, 1868). Muybridge said (ANIMALS IN MOTION, p. 1) that he was making photographic surveys for the Federal Government in 1872. Other activities of this early period are mentioned in PHOTOGRAPHY AND THE AMERICAN SCENE.

[4] The San Francisco Chronicle, June 16, 1878, p. 5, c. 6, stated that Stanford began the Muybridge work as a result of a "grave discussion" among horsemen on the phases of a trotting horse's gait. The San Francisco Alta California, July 8, 1878, p. 1, c. 1, reported that the work was begun to secure results in training one of his horses in the hope that it would become "the wonder of the world." George T. Clark discusses the Muybridge work at Palo Alto in Chapter XI of LELAND STANFORD (Stanford University, California, 1931). Over twenty years later, however, Muybridge said that Stanford and MacCrellish were the original "disputants." See Muybridge, DESCRIPTIVE ZOÖPRAXOGRAPHY (1893) p. 4.

[5] The San Francisco Bulletin, Aug. 4, 1877, p. 3, c. 3, reported new efforts in photographing the horse in motion and their successful outcome with Stanford's trotter, Occident. This account also described briefly the Muybridge experiments at sea.

[6] Muybridge copyrighted photographs of the horse in motion as early as 1877; see plate opposite p. 350 in Clark, LELAND STANFORD. The Philadelphia Photographer, v. 16, Jan., 1879, p. 23, announced that a descriptive circular of horse photographs could be secured from Muybridge "or $1.50 each will bring you copies of the groups of positions." An extensive collection of copyrighted photographs was apparently bound together in 1881 with the title, "Attitudes of animals in motion, a series of photographs illustrating the consecutive positions assumed by animals in performing various movements." (See Clark, LELAND STANFORD.) A copy of this volume appears in the Library of Congress holdings. The earliest periodical illustration of Muybridge horse photographs that I have found is in the Scientific American, v. 39, Oct. 19, 1878, p. 239.

[7] The first illustrated lectures in San Francisco are reported by the San Francisco Alta California, July 8 and 9, 1878, p. 1, (Photostatic material taken from California newspapers and supplied by the California State Library, Sacramento.) He lectured on the same subject in Sacramento in the fall. (Sacramento Bee, Sept. 18 and 19, 1878, p. 3.) Photographs of the dog, Bulldozer, urged into action by a captive rabbit, are reported in the San Francisco Call, Dec. 23, 1879, p. 6. An extensive list of the foreign institutions before which Muybridge lectured is given in Appendix A, p. 3 of DESCRIPTIVE ZOÖPRAXOGRAPHY published at the Lakeside Press for the University of Pennsylvania (1893). Lectures in New York City are reported in the New York Times, Nov. 18, 1882, and the New York Daily Tribune, same date.

[8] San Francisco Bulletin, May 5, 1880, p. 1, San Francisco Alta California, and San Francisco Call, same date. The first person who actually projected the Muybridge photographs in the zoetrope appears to have been W. B. Tegetmeier, who reported it in the Field (London) June 28, 1879, p. 756. The illusion of motion thus produced had the result that "all previous ideas of the action of the racer were blown to the winds." Tegetmeier's procedure may have been the incentive for Muybridge's further efforts in this direction.

[9] The most extensive description Muybridge gave of his zoöpraxiscope is in the preface to ANIMALS IN MOTION.

[10] The controversy over the invention of the motion picture can be followed in Journal of the Franklin Institute, v. 145, p. 310 (1898); Motion Picture Magazine, v. 8, p. 93, Nov. 1914; Journal of the Franklin Institute, v. 207, p. 825 (1929); v. 208, p. 417 (1929); Lloyd Goodrich, THOMAS EAKINS (N. Y., 1933), pp. 67-71. Muybridge mentions it in his preface to ANIMALS IN MOTION, p. 5. In this last reference, incidentally, he said that in 1888 he consulted with Thomas A. Edison about the possibility of synchronizing the phonograph with his zoöpraxiscope, but that the phonograph did not then have sufficient volume. Muybridge predicted (1902) that in the future, it would be possible to reproduce together pictures and sound of an "entire opera."

[11] As has been pointed out elsewhere (Journal of the Franklin Institute, v. 208, p. 420, 1929), Muybridge's lectures utilizing his zoöpraxiscope were, when he charged admission, the first motion pictures "commercially shown." Certainly, the showings at the Chicago World's Fair of 1893 were "commercial," as were undoubtedly many before this date. For his exhibition at the Chicago Fair, see DESCRIPTIVE ZOÖPRAXOGRAPHY.

[12] J. D. B. Stillman, THE HORSE IN MOTION (Boston, 1882). For an extensive review of this book see the Century Magazine, n.s., v. 2, (1882), pp. 381-388.

[13] The disagreement is described at some length in Clark's LELAND STANFORD, Chapter XI. Muybridge's letter was written to the editor of the Philadelphia

Photographer and appeared in the issue of March, 1879, v. 16, p. 71. The cost of Stanford's experiments has been variously estimated. The San Francisco *Call* reported it as "between $40,000 and $50,000."

[14] The projection of the human figure is reported briefly in the San Francisco *Call,* May 5, 1880, and the New York *Times,* Nov. 18, 1882. The exhibition at Meissonier's also included human figures in motion. Muybridge stated (THE HUMAN FIGURE IN MOTION, [London, 1907], p. 7) that his California work included "feats of the gymnasium and the field by some California athletes." The Eakins-Muybridge correspondence is reported in Goodrich, THOMAS EAKINS, p. 67. I have described the introduction of the gelatin dry plate in PHOTOGRAPHY AND THE AMERICAN SCENE, Chapter 18. That Muybridge was eager to try photographing animals by dry plates is indicated in a letter by Dr. J. D. B. Stillman, April 11, 1882; reprinted in Clark, LELAND STANFORD, p. 375.

[15] Talcott Williams in the *Century Magazine,* n.s., v. 12, pp. 356-368, July, 1887, stated that J. B. Lippincott "liberally advanced the preliminary expenses," and that five guarantors provided the remainder, the total cost being $30,000. Muybridge stated (DESCRIPTIVE ZOÖPRAXOGRAPHY, p. 9) that nearly $40,000 had been expended. Possibly the latter sum included the cost of publication of the eleven-volume ANIMAL LOCOMOTION in 1887. The list of underwriters also appears in DESCRIPTIVE ZOÖPRAXOGRAPHY, p. 8; the list of commission members in ANIMAL LOCOMOTION: THE MUYBRIDGE WORK AT THE UNIVERSITY OF PENNSYLVANIA (Philadelphia, 1888) in the prefatory note by Dr. Pepper. Muybridge gives the names of his two assistants, Rondinella and Bell, in ANIMALS IN MOTION, p. 6. See also L. F. Rondinella, "Muybridge's Motion Pictures," *Journal of the Franklin Institute,* v. 208, pp. 417-420 (1929).

[16] The Muybridge subjects are reported in ANIMAL LOCOMOTION: THE MUYBRIDGE WORK AT THE UNIVERSITY OF PENNSYLVANIA, p. 17, and in Muybridge, THE HUMAN FIGURE IN MOTION, pp. 8 and 9. The first reference reported that in addition to the Zoological Gardens and Muybridge's studio on the campus, some of the photographs were made at the "Gentlemen's Driving Park."

[17] The most extensive discussion of these procedures is in ANIMAL LOCOMOTION: THE MUYBRIDGE WORK AT THE UNIVERSITY OF PENNSYLVANIA, "The Mechanism of Instantaneous Photography" by Prof. W. D. Marks, pp. 9-33; and the Muybridge books, DESCRIPTIVE ZOÖPRAXOGRAPHY, pp. 10-26, and ANIMALS IN MOTION, pp. 11-14.

[18] Most of this bibliographic information comes from Muybridge, DESCRIPTIVE ZOÖPRAXOGRAPHY, Prospectus in Appendix B. The title of the eleven-volume set is ANIMAL LOCOMOTION; AN ELECTRO-PHOTOGRAPHIC INVESTIGATION OF CONSECUTIVE PHASES OF ANIMAL MOVEMENTS, 781 plates (Philadelphia, 1887). The Library of Congress has a set in 16 volumes, but this may be a set of the unbound plates subsequently bound. All the contemporary notices refer to 11 volumes. The complete catalog of the plates, published separately, also bears this title, but with the additional subtitle, *Prospectus and Catalogue of Plates,* J. B. Lippincott (Philadelphia, 1887). It contains 50 pages, variously numbered. Despite the long lists of subscribers, a complete set of 781 plates is now difficult to find. Extraordinary as it may seem, not even does the University of Pennsylvania own a copy although they do have about 700 unbound plates. From a survey made in the summer of 1953, the following libraries have copies of the original Muybridge work of 1887. The listing is taken from a report sent to me by each library: [1] The John Crerar Library, Chicago. 11 volumes. (Whether all 781 plates were present was not indicated.) [2] Ryerson Library, The Art Institute of Chicago. 11 volumes containing 732 plates. [3] Stanford University Libraries, California. About half the total number of loose plates. [4] University of California, Berkeley. 19 plates. [5] Library, Museum of Comparative Zoology, Harvard University. 138 loose plates. [6] New York Public Library. 11 volumes, 781 plates with "mutilations scattered through the set." [7] A California book dealer had a complete set of 11 volumes in the summer of 1953 for $1750.

[19] ANIMAL LOCOMOTION: THE MUYBRIDGE WORK AT THE UNIVERSITY OF PENNSYLVANIA, "A Study of some Normal and Abnormal Movements Photographed by Muybridge," pp. 103-133. On page 133, Dercum corrected the designations on four of the Muybridge plates.

[20] For biographical material on Muybridge see Note 1. The information on the remaining publications of Muybridge is taken from actual copies at the University of Kansas Library. The University of California Library informed me that they have a 5th impression of ANIMALS IN MOTION, dated 1925.

DETAILED CONTENTS

The sequence of phases in most of the plates is from left to right. Although the individual frames are lightly numbered, an arrow is placed beneath each plate where the sequence is from right to left. The time interval between frames is given in all cases where it is known.

MEN

xv

THE HUMAN FIGURE IN MOTION

MEN

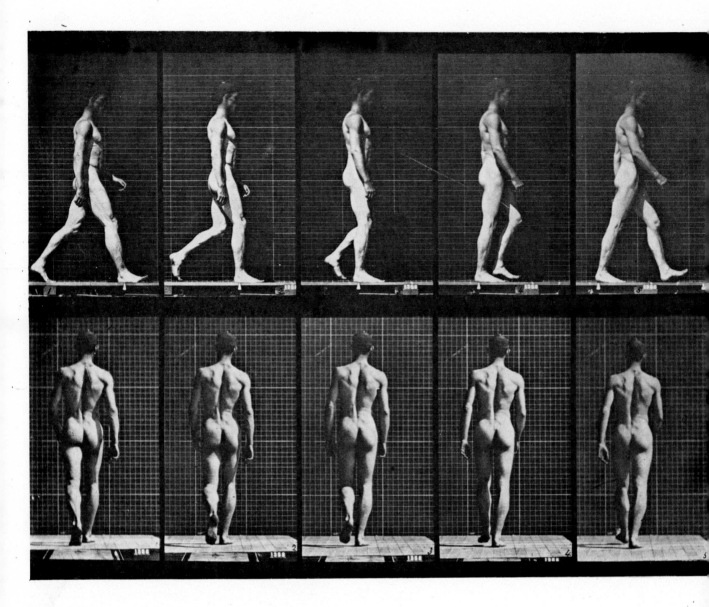

MAN WALKING AT ORDINARY SPEED (.083 second)

PLATE 1

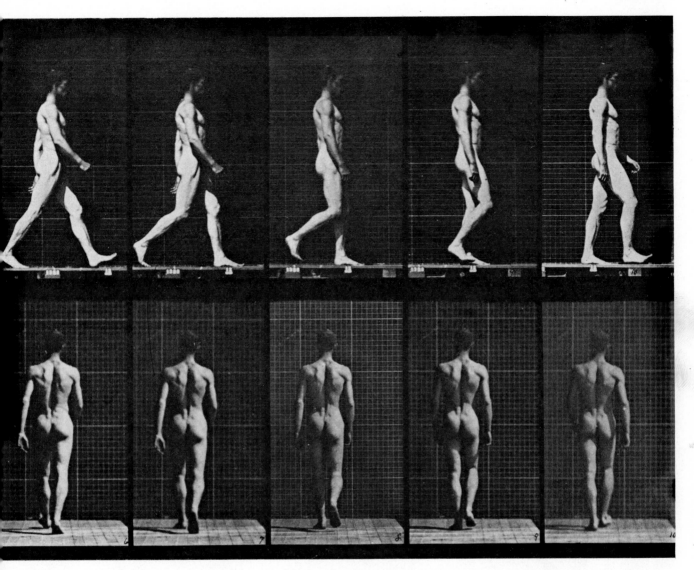

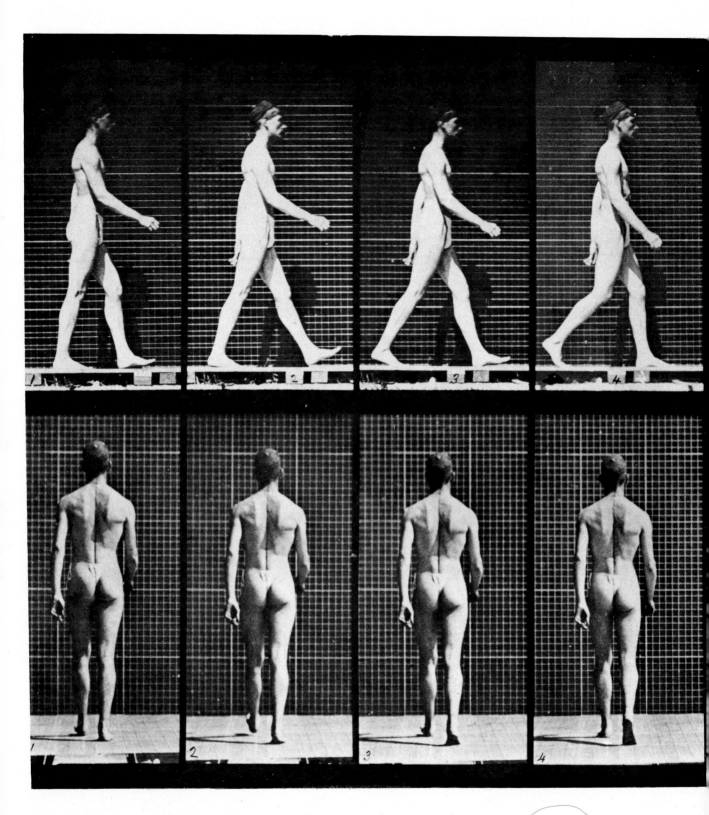

MAN WALKING AT ORDINARY SPEED

PLATE 2

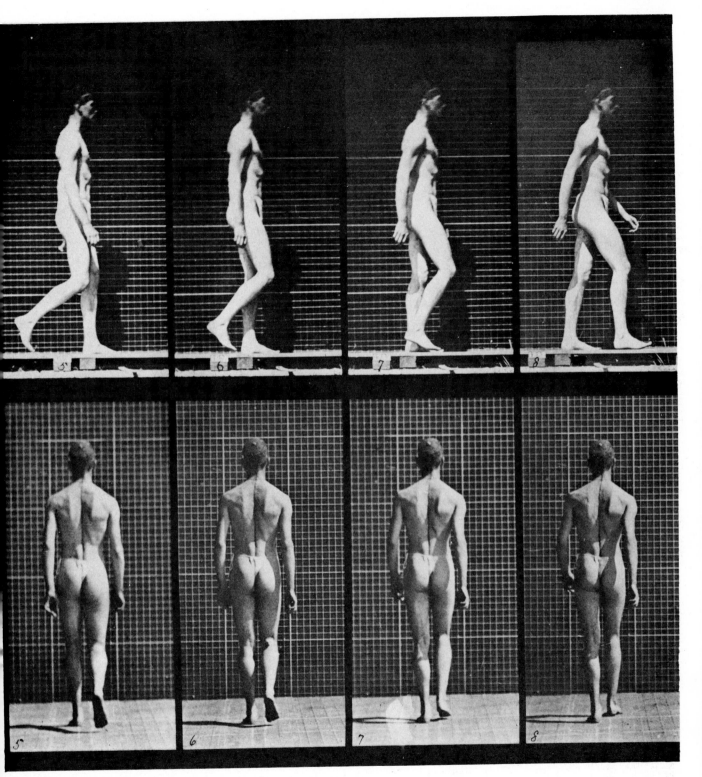

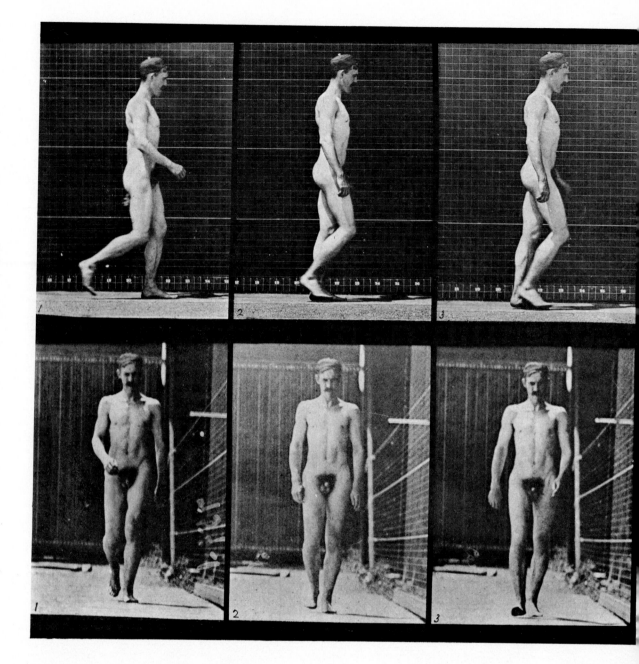

MAN WALKING AT ORDINARY SPEED

PLATE 3

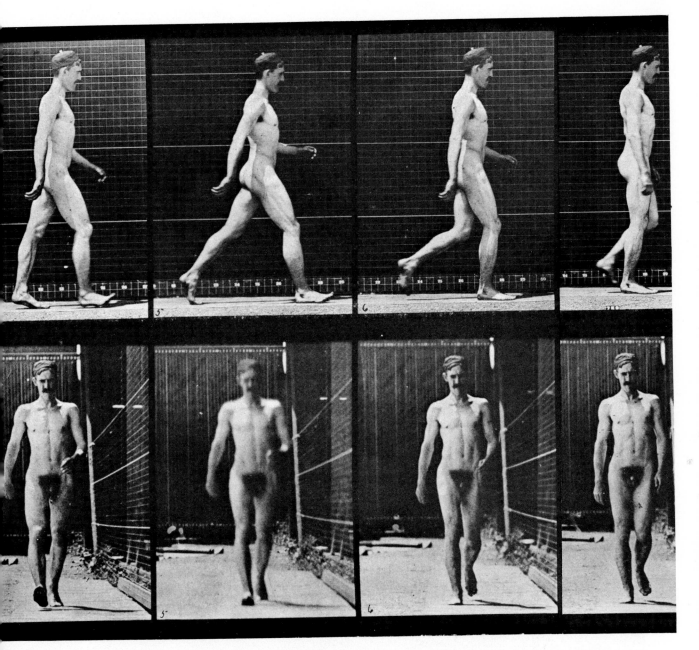

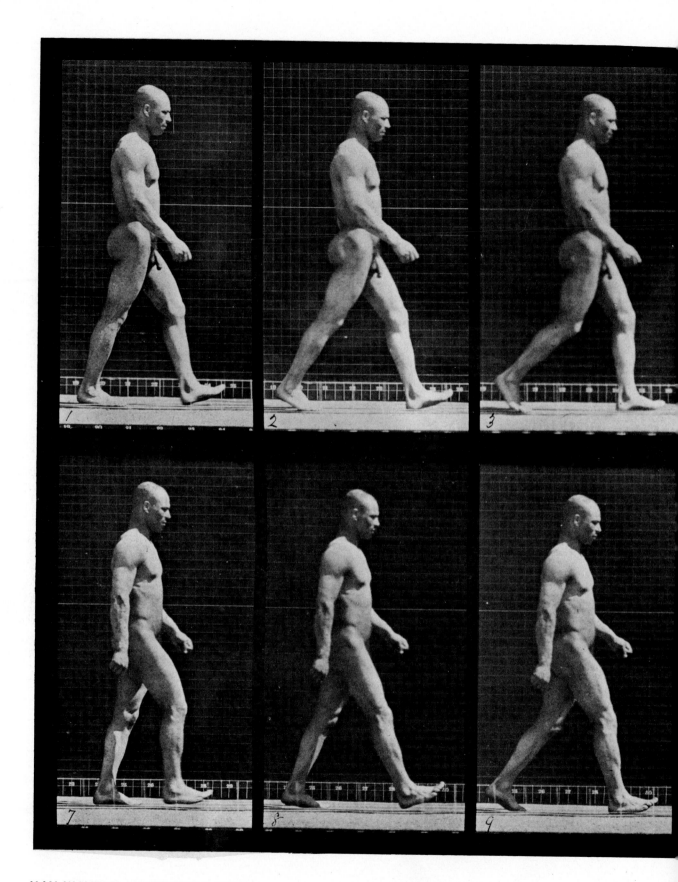

MAN WALKING AT ORDINARY SPEED

PLATE 4

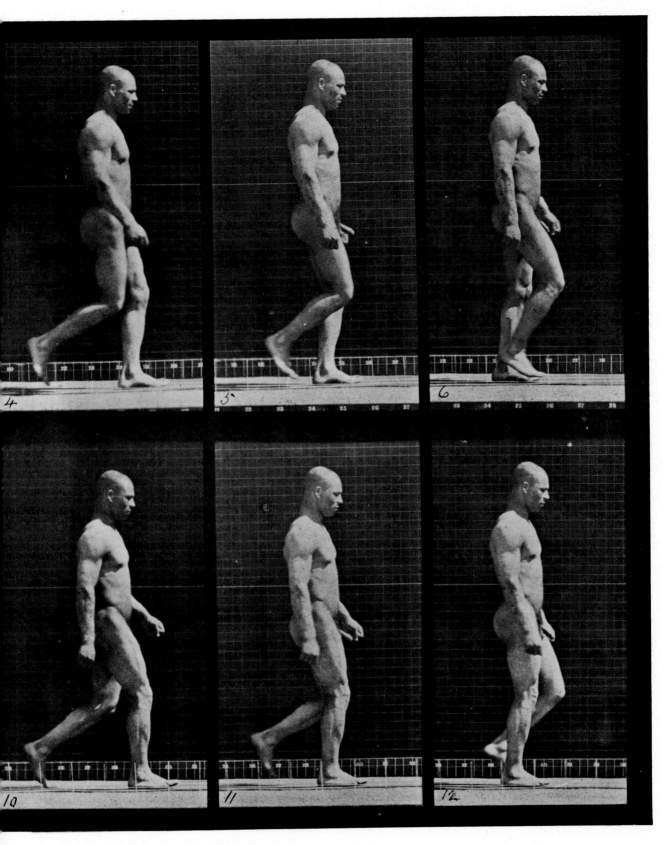

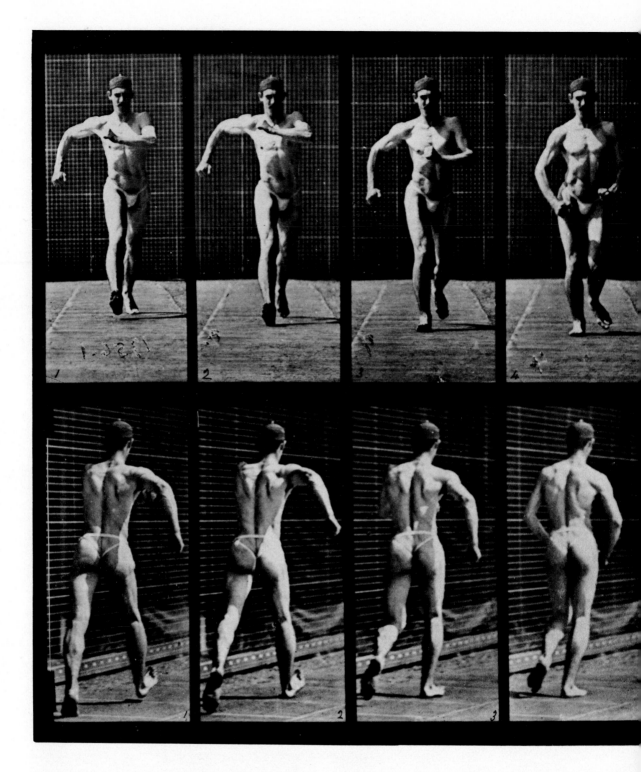

MAN WALKING AT HALF-STRIDE (.069 second)

PLATE 5

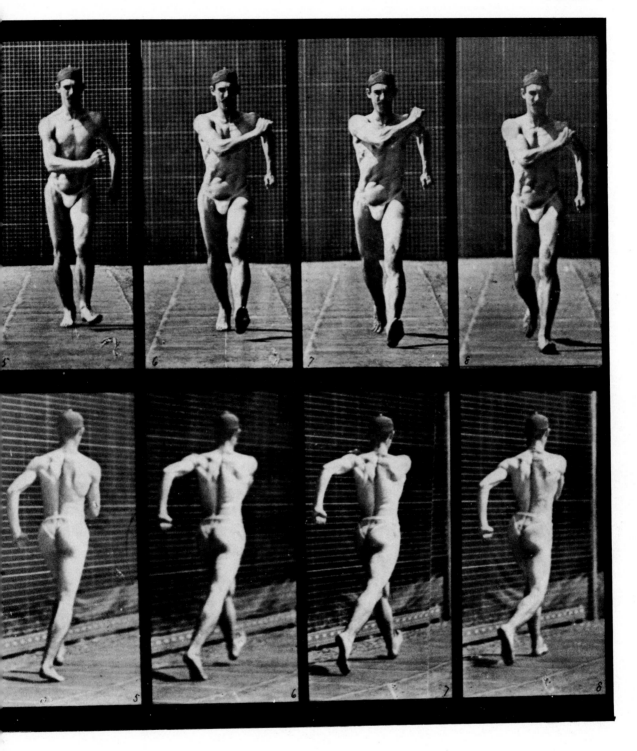

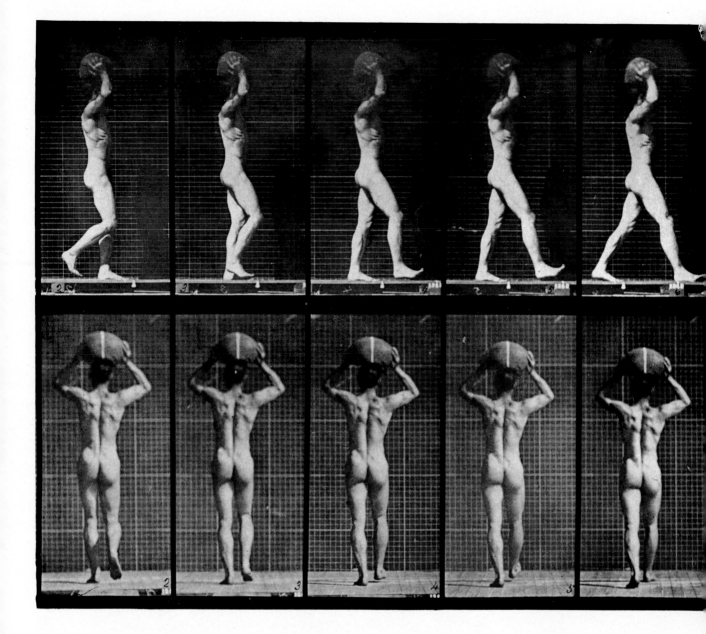

MAN WALKING AND CARRYING 75-LB. BOULDER ON HEAD

PLATE 6

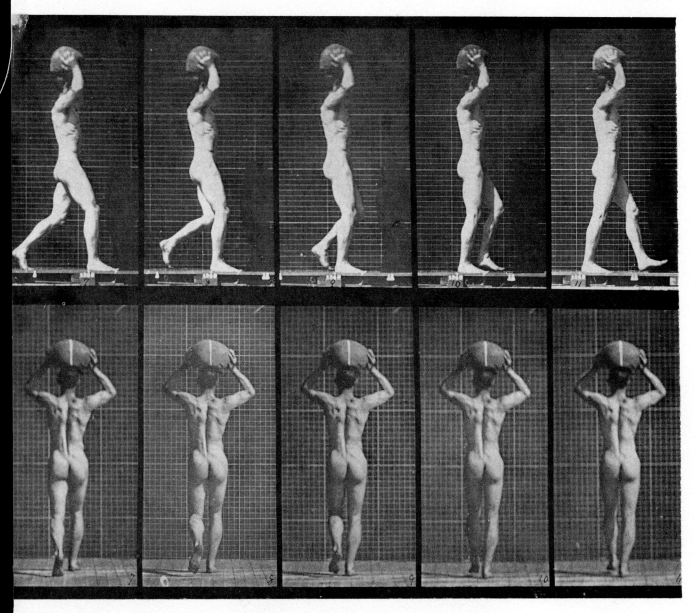

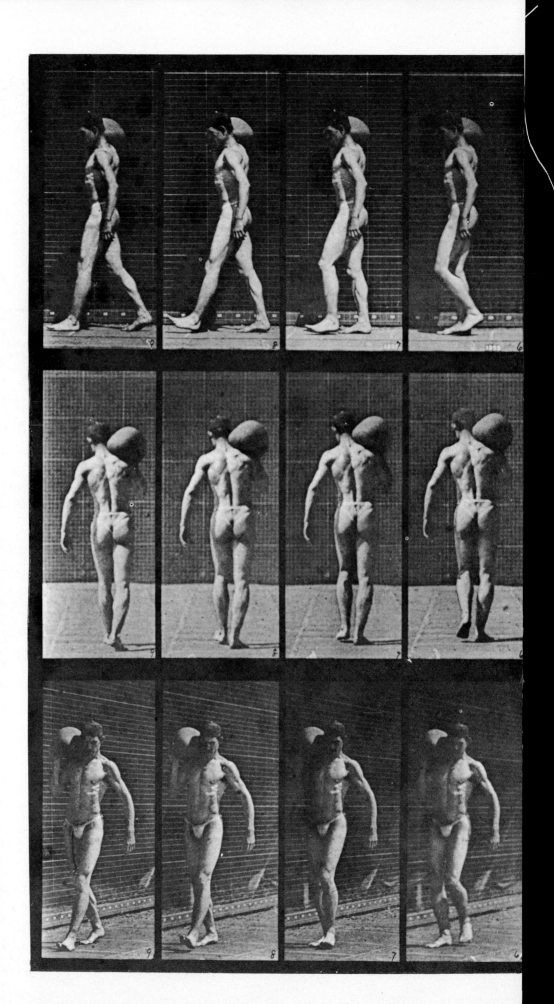

PLATE 7

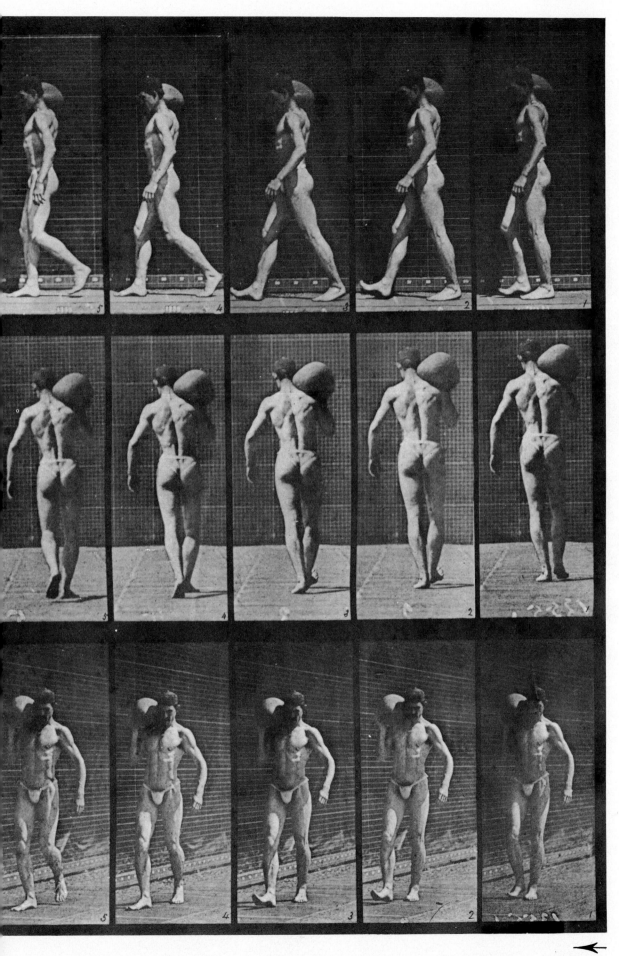

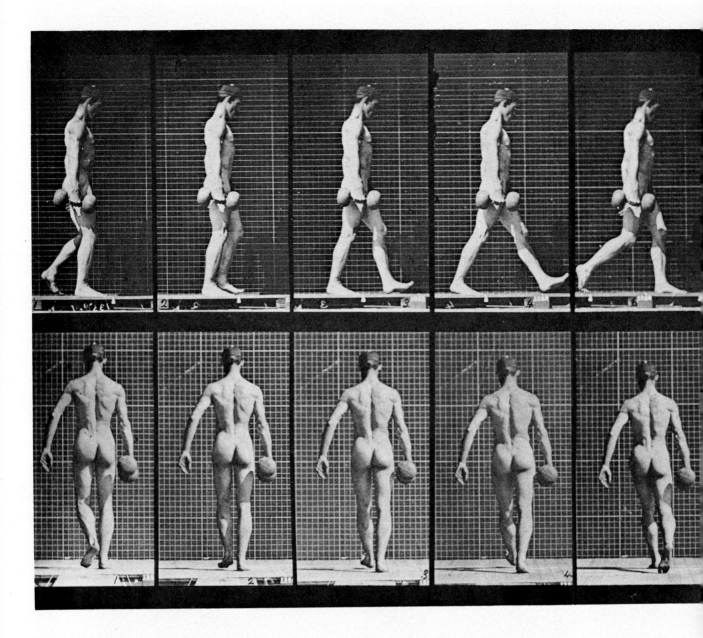

MAN WALKING AND CARRYING 50-LB. DUMBBELL IN ONE HAND· (.099 second)

PLATE 8

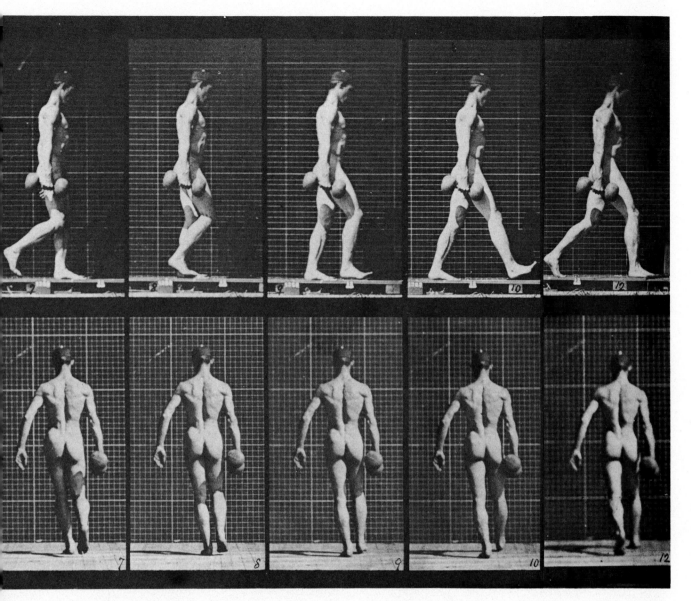

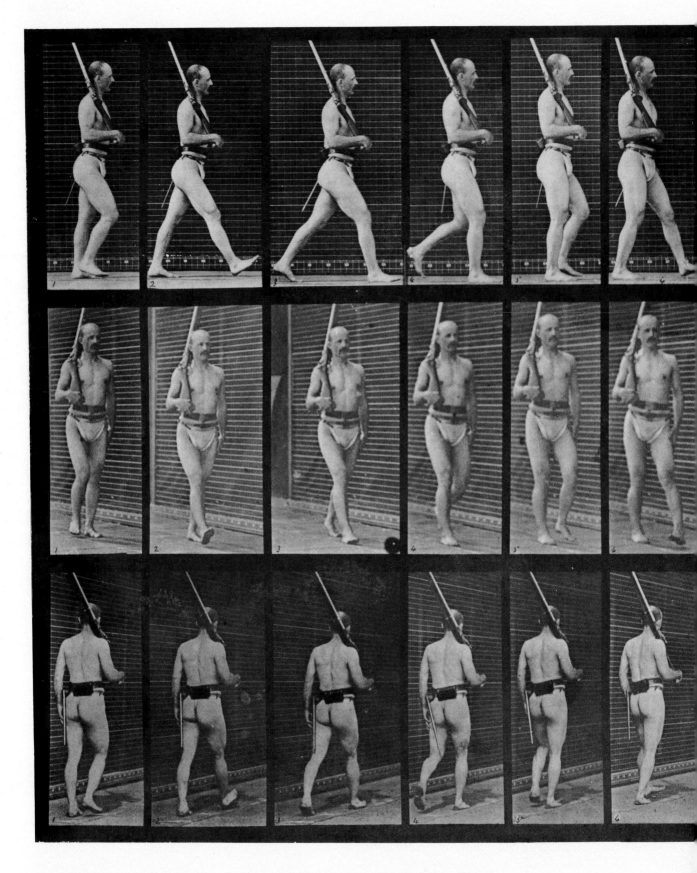

MAN WALKING AND TURNING CARRYING RIFLE ON SHOULDER (.161 second)

PLATE 9

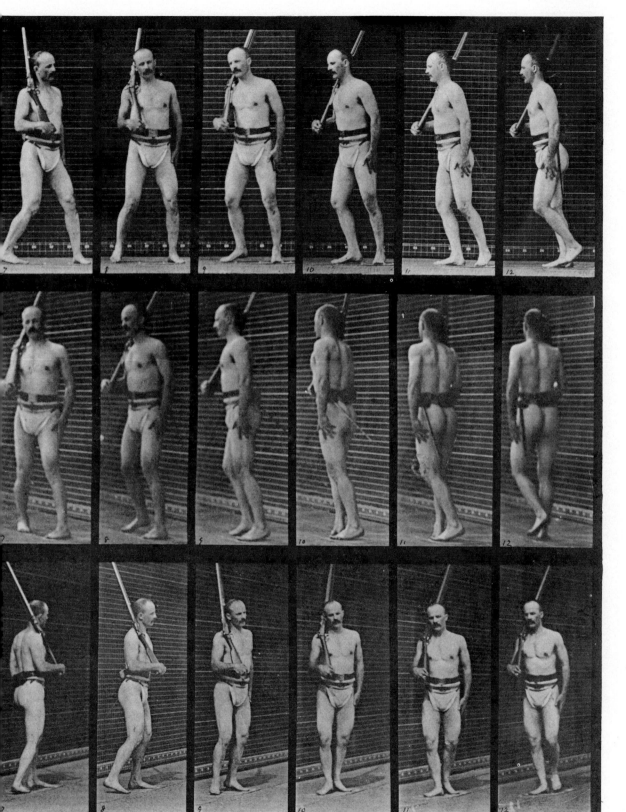

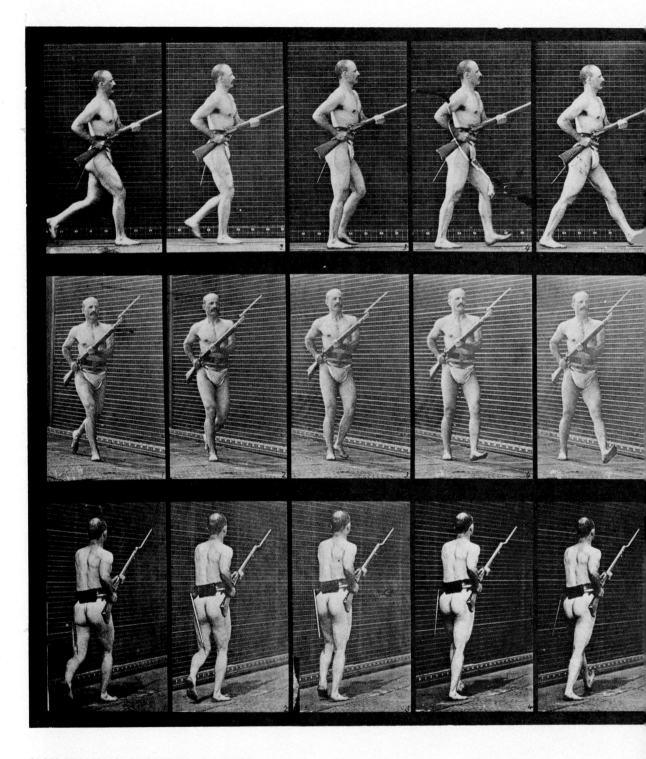

MAN WALKING AND CARRYING RIFLE

PLATE 10

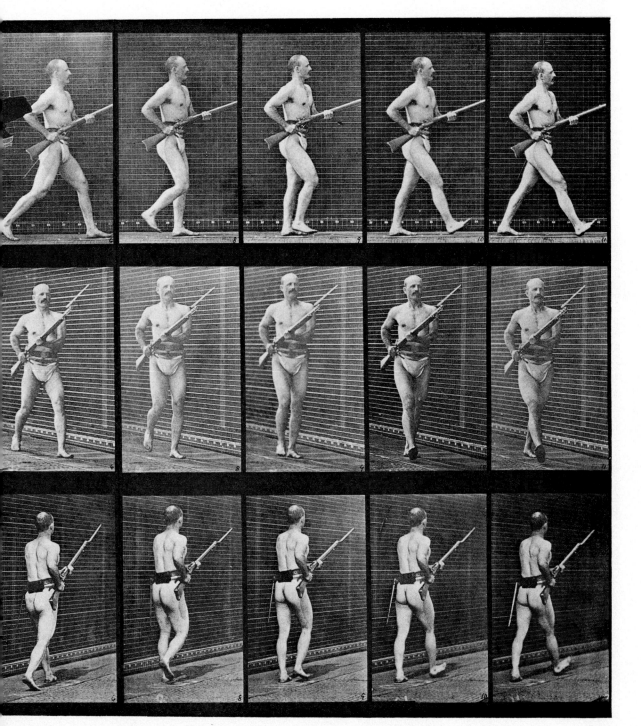

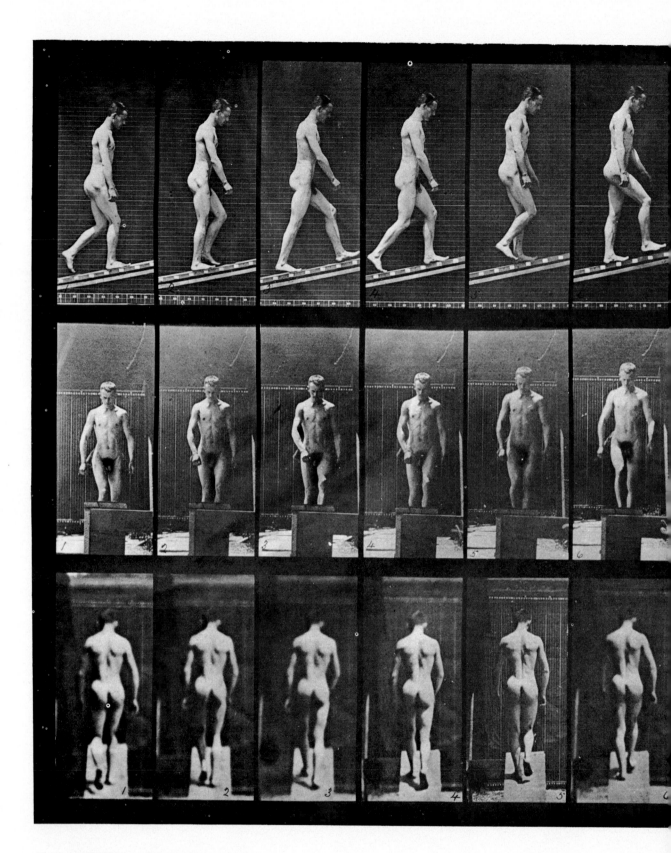

MAN WALKING UP INCLINED PLANE

PLATE 11

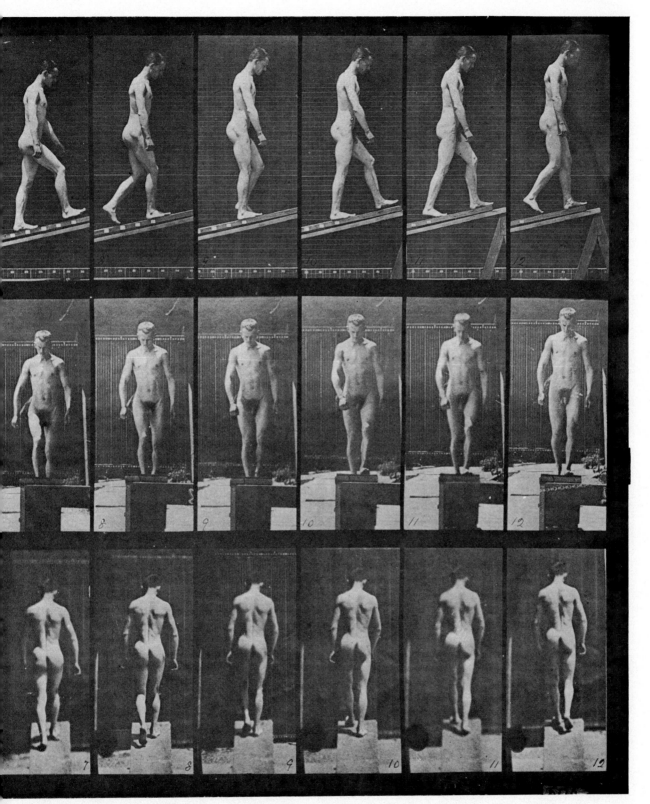

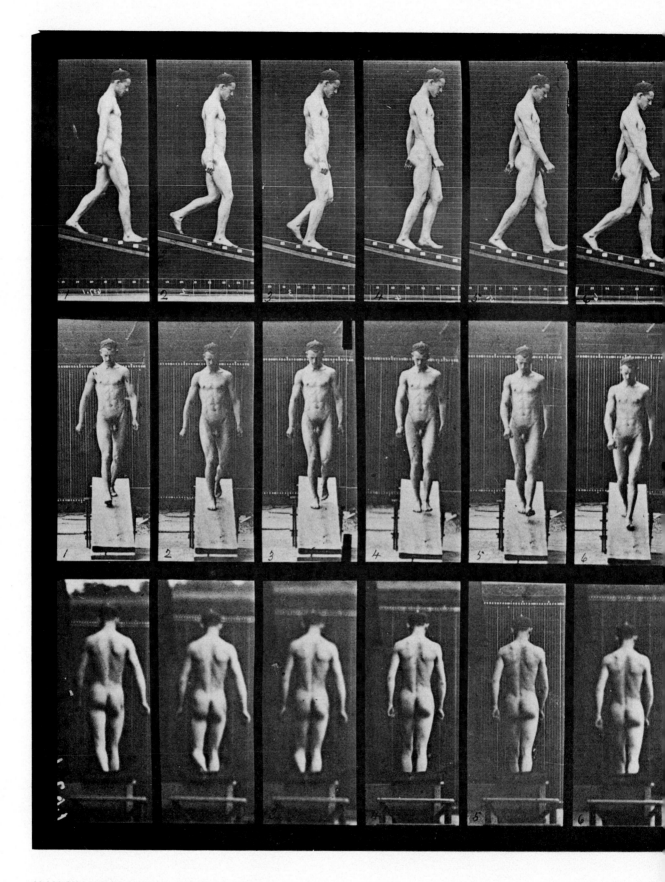

MAN WALKING DOWN INCLINED PLANE

PLATE 12

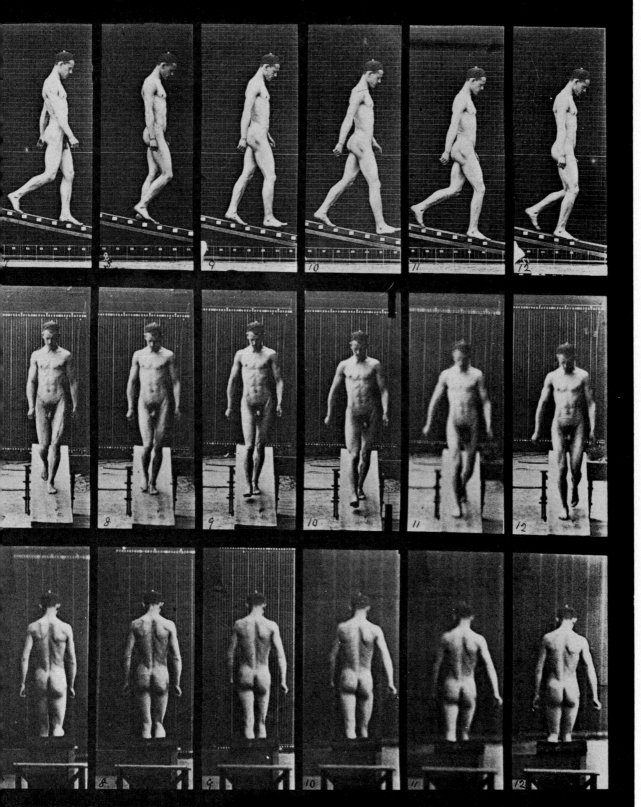

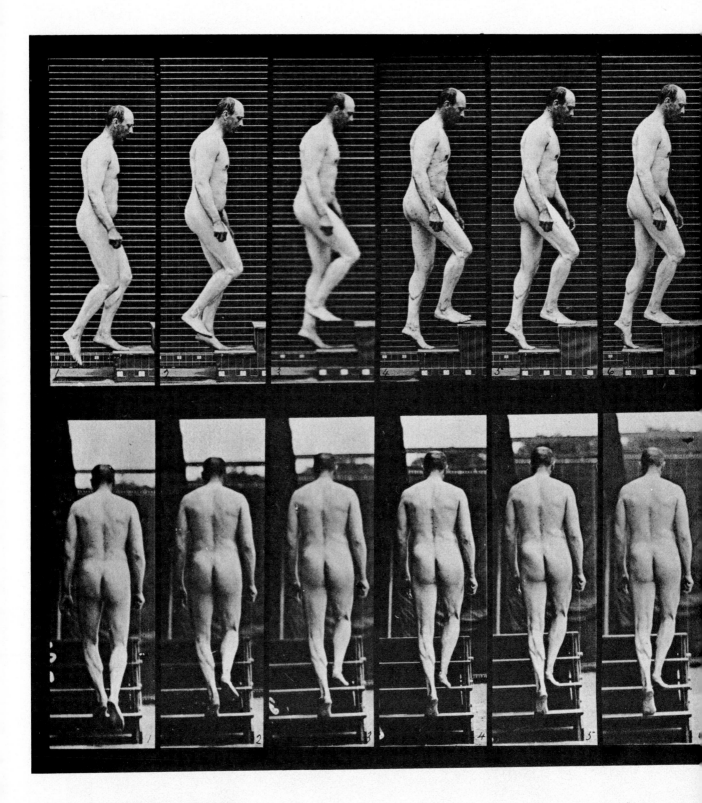

ELDERLY MAN WALKING UPSTAIRS

PLATE 13

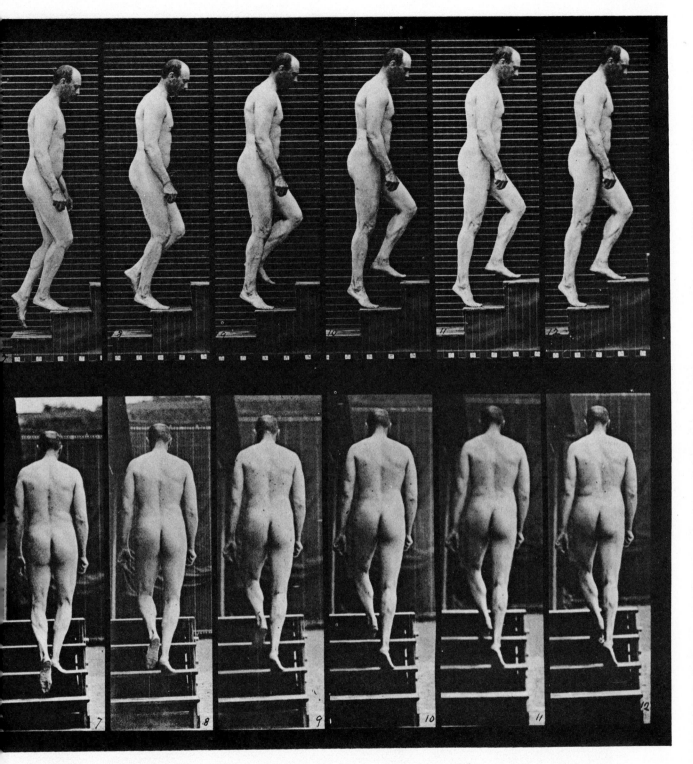

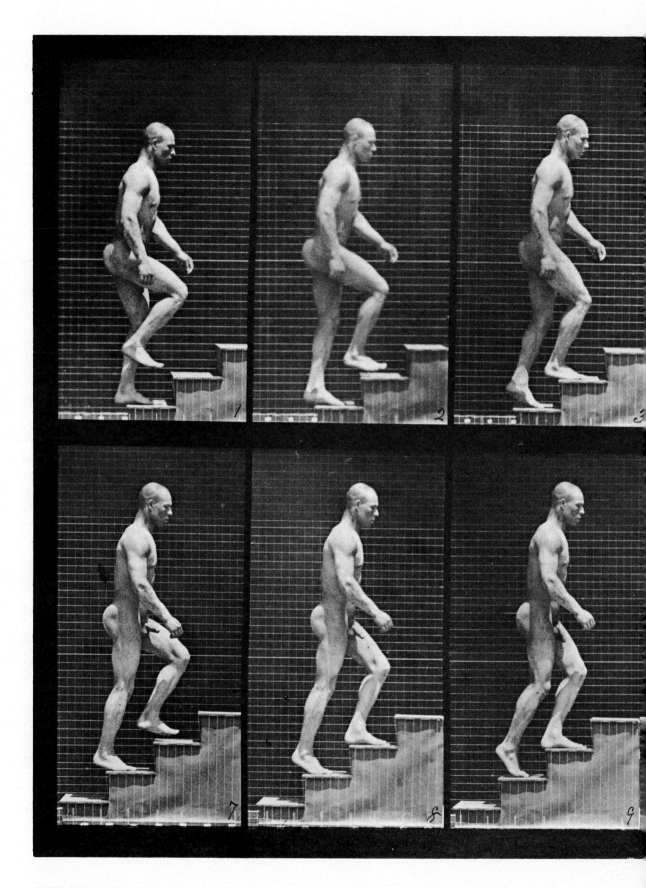

MAN WALKING UPSTAIRS

PLATE 14

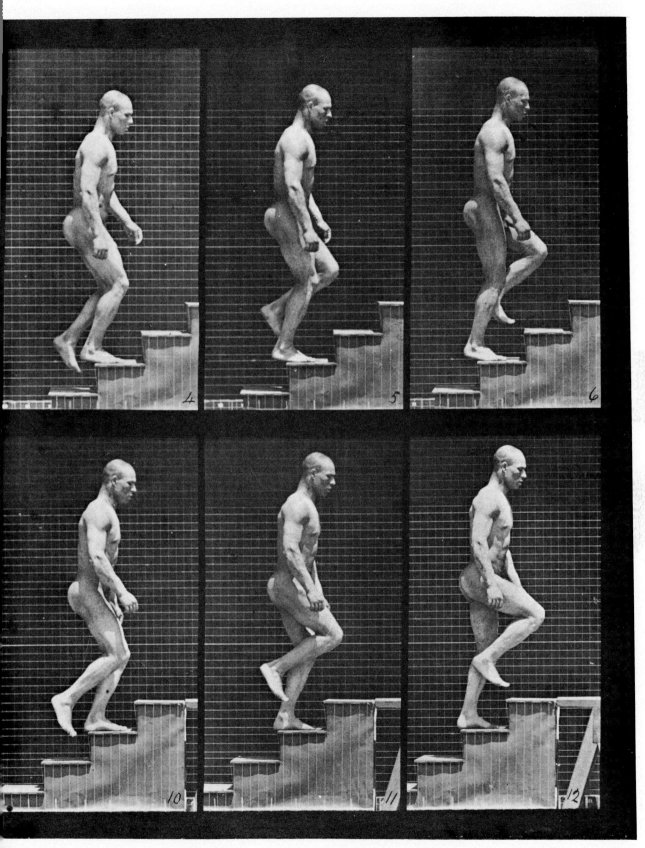

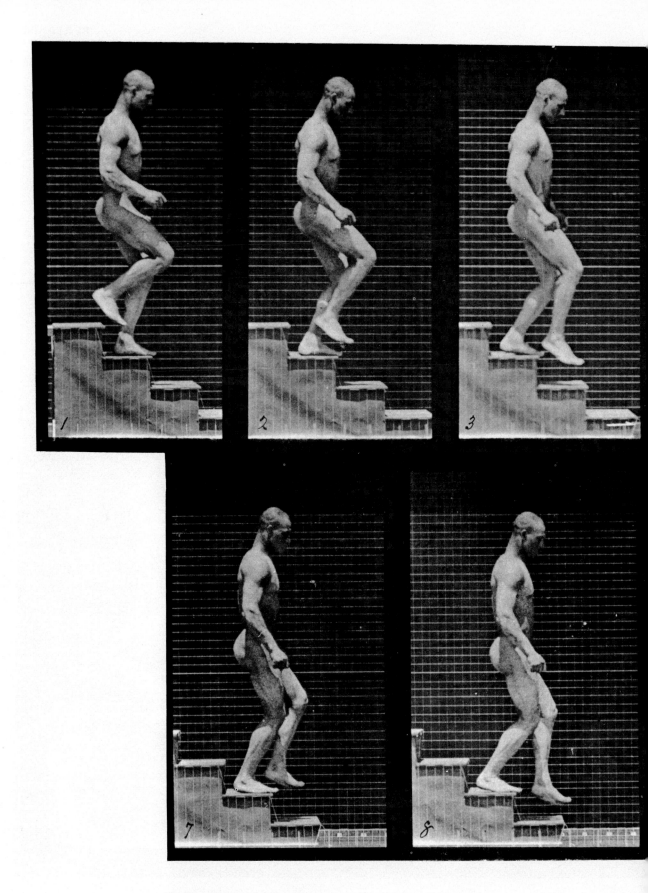

MAN WALKING DOWNSTAIRS

PLATE 15

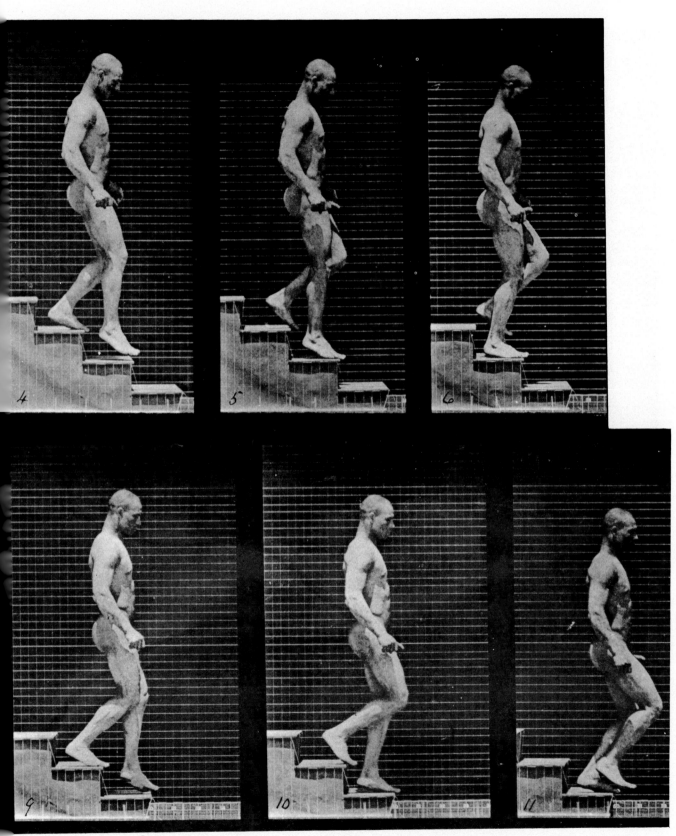

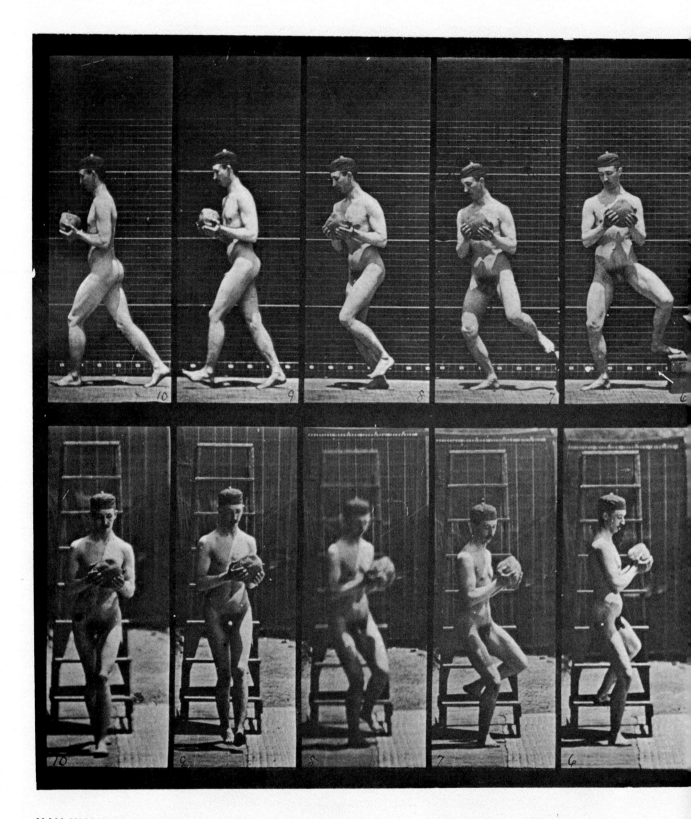

MAN WALKING DOWNSTAIRS BACKWARDS, TURNING, WALKING AWAY WHILE CARRYING ROCK

PLATE 16

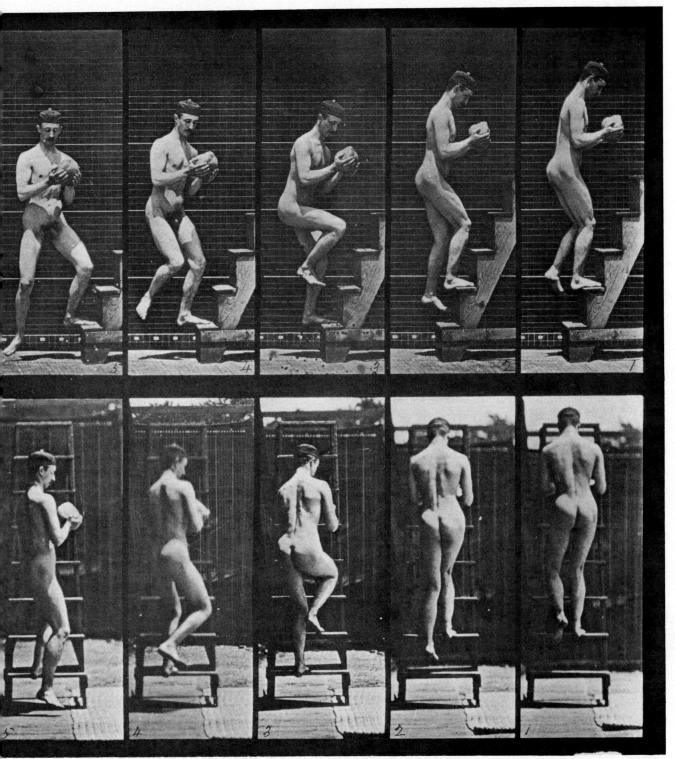

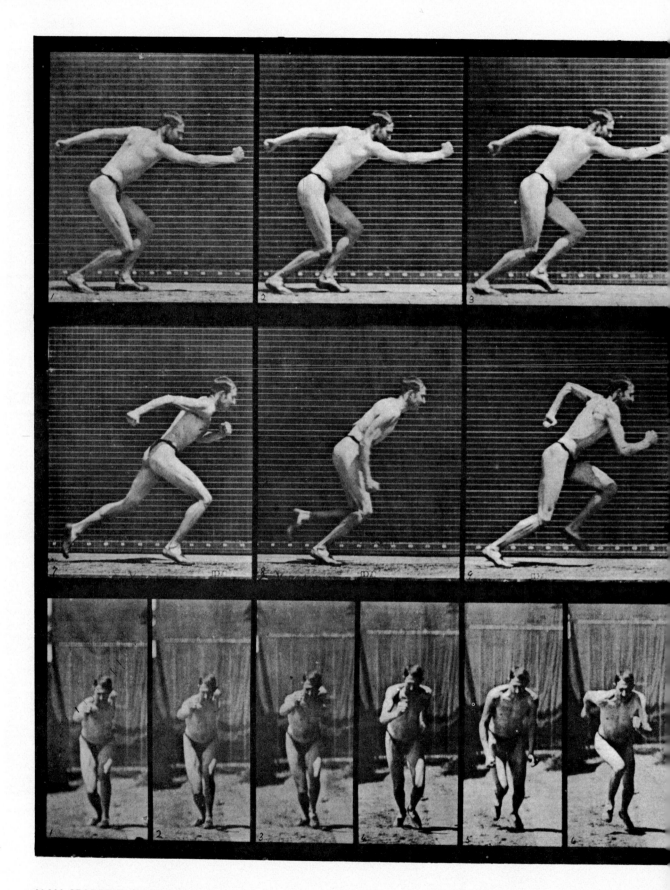

MAN STARTING RACE (.093 second)

PLATE 17

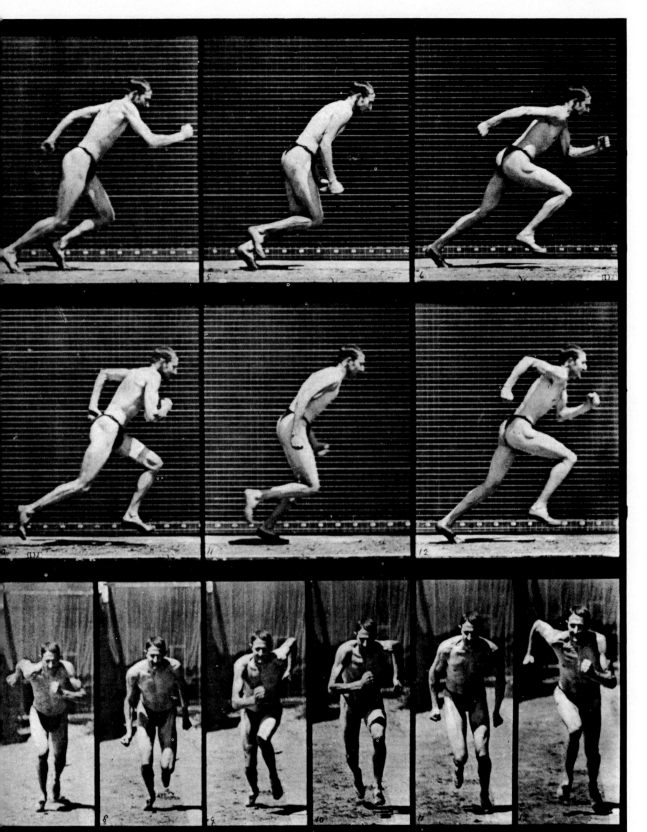

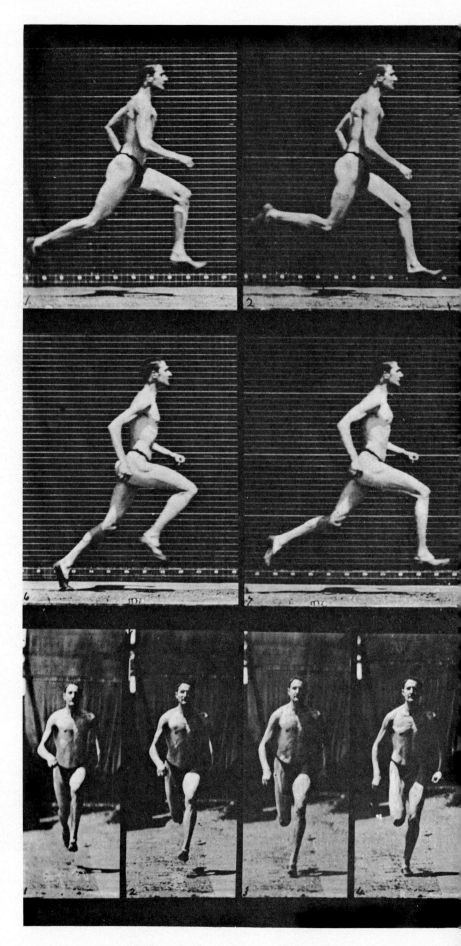

MAN RUNNING (.042 second)

PLATE 18

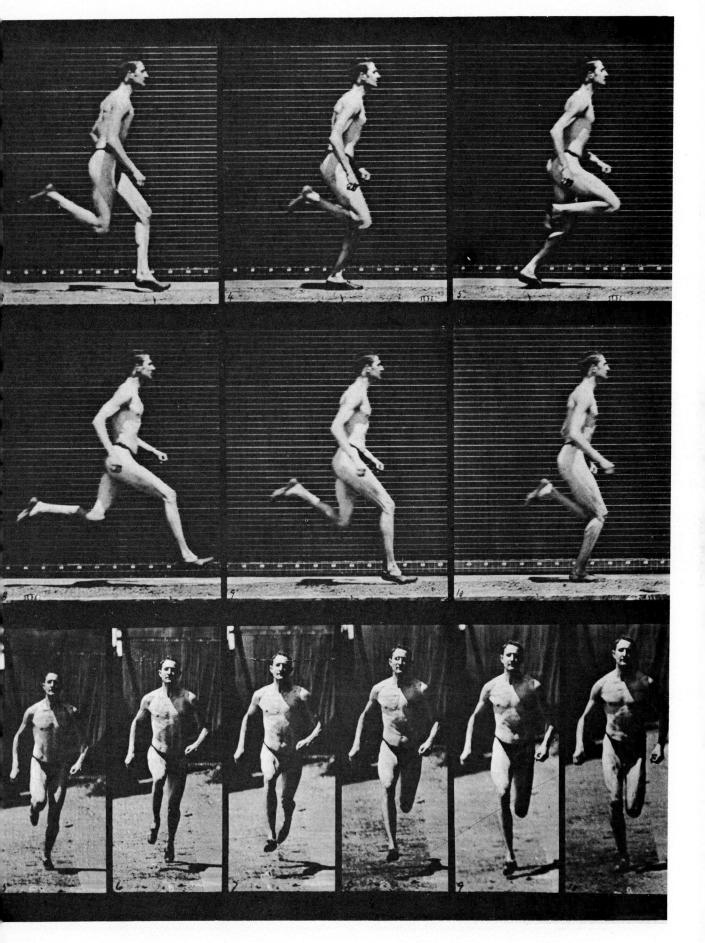

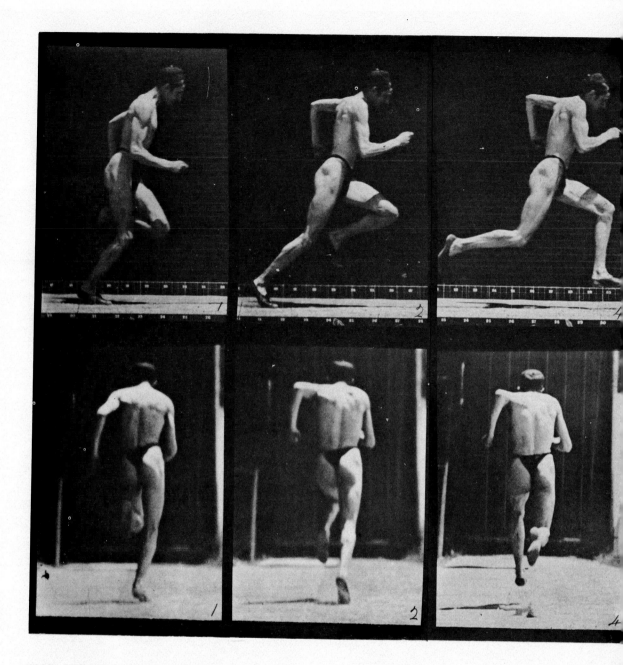

MAN RUNNING

PLATE 19

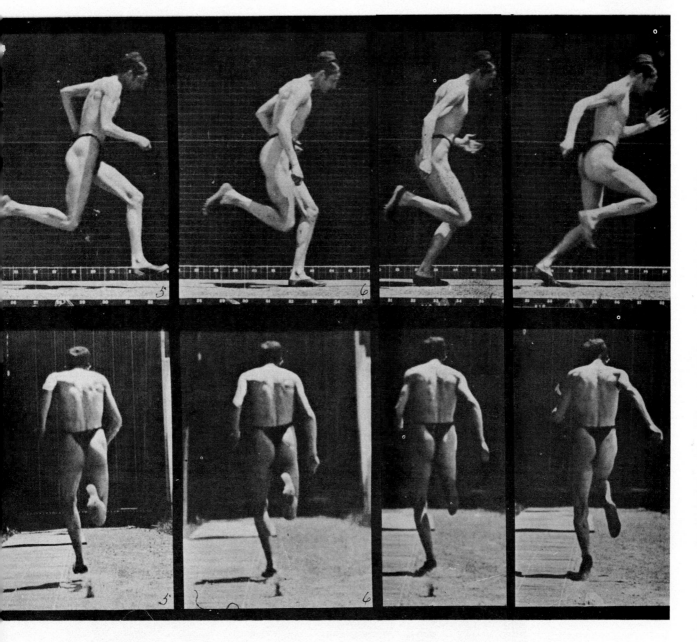

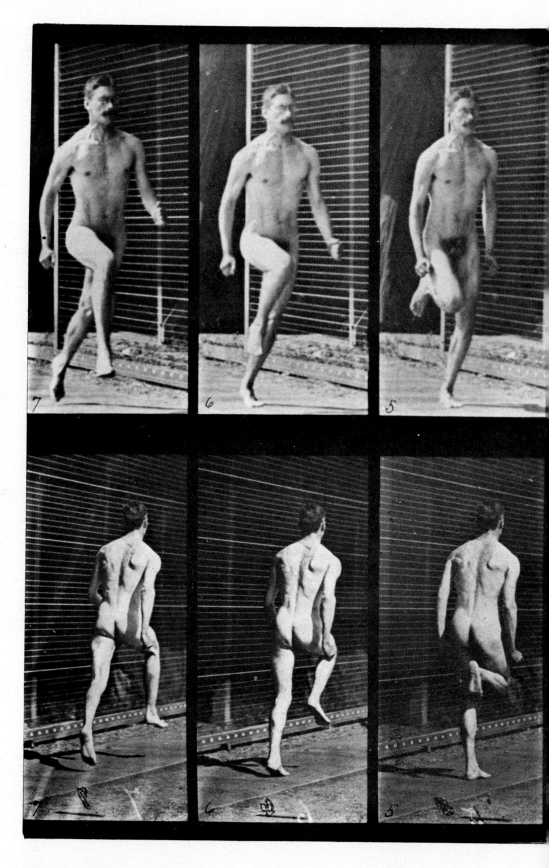

MAN RUNNING (.057 second)

PLATE 20

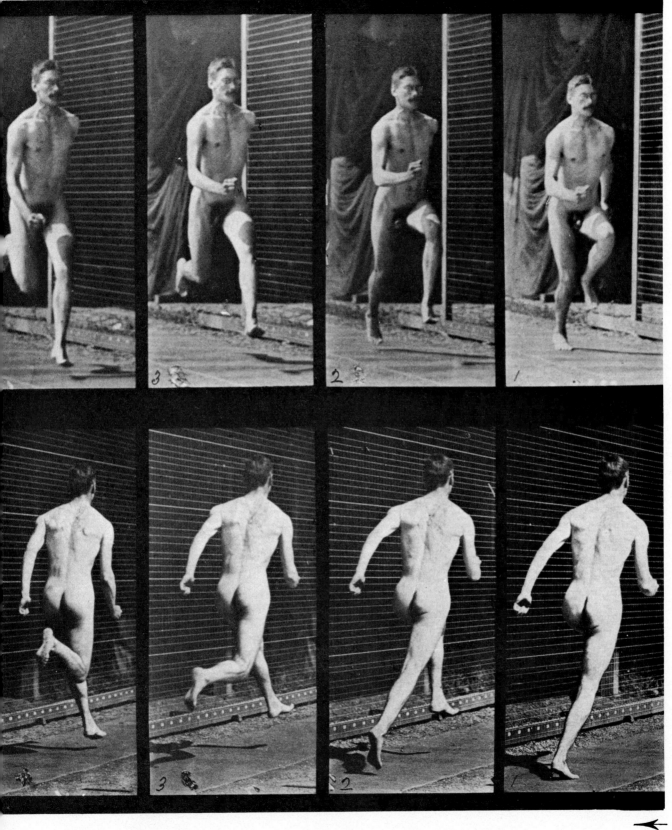

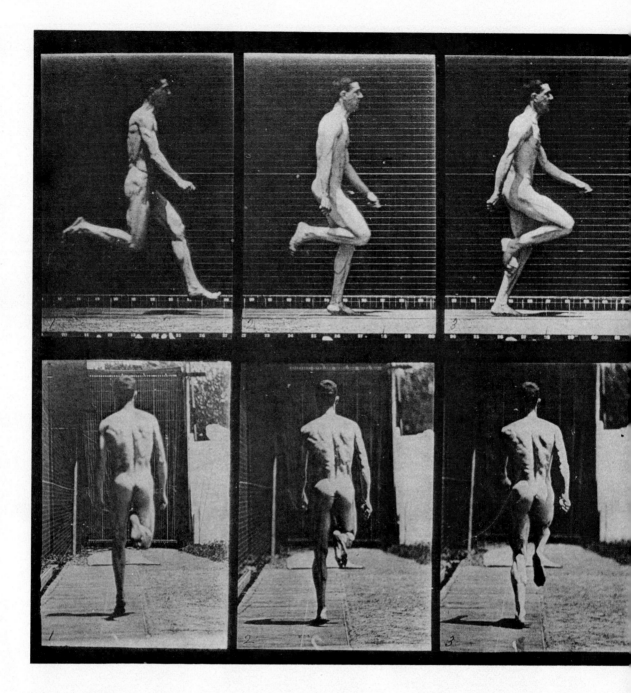

MAN RUNNING

PLATE 21

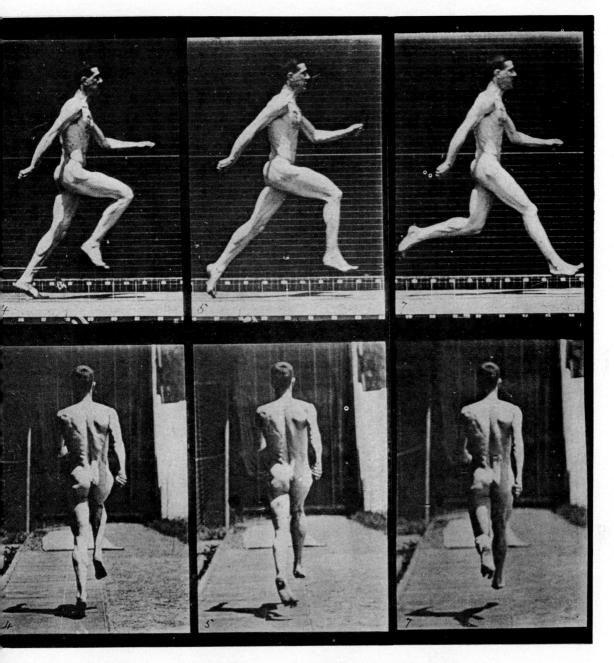

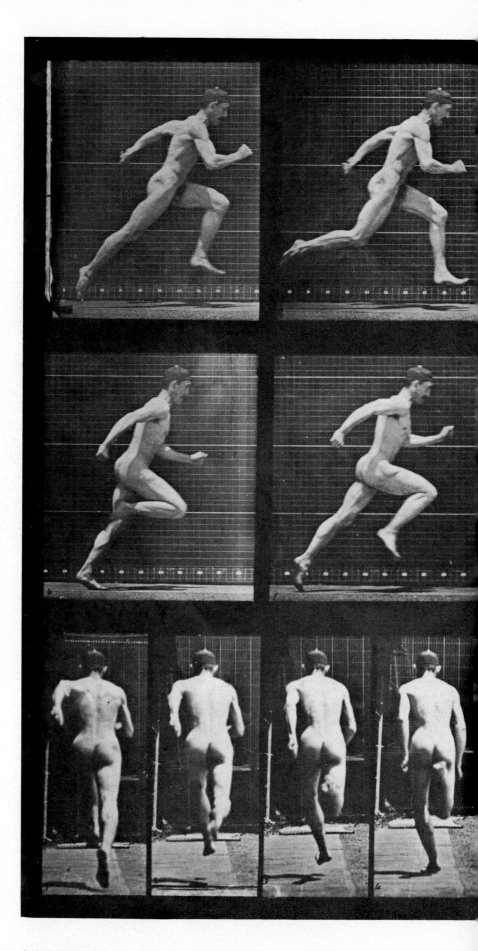

MAN RUNNING

PLATE 22

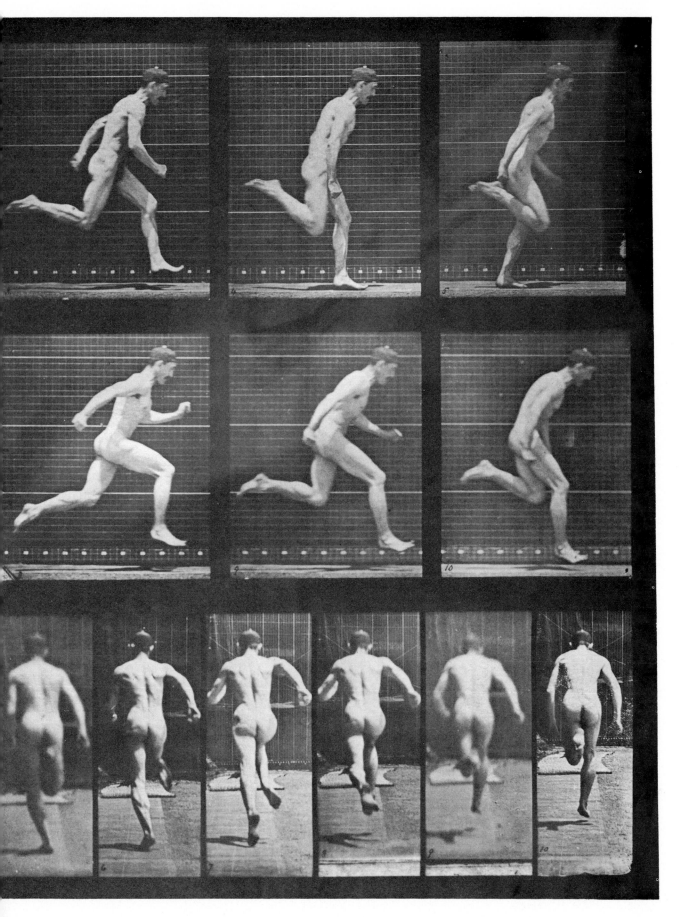

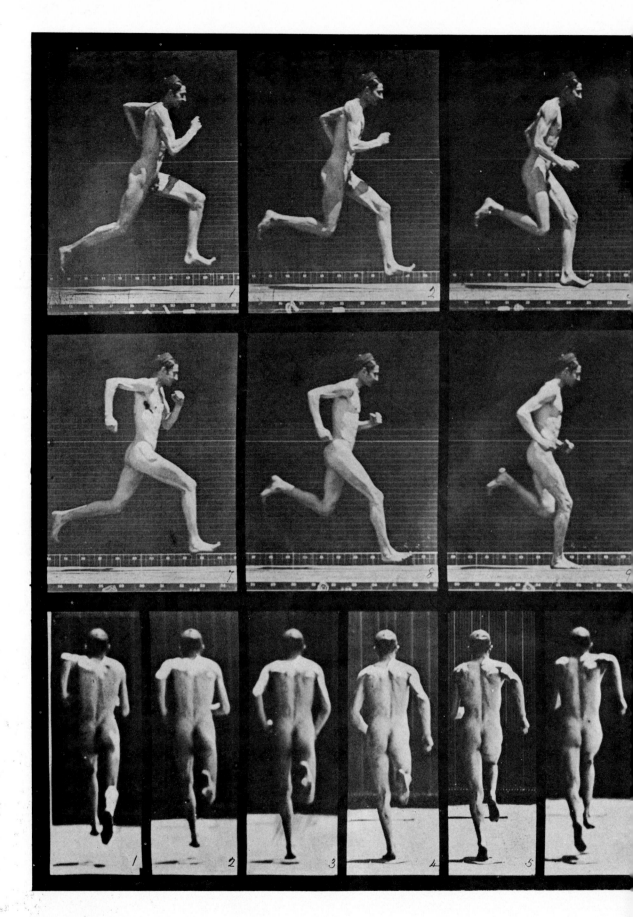

MAN RUNNING

PLATE 23

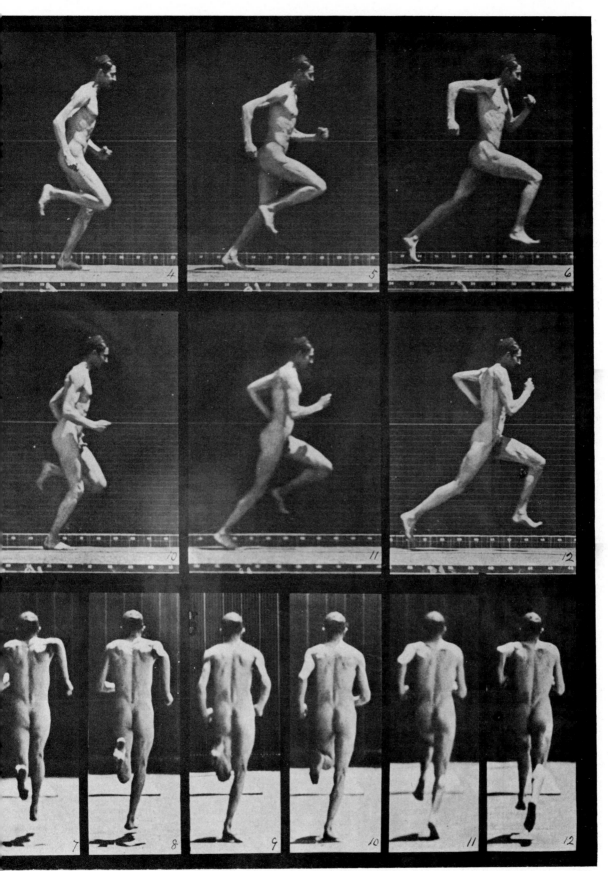

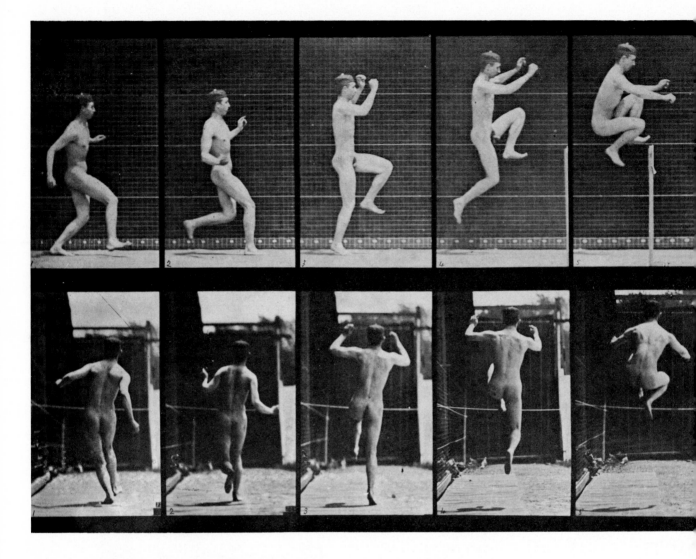

MAN PERFORMING STRAIGHT HIGH JUMP

PLATE 24

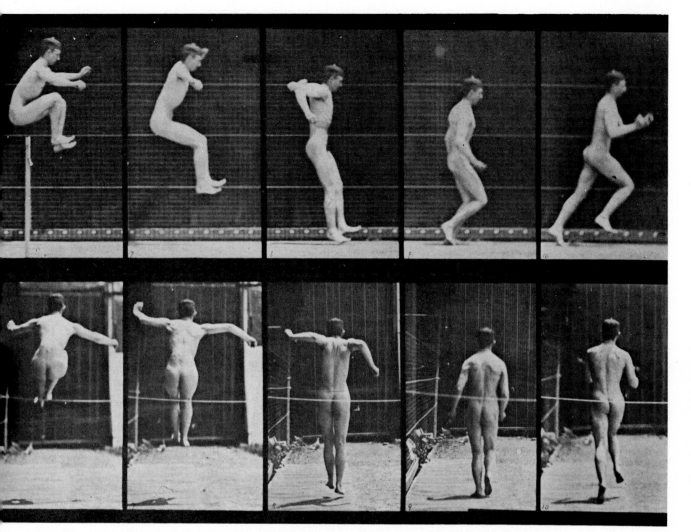

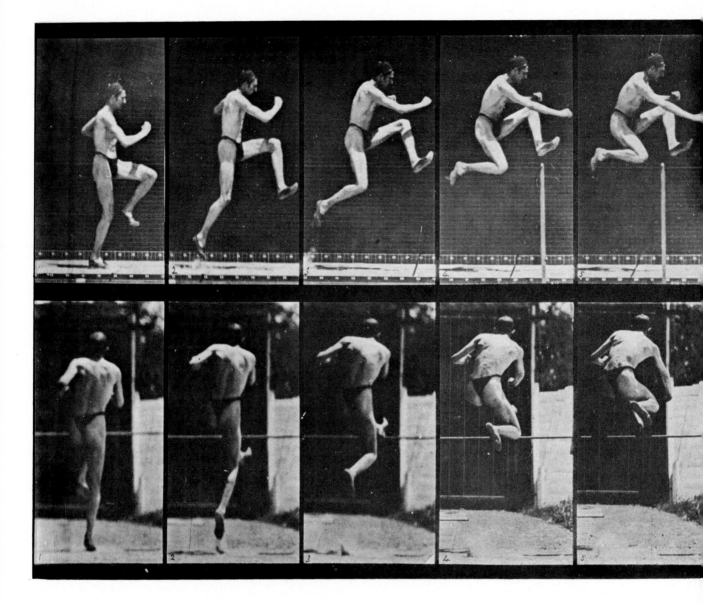

MAN PERFORMING STRAIGHT HIGH JUMP (.063 second)

PLATE 25

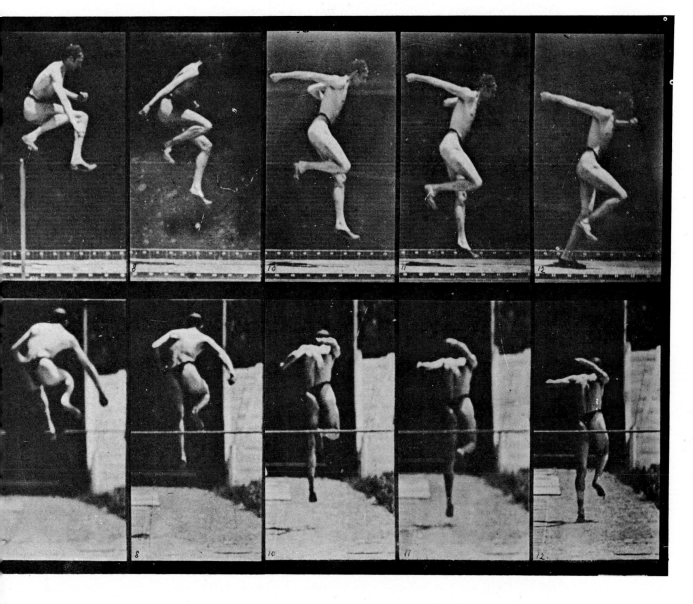

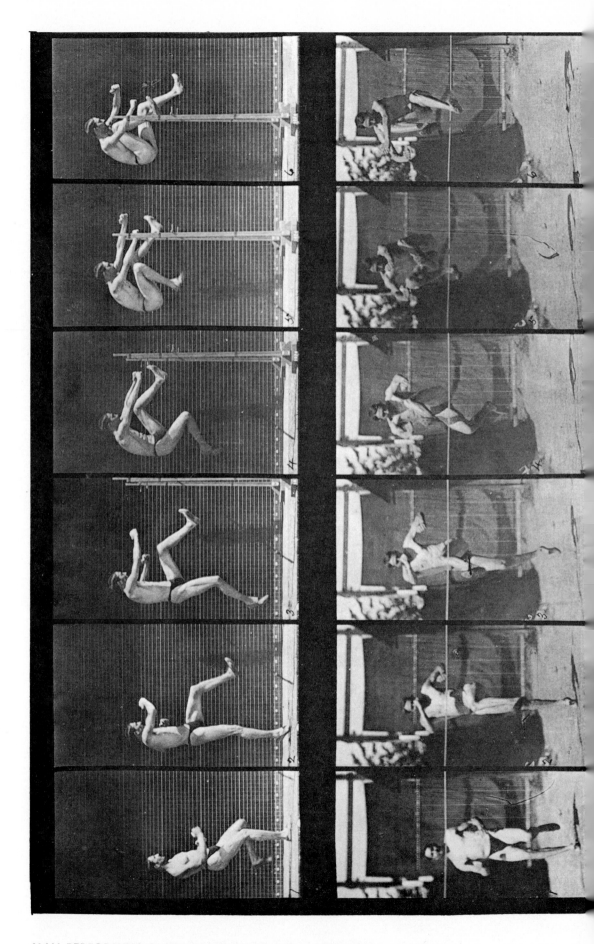

MAN PERFORMING RUNNING STRAIGHT HIGH JUMP (.087 second)

PLATE 26

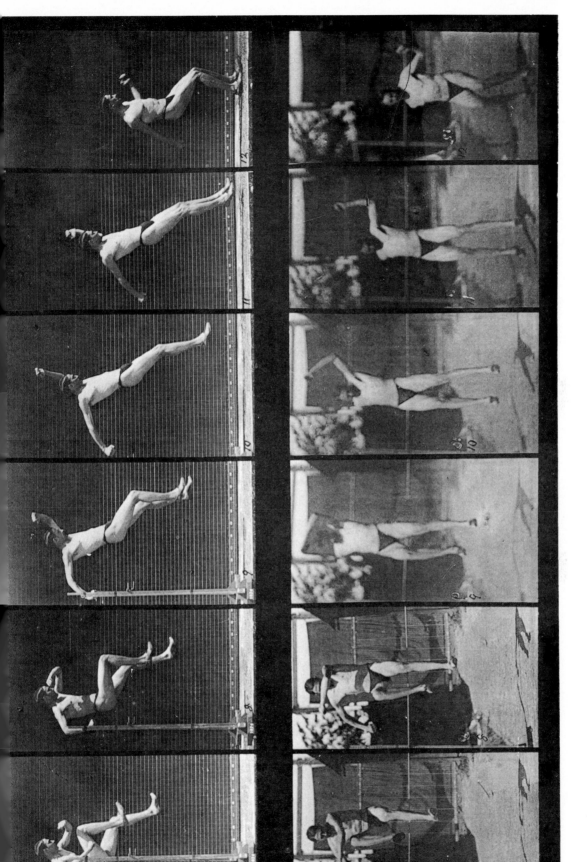

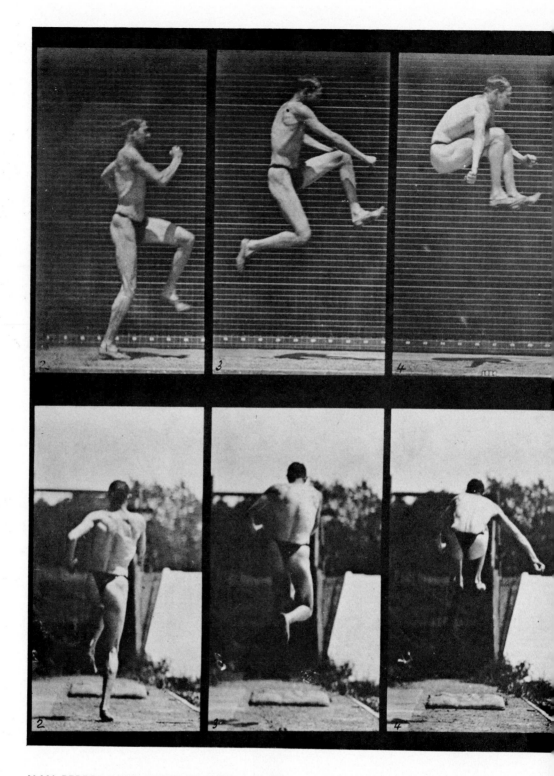

MAN PERFORMING RUNNING BROAD JUMP

PLATE 27

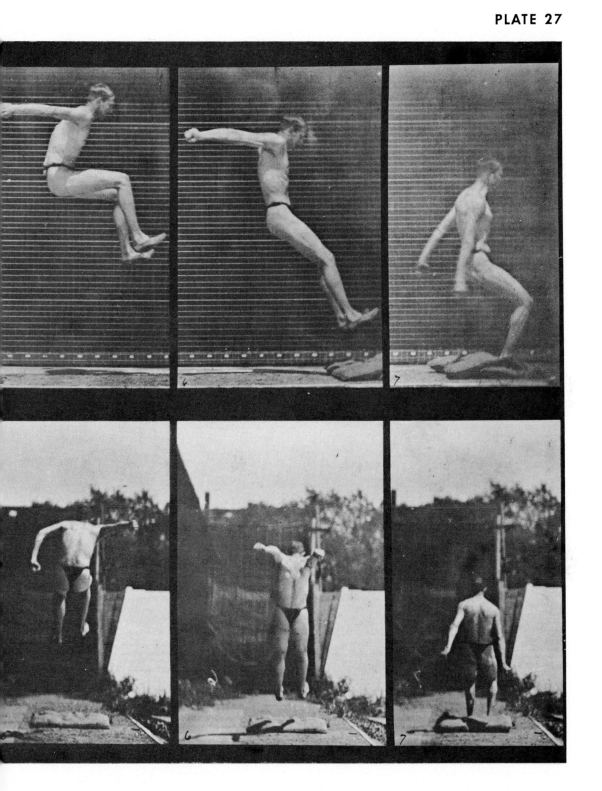

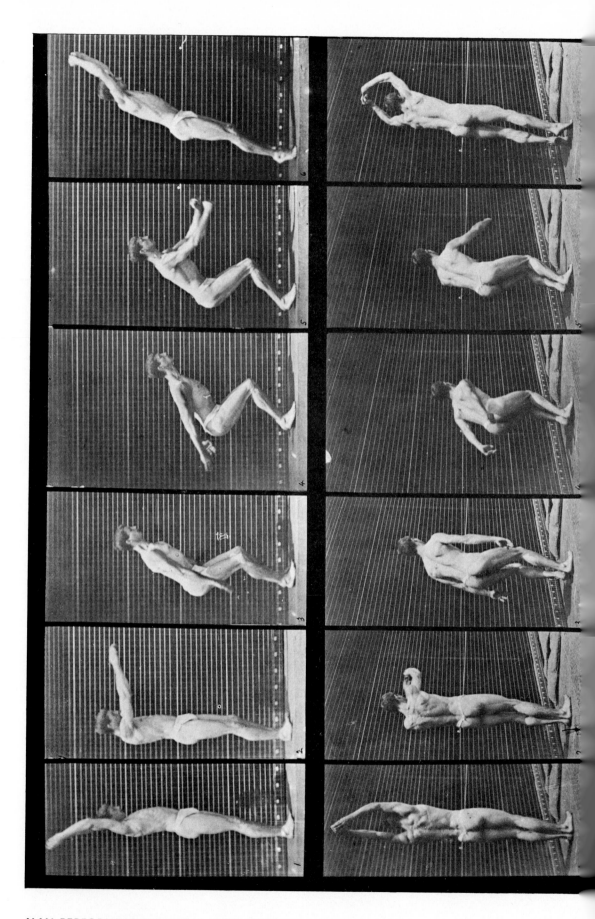

MAN PERFORMING STANDING HIGH JUMP (.139 second)

PLATE 28

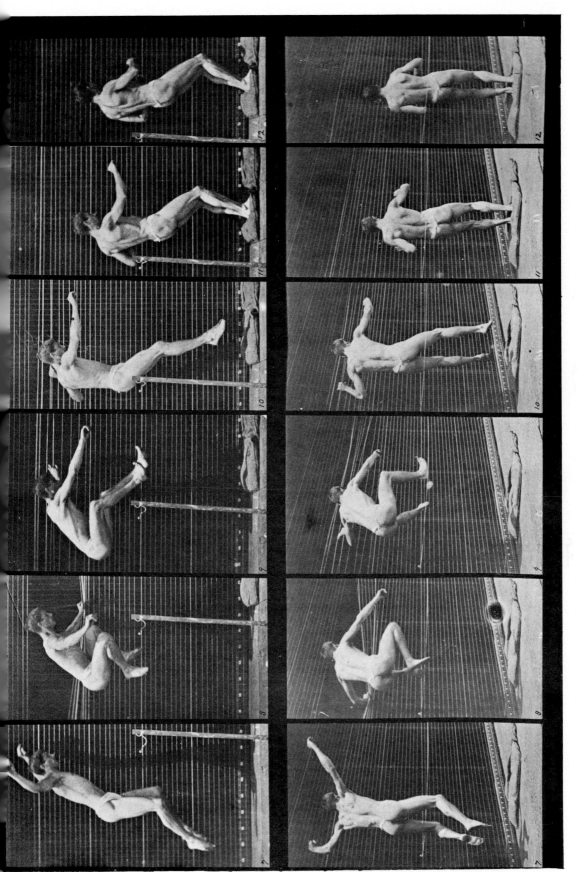

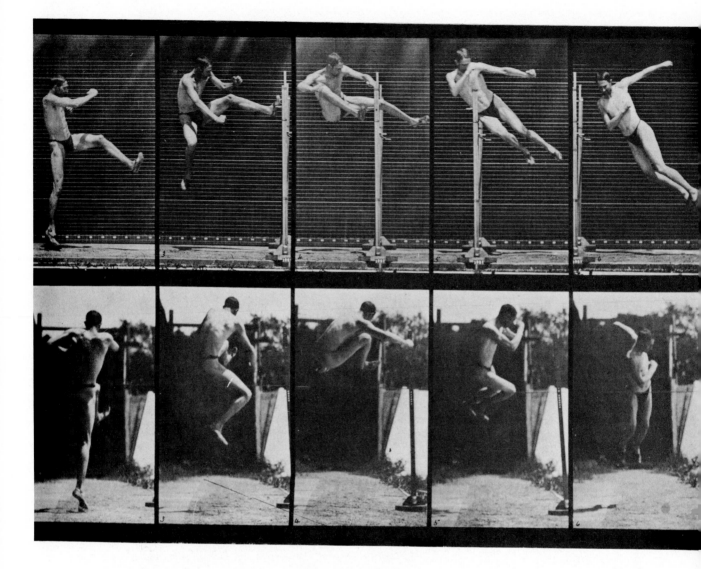

MAN PERFORMING RUNNING TWIST HIGH JUMP (.160 second)

PLATE 29

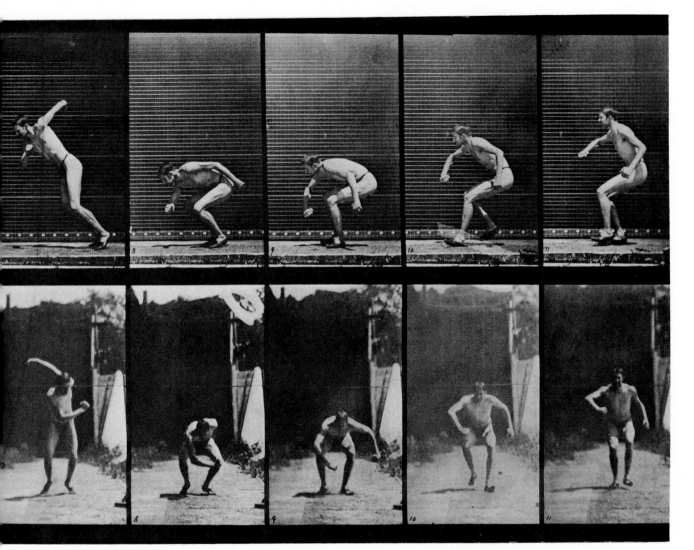

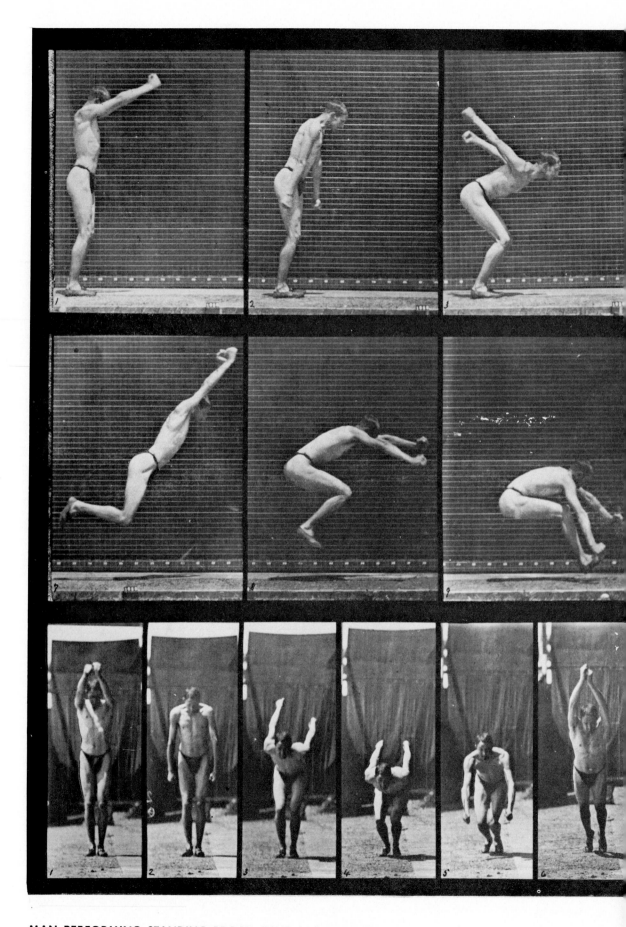

MAN PERFORMING STANDING BROAD JUMP (.156 second)

PLATE 30

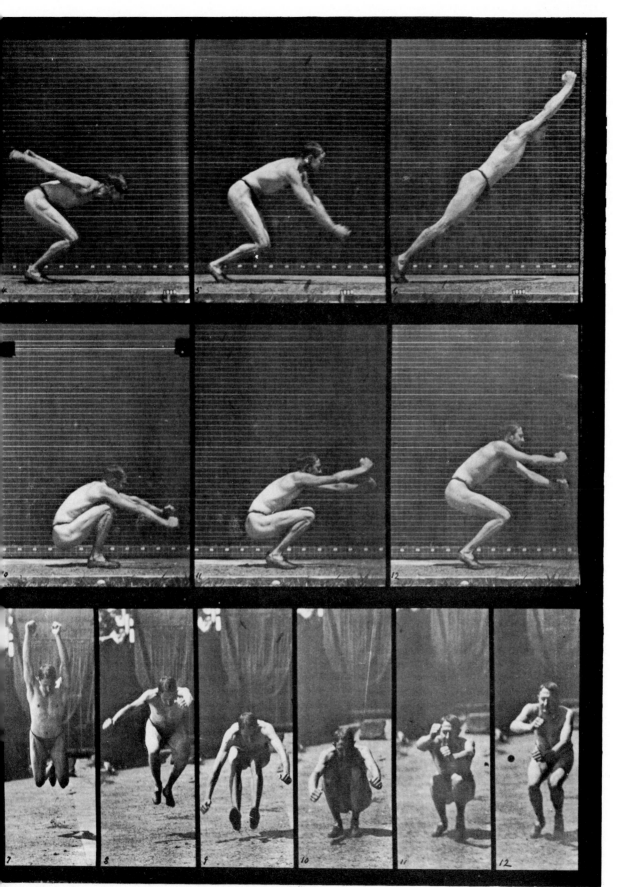

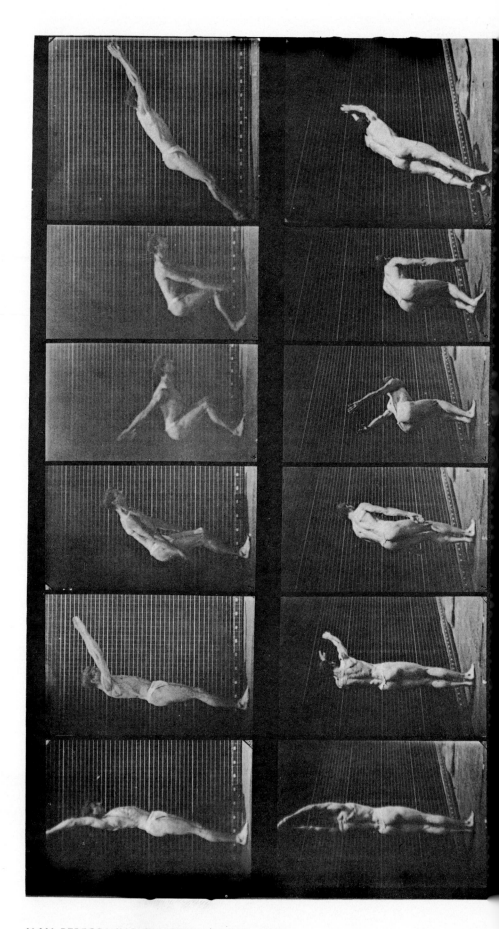

MAN PERFORMING STANDING BROAD JUMP

PLATE 31

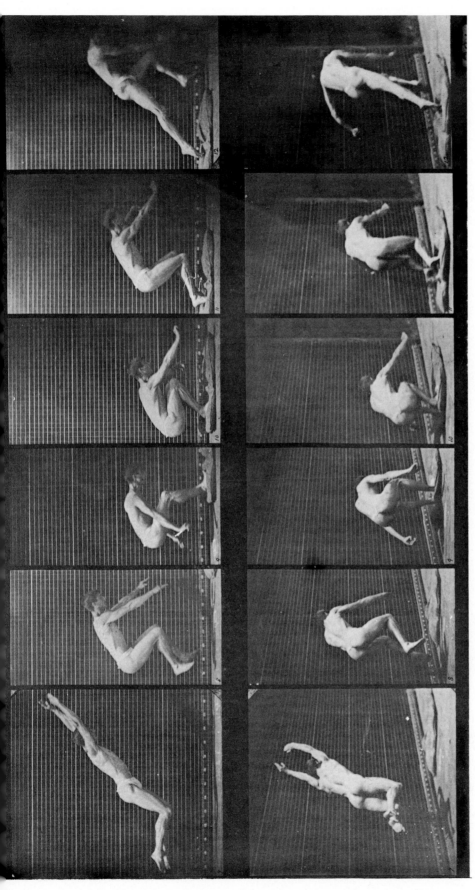

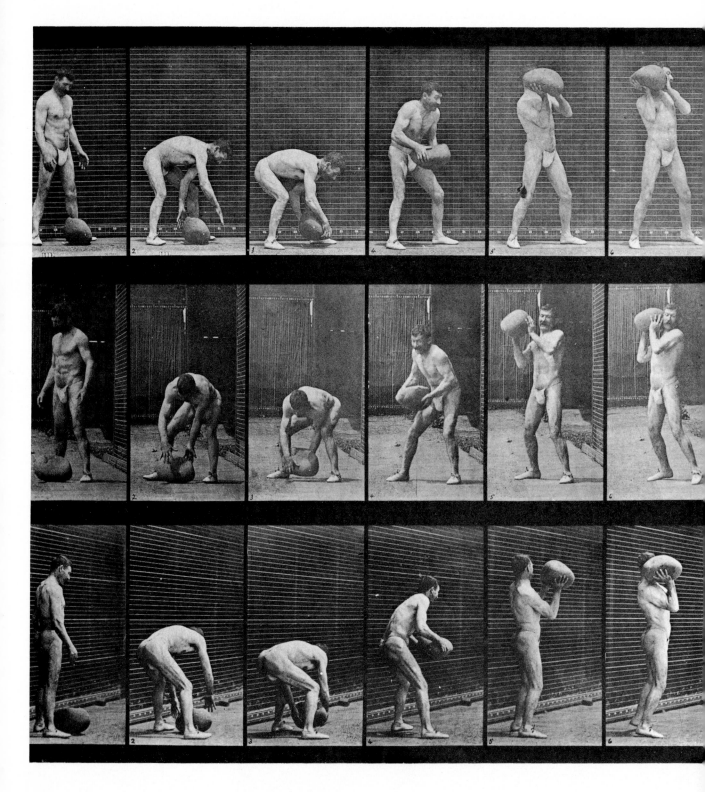

MAN LIFTING AND HEAVING 75-LB. BOULDER (.489 second)

PLATE 32

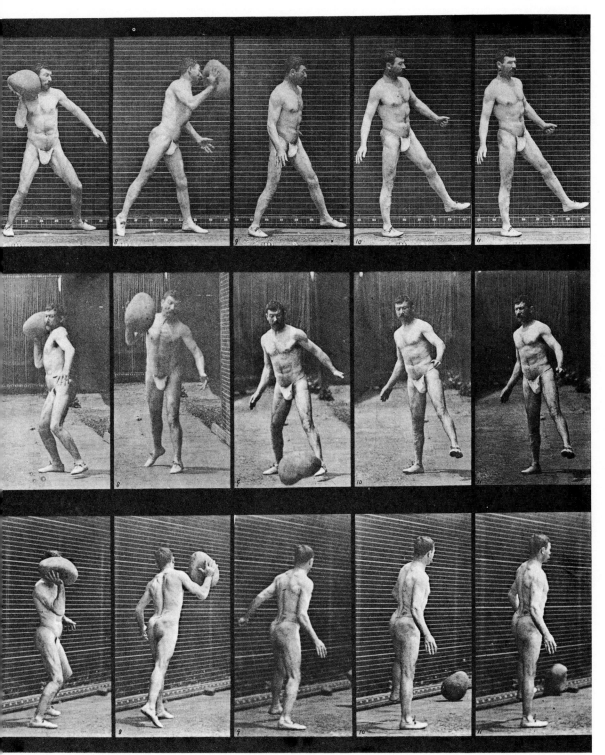

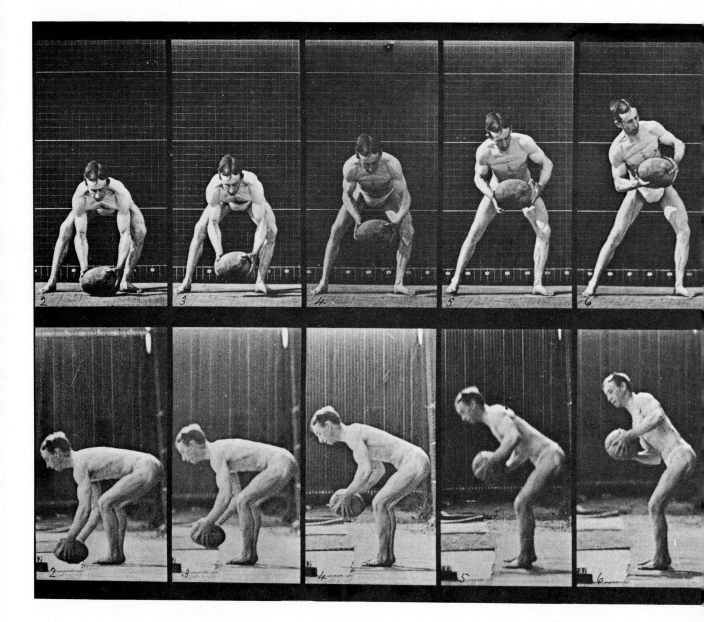

MAN LIFTING 75-LB. BOULDER

PLATE 33

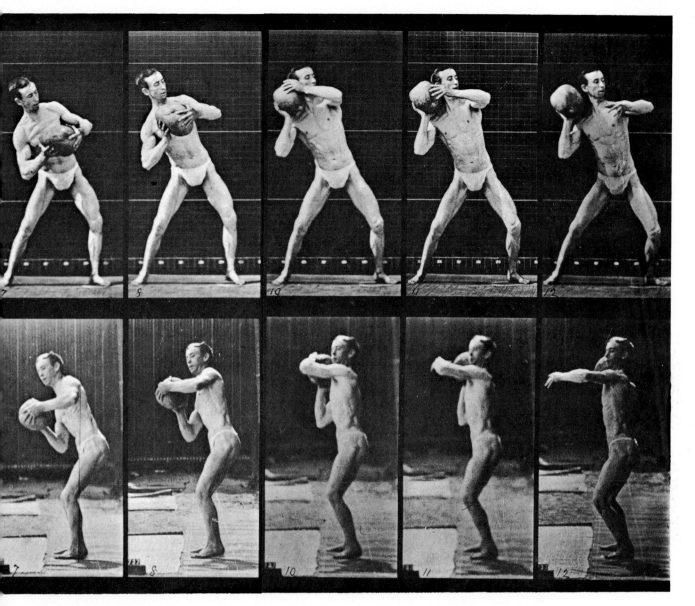

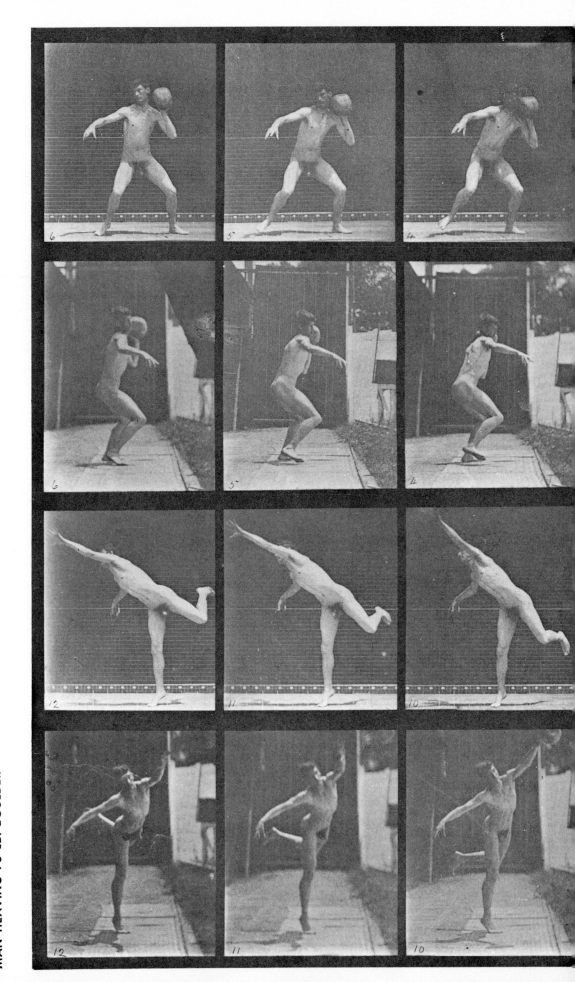

MAN HEAVING 75-LB. BOULDER

PLATE 34

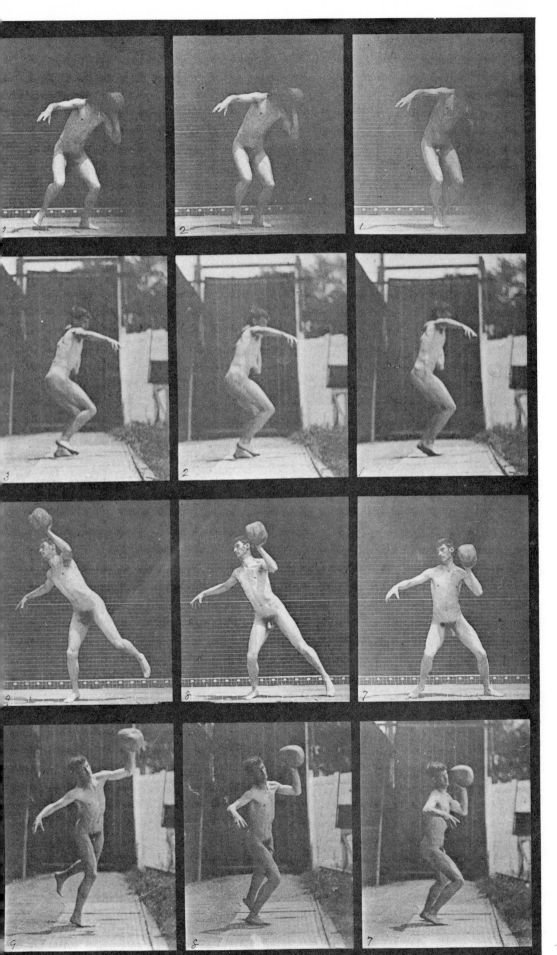

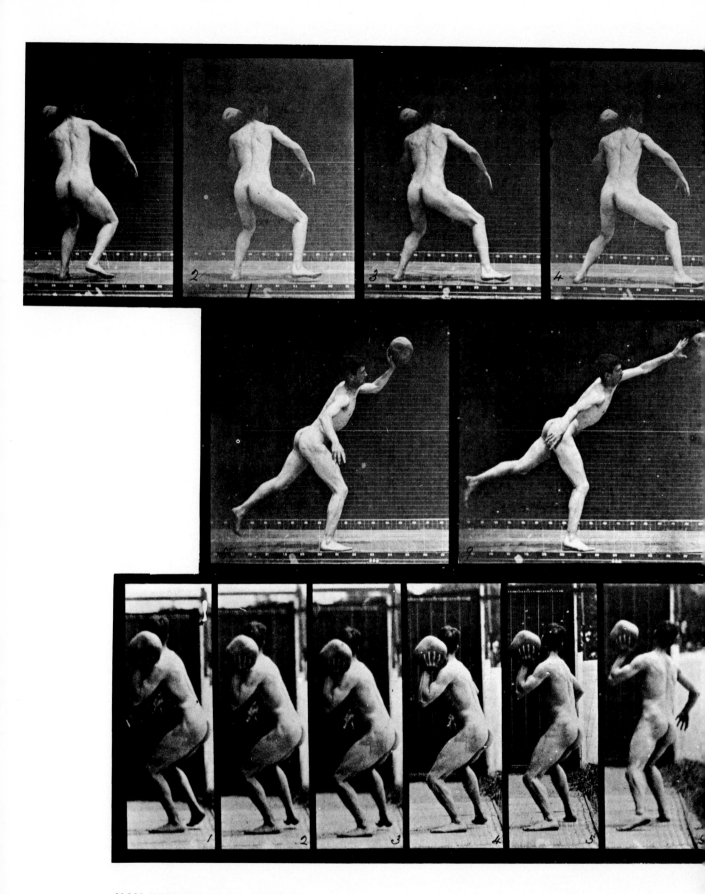

MAN HEAVING 75-LB. BOULDER

PLATE 35

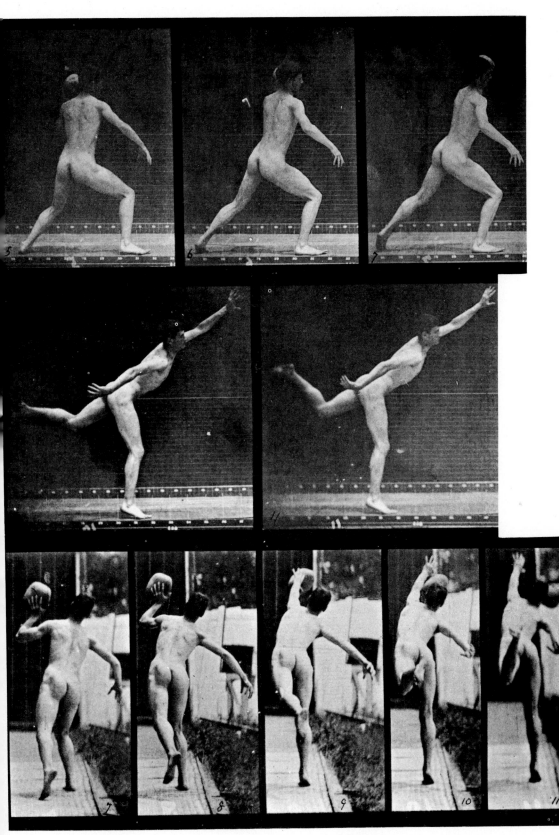

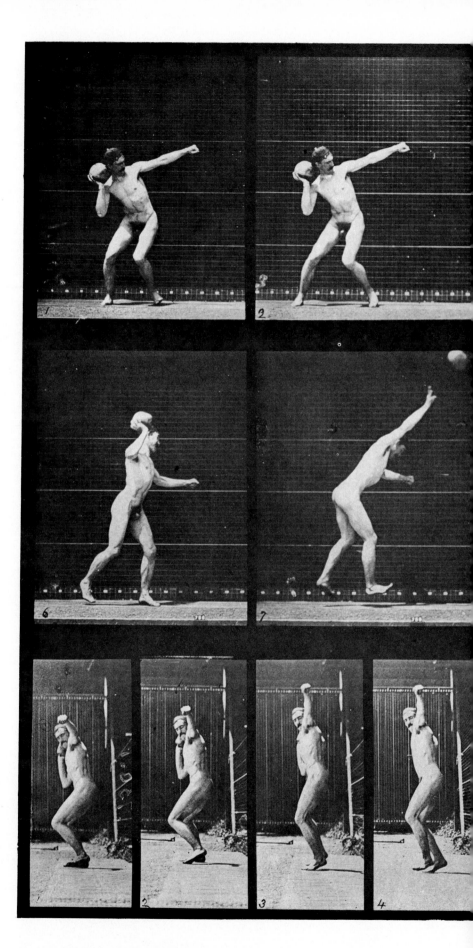

MAN HEAVING 75-LB. BOULDER

PLATE 36

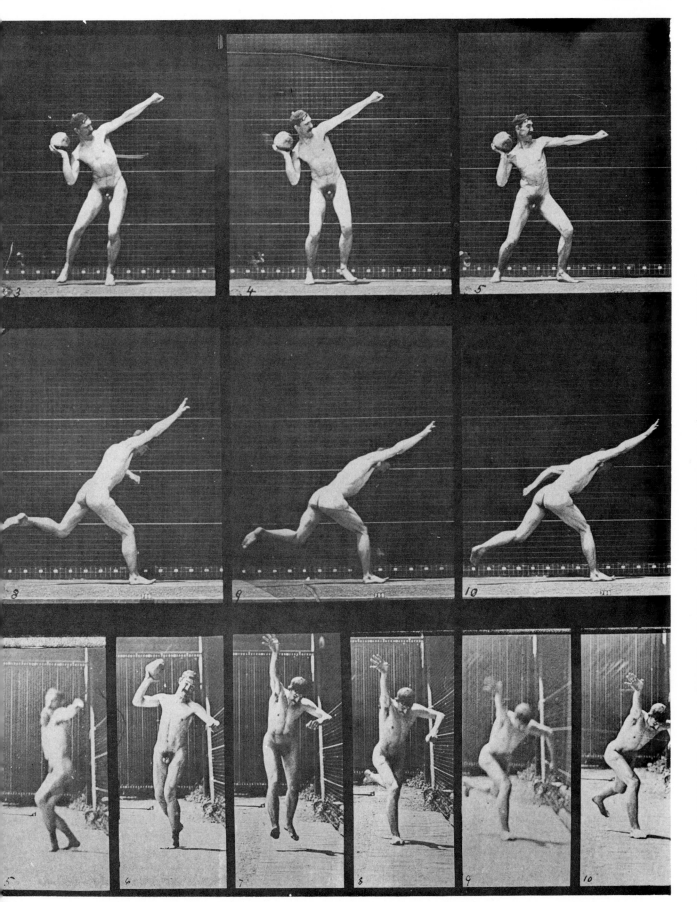

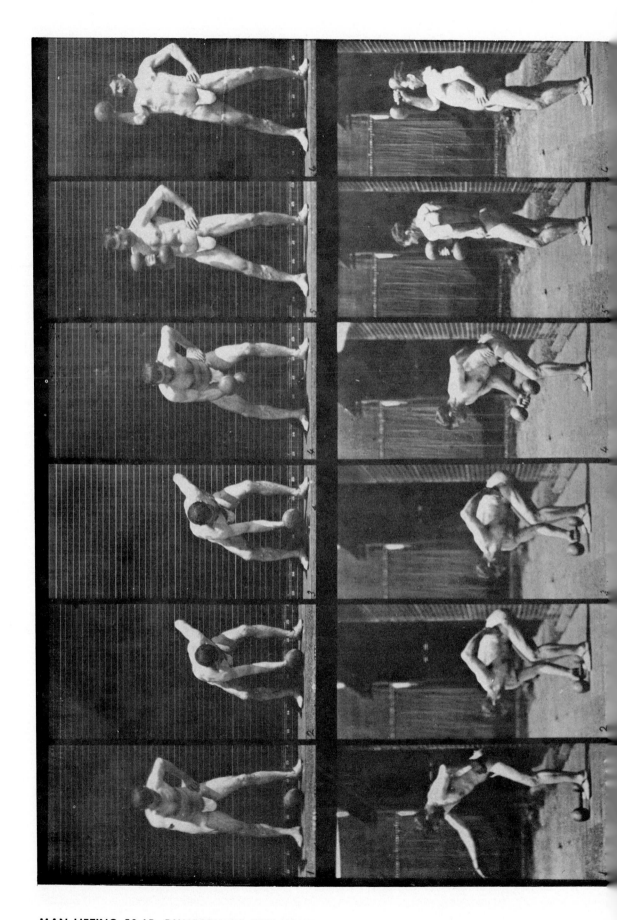

MAN LIFTING 50-LB. DUMBBELL IN ONE HAND

PLATE 37

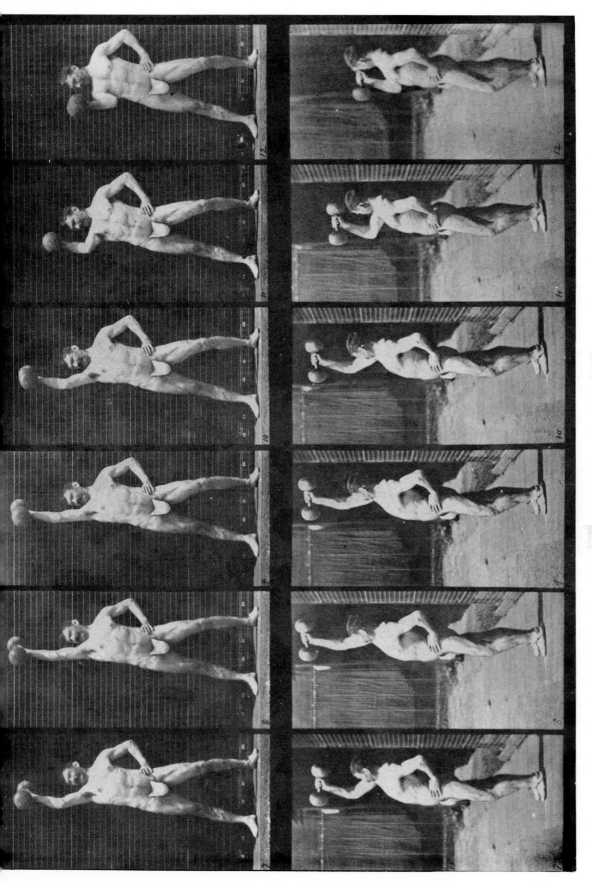

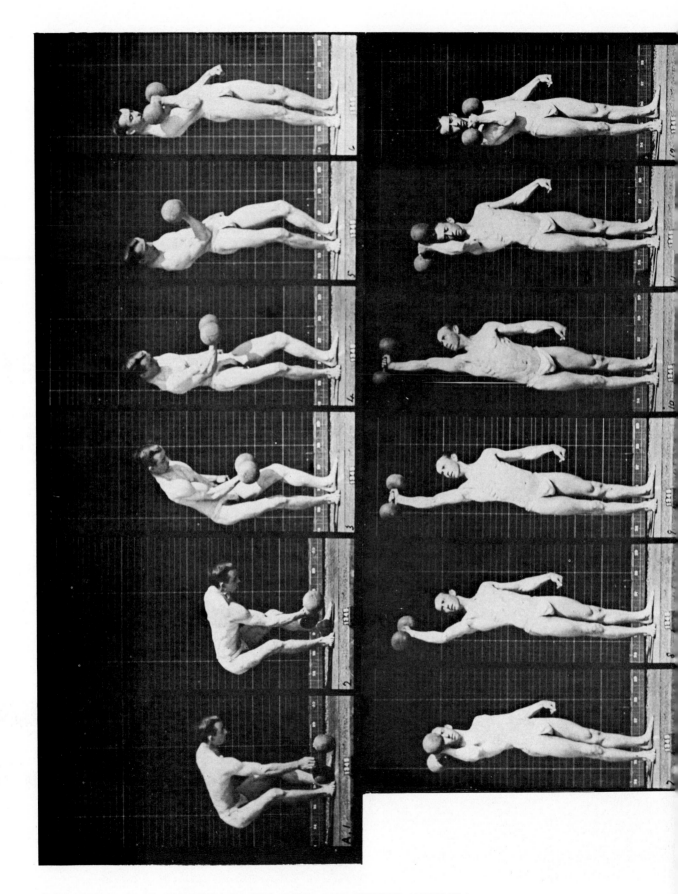

MAN LIFTING 50-LB. DUMBBELL IN ONE HAND AND FLEXING MUSCLES

PLATE 38

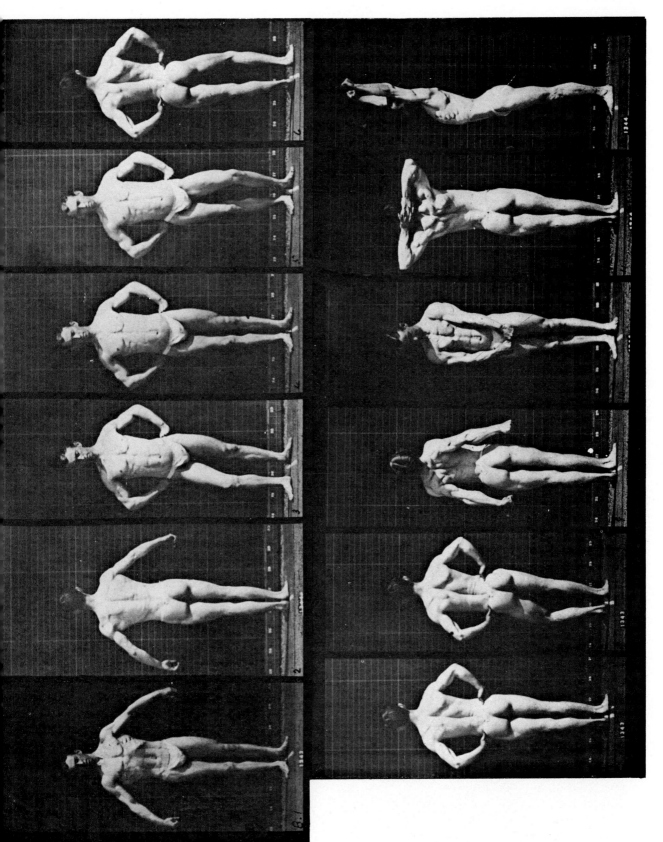

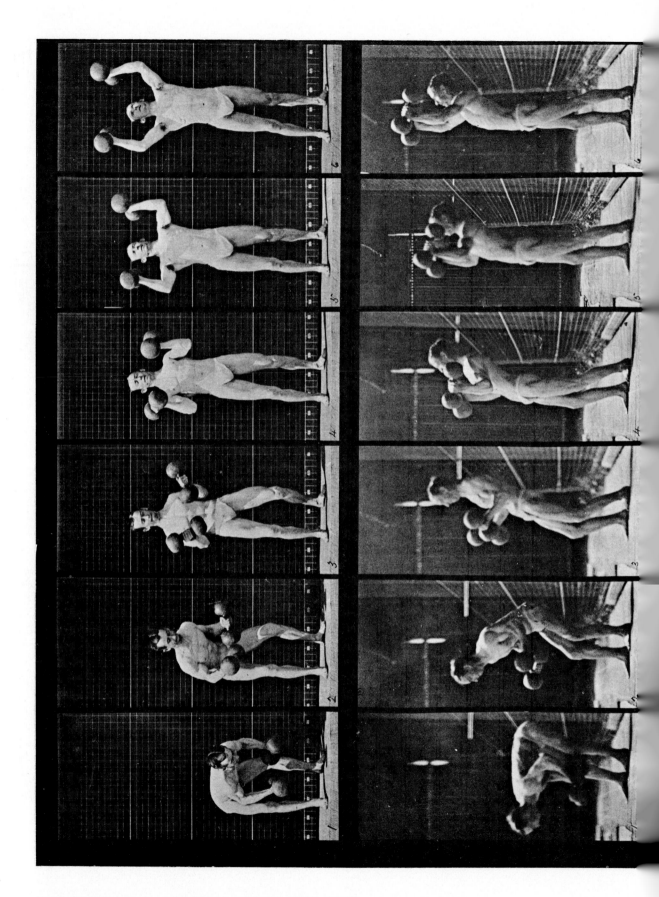

MAN LIFTING 50-LB. DUMBBELLS, ONE IN EACH HAND

PLATE 39

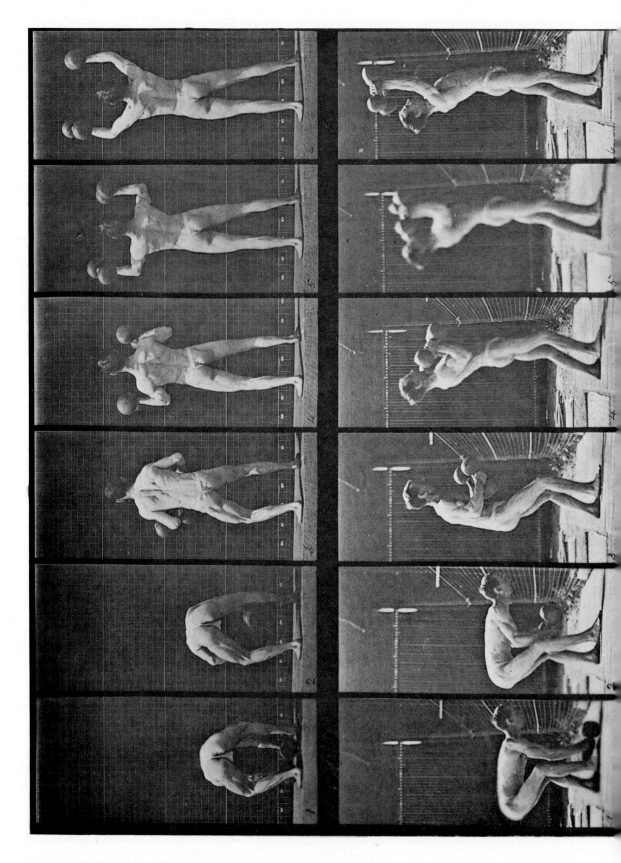

MAN LIFTING 50-LB. DUMBBELLS, ONE IN EACH HAND

PLATE 40

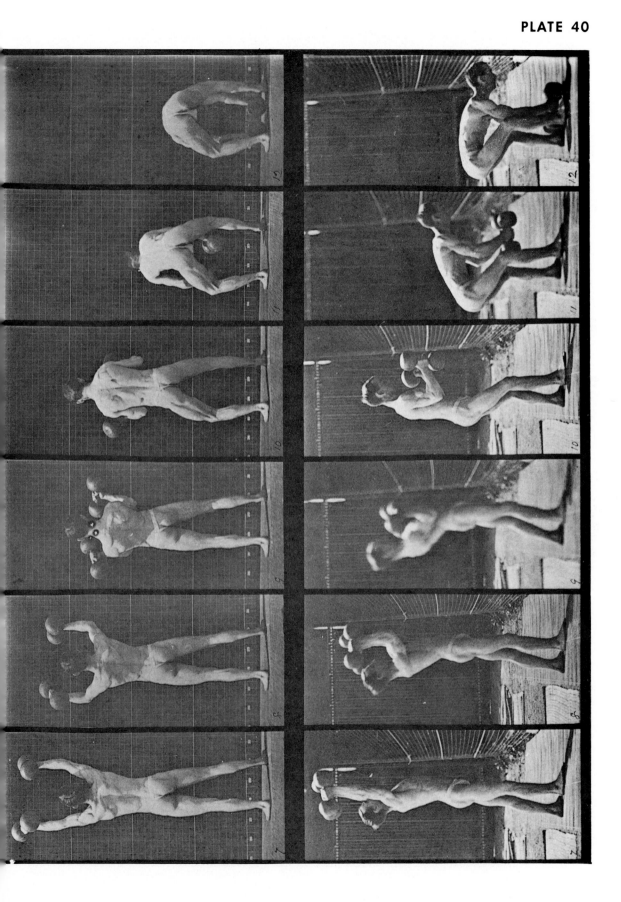

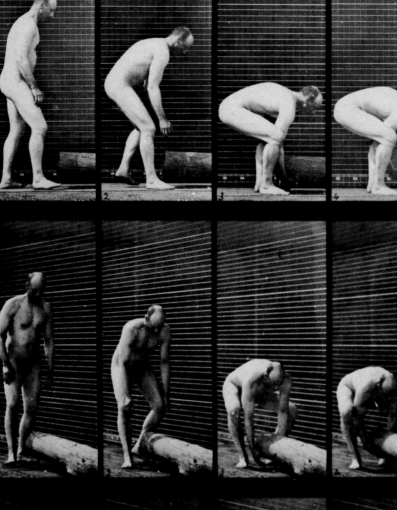
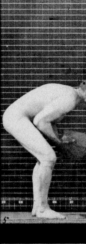

ELDERLY MAN LIFTING LOG

PLATE 41

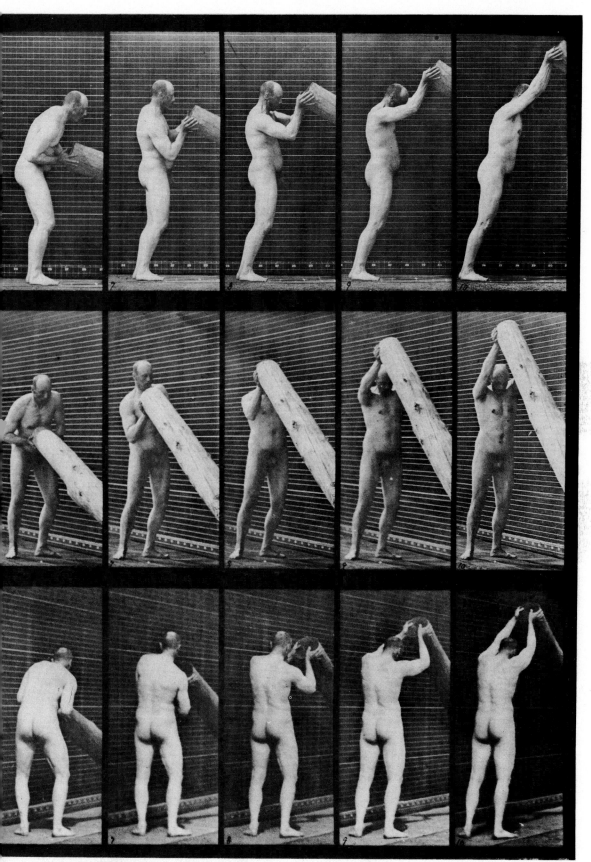

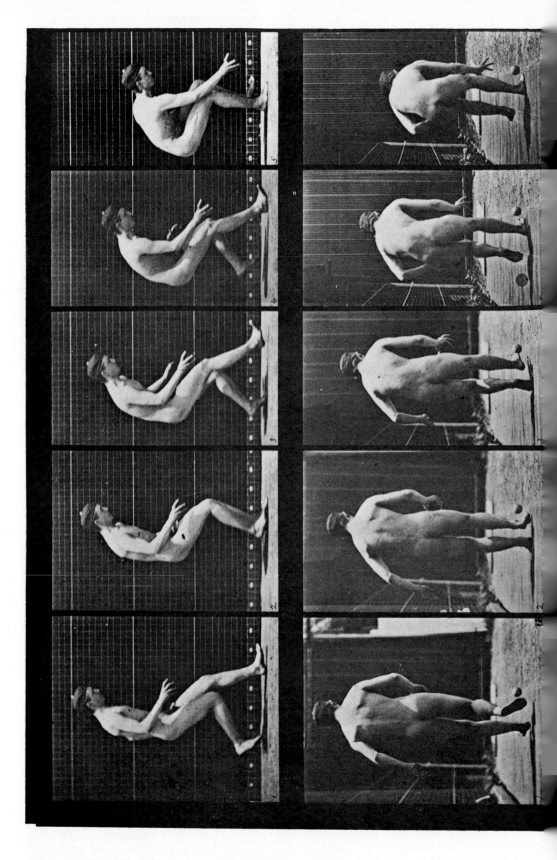

MAN PICKING UP AND THROWING BASEBALL (.075 second)

PLATE 42

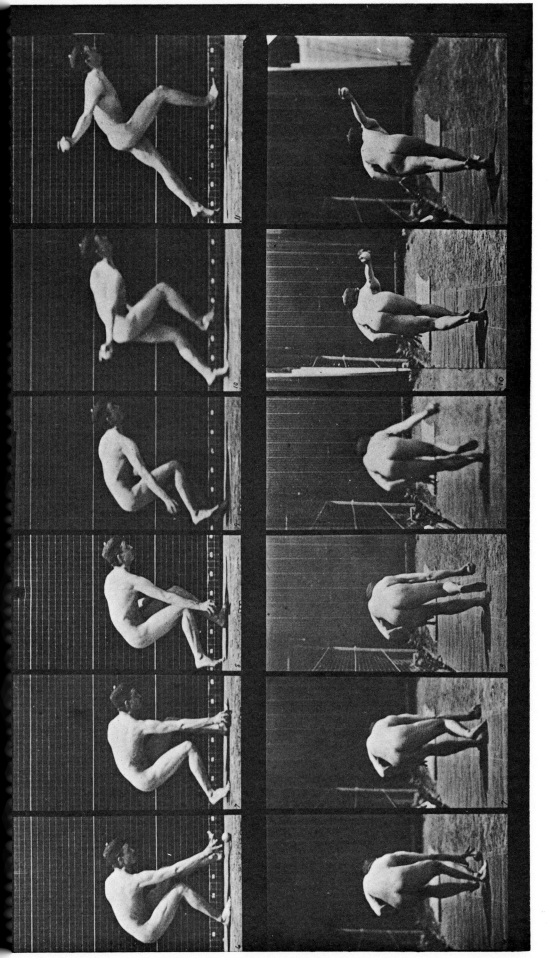

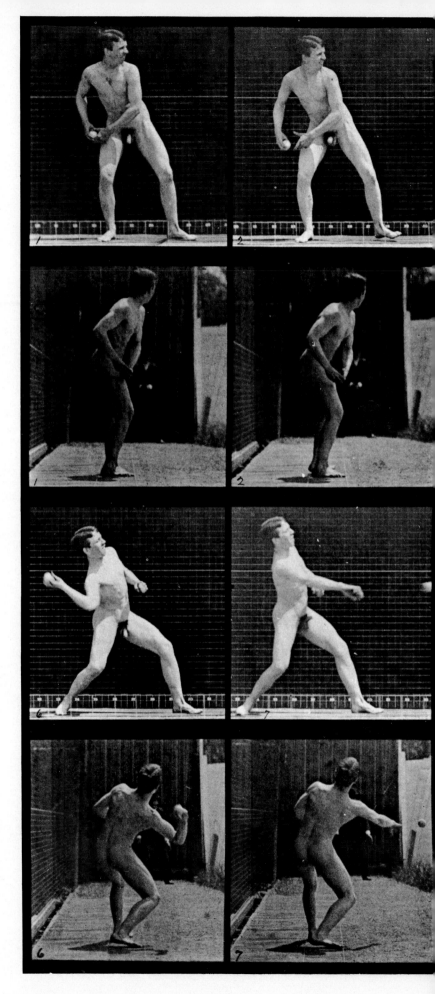

PLATE 43

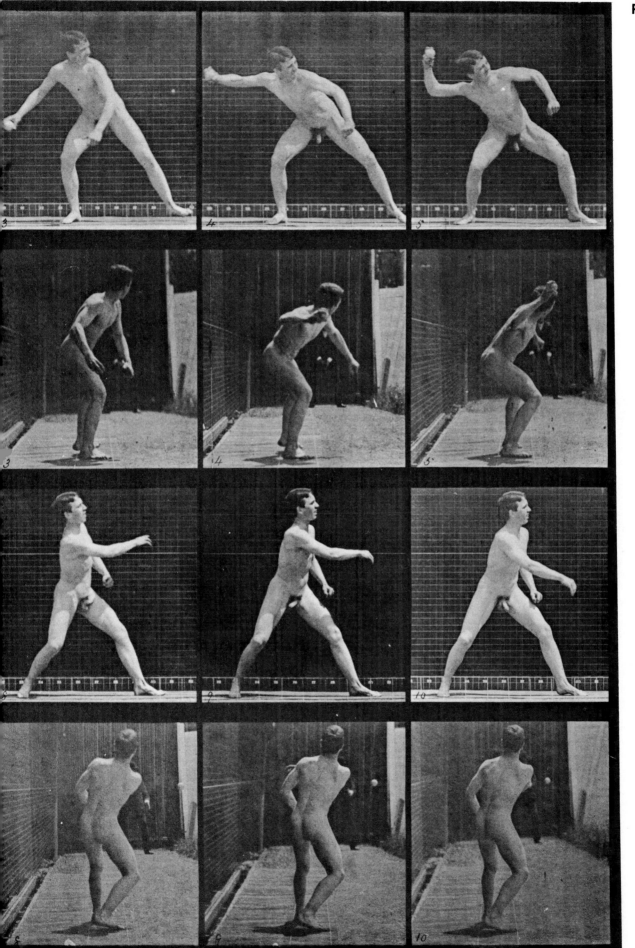

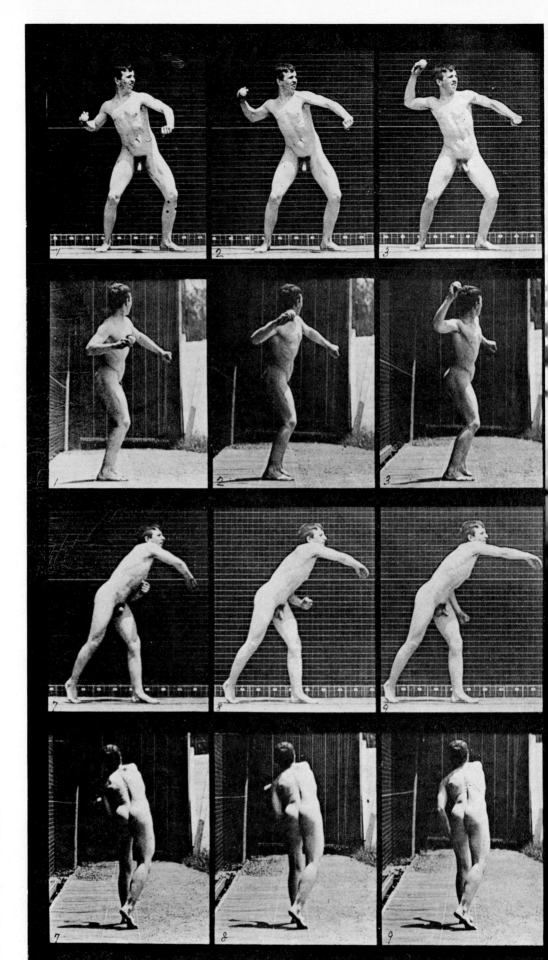

PLATE 44

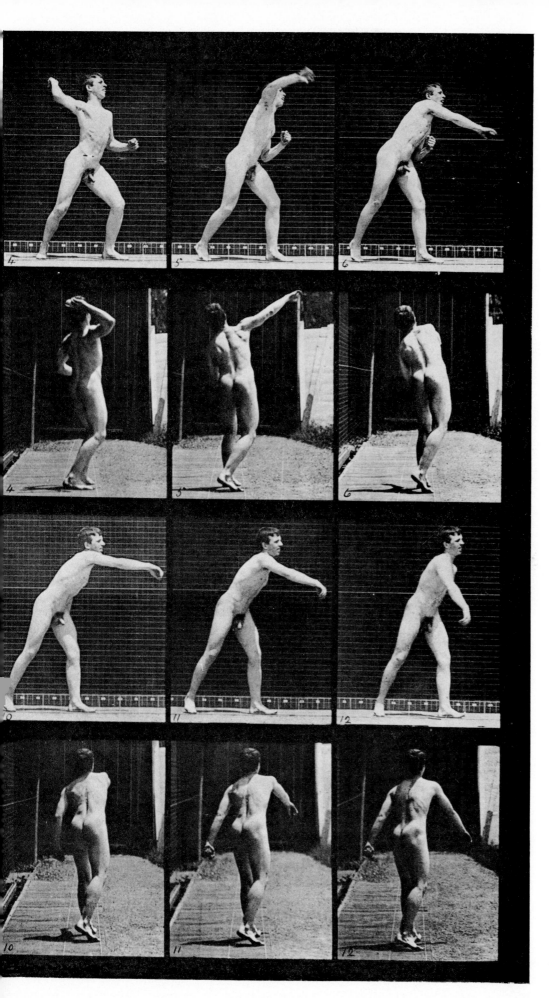

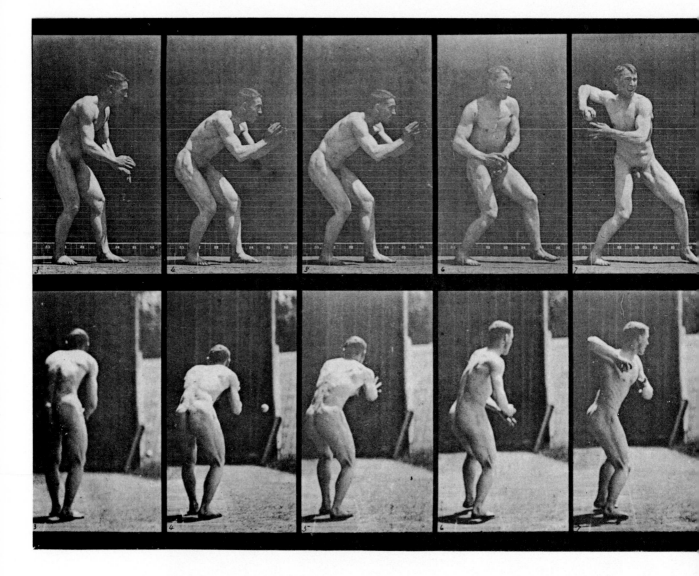

MAN CATCHING AND THROWING BASEBALL

PLATE 45

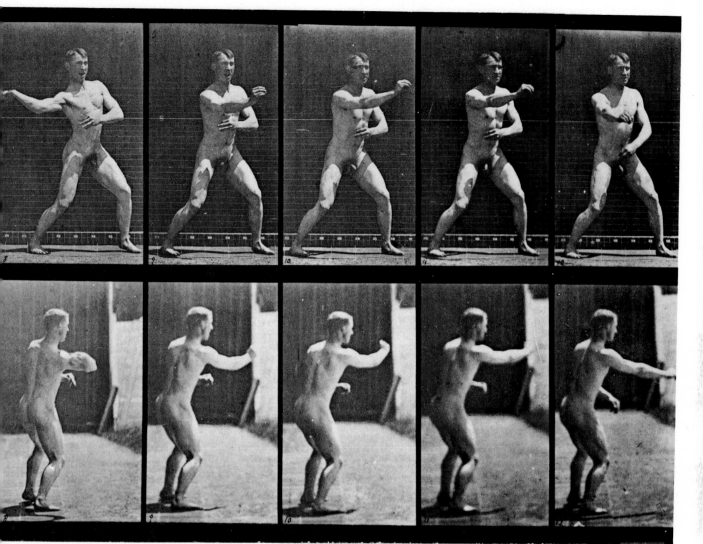

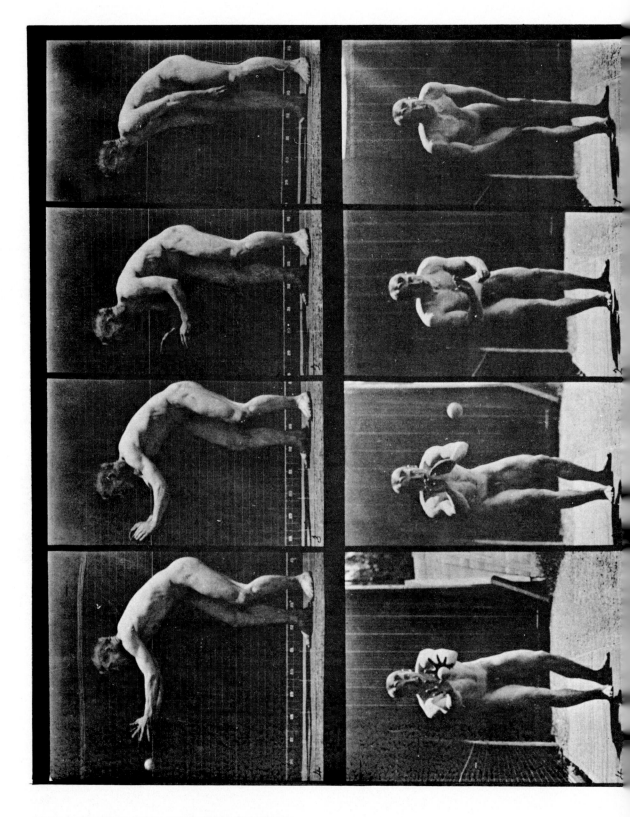

MAN CATCHING AND THROWING BASEBALL.

PLATE 46

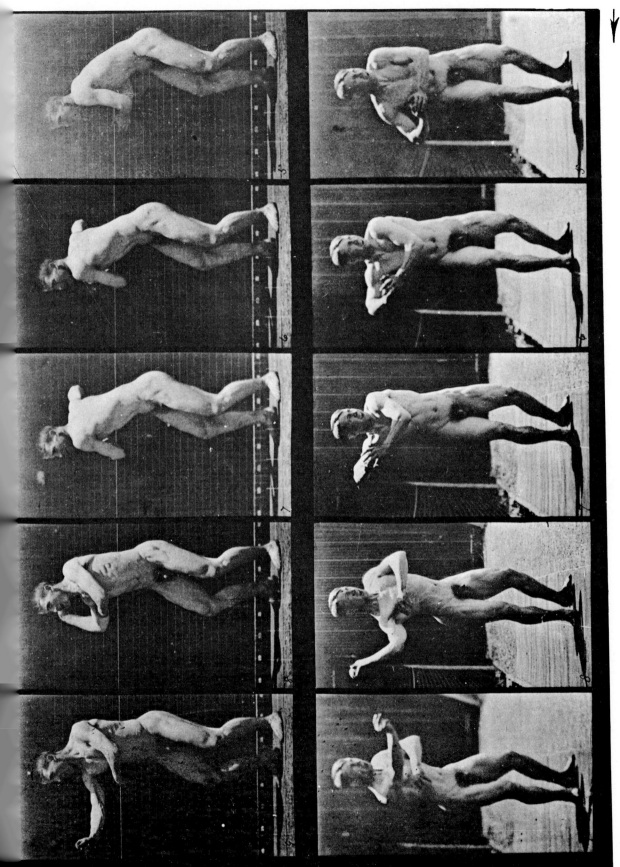

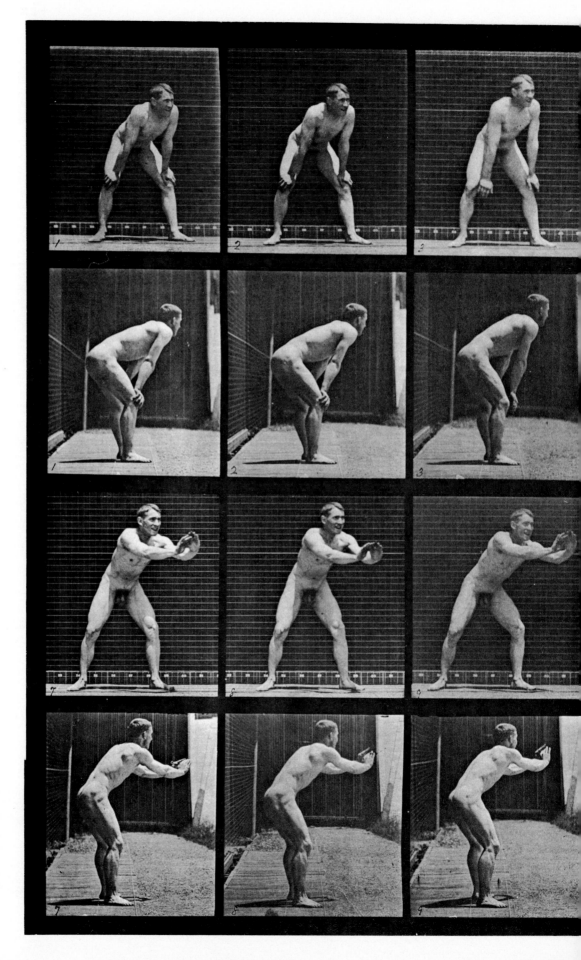

PLATE 47

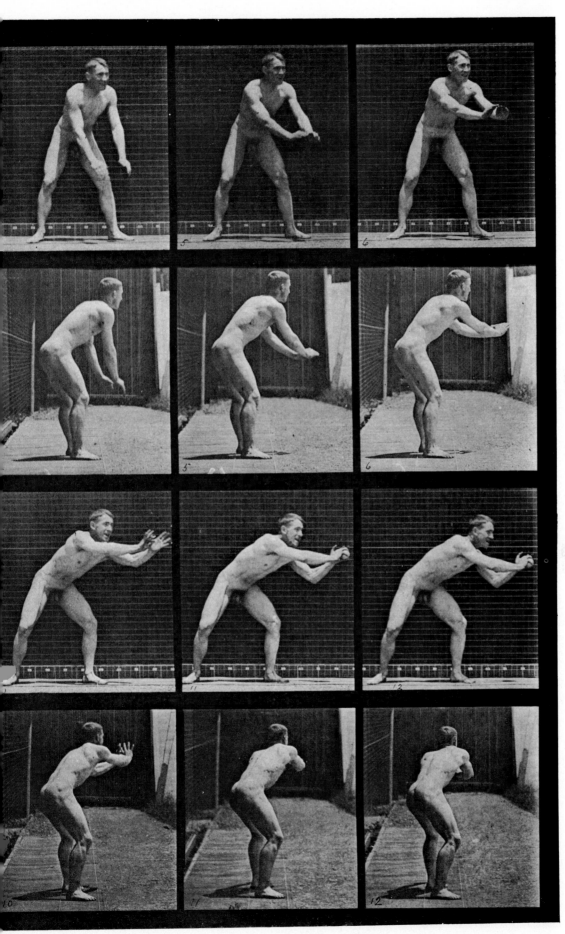

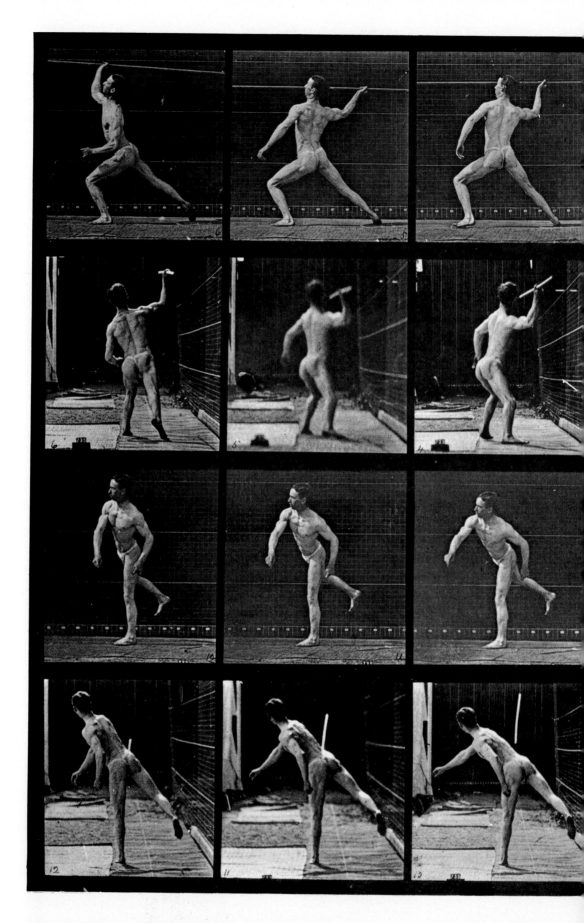

MAN THROWING JAVELIN

PLATE 48

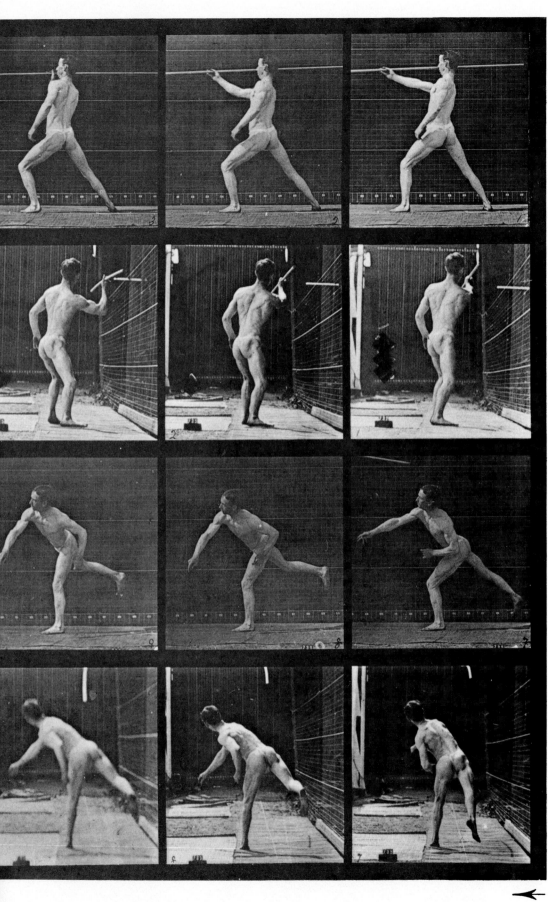

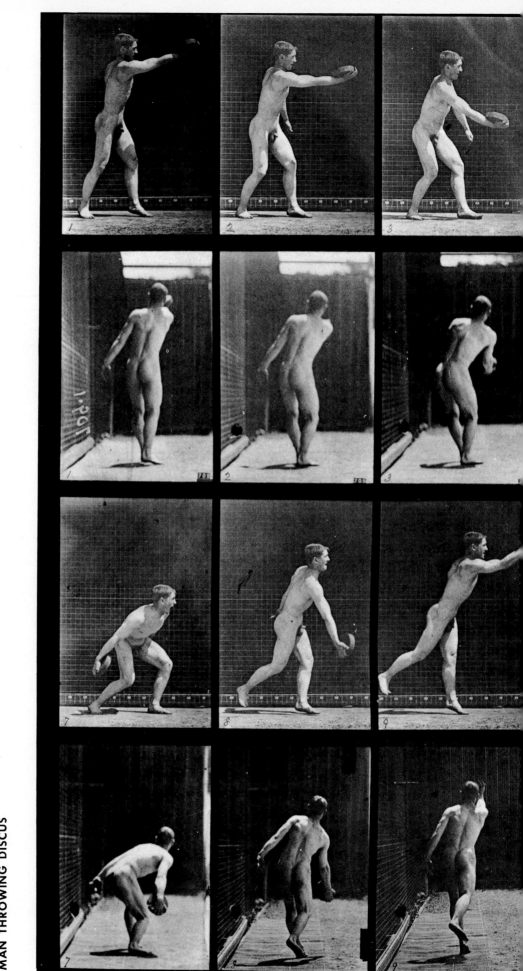

PLATE 49

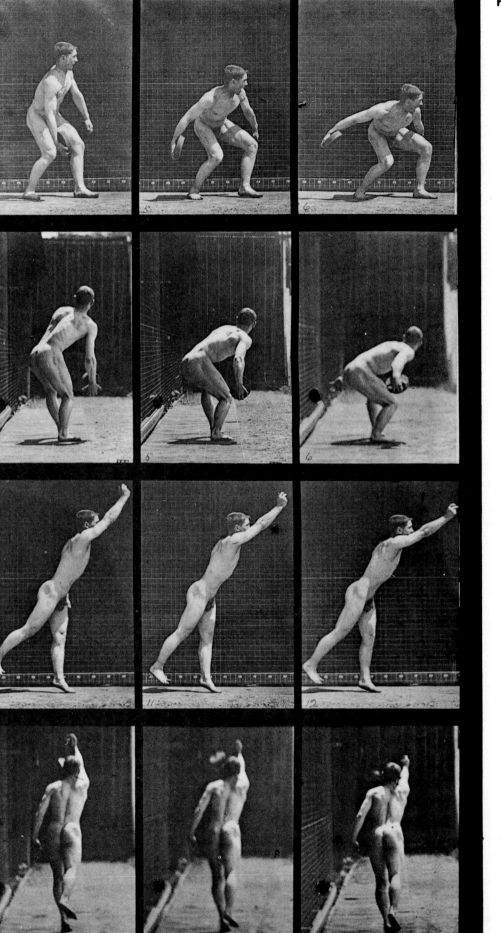

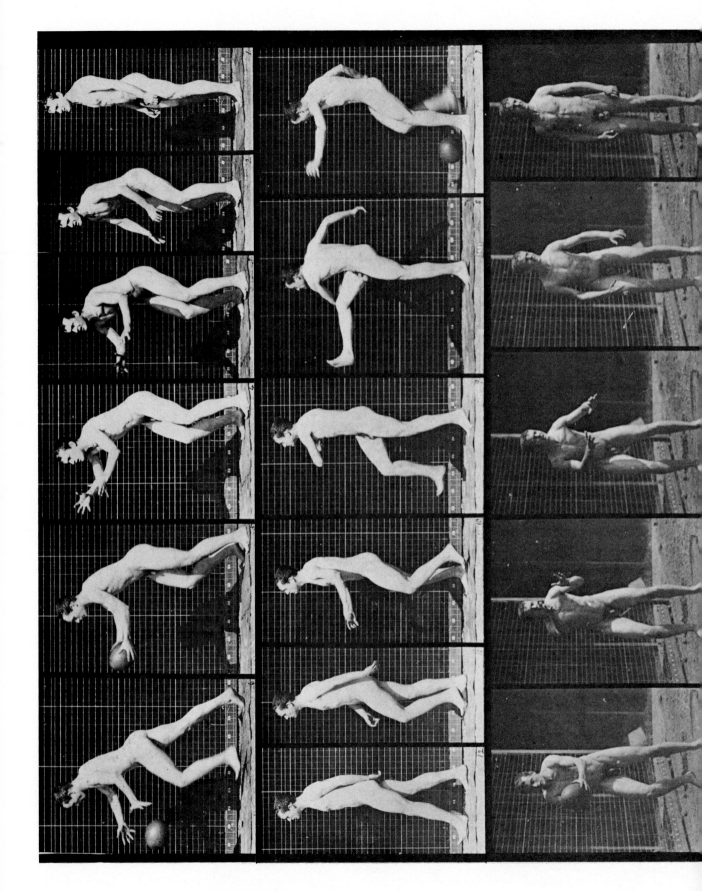

MAN CATCHING AND KICKING FOOTBALL

PLATE 50

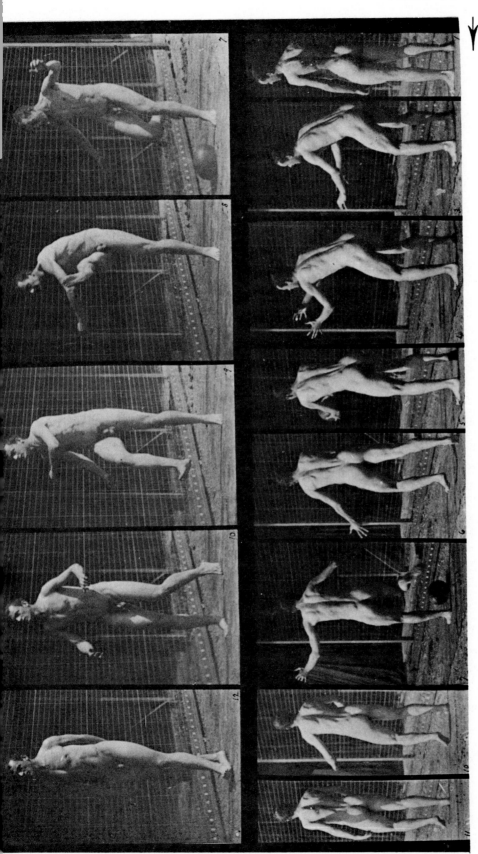

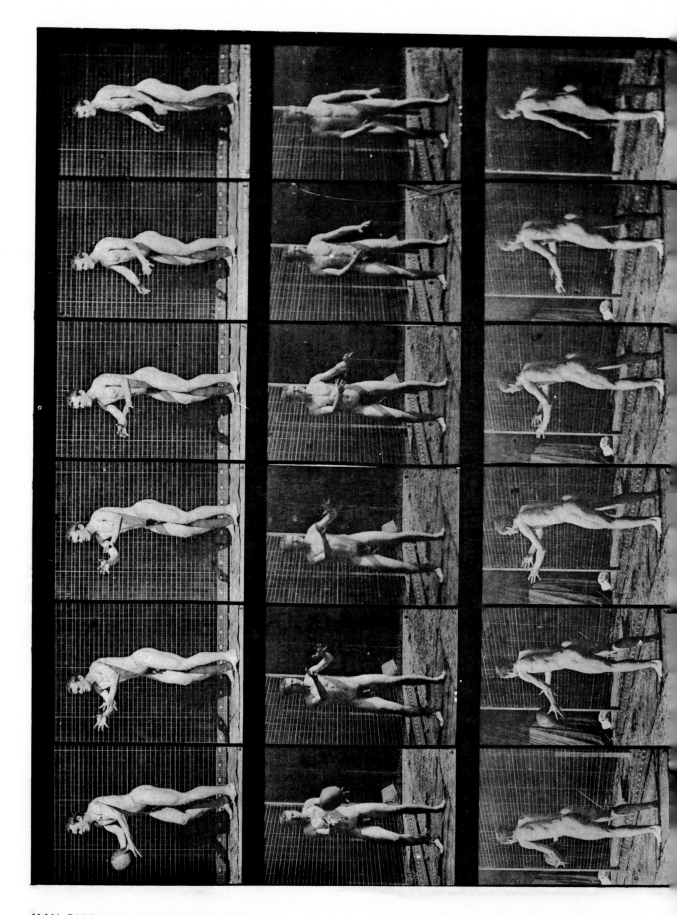

MAN CATCHING AND KICKING FOOTBALL

PLATE 51

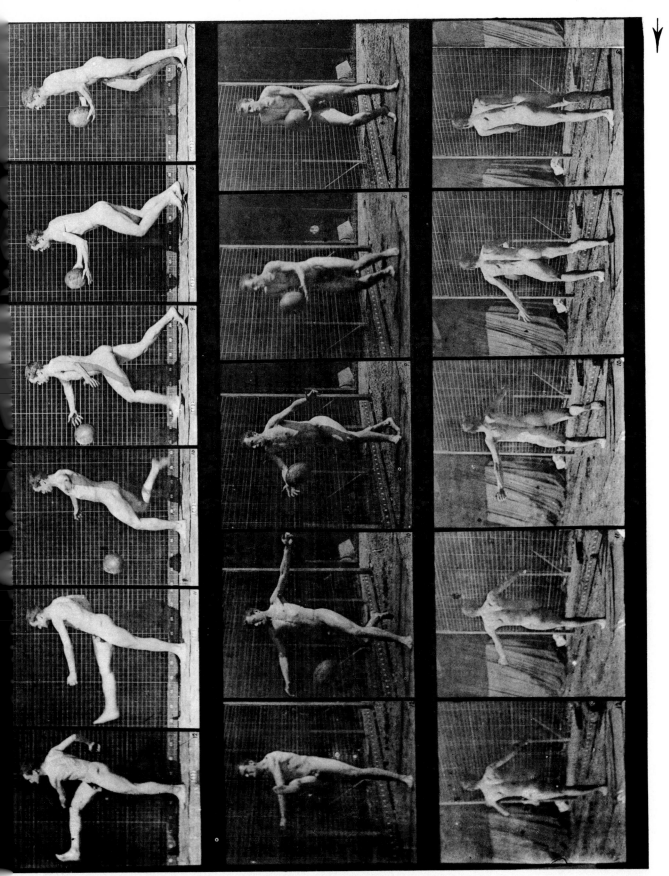

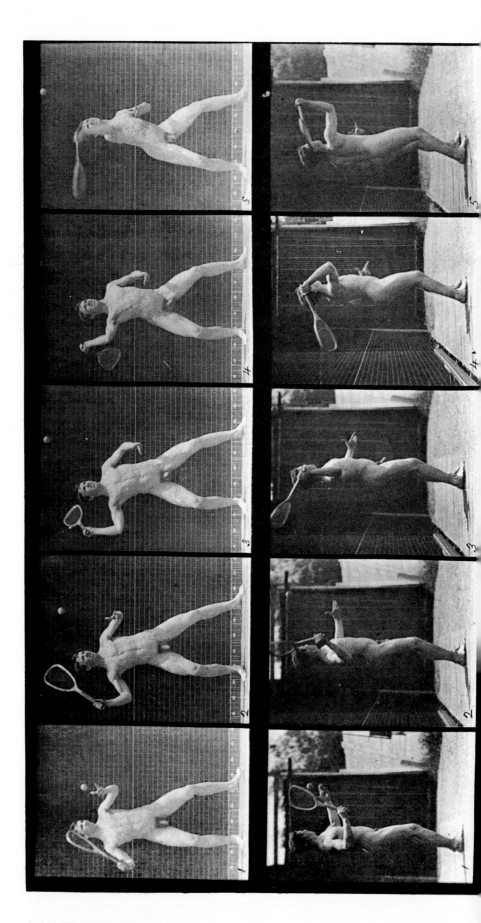

MAN SERVING TENNIS BALL

PLATE 52

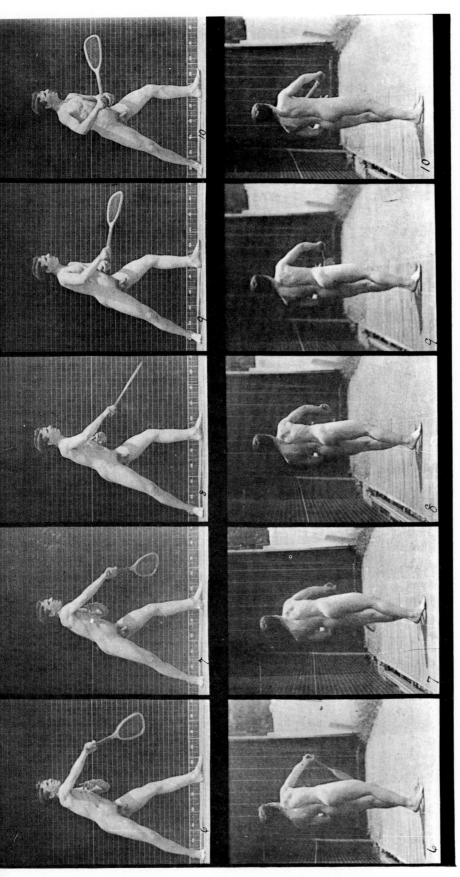

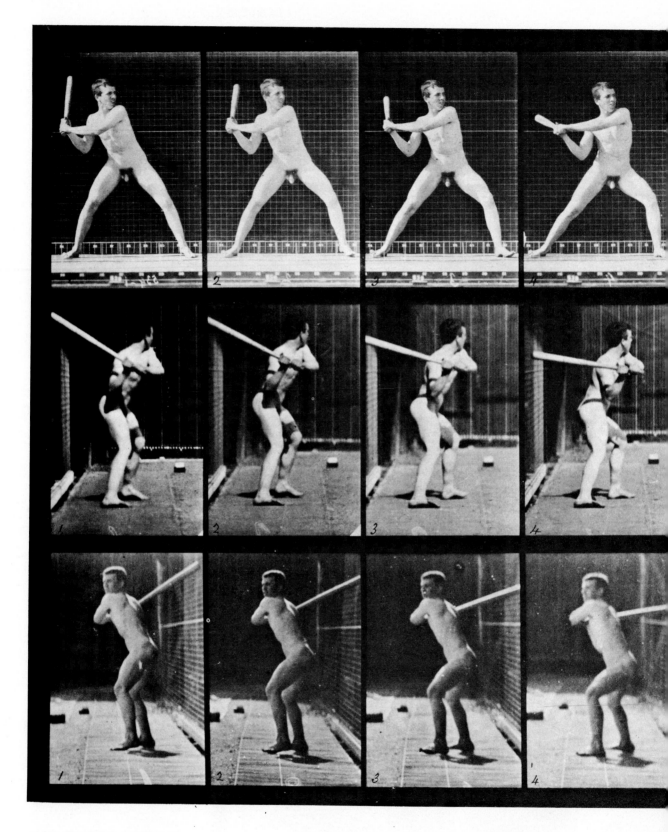

MAN BATTING BASEBALL

PLATE 53

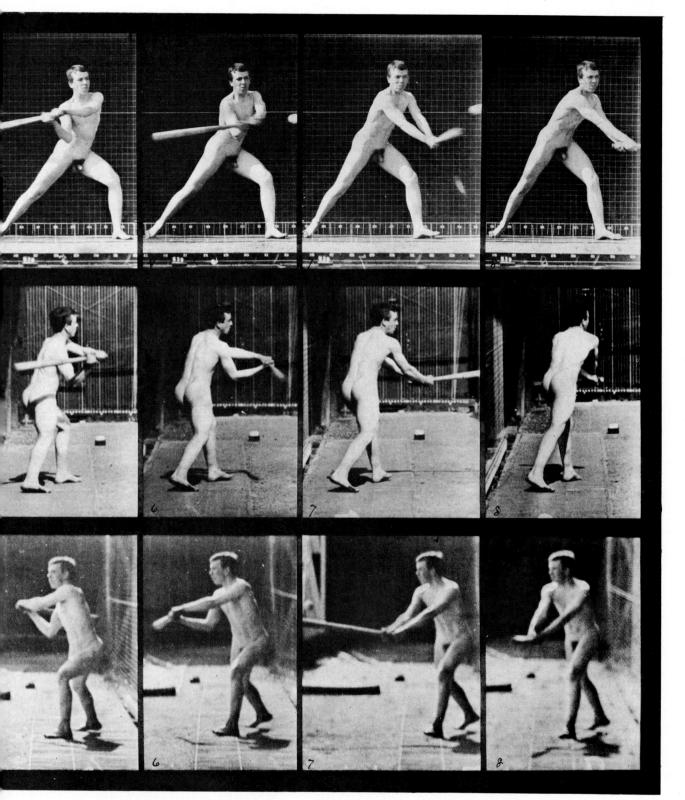

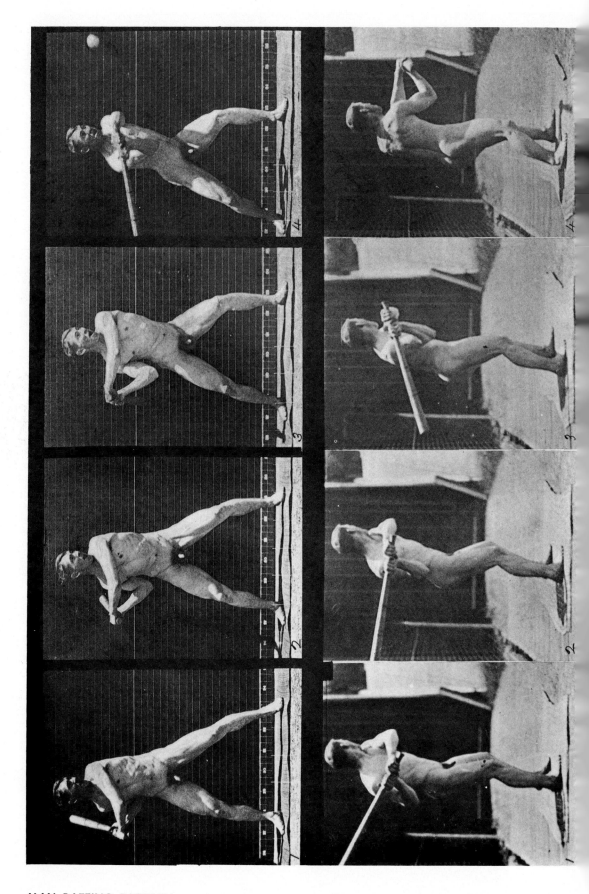

MAN BATTING BASEBALL

PLATE 54

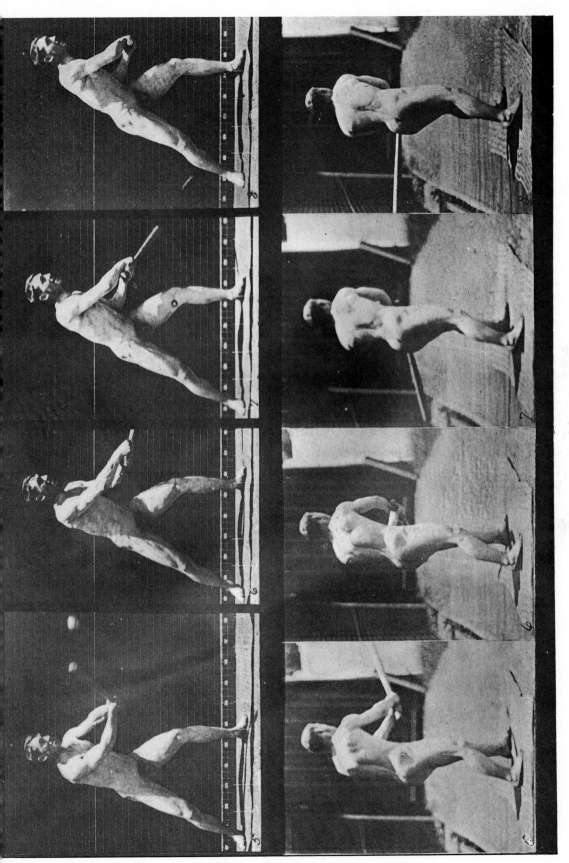

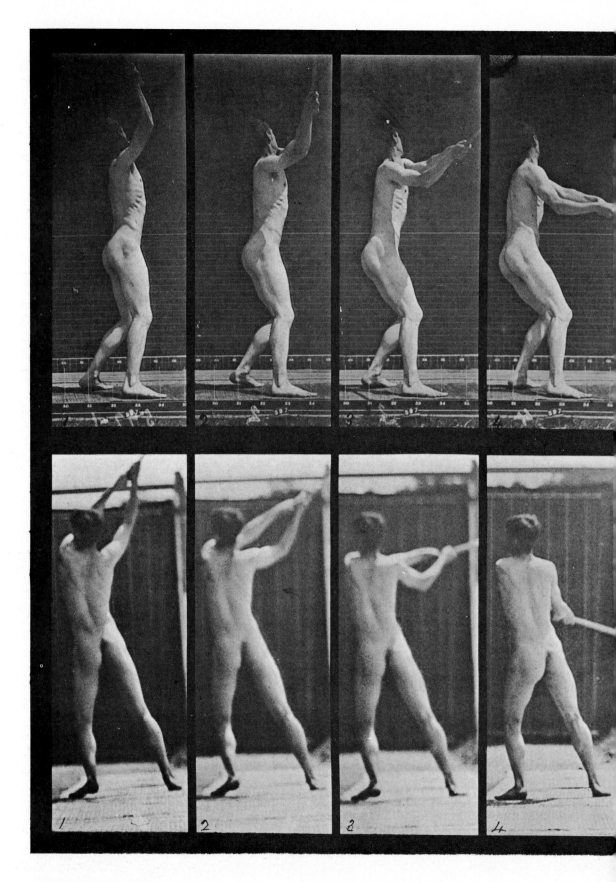

MAN SWINGING BAT

PLATE 55

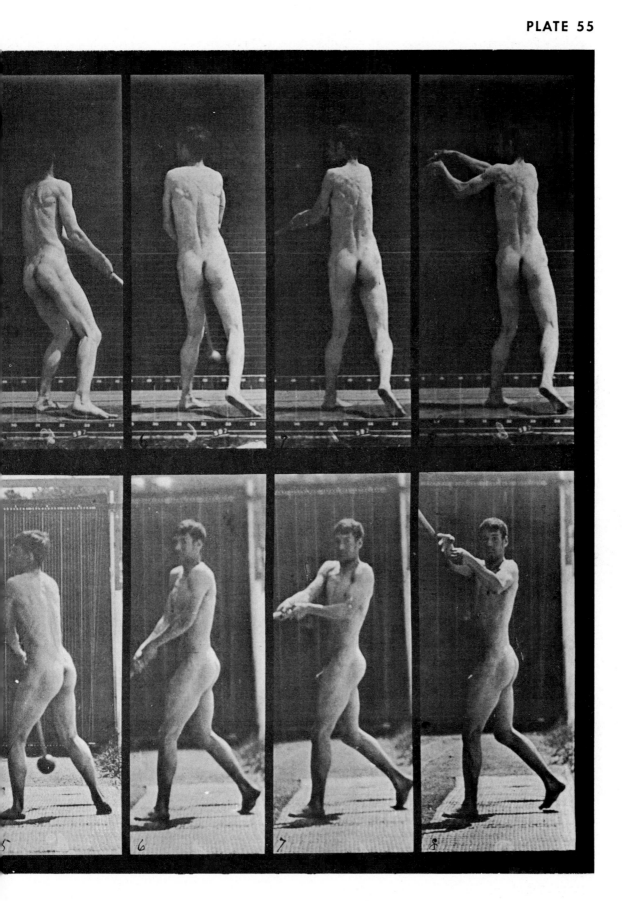

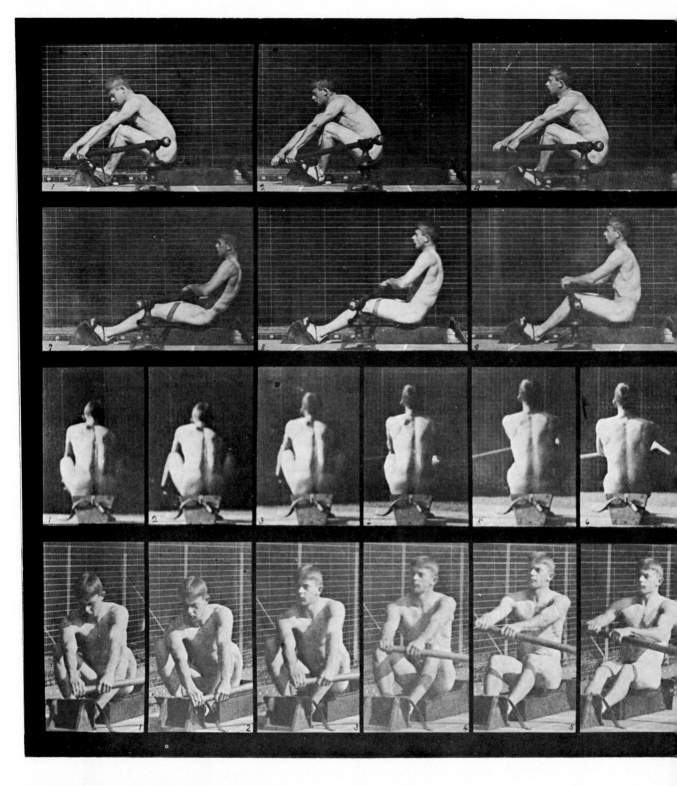

MAN ROWING WITH ROWING MACHINE

PLATE 56

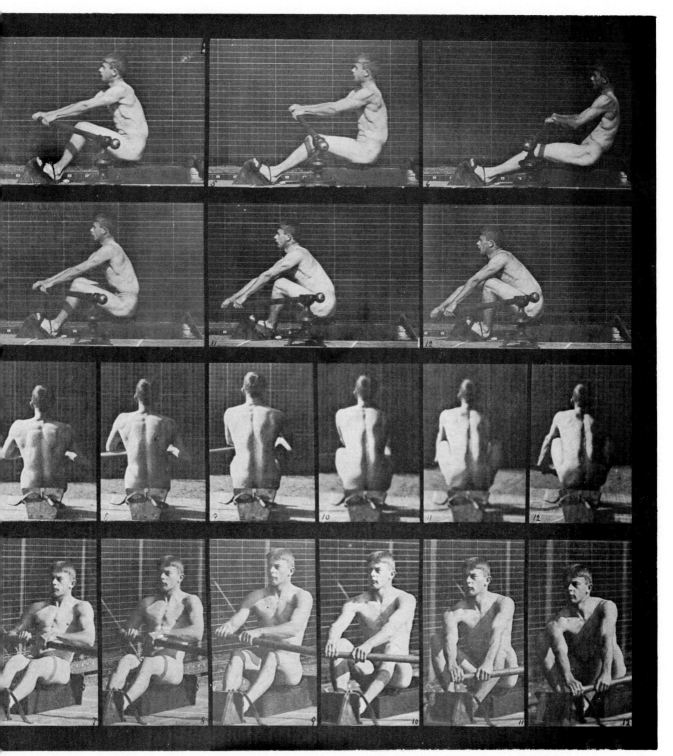

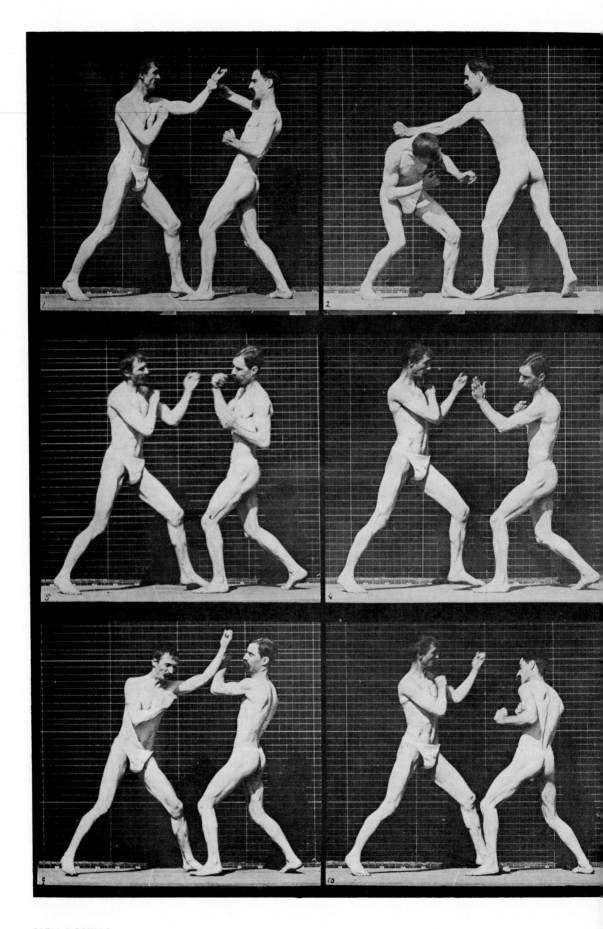

MEN BOXING

PLATE 57

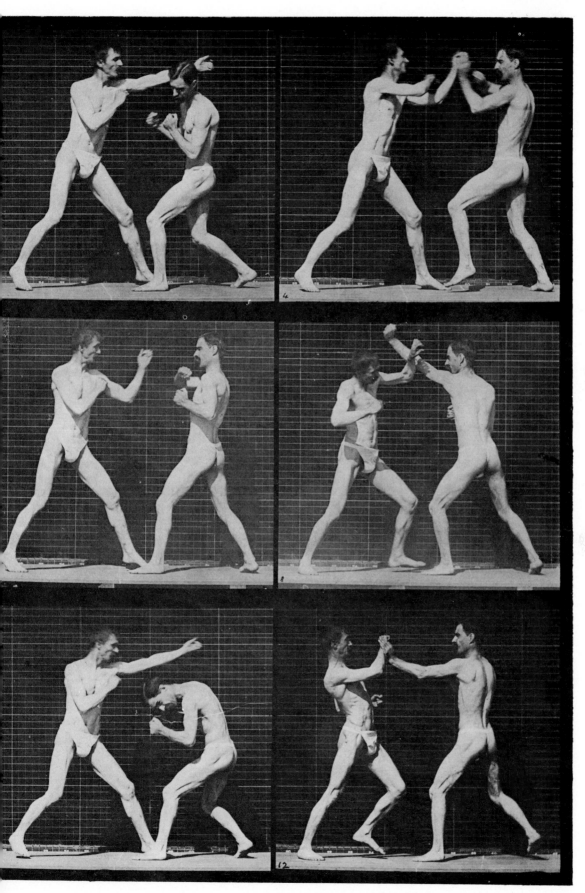

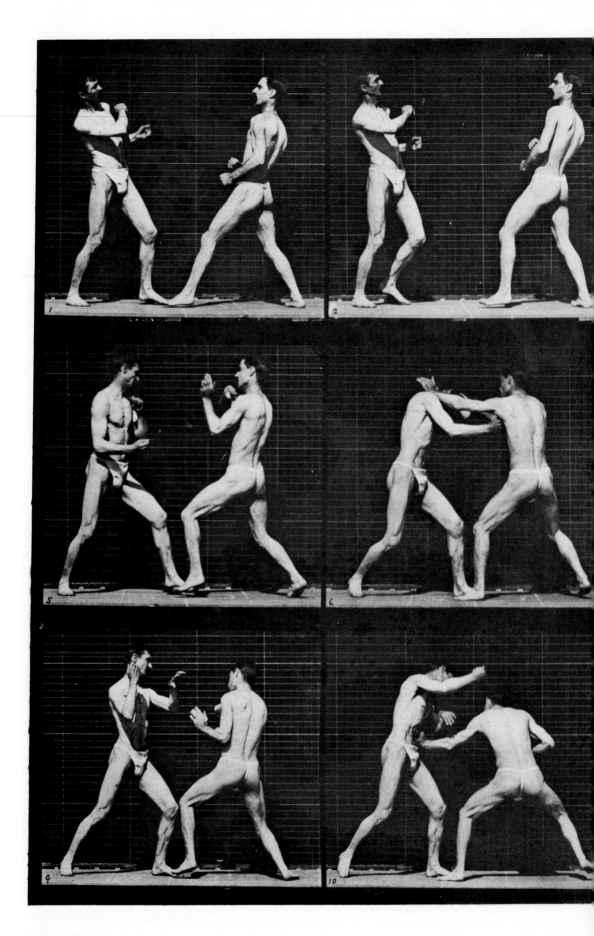

MEN BOXING

PLATE 58

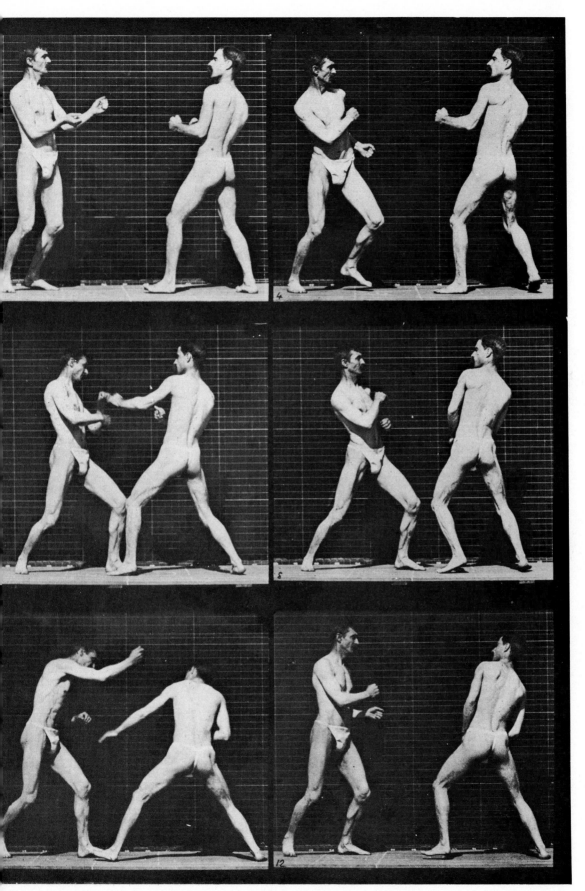

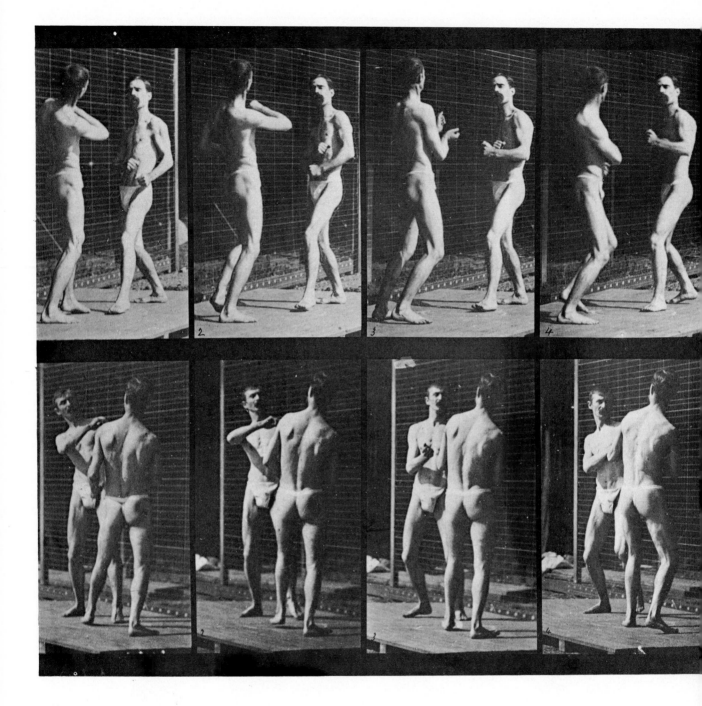

MEN BOXING

PLATE 59

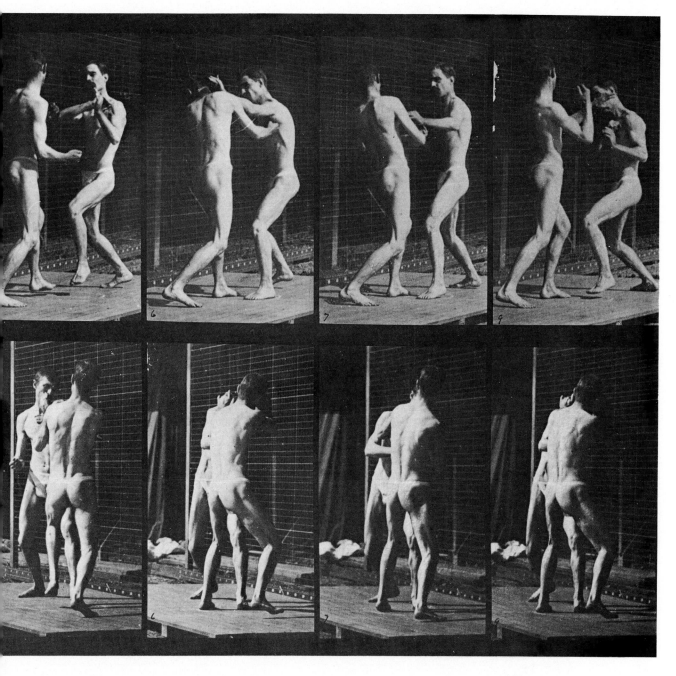

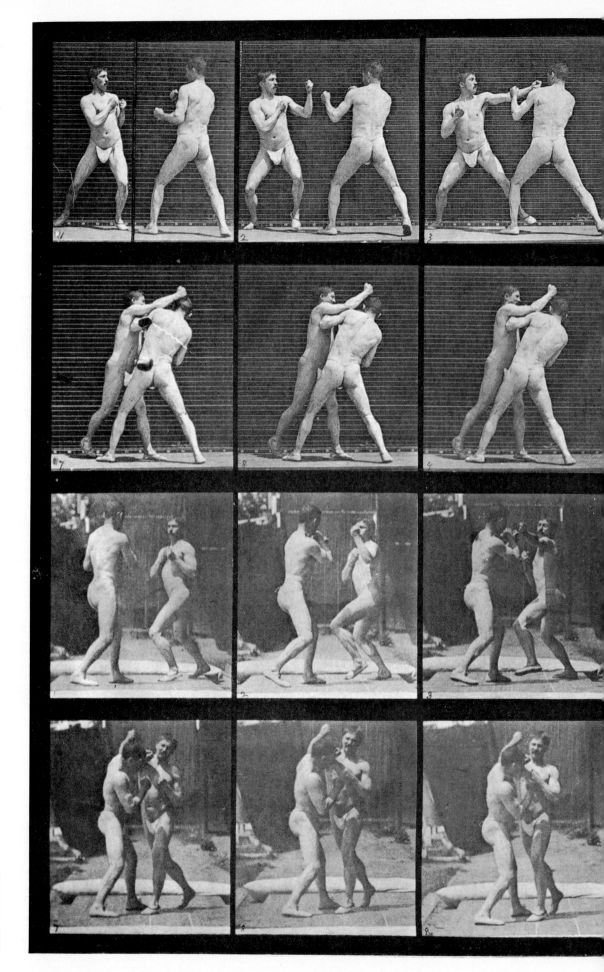

PLATE 60

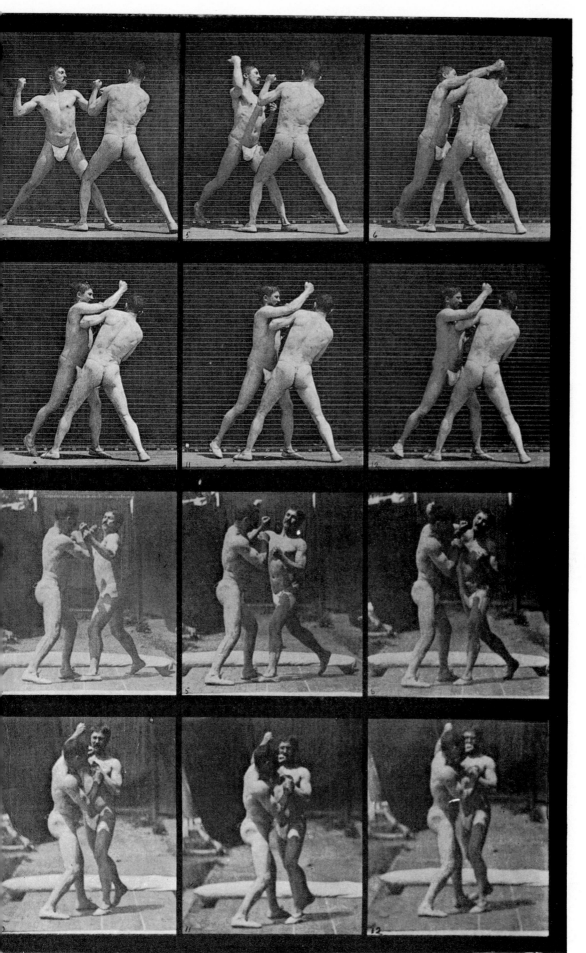

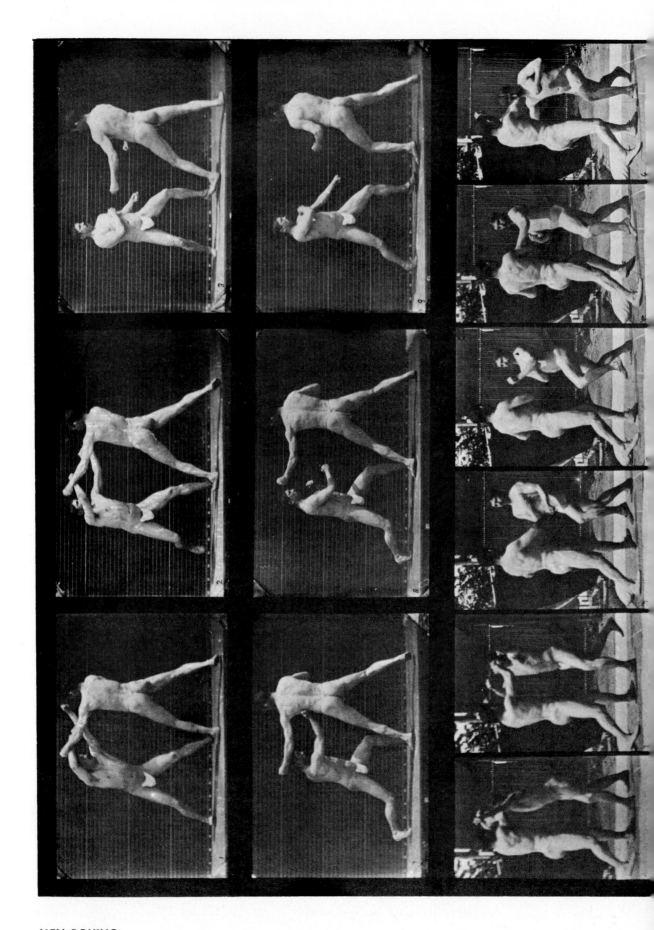

MEN BOXING

PLATE 61

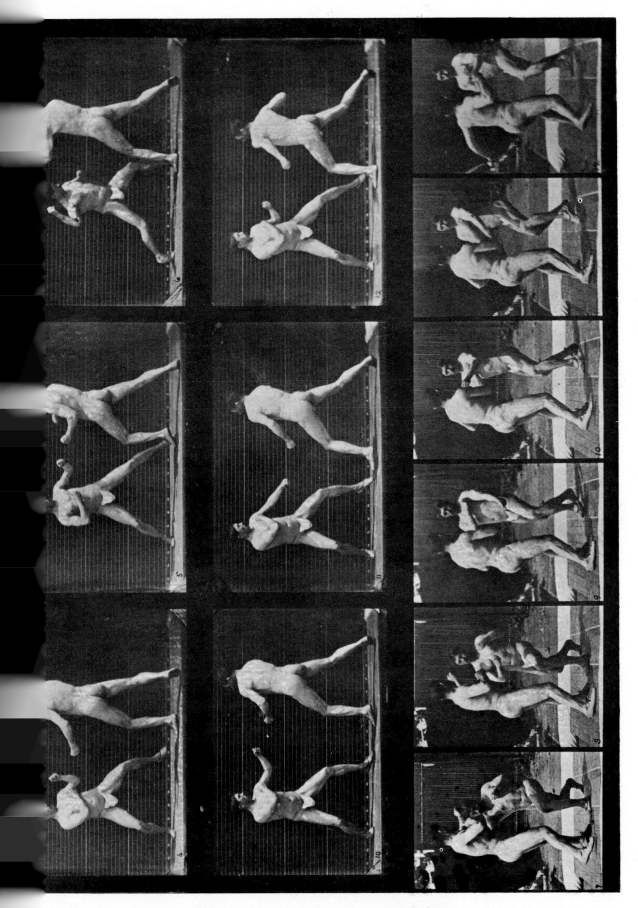

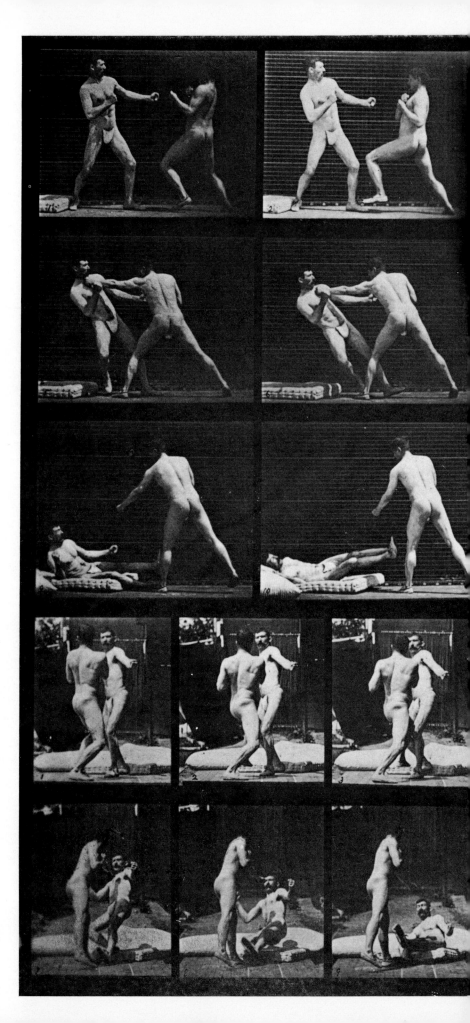

PLATE 62

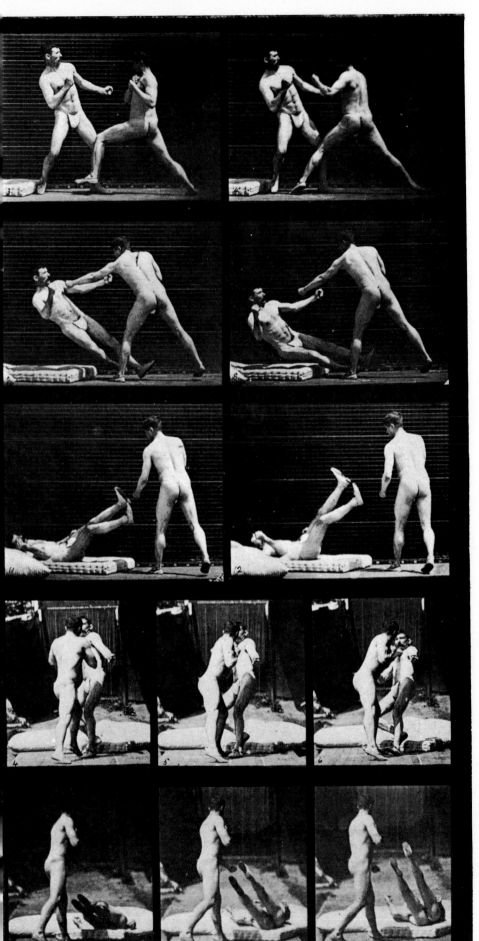

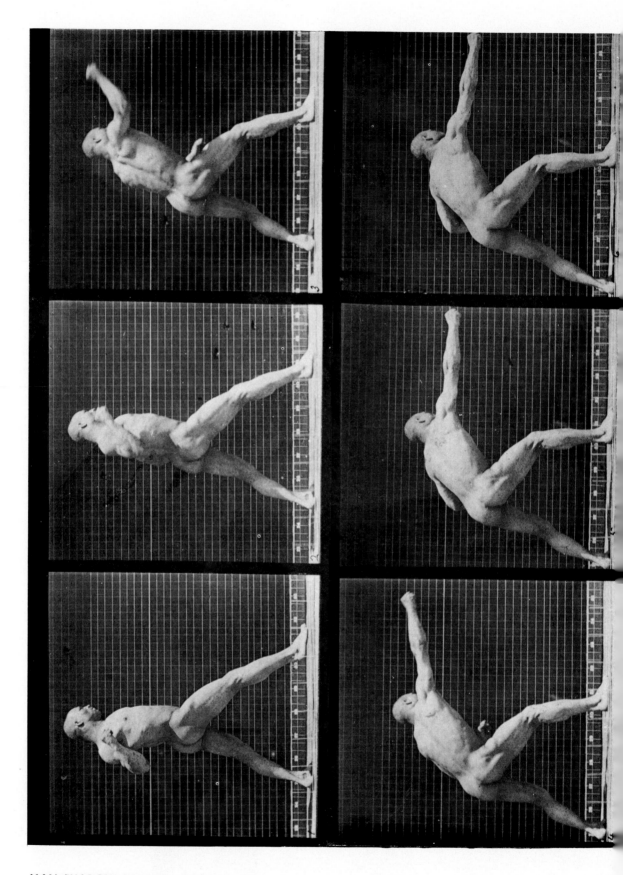

MAN SHADOW BOXING (.112 second)

PLATE 63

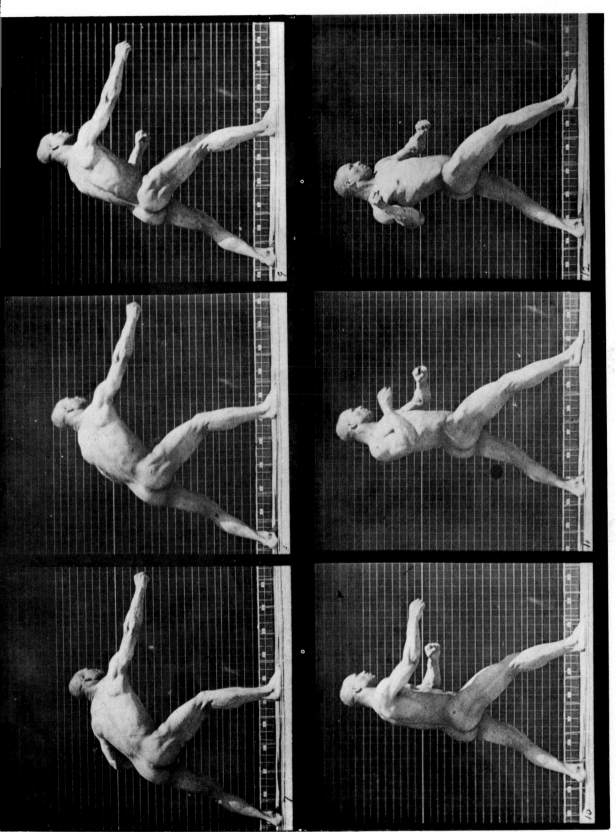

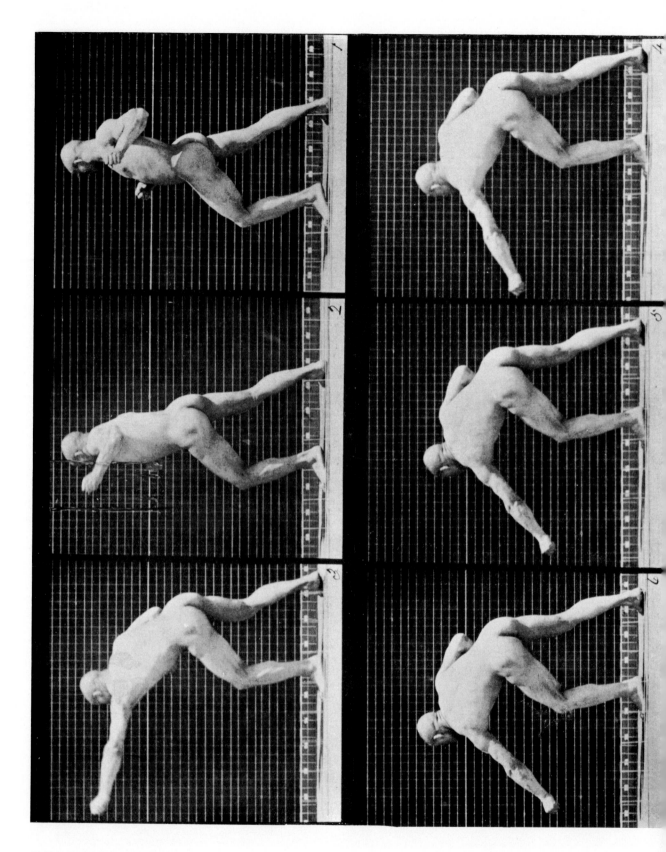

MAN SHADOW BOXING

PLATE 64

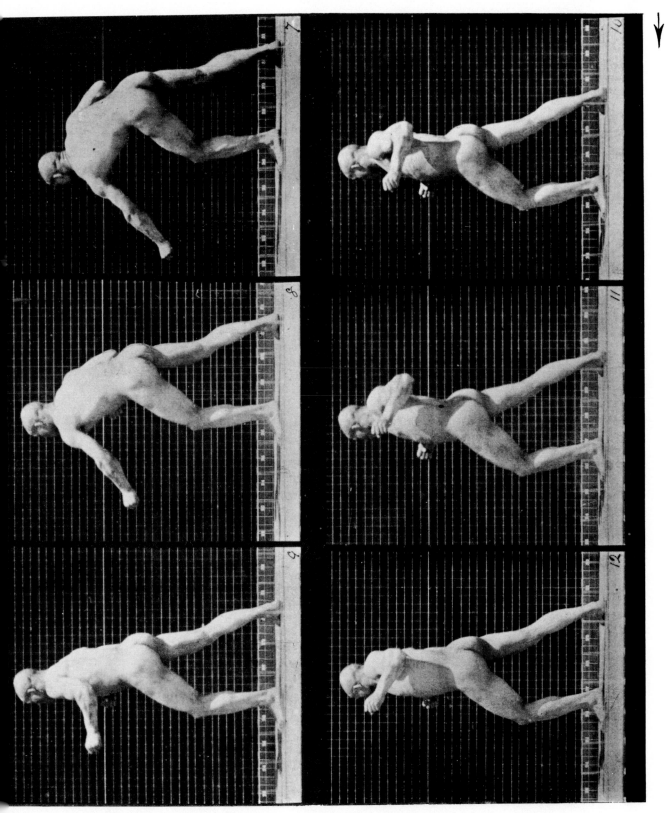

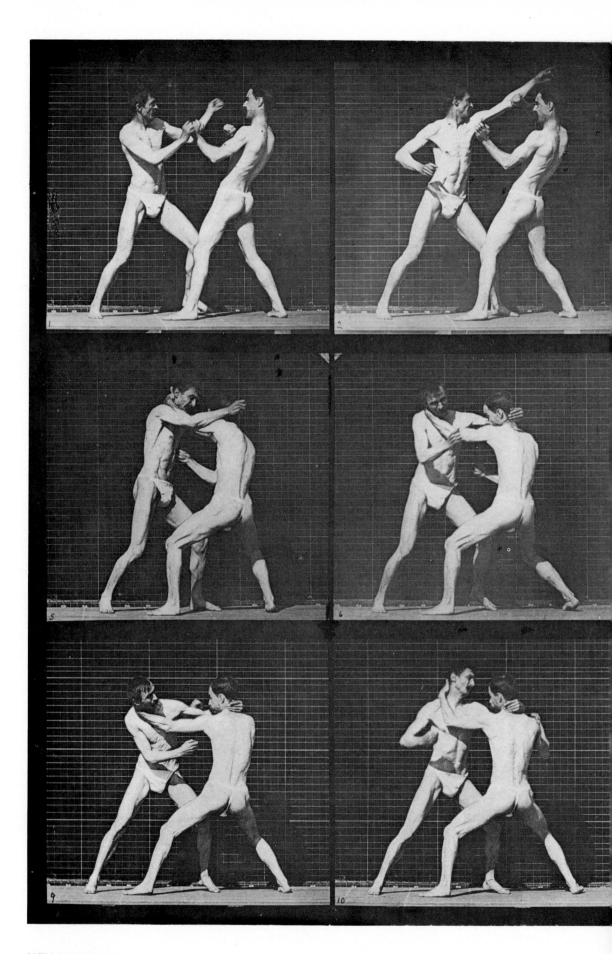

MEN WRESTLING

PLATE 65

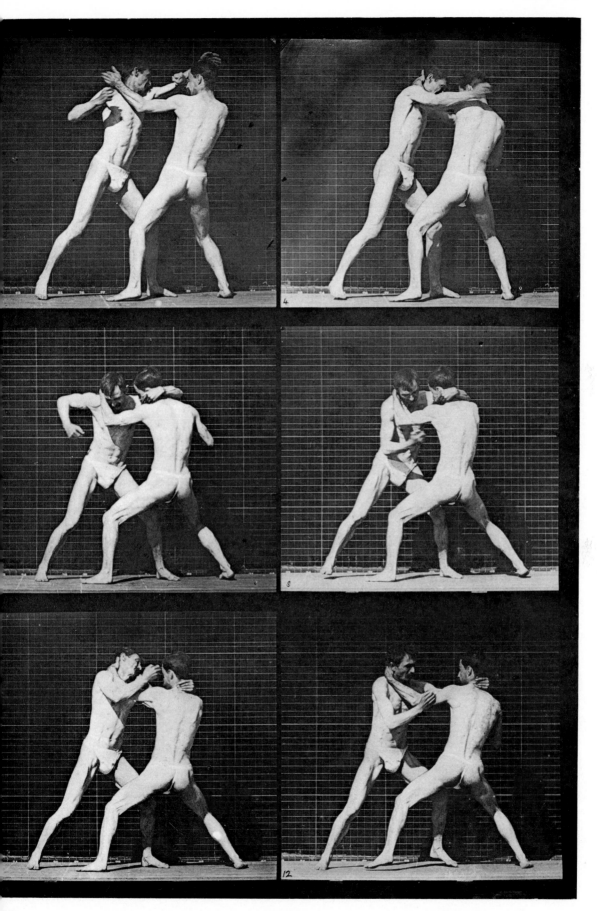

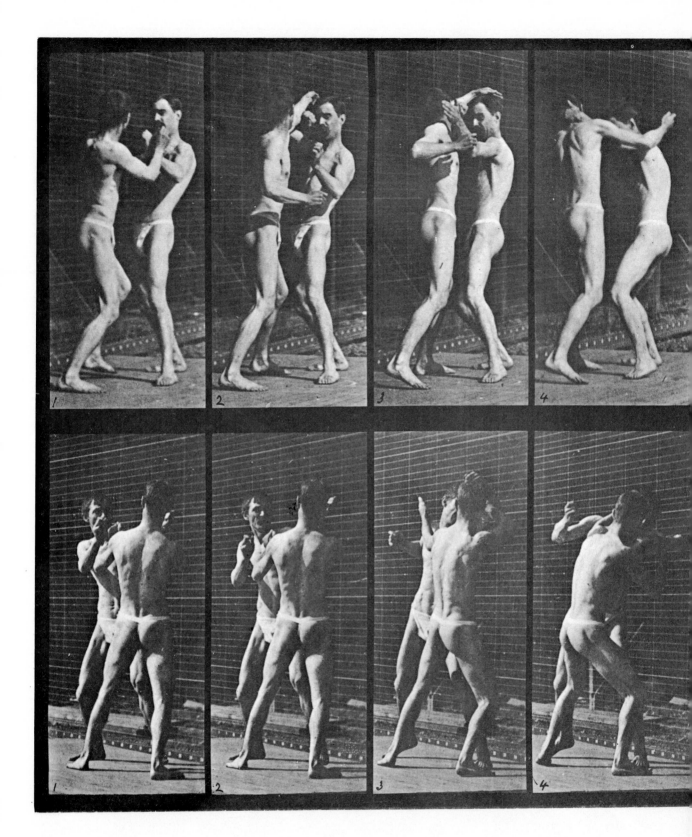

MEN WRESTLING

PLATE 66

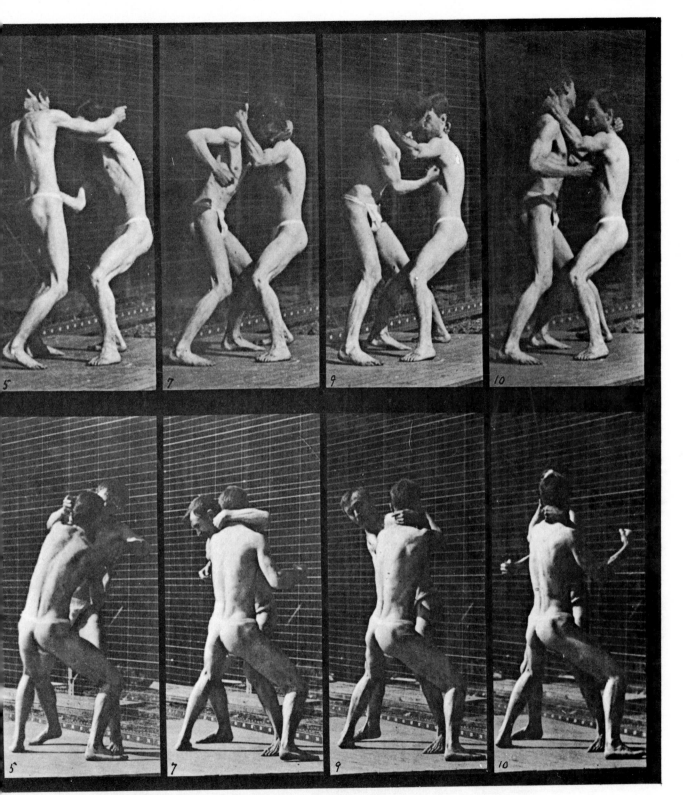

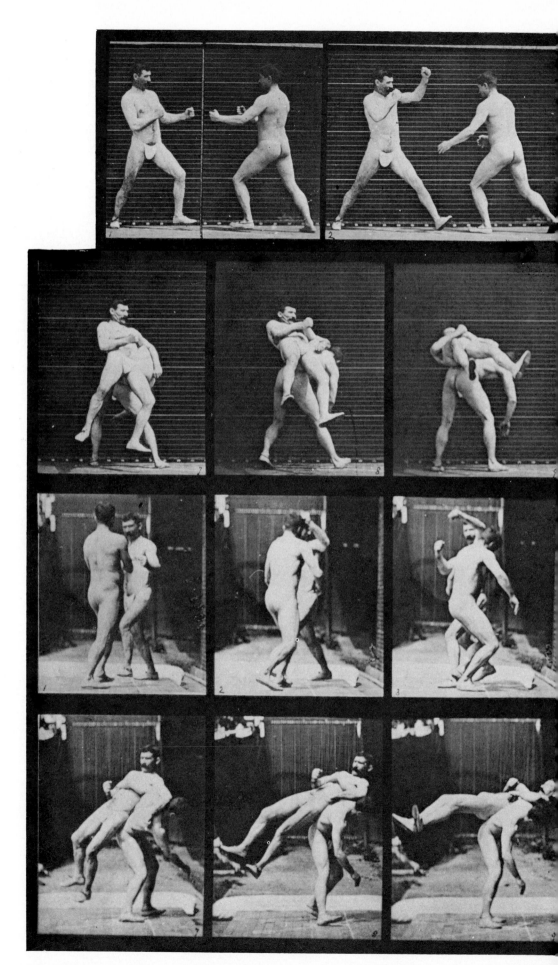

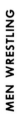

PLATE 67

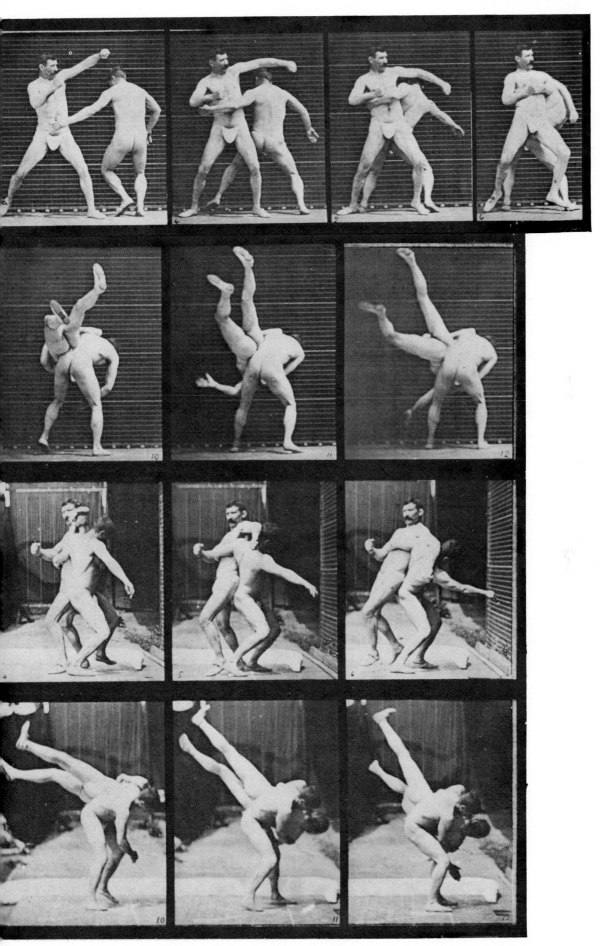

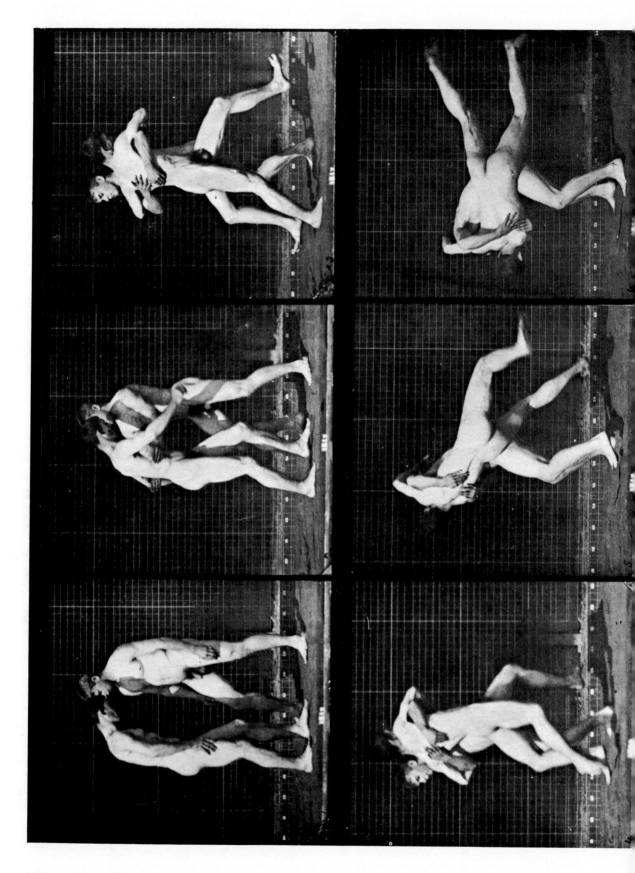

MEN WRESTLING

PLATE 68

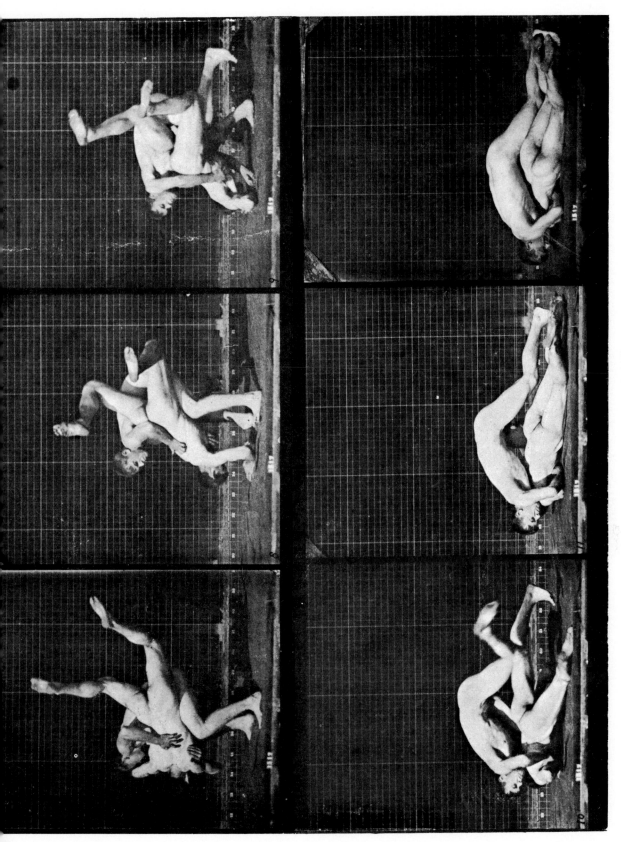

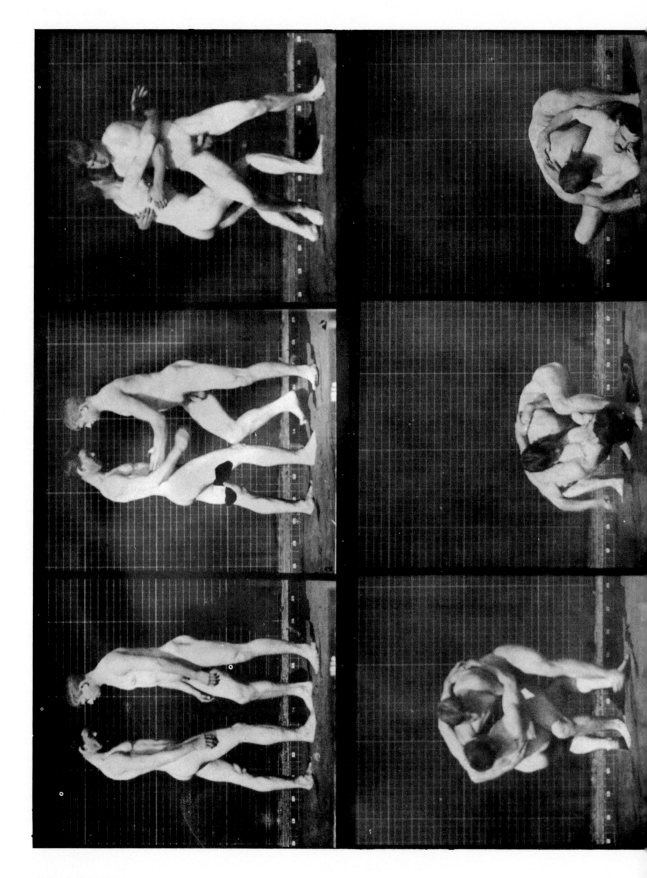

MEN WRESTLING

PLATE 69

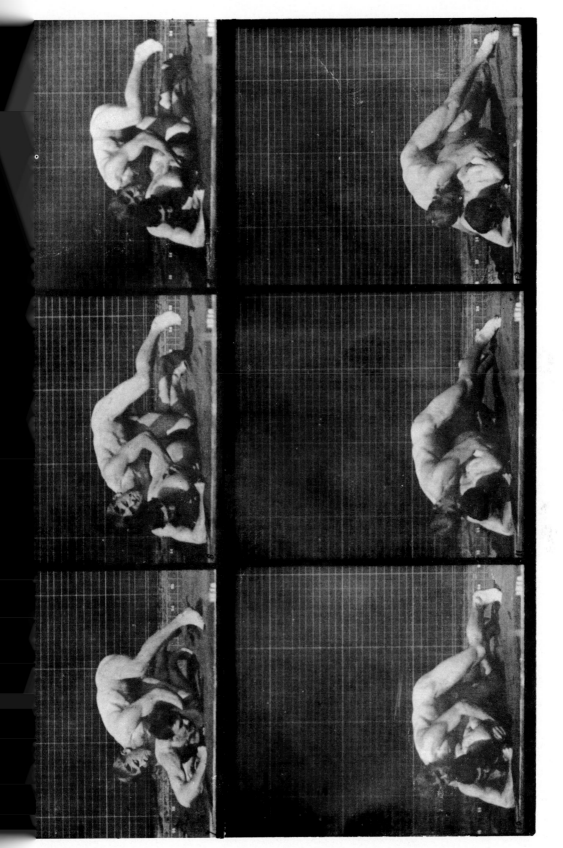

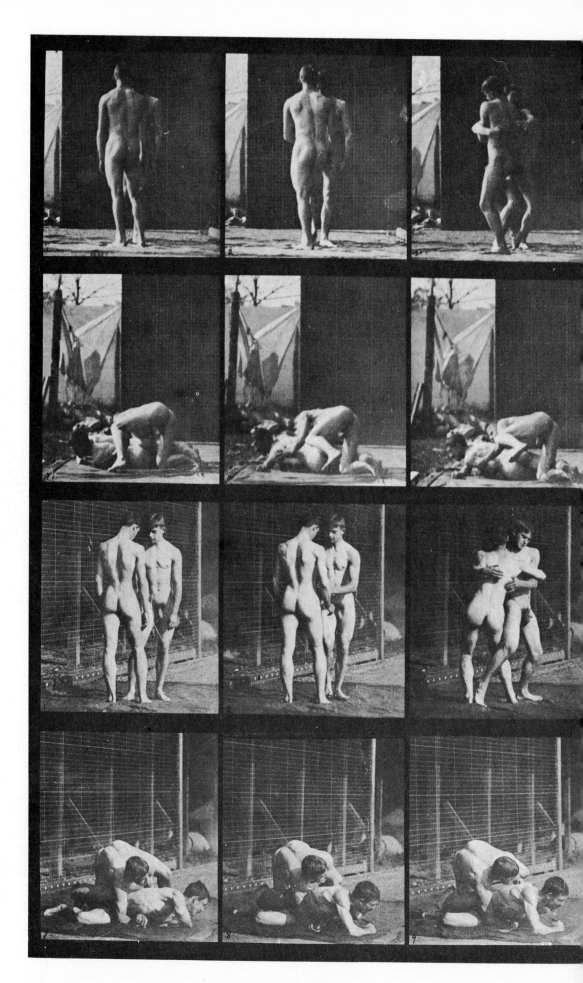

PLATE 70

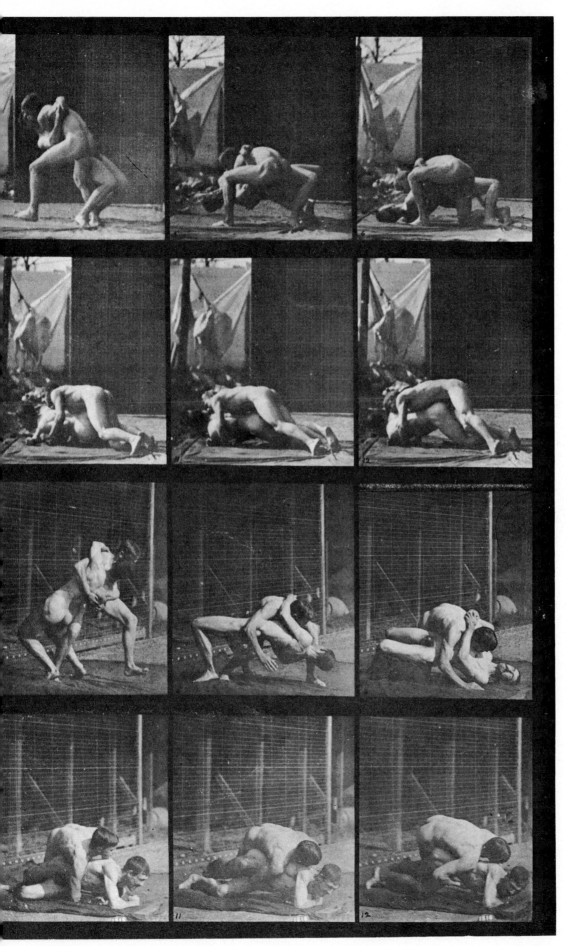

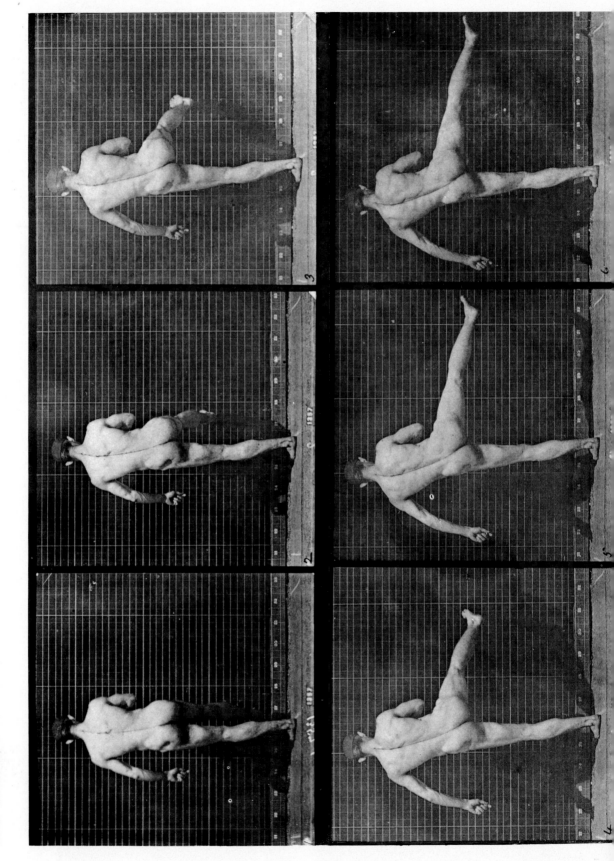

PLATE 71

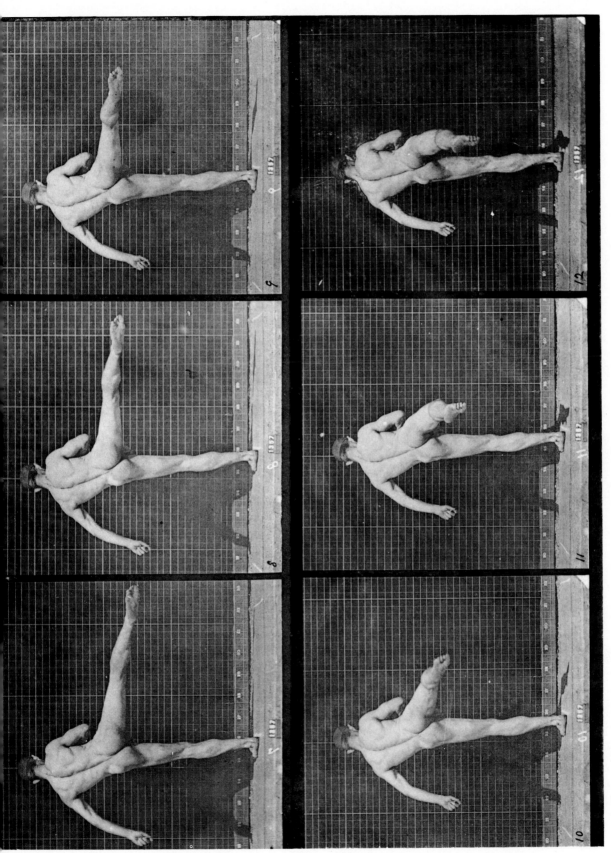

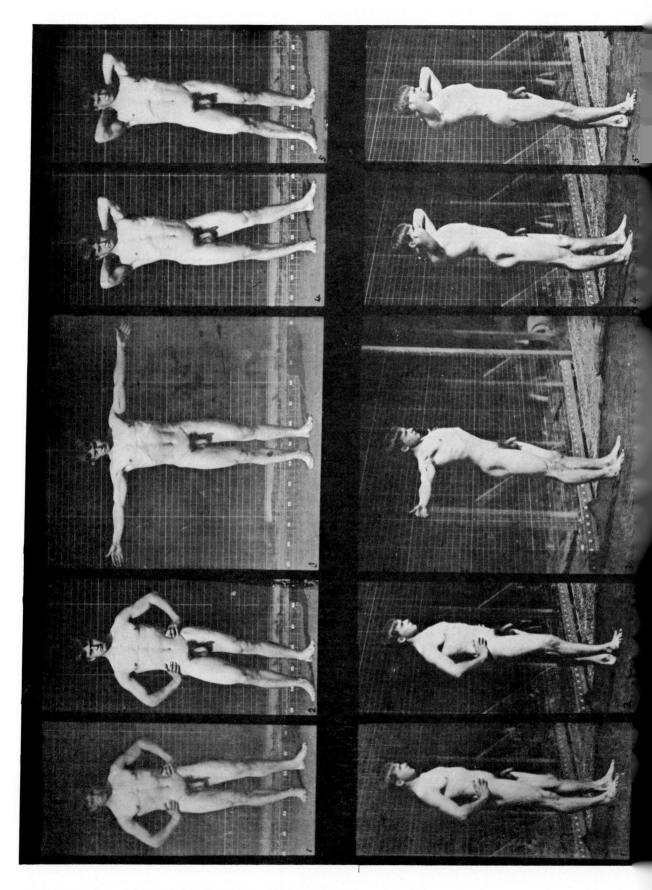

MAN STANDING, HANDS BEHIND HEAD, ARMS AKIMBO

PLATE 72

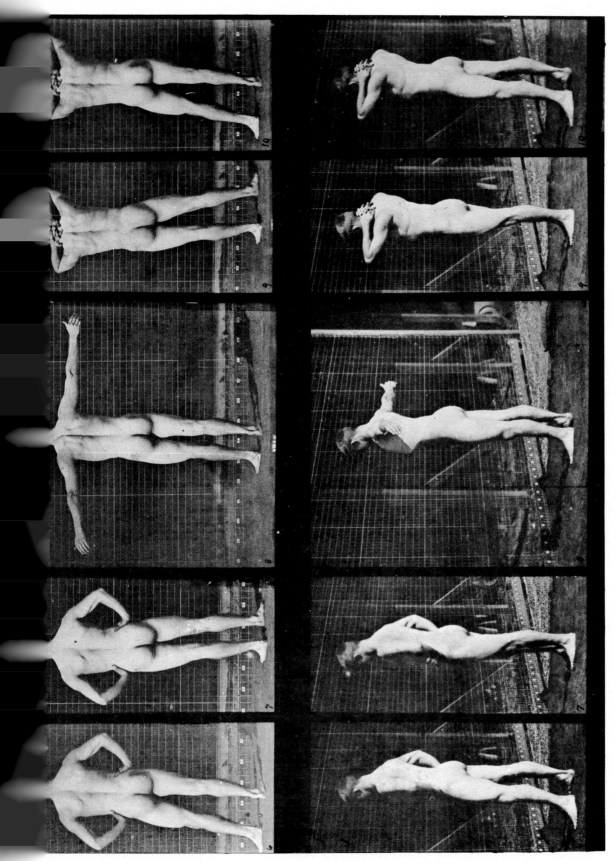

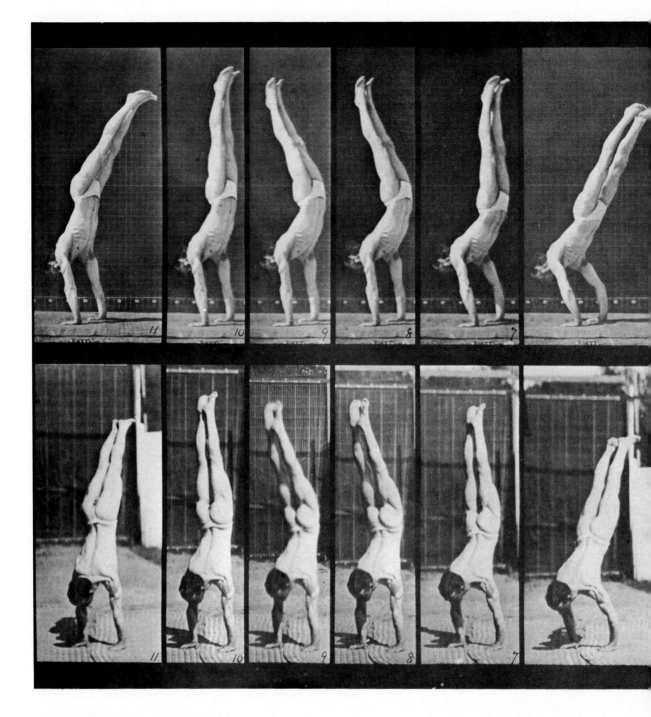

MAN PERFORMING HAND STAND

PLATE 73

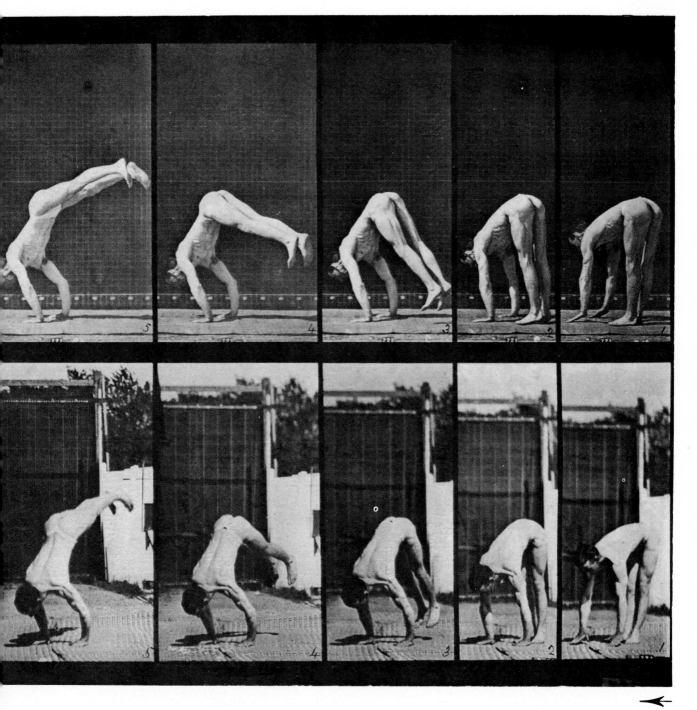

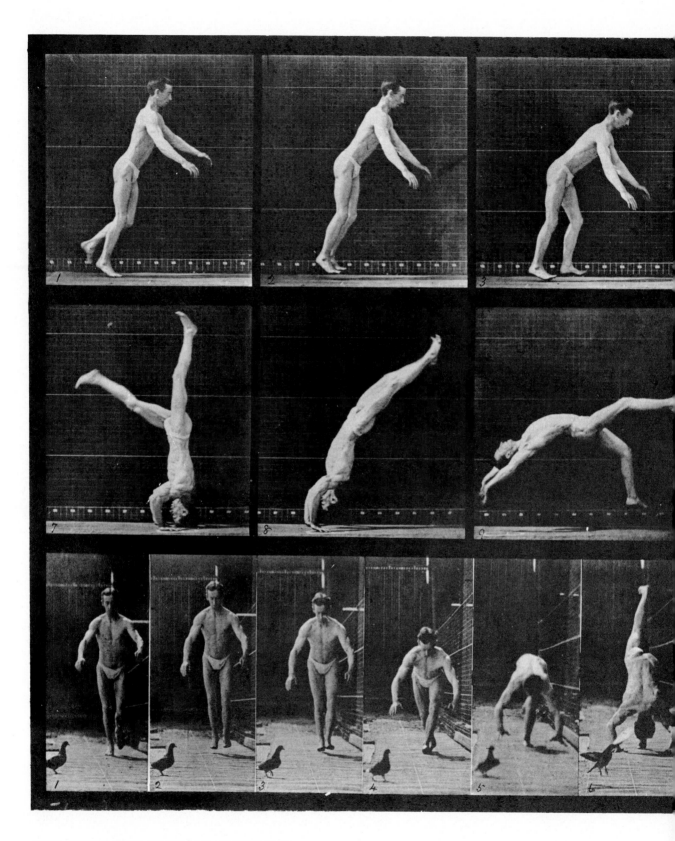

MAN PERFORMING FORWARD HANDSPRING

PLATE 74

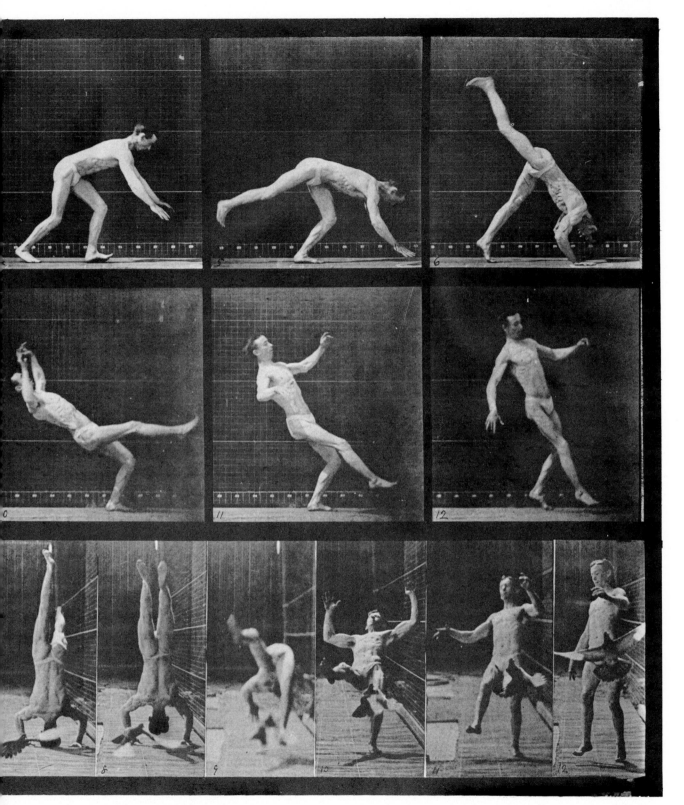

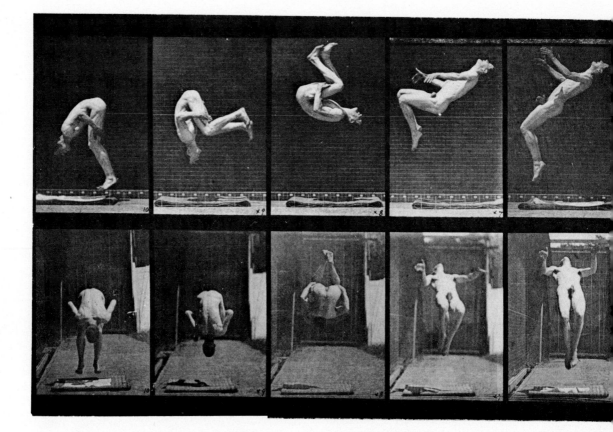

MAN PERFORMING BACK SOMERSAULT

PLATE 75

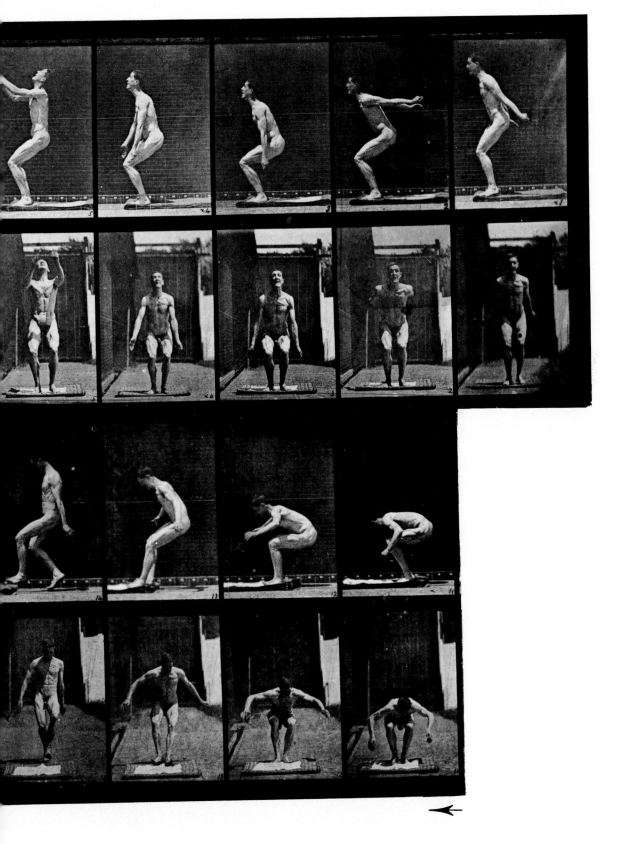

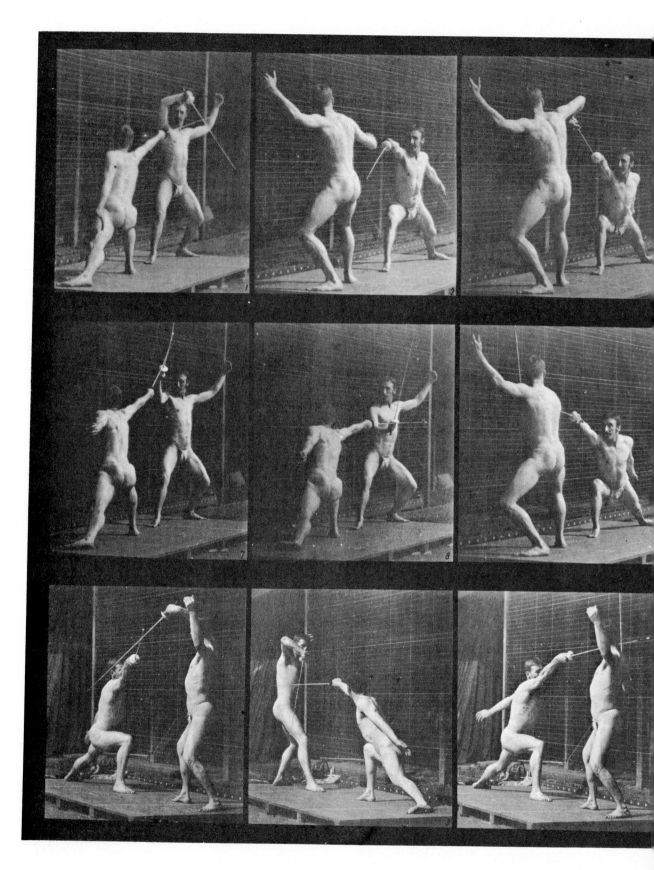

MEN FENCING

PLATE 76

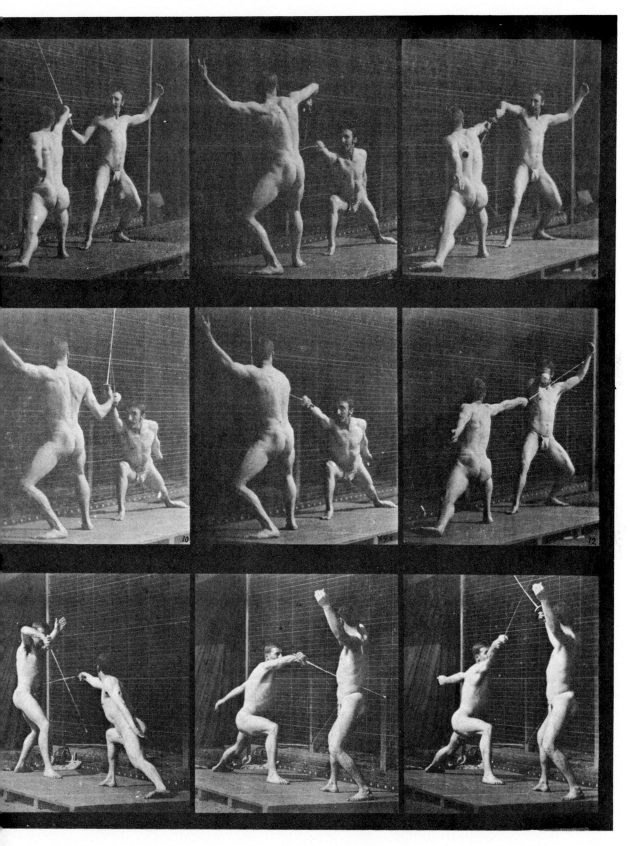

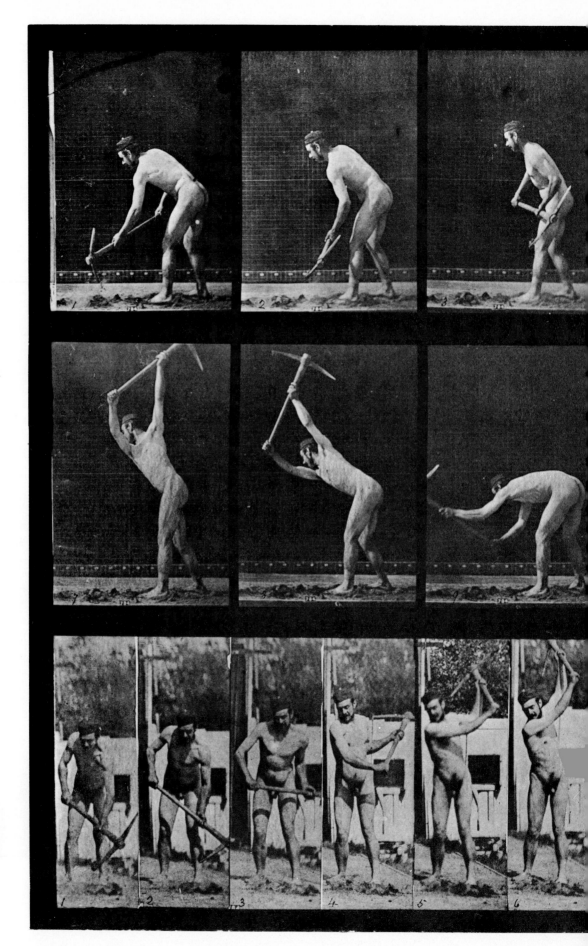

PLATE 77

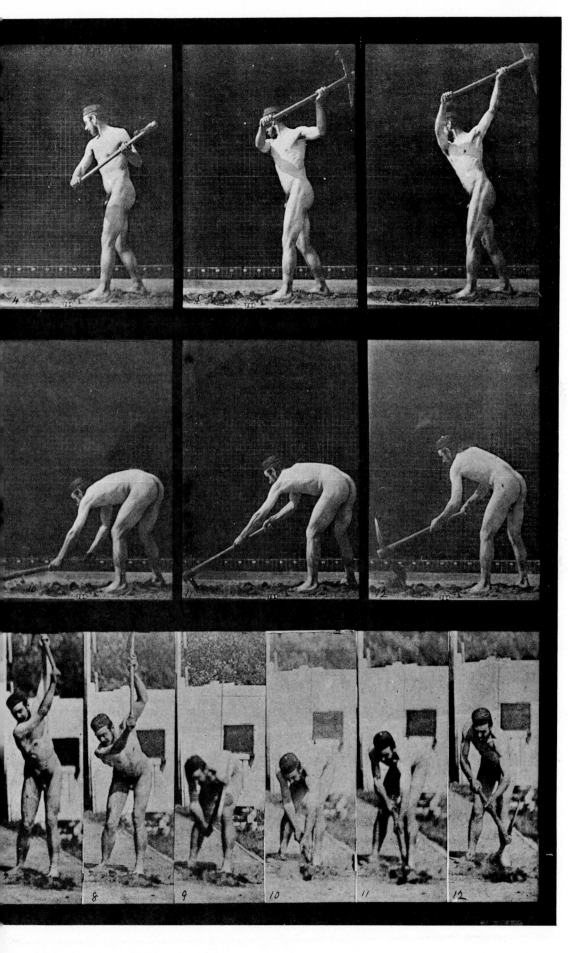

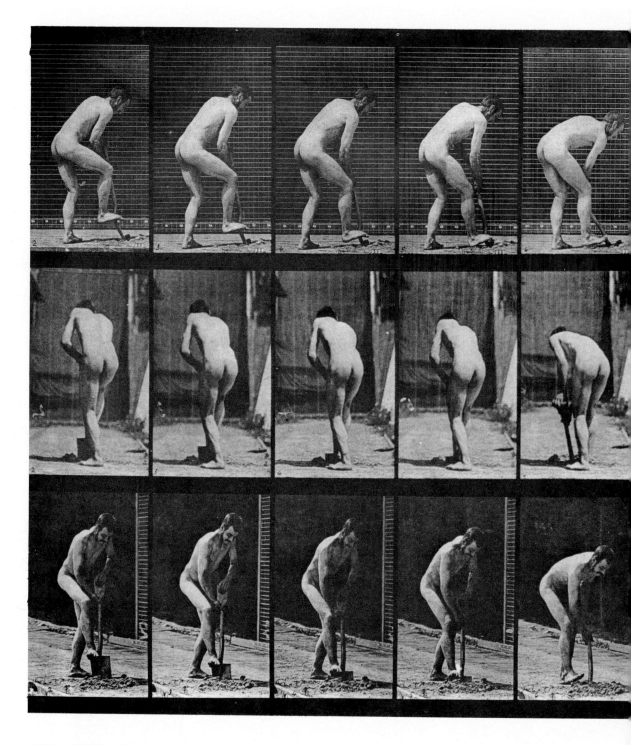

MAN DIGGING WITH SPADE

PLATE 78

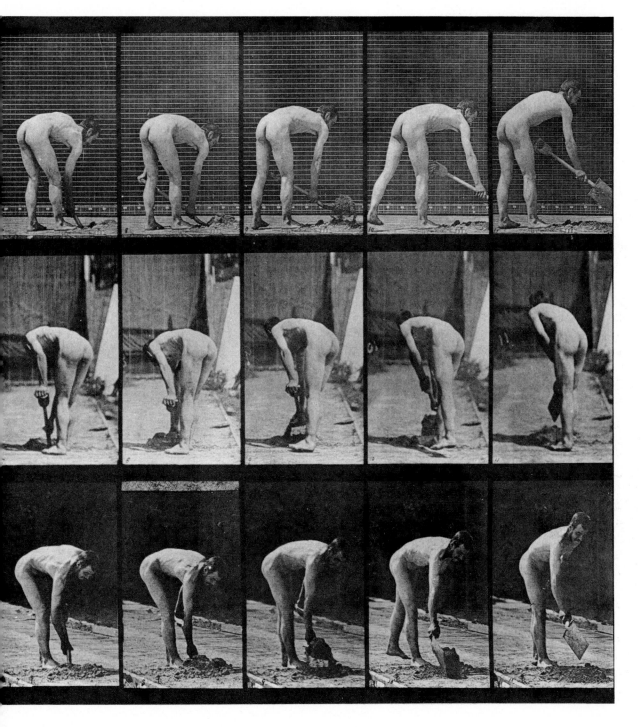

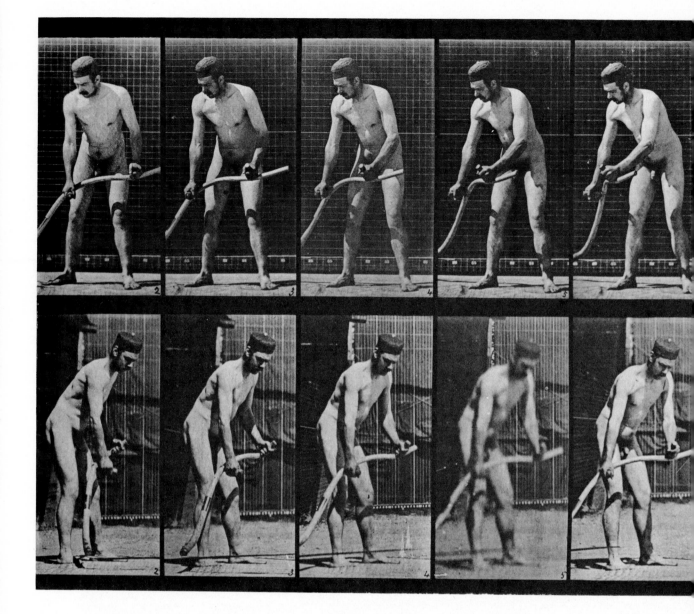

MAN SWINGING SCYTHE

PLATE 79

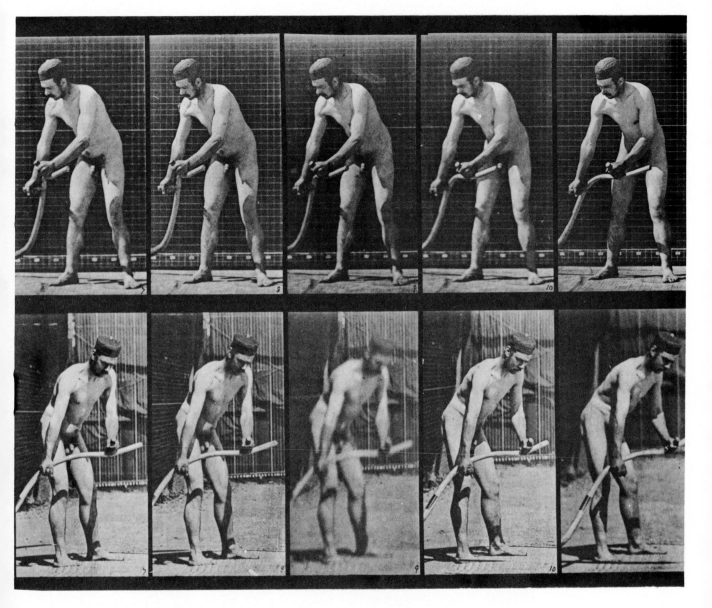

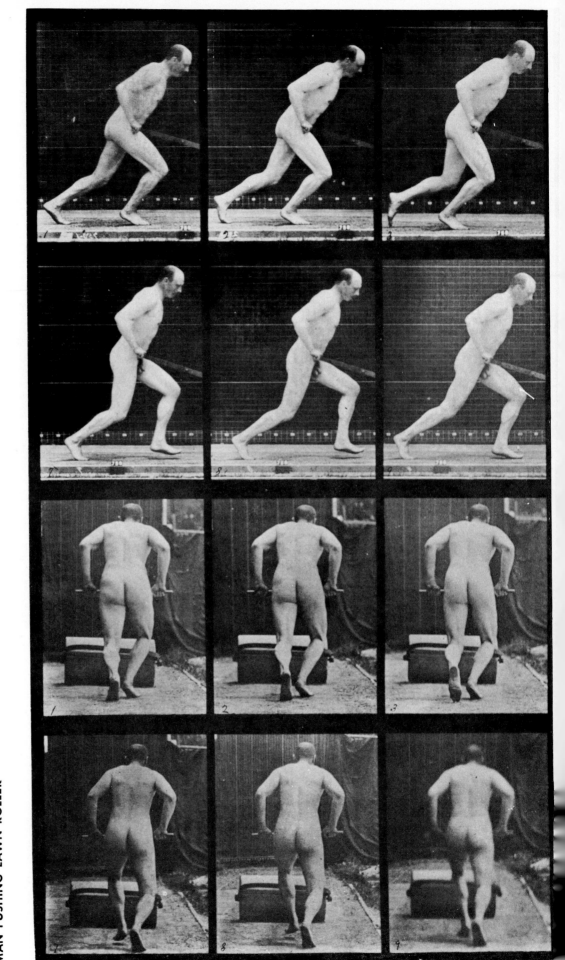

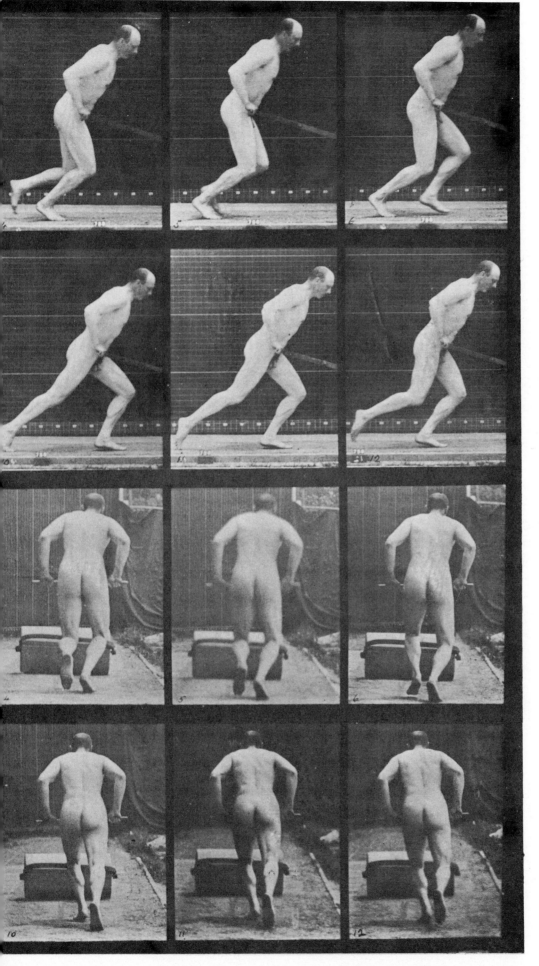

PLATE 80

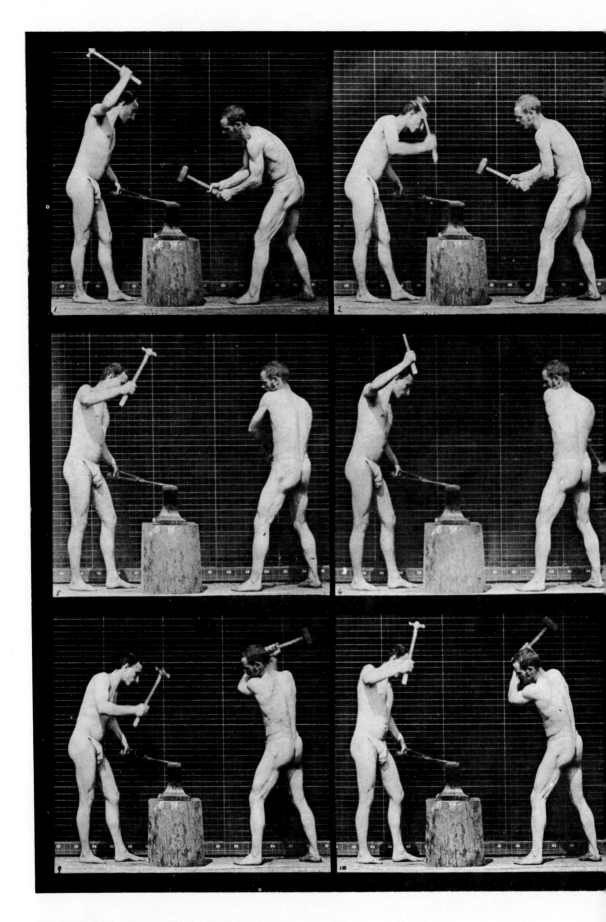

BLACKSMITHS HAMMERING AT ANVIL (.133 second)

PLATE 81

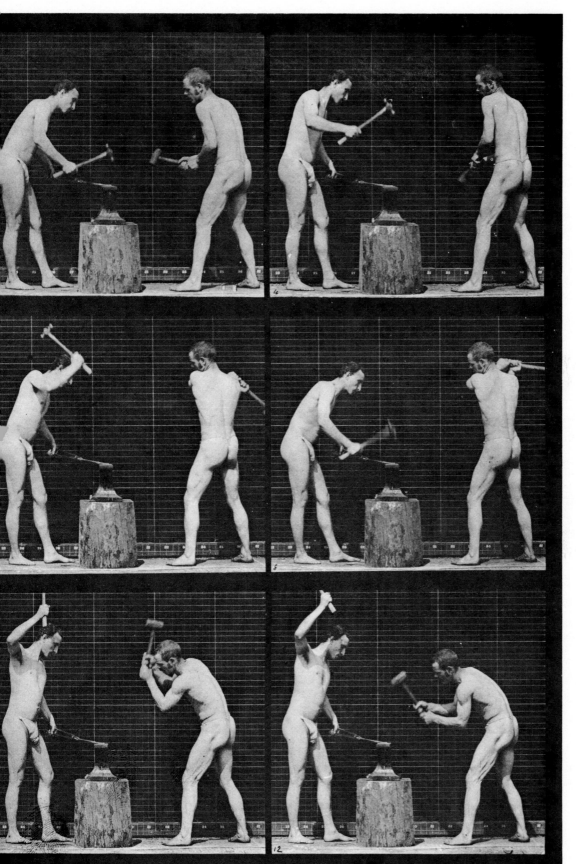

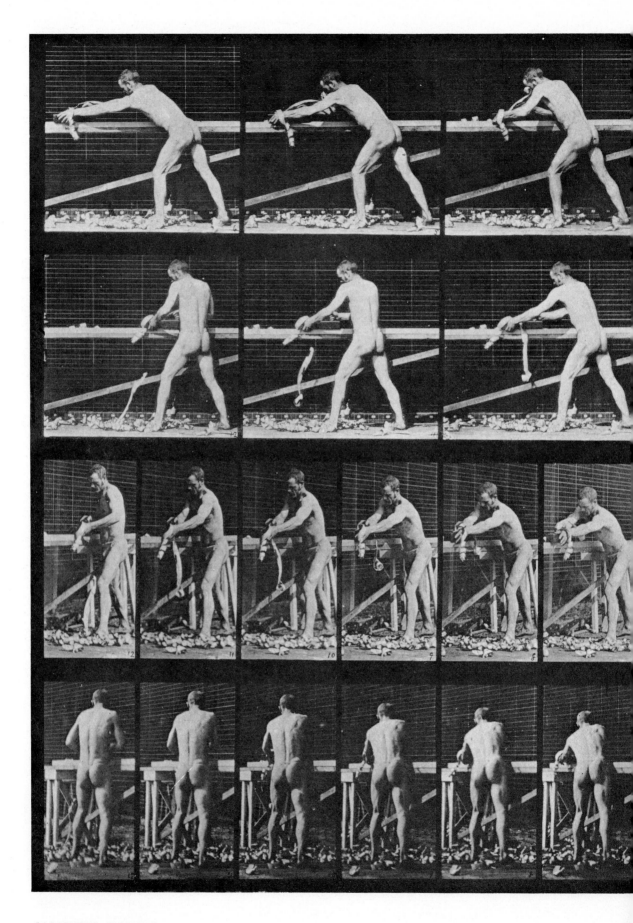

CARPENTER PLANING

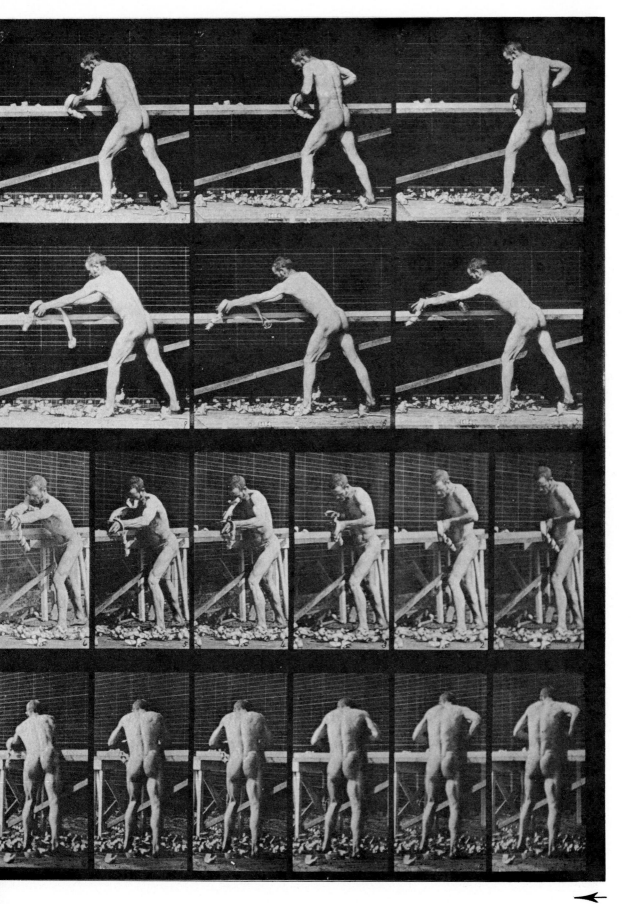

PLATE 82

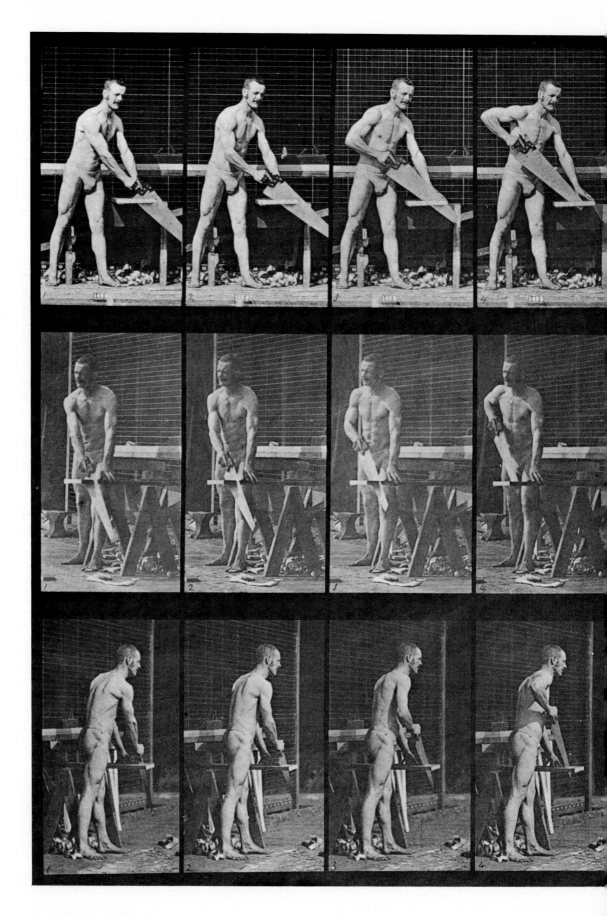

CARPENTER SAWING

PLATE 83

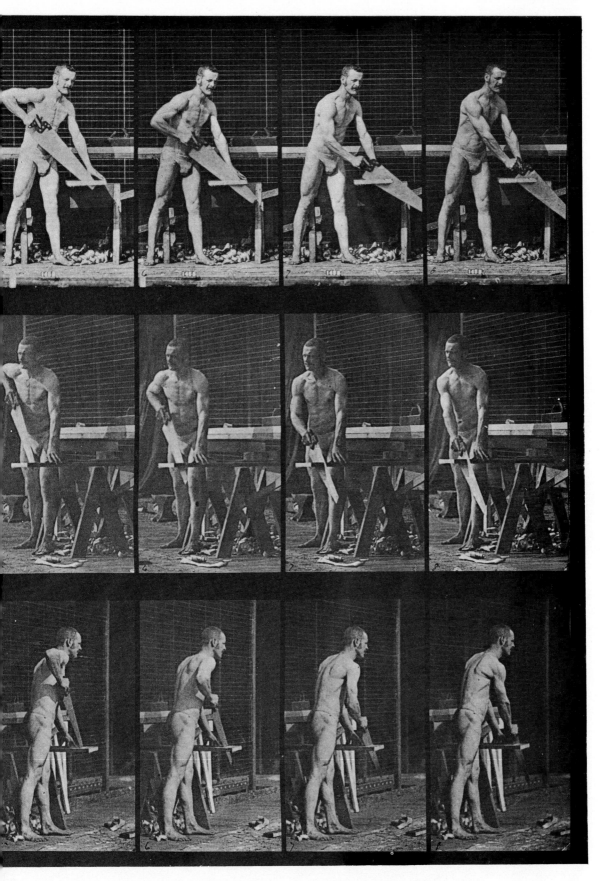

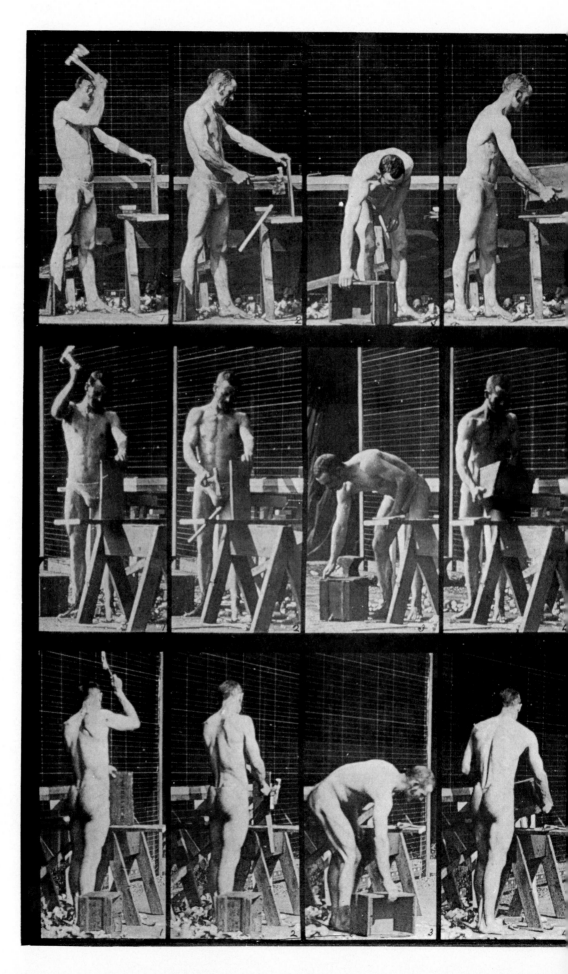

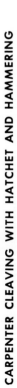

PLATE 84

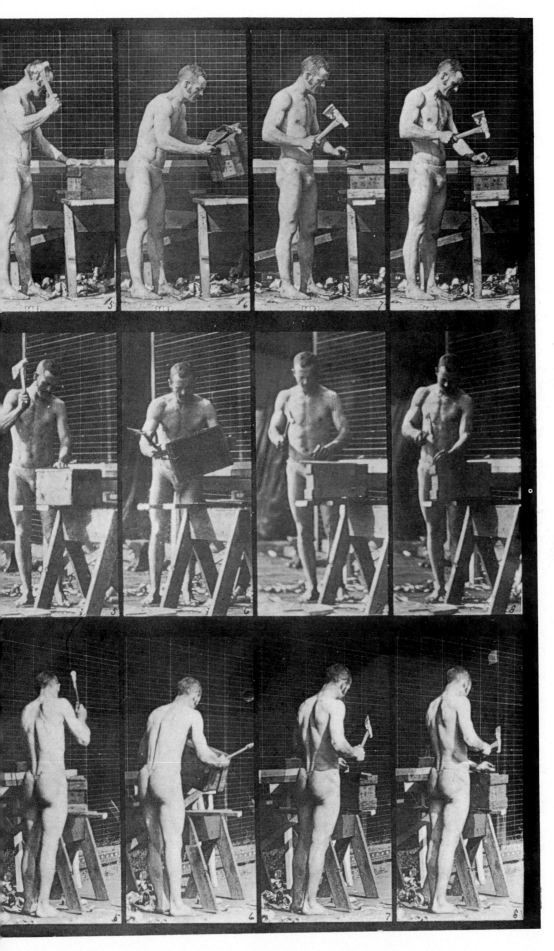

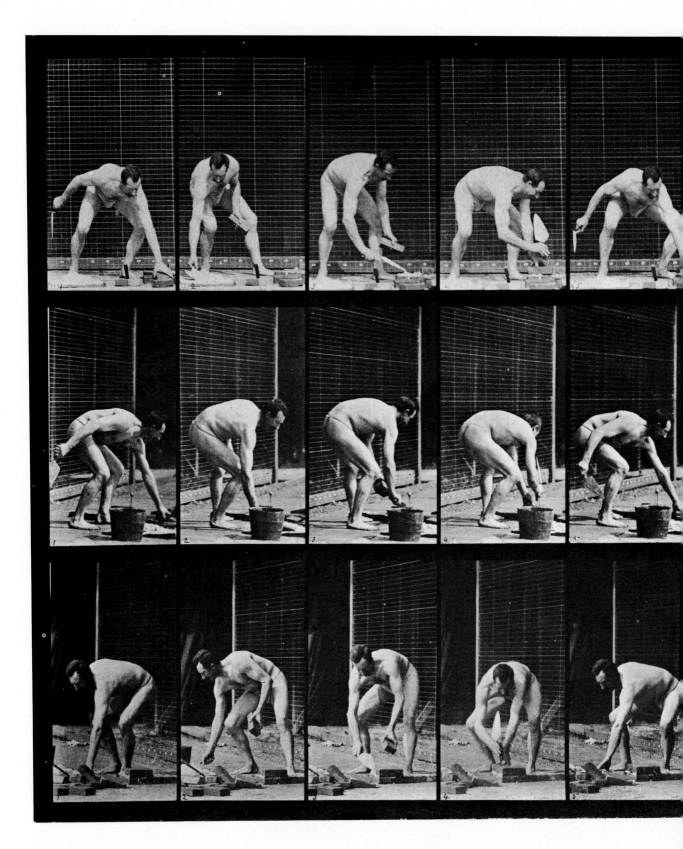

MAN LAYING BRICK

PLATE 85

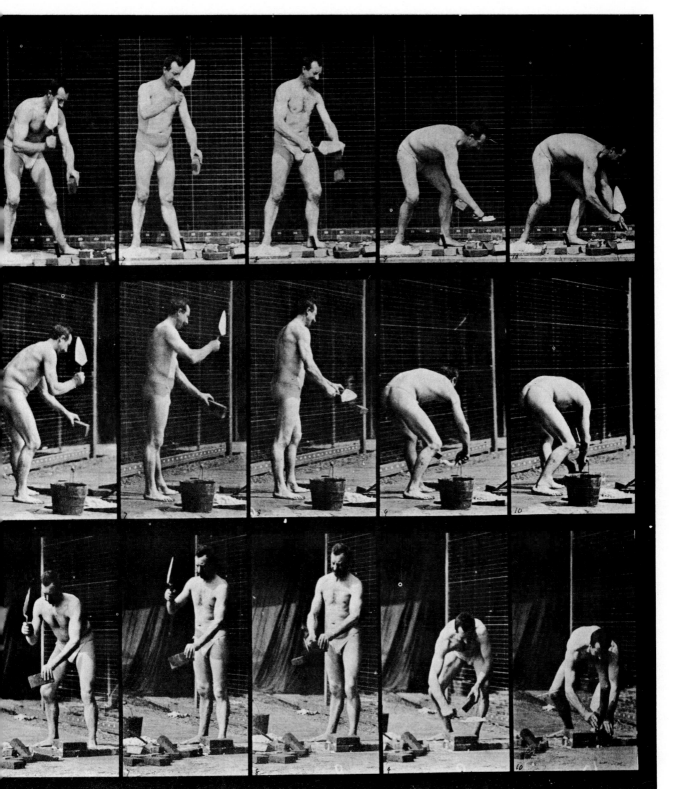

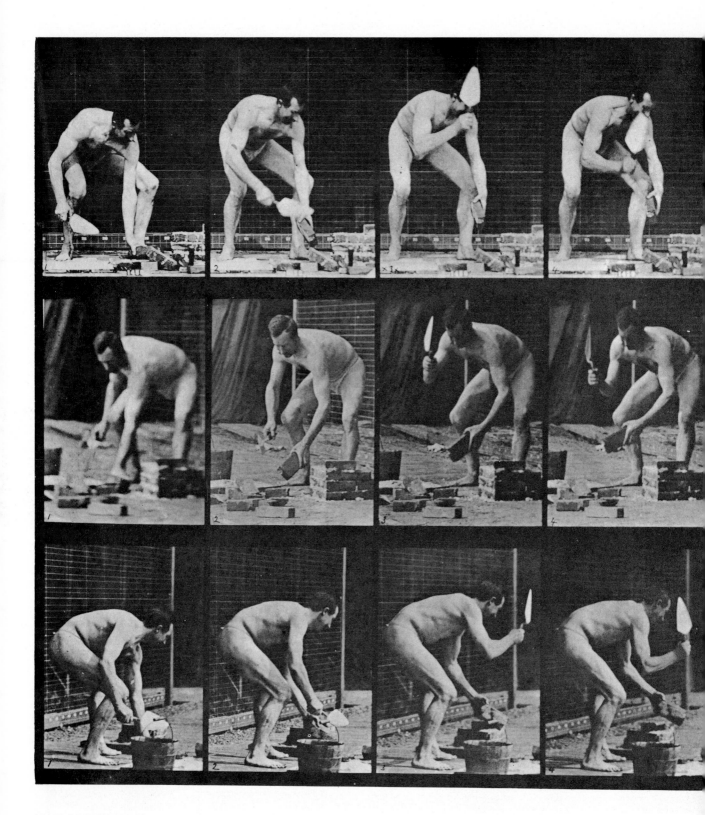

MAN LAYING BRICK

PLATE 86

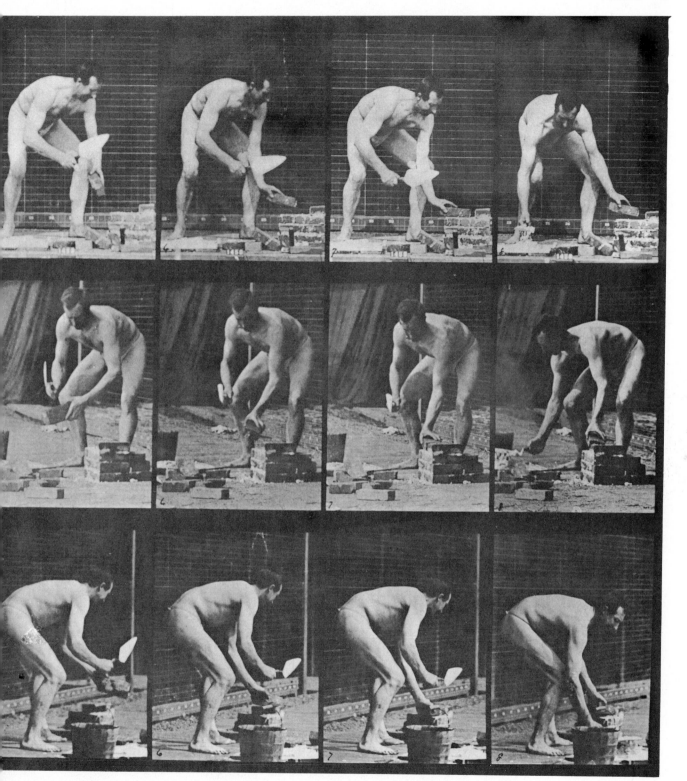

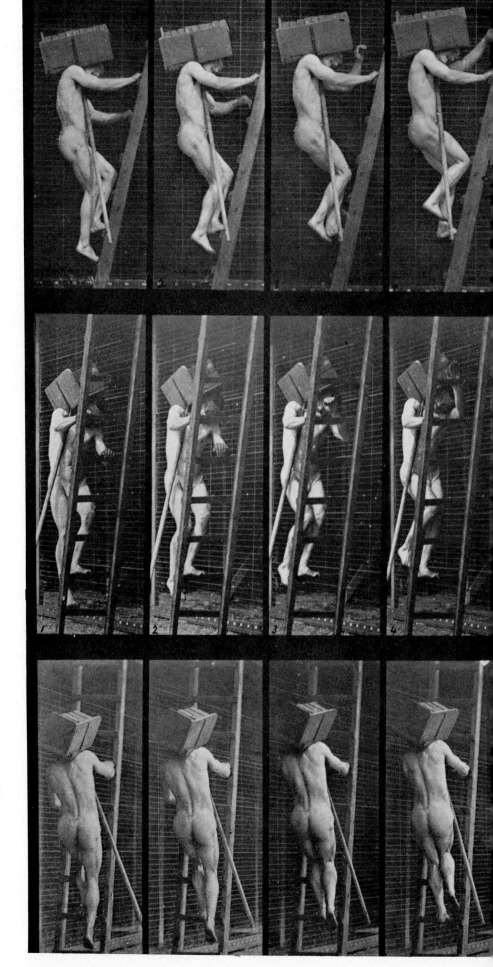

PLATE 87

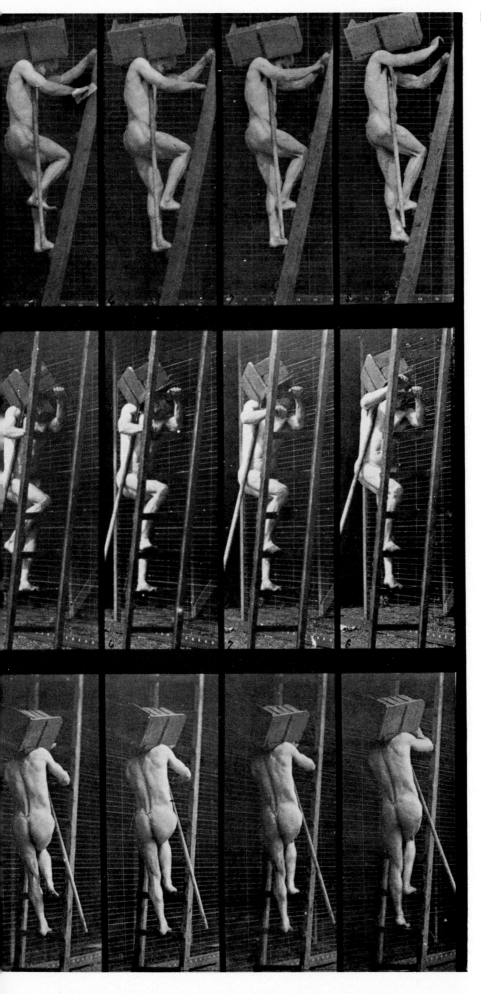

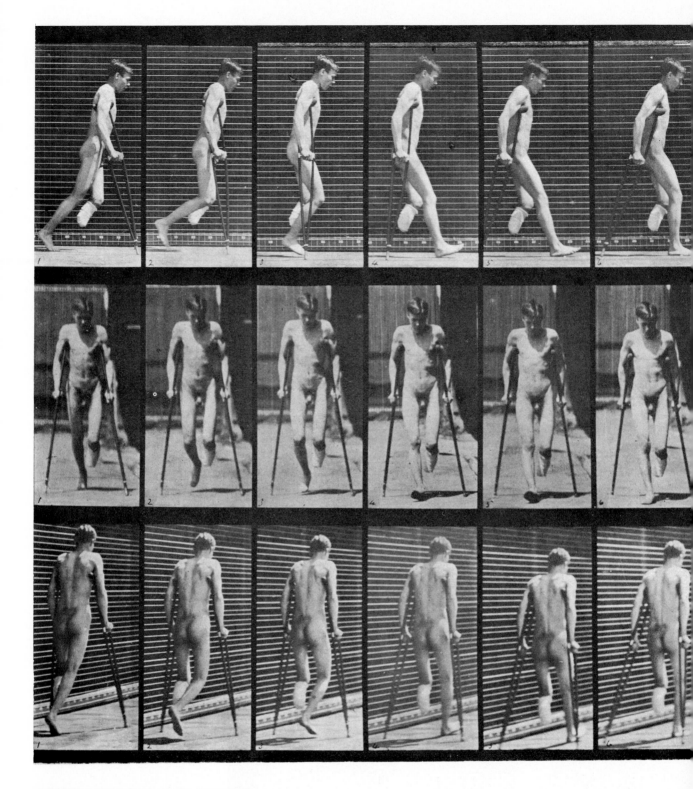

AMPUTEE WALKING WITH CRUTCHES

PLATE 88

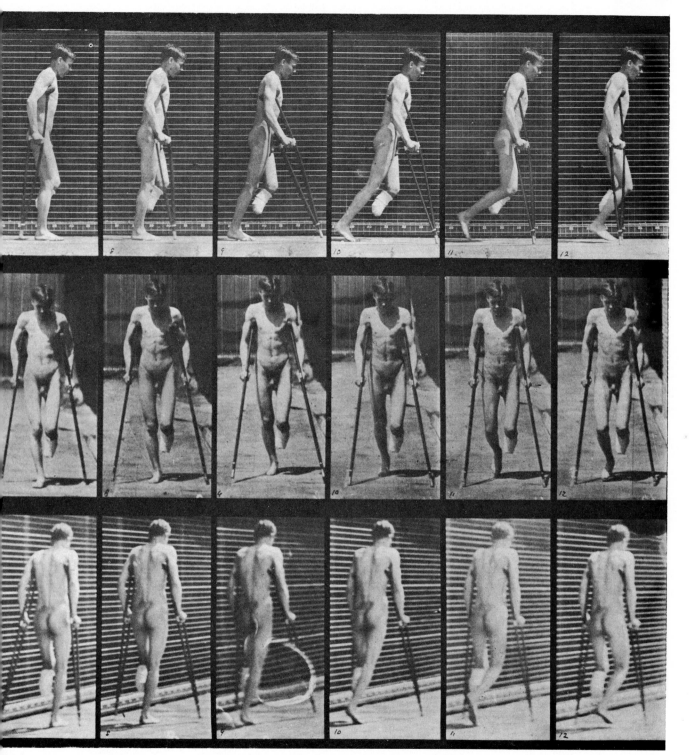

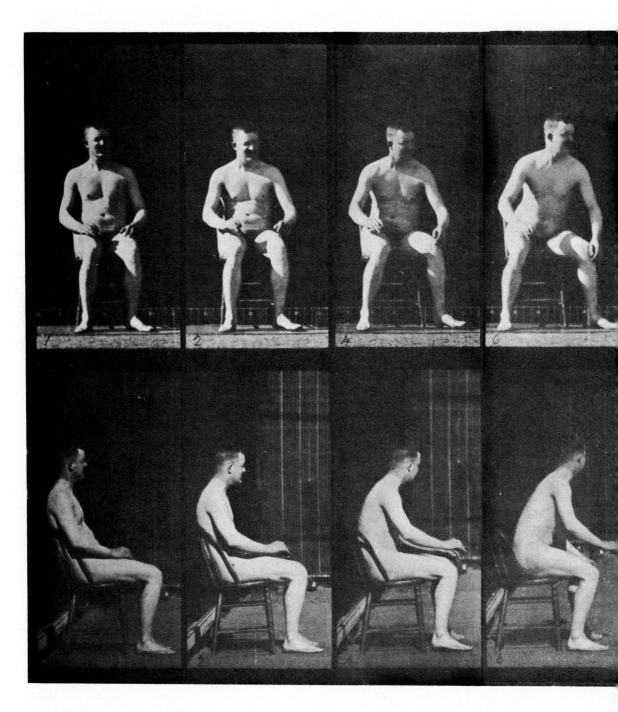

MAN RISING FROM CHAIR

PLATE 89

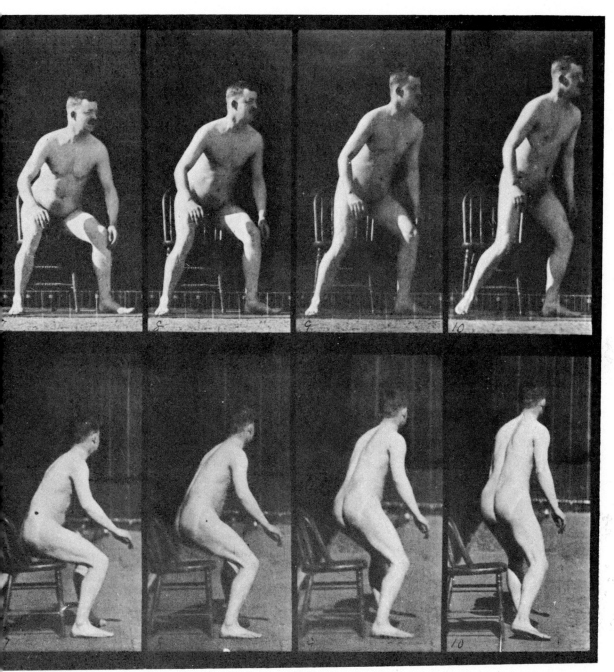

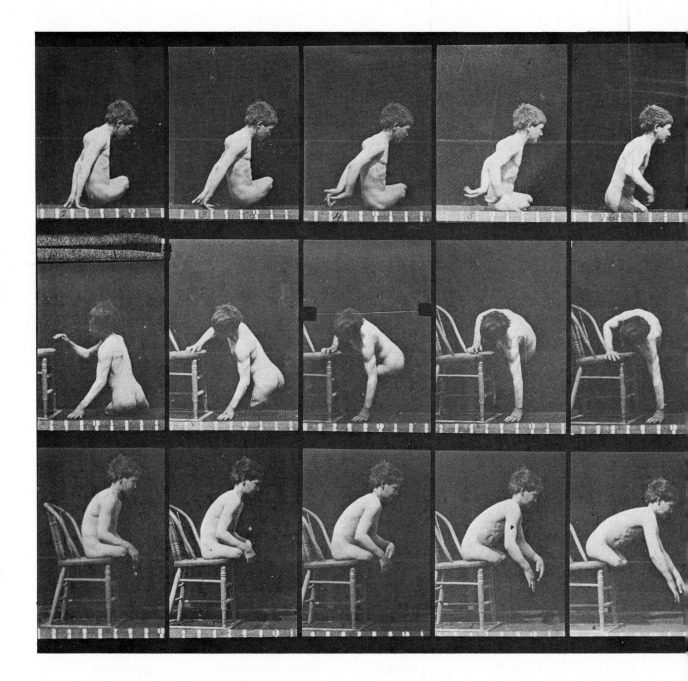

LEGLESS BOY CLIMBING IN AND OUT OF CHAIR

PLATE 90

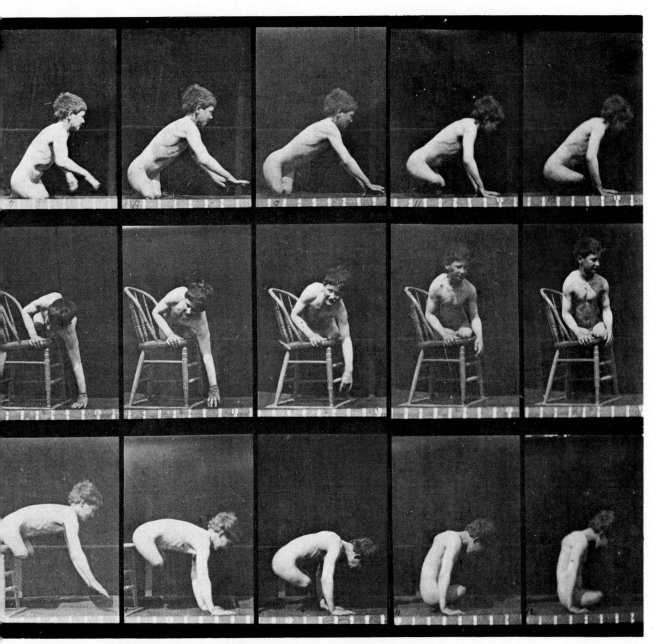

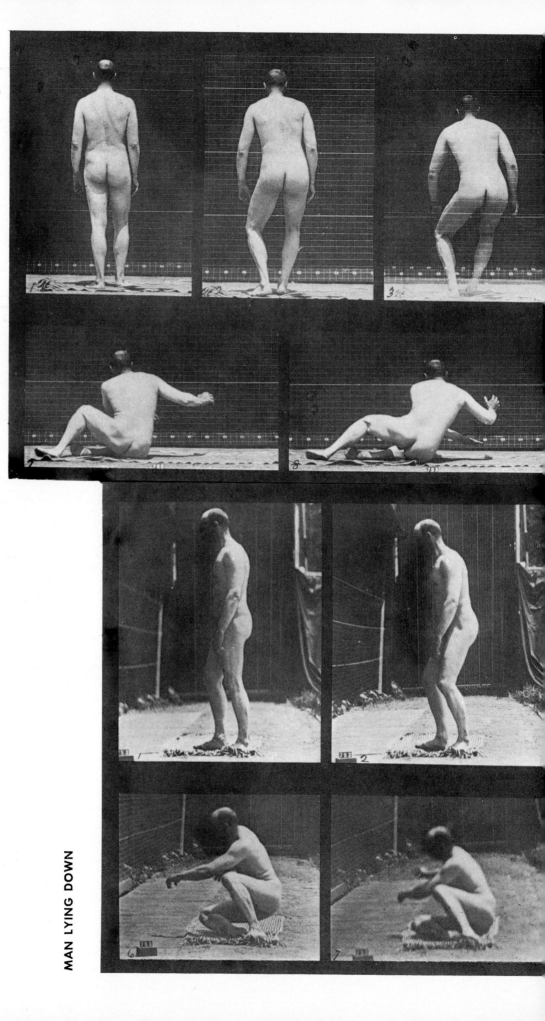

PLATE 91

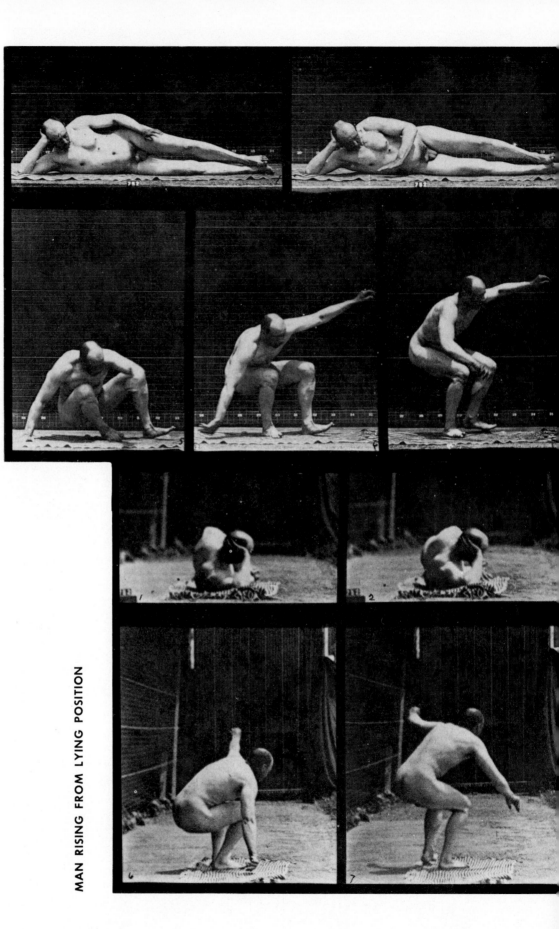

PLATE 92

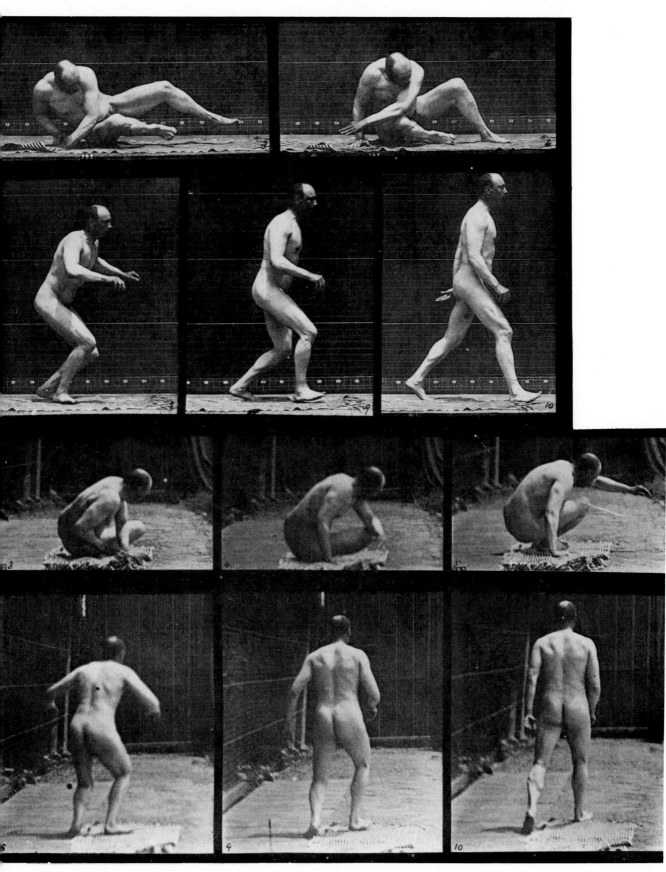

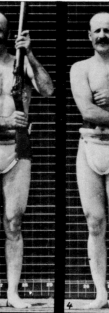
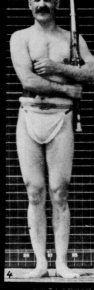
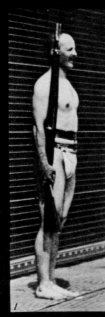
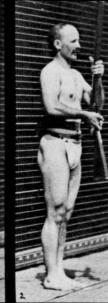
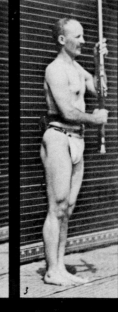
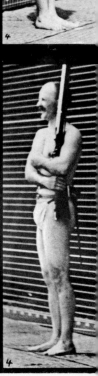

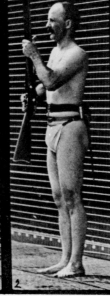
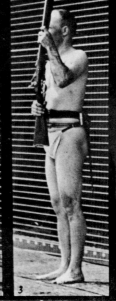

PLATE 93

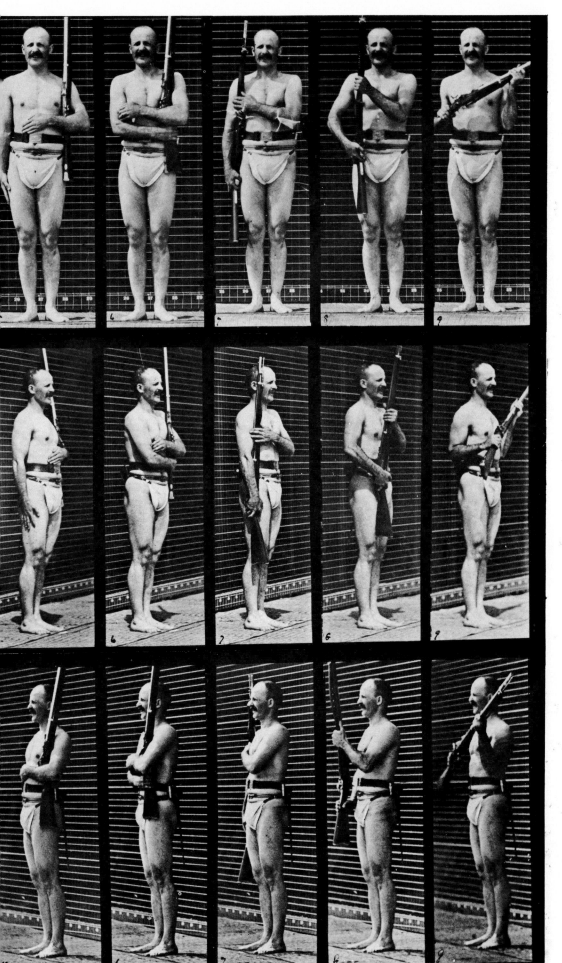

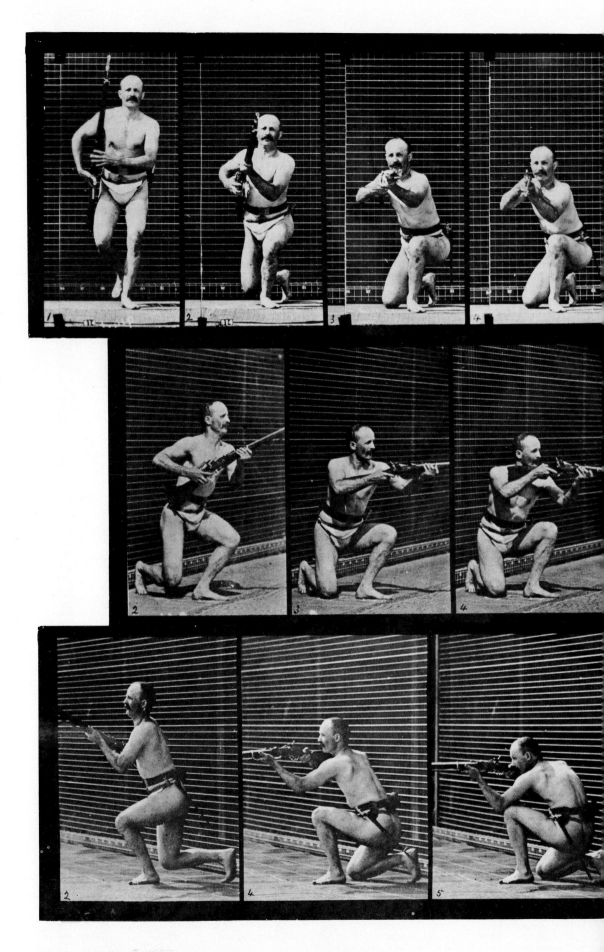

MAN ASSUMING KNEELING POSITION AND AIMING RIFLE

PLATE 94

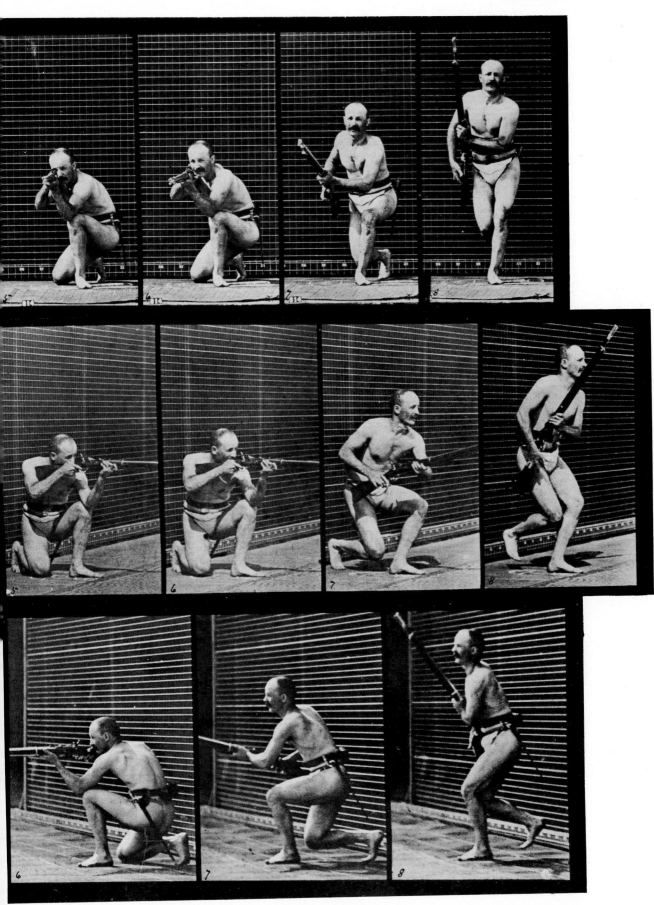

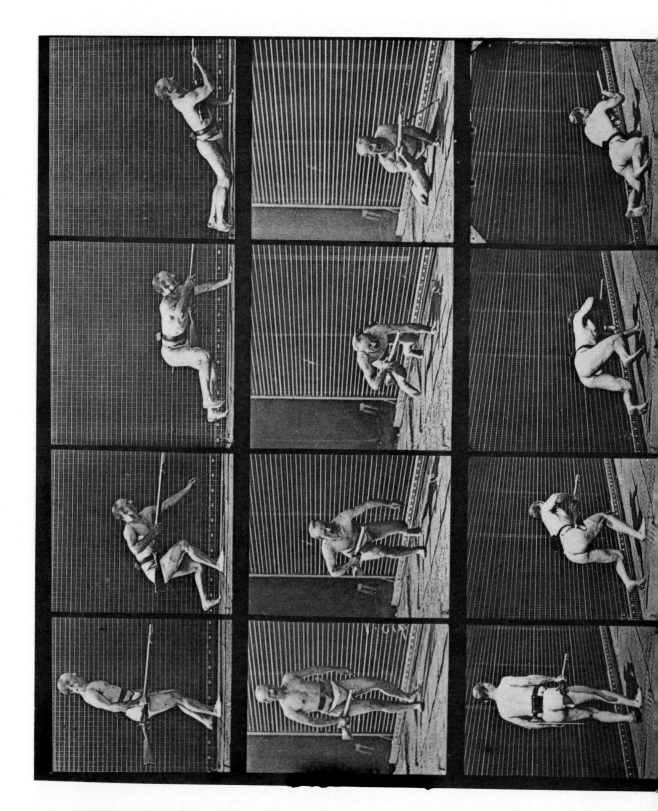

MAN FALLING PRONE AND AIMING RIFLE

PLATE 95

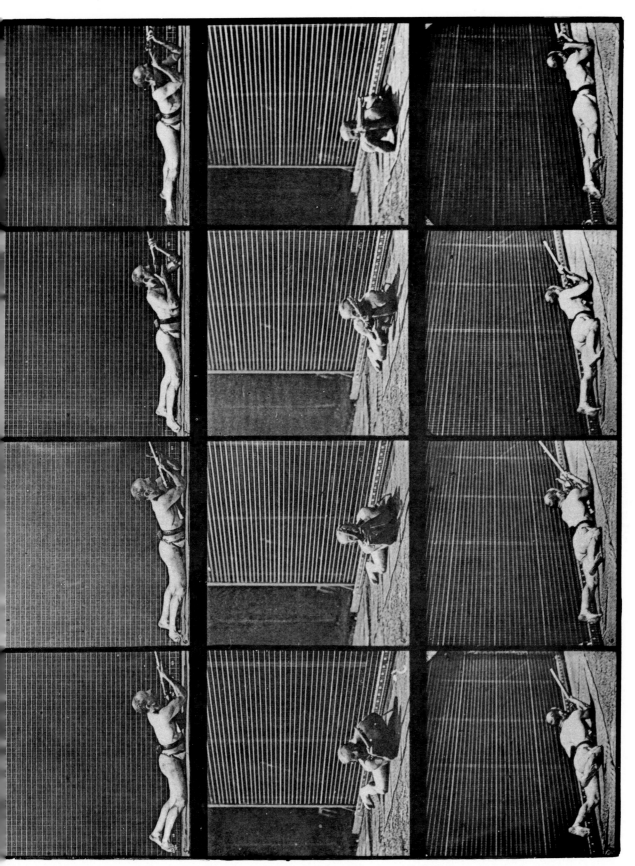

WOMEN

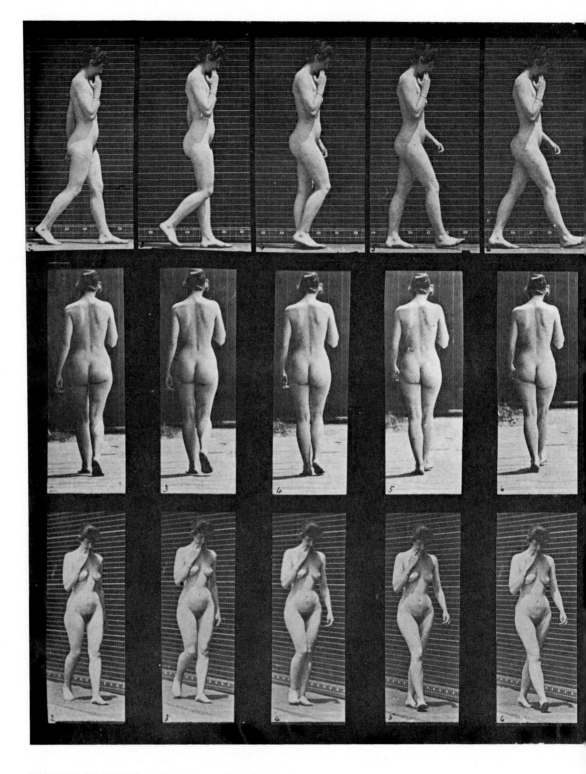

WOMAN WALKING WITH HAND TO MOUTH

PLATE 96

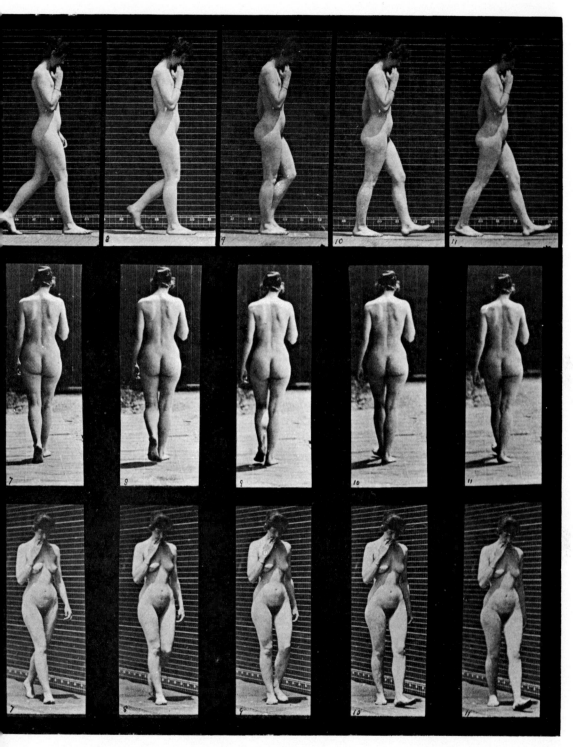

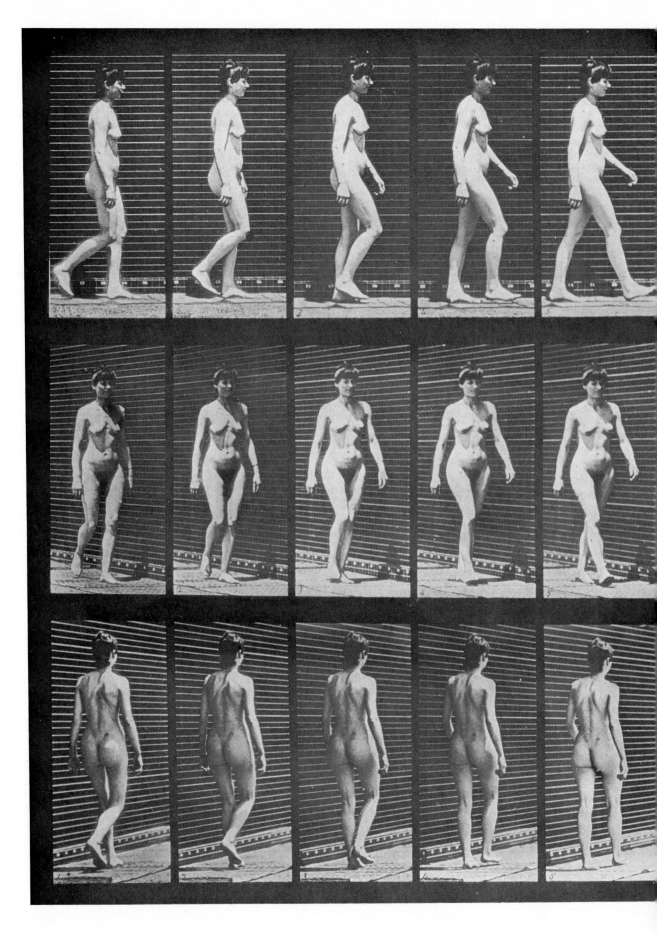

WOMAN WALKING

PLATE 97

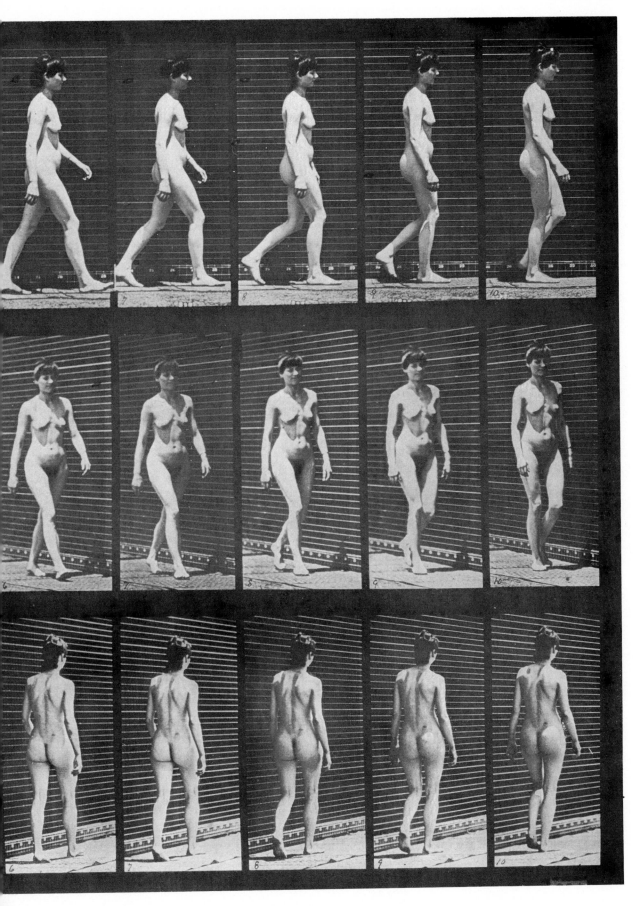

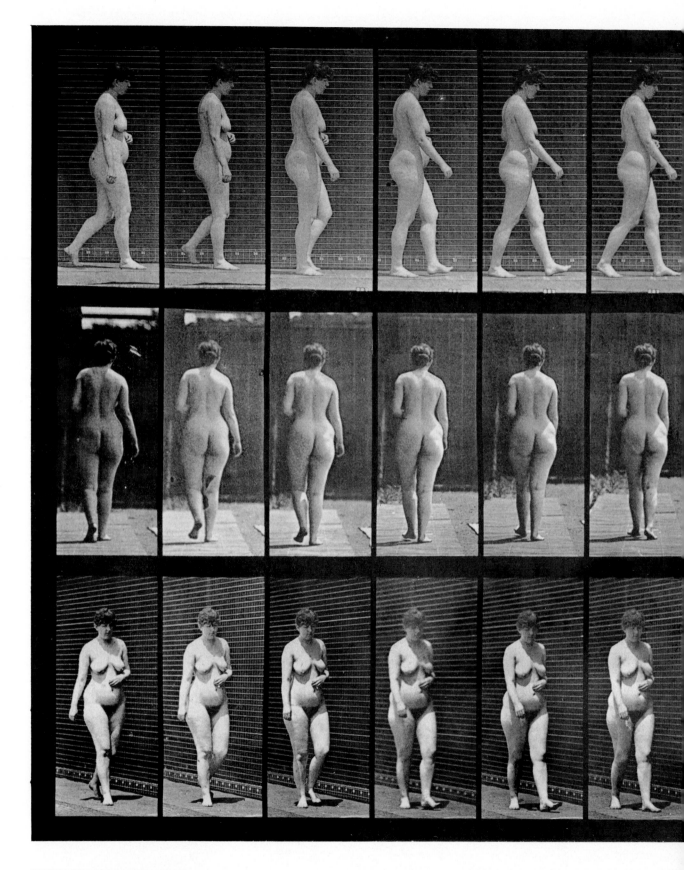

STOUT WOMAN WALKING

PLATE 98

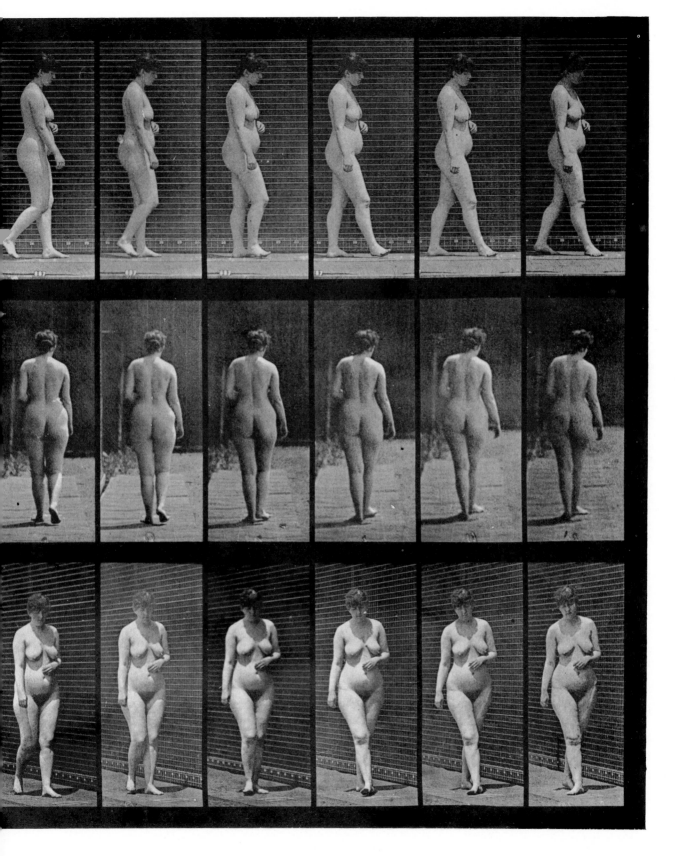

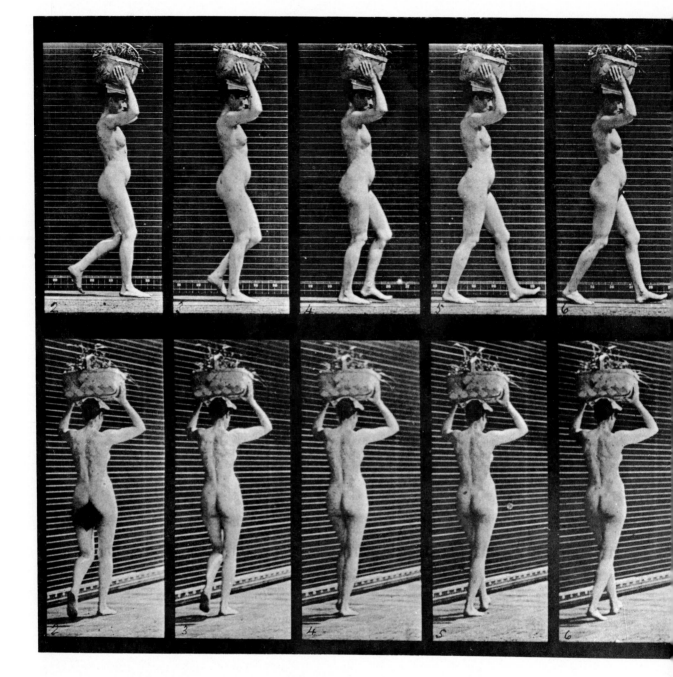

WOMAN WALKING, HOLDING BASKET ON HEAD

PLATE 99

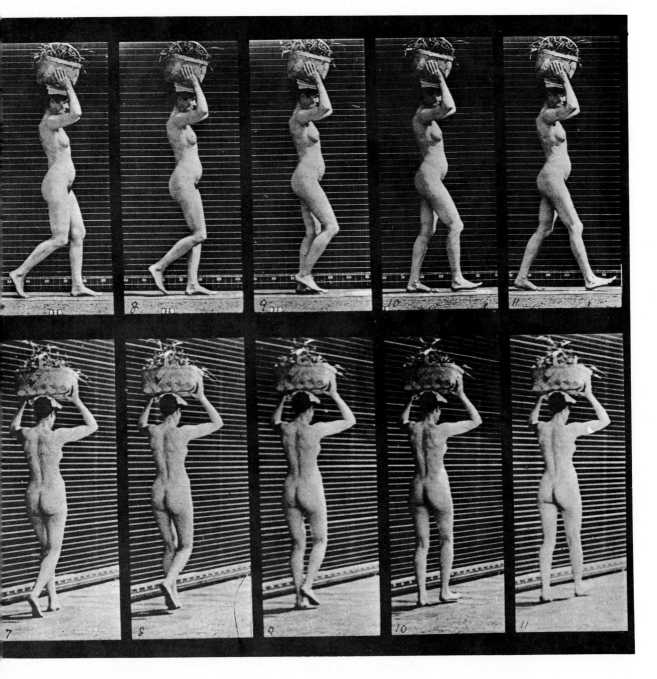

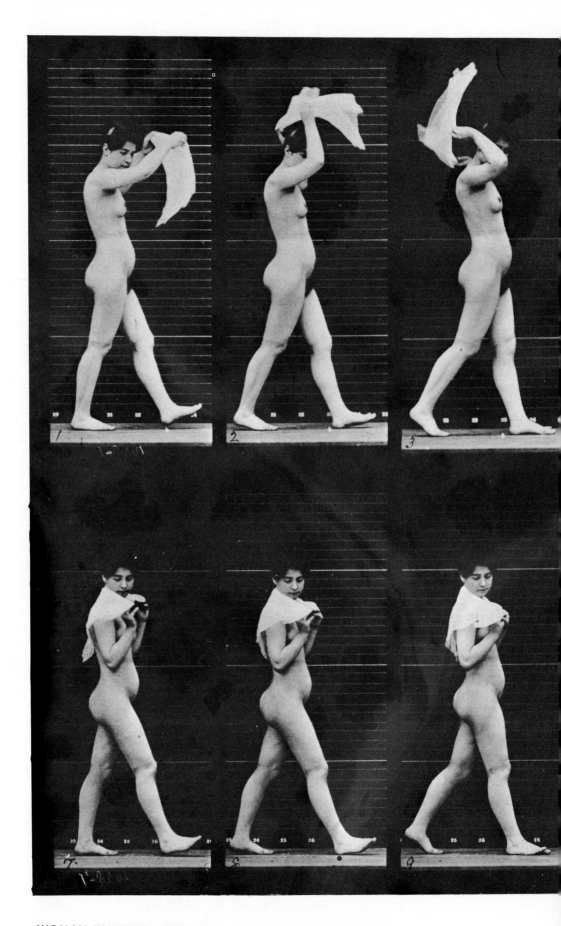

WOMAN WALKING, THROWING SCARF OVER SHOULDERS

PLATE 100

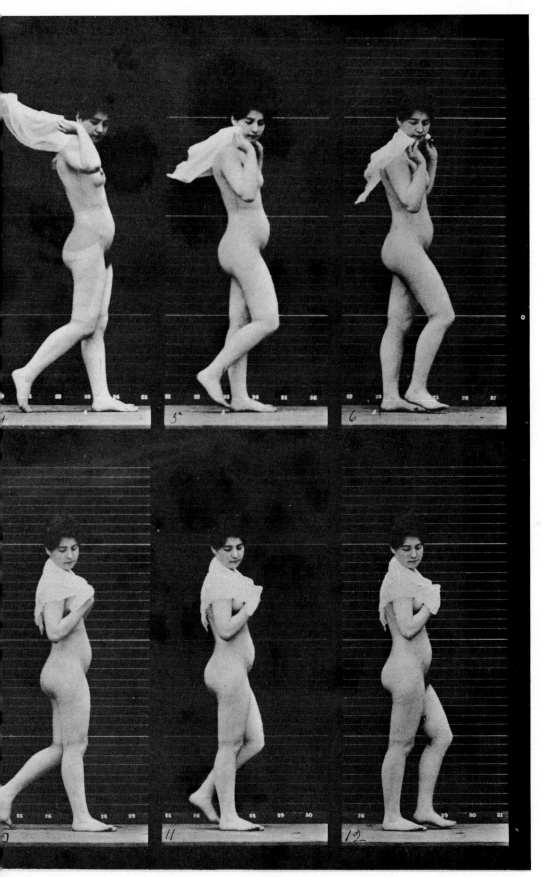

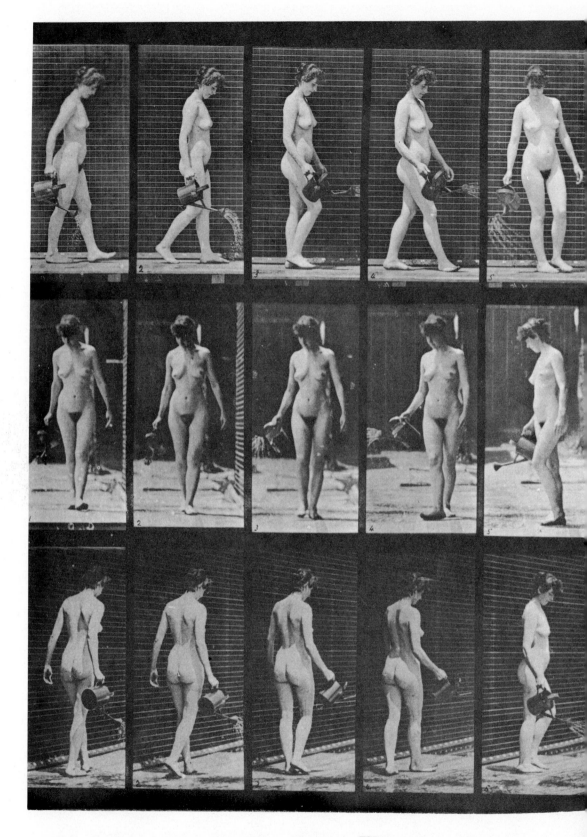

WOMAN WALKING AND TURNING WHILE POURING WATER FROM WATERING CAN

PLATE 101

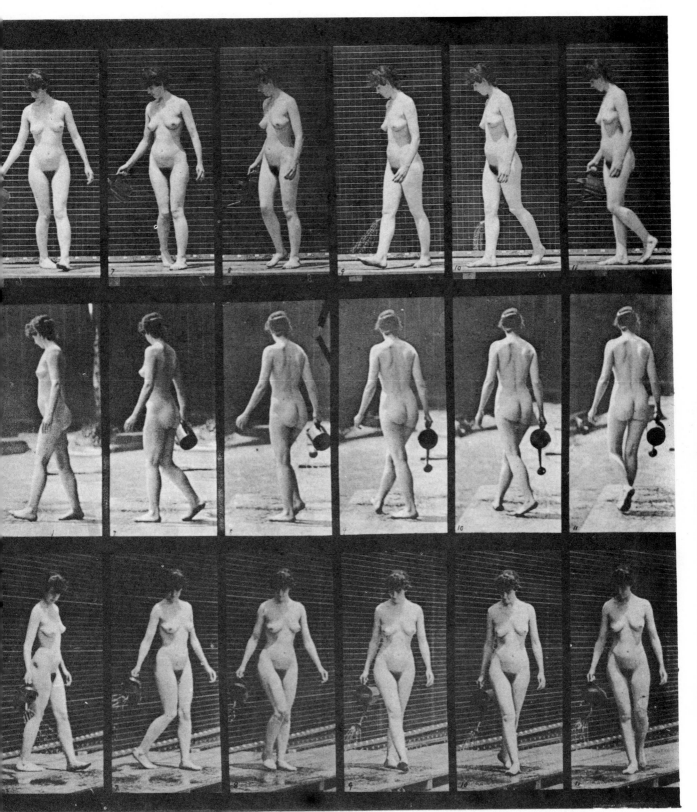

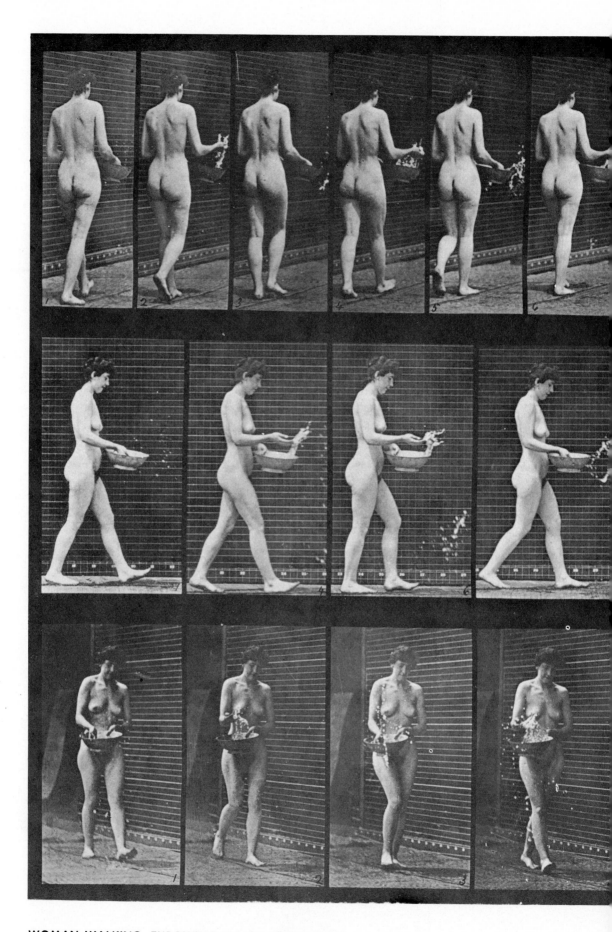

WOMAN WALKING, THROWING WATER FROM BASIN

PLATE 102

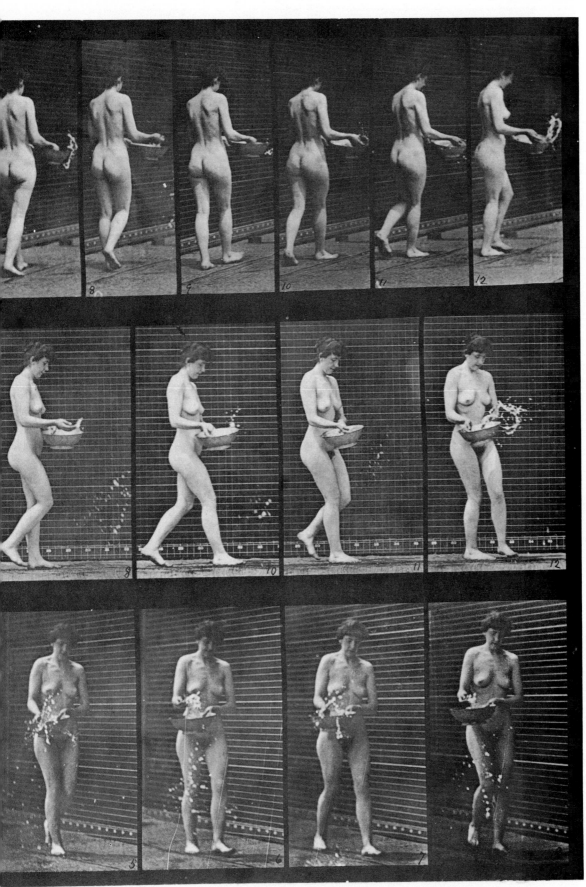

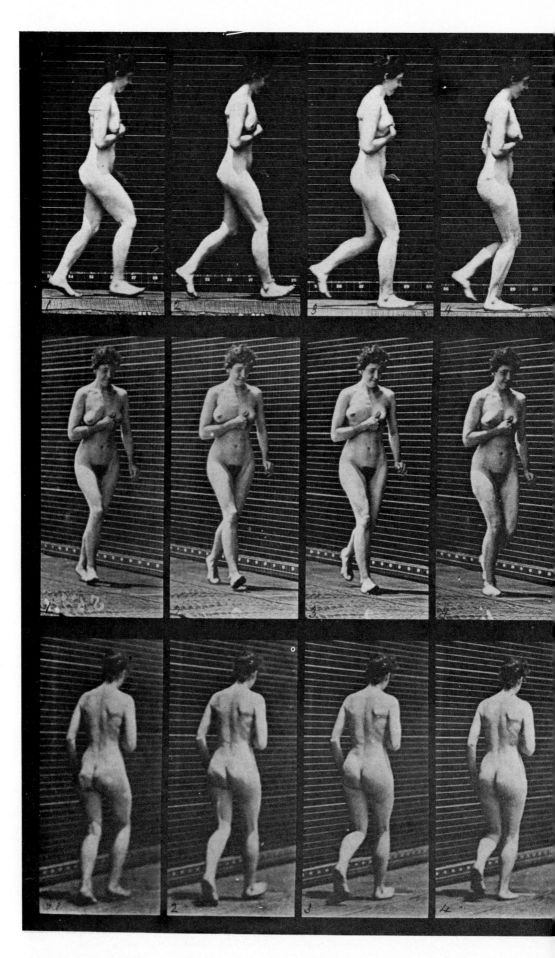

WOMAN RUNNING

PLATE 103

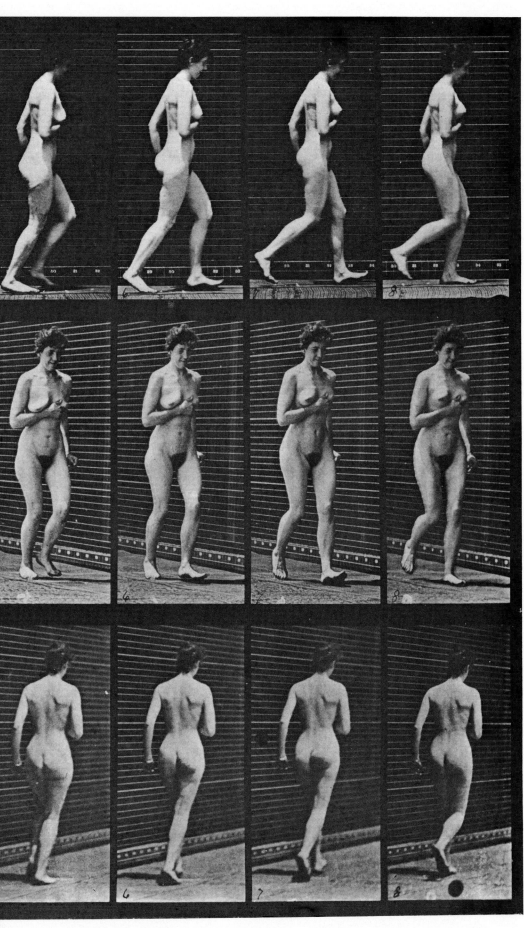

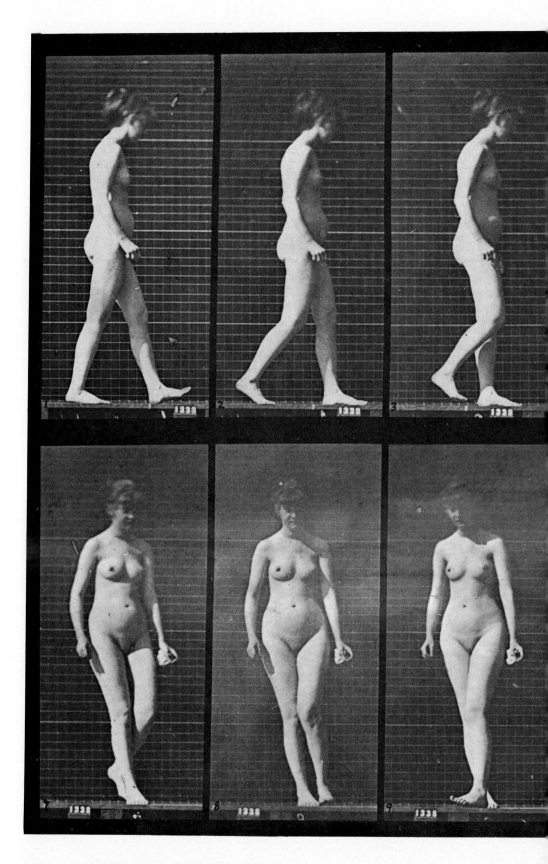

WOMAN WALKING AND TURNING AROUND

PLATE 104

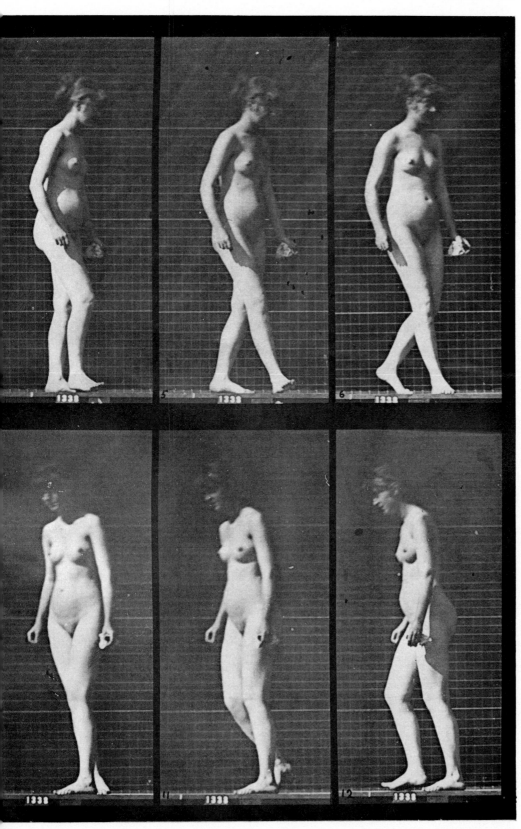

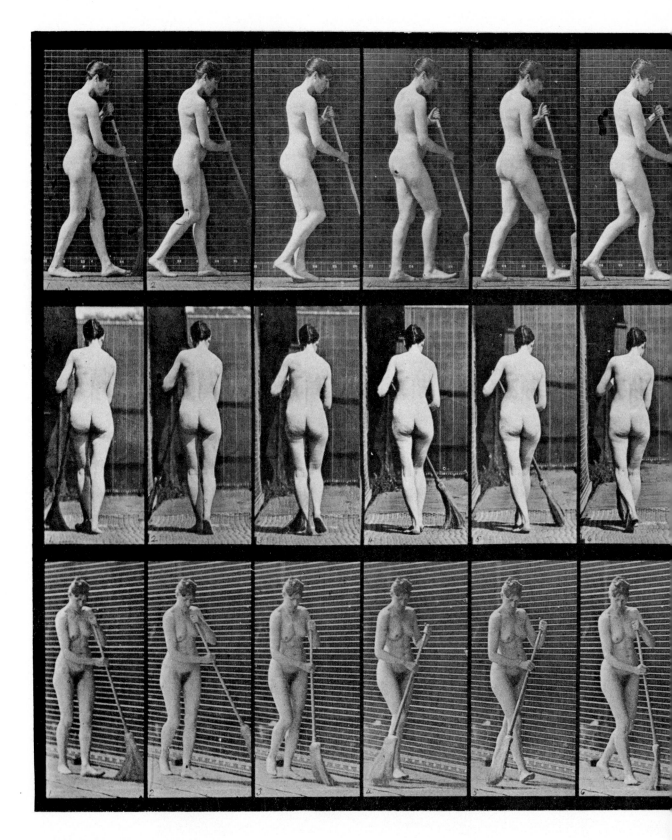

WOMAN SWEEPING WITH BROOM

PLATE 105

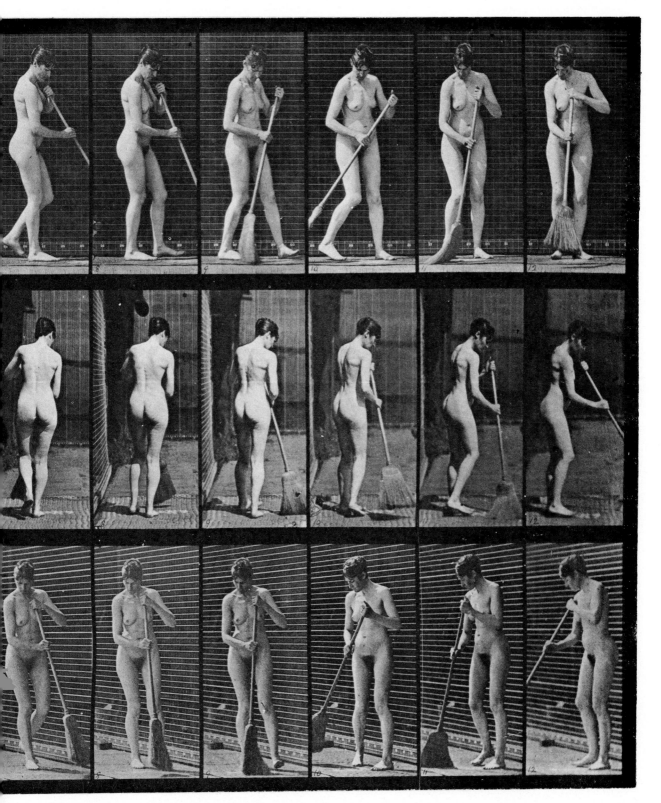

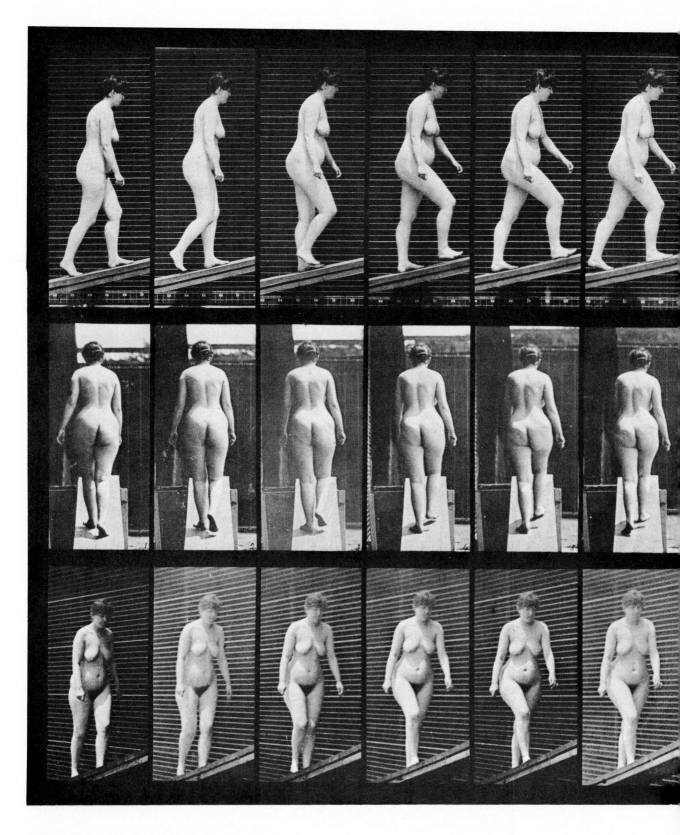

STOUT WOMAN WALKING UP INCLINE

PLATE 106

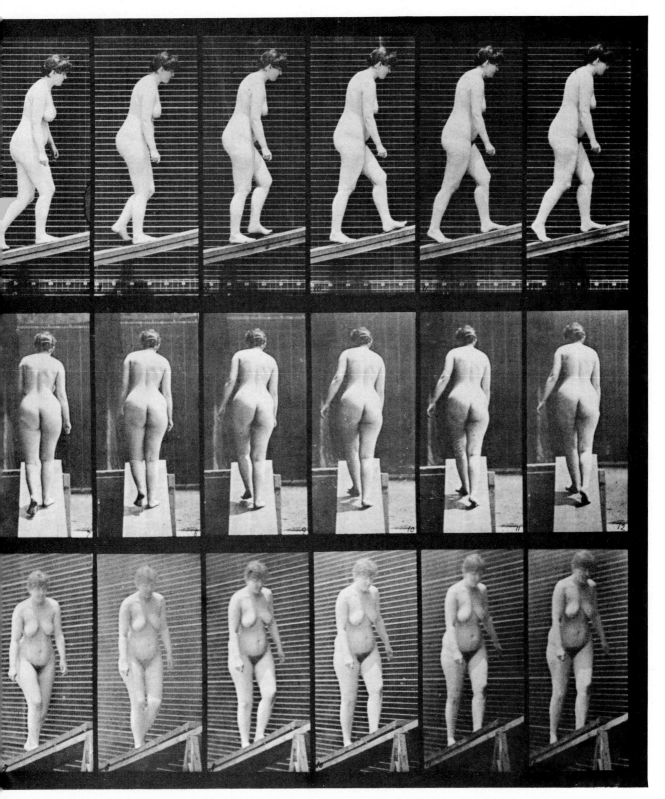

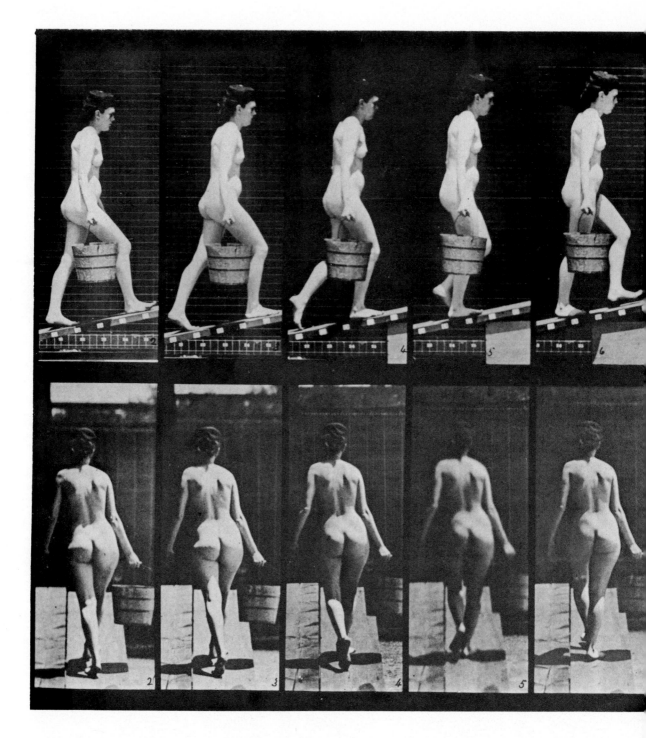

WOMAN WALKING UP INCLINE CARRYING ONE BUCKET

PLATE 107

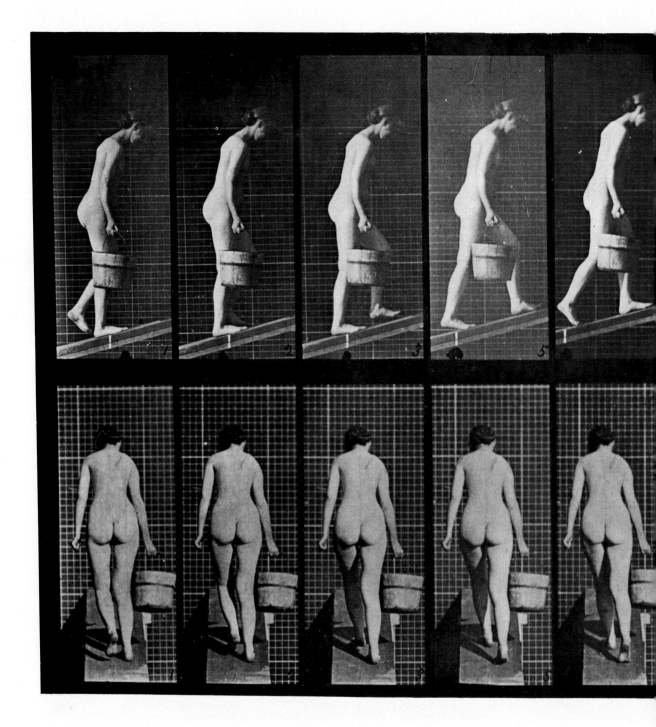

WOMAN WALKING UP INCLINE CARRYING ONE BUCKET

PLATE 108

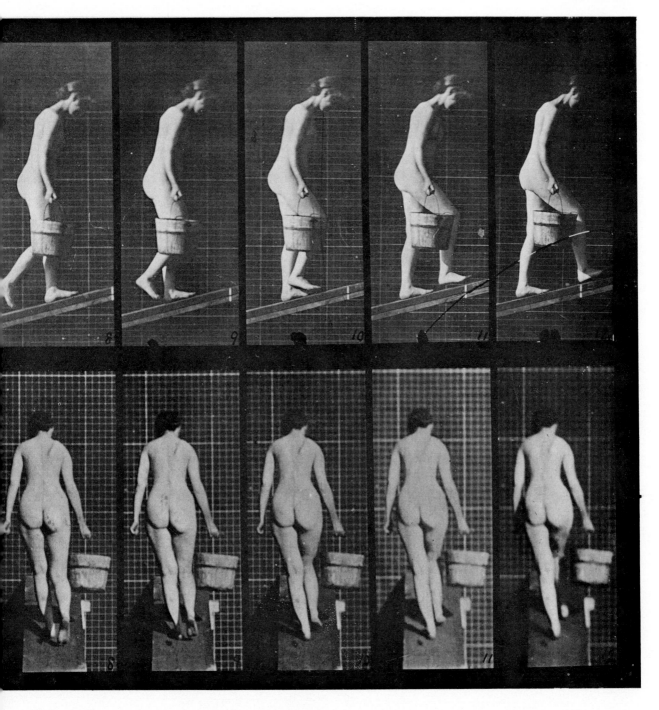

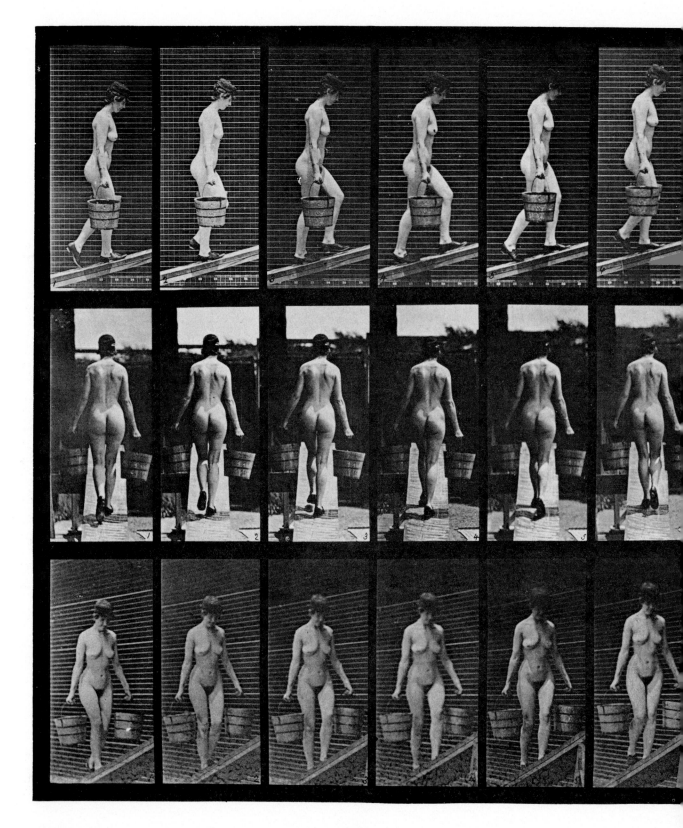

WOMAN WALKING UP INCLINE CARRYING TWO BUCKETS

PLATE 109

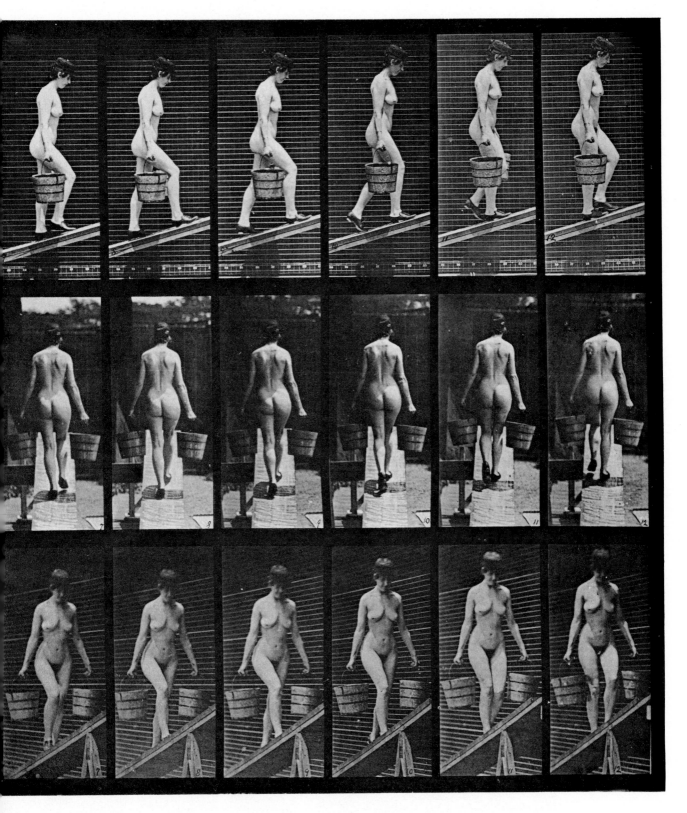

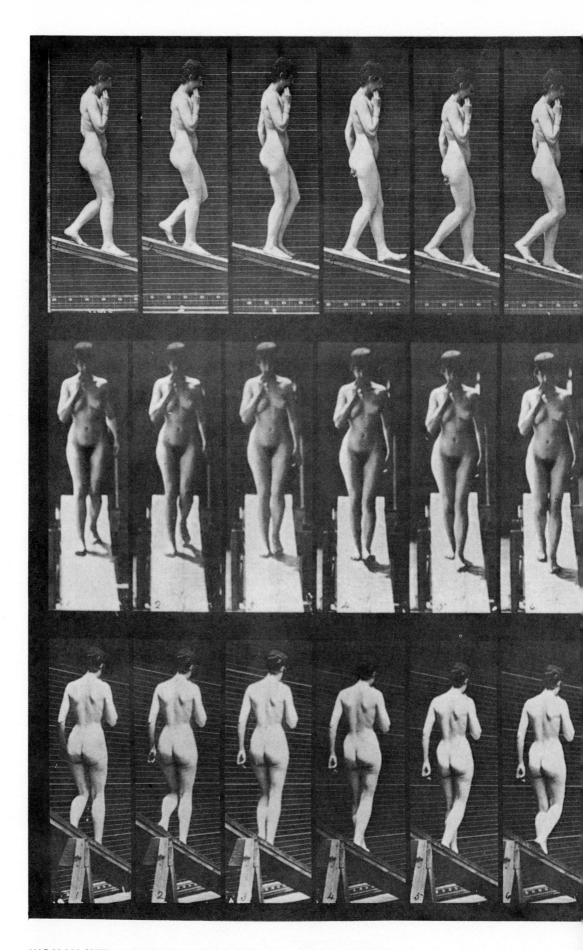

WOMAN WITH HAND TO MOUTH WALKING DOWN INCLINE

PLATE 110

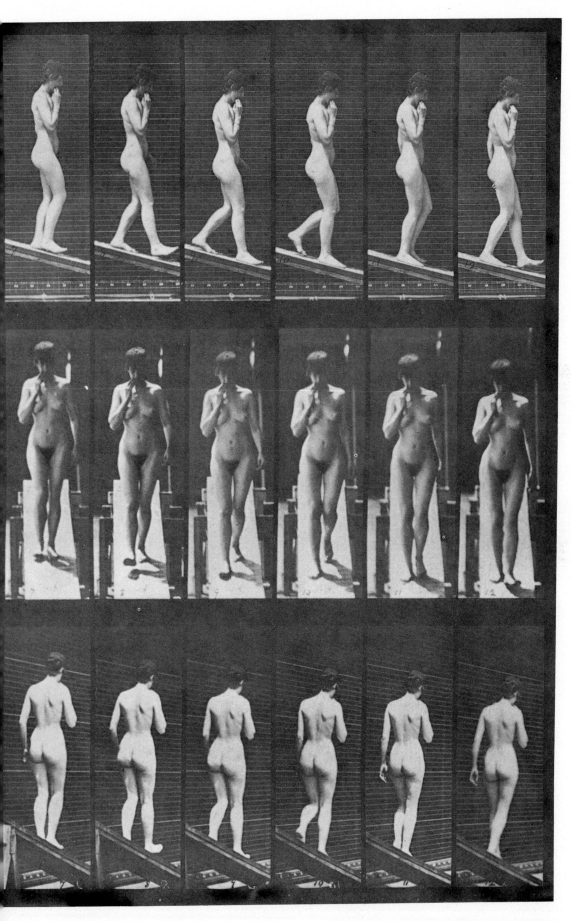

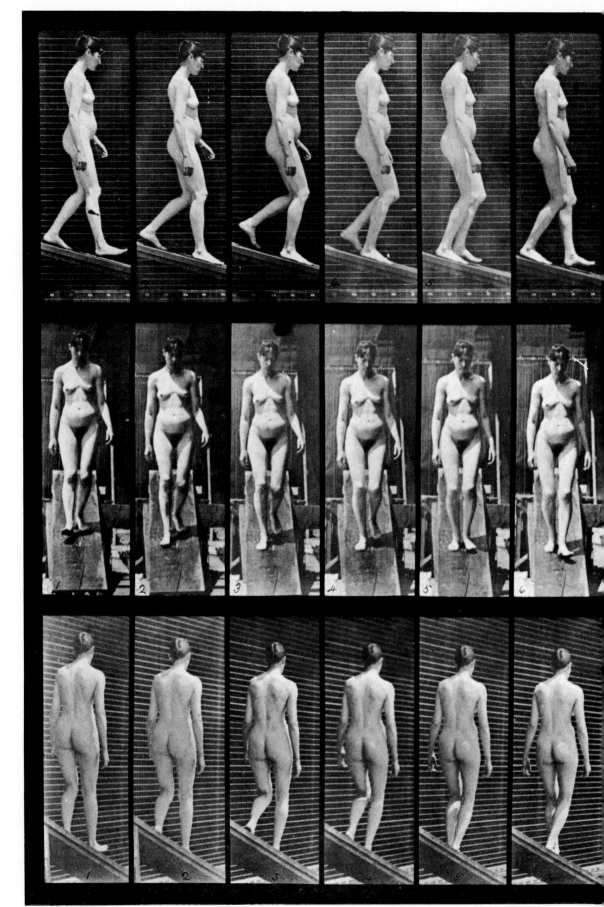

PLATE 111

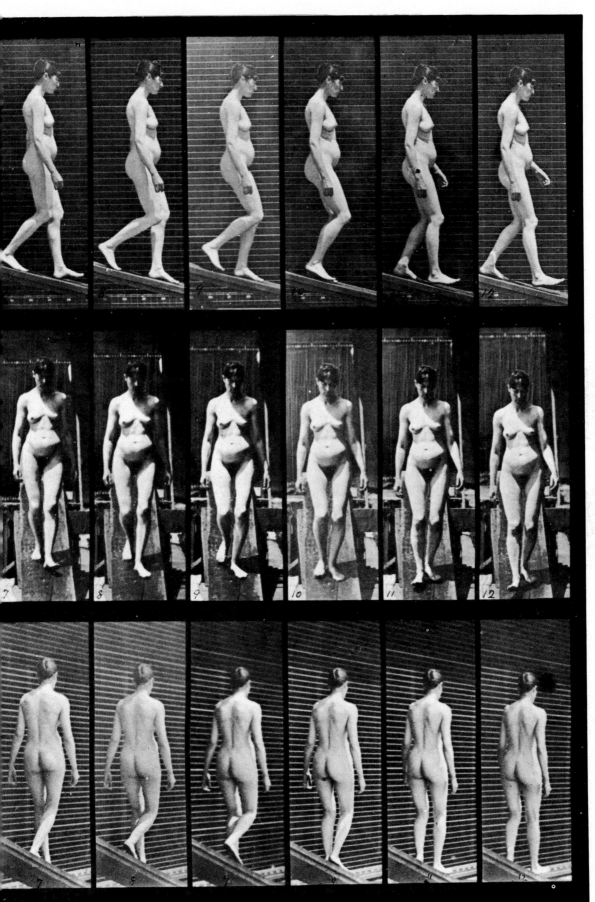

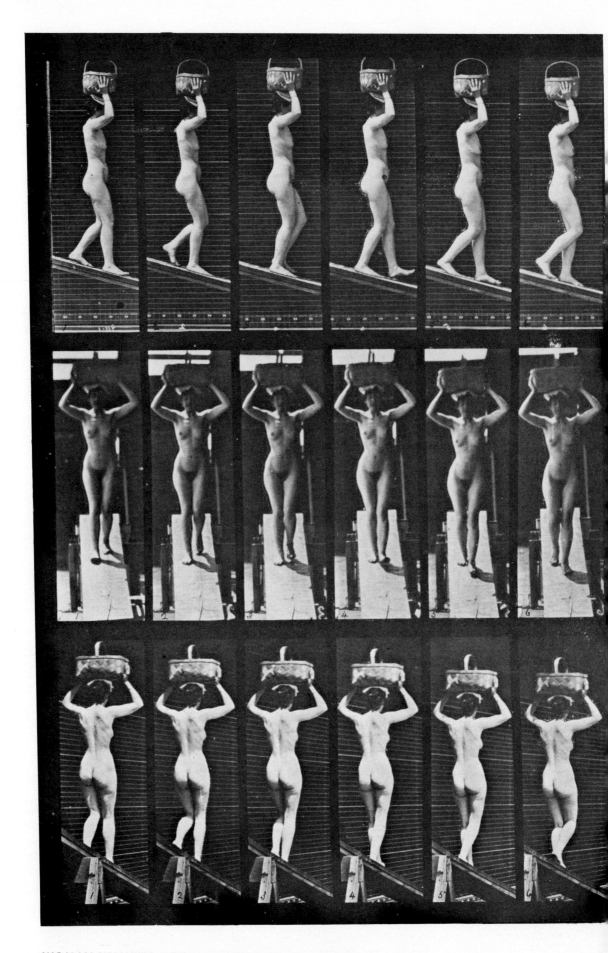

WOMAN WALKING DOWN INCLINE HOLDING BASKET ON HEAD

PLATE 112

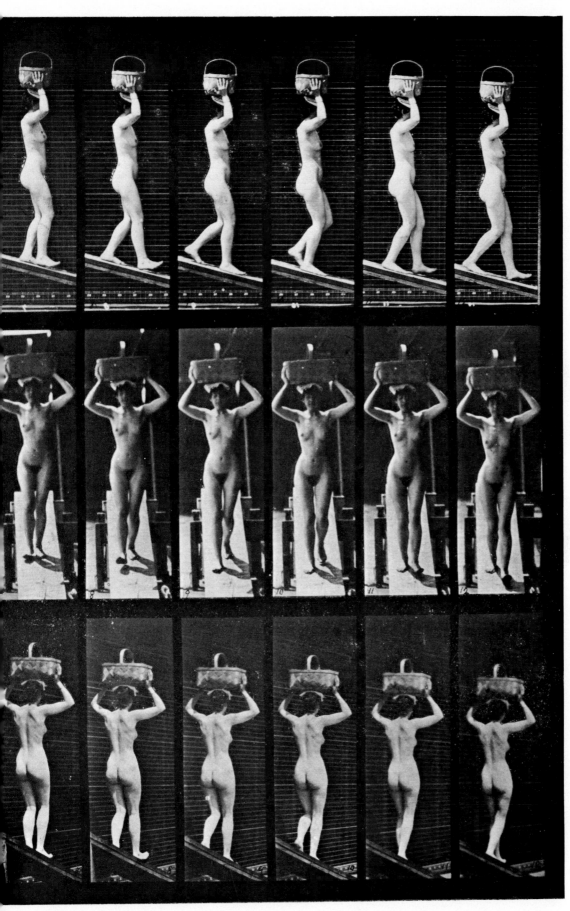

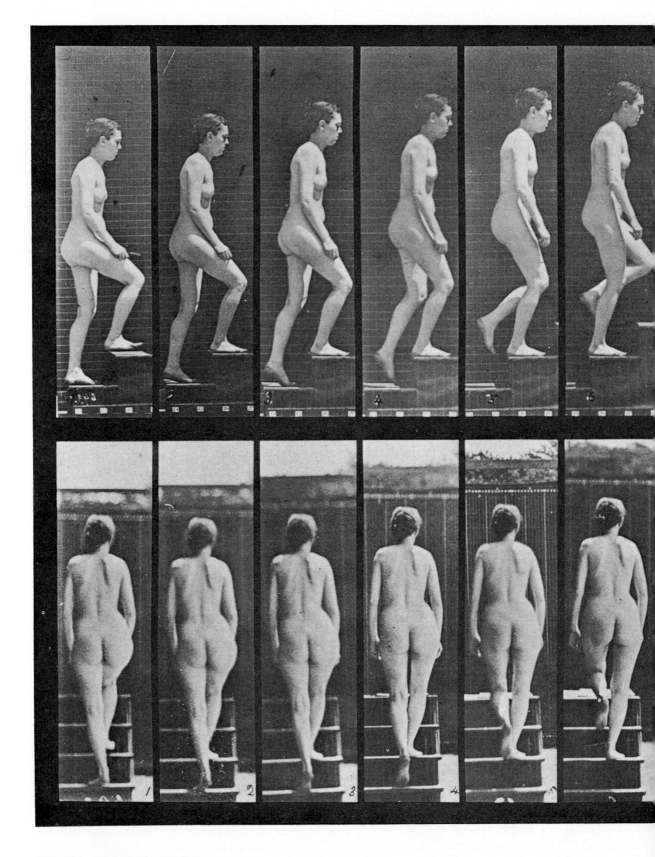

WOMAN WALKING UPSTAIRS

PLATE 113

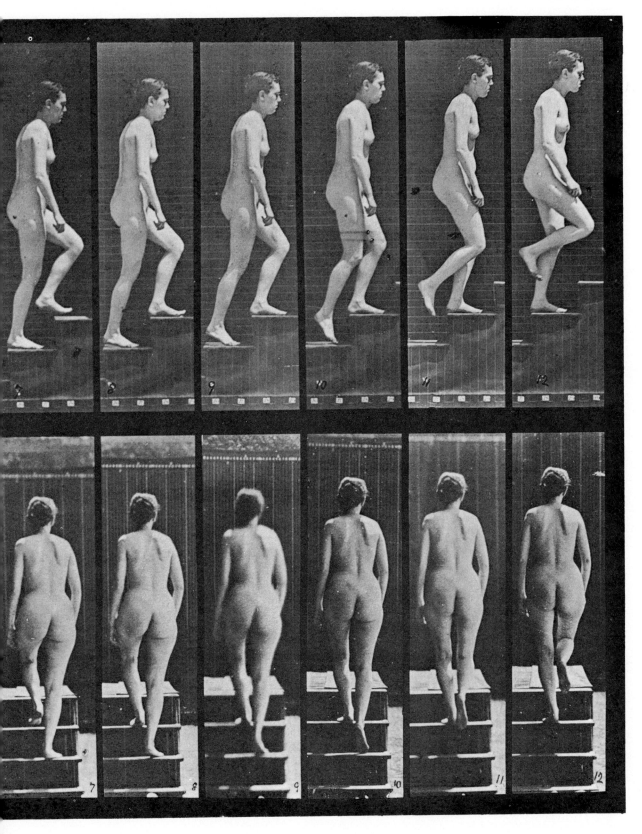

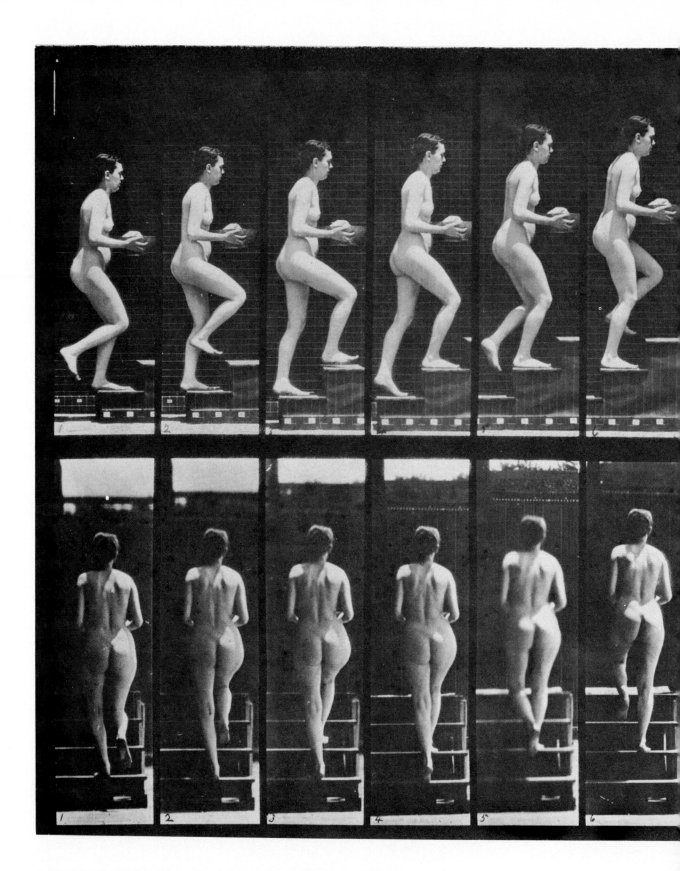

WOMAN WALKING UPSTAIRS CARRYING BOWL, AND TWISTING

PLATE 114

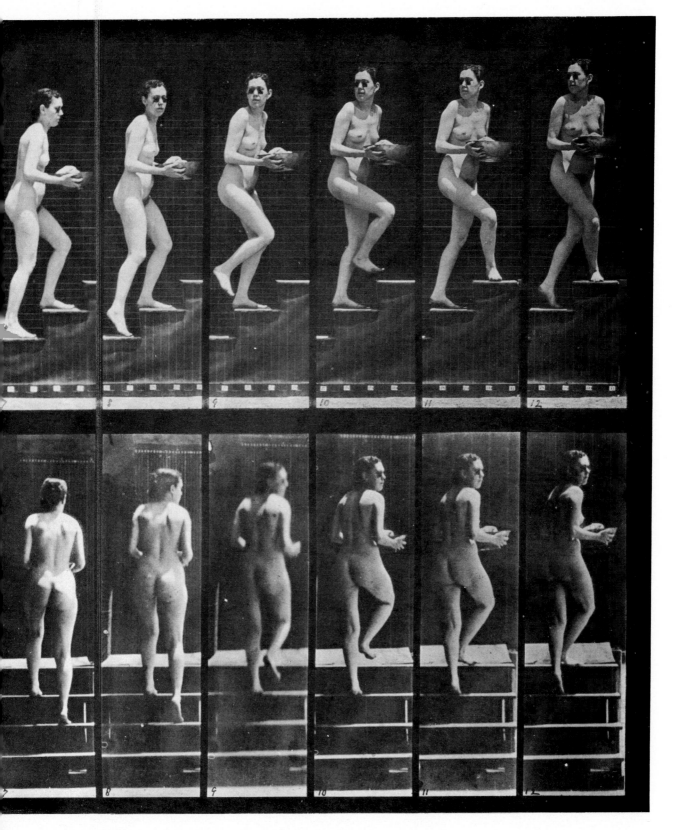

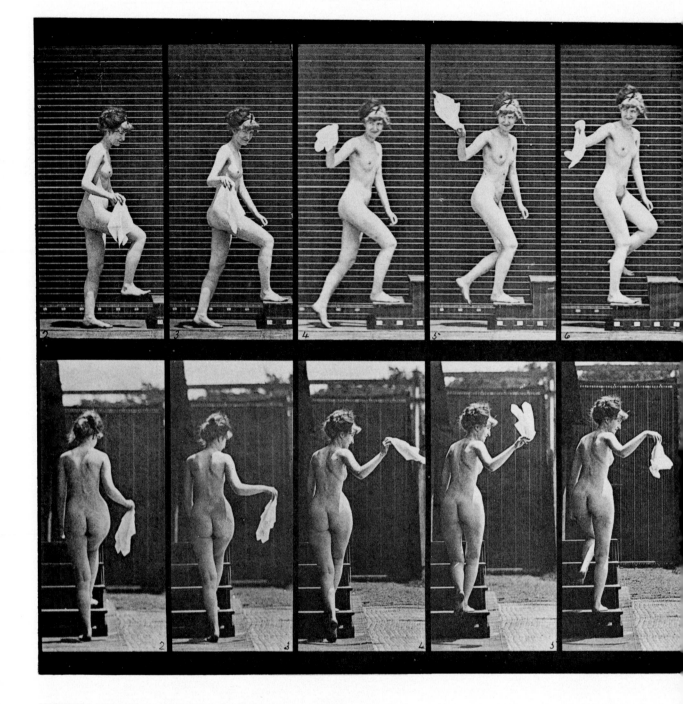

WOMAN WALKING UPSTAIRS AND WAVING HANDKERCHIEF

PLATE 115

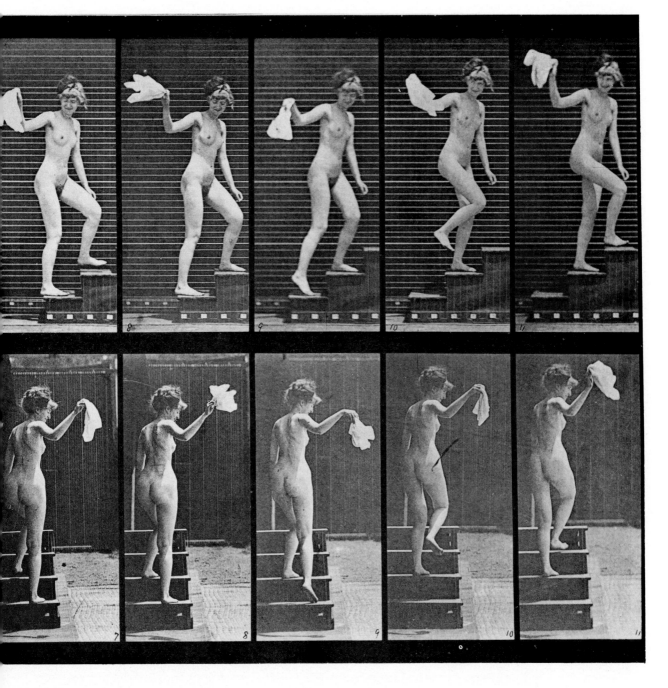

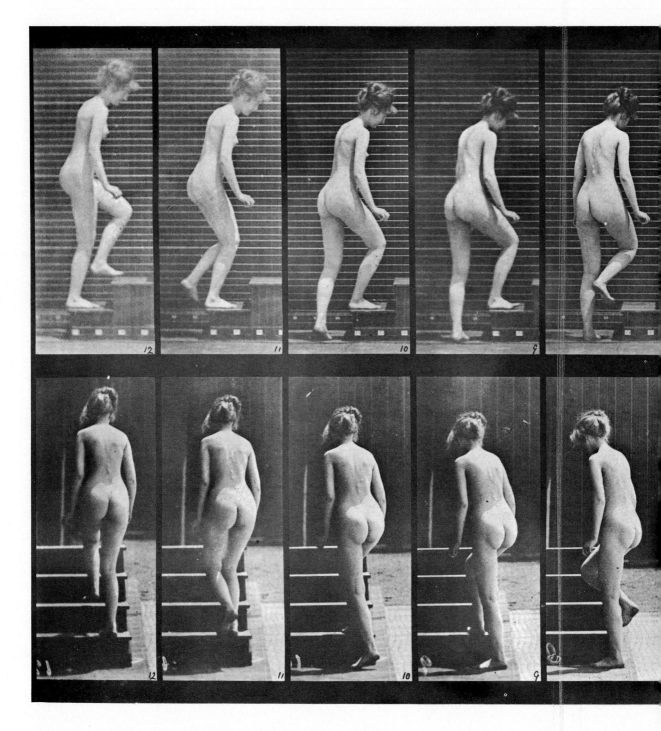

WOMAN TURNING AND WALKING UPSTAIRS (.284 second)

PLATE 116

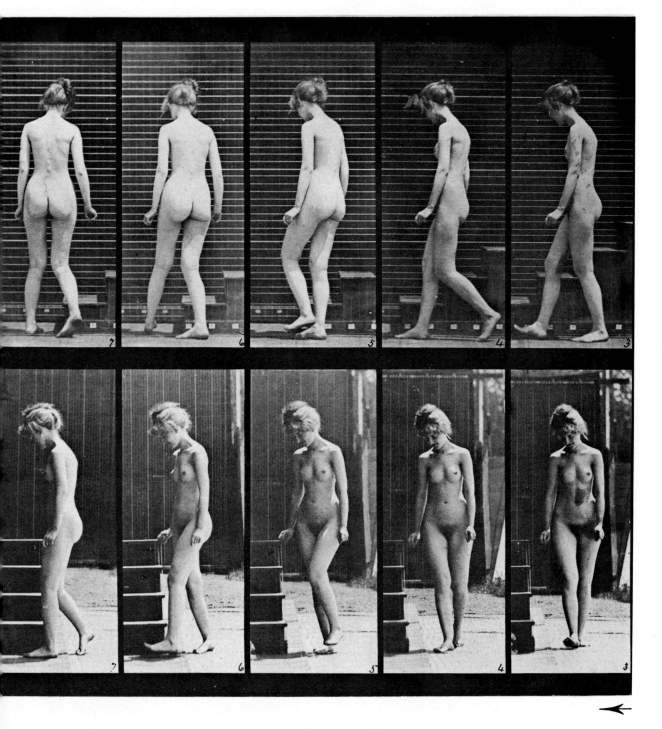

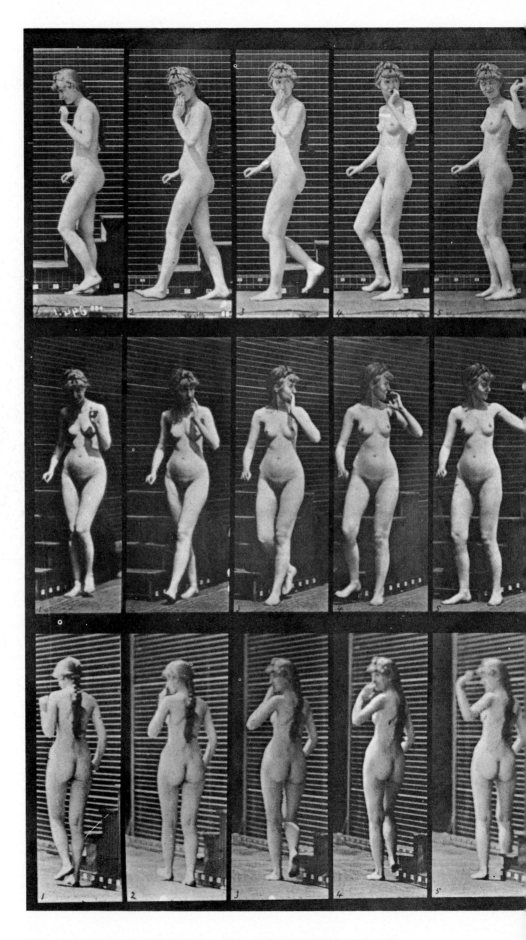

WOMAN TURNING, THROWING KISS, AND WALKING UPSTAIRS

PLATE 117

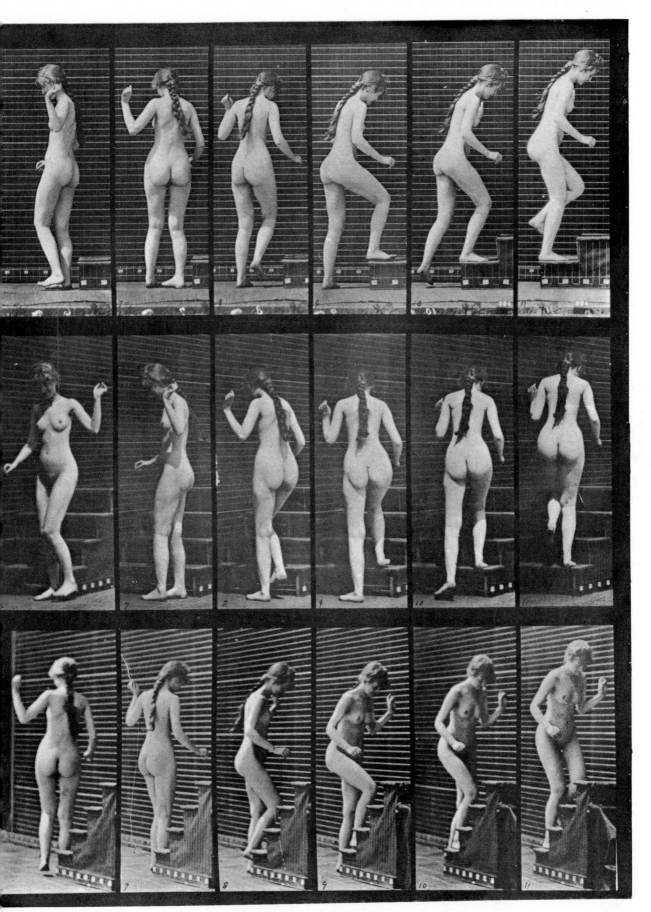

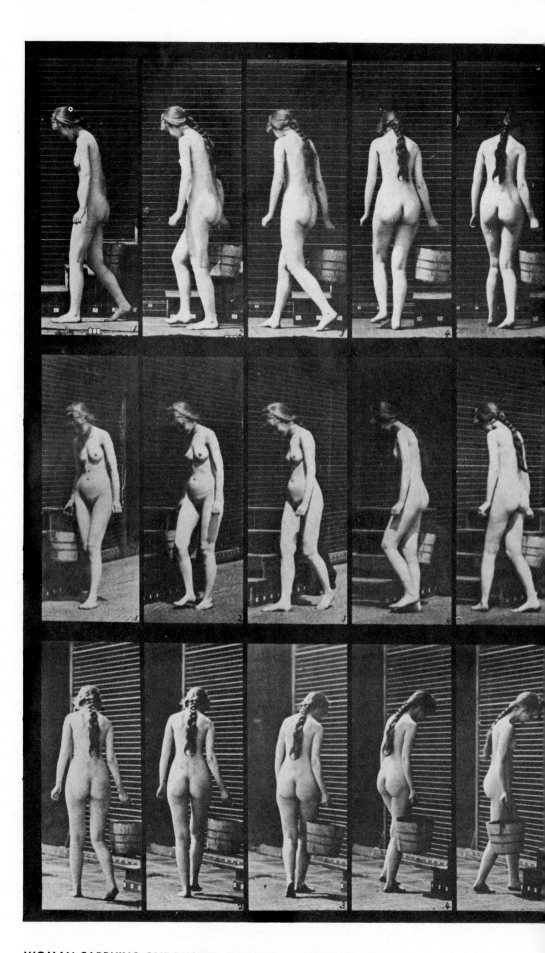

WOMAN CARRYING ONE BUCKET, TURNING, WALKING UPSTAIRS (.325 second)

PLATE 118

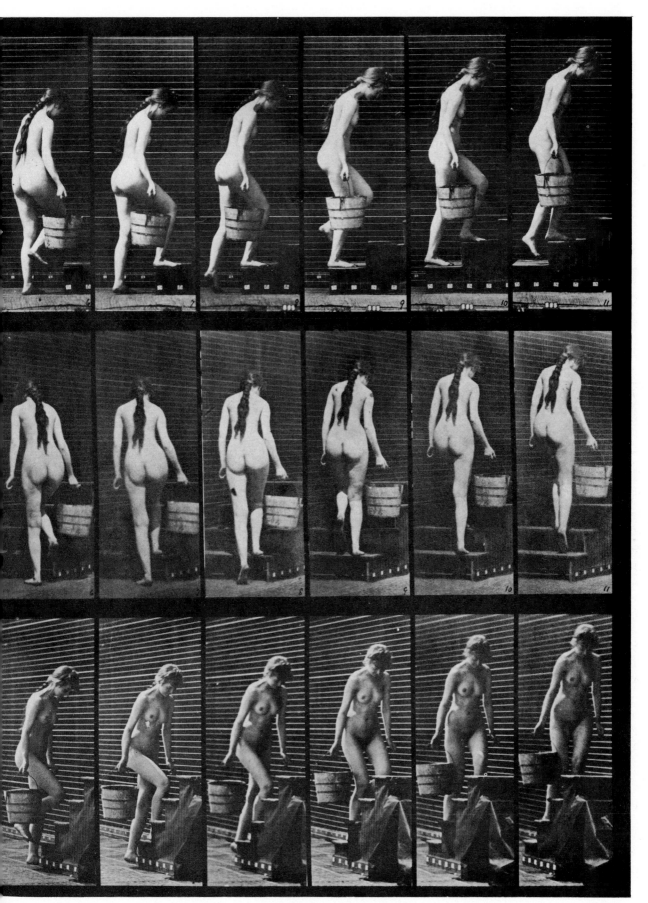

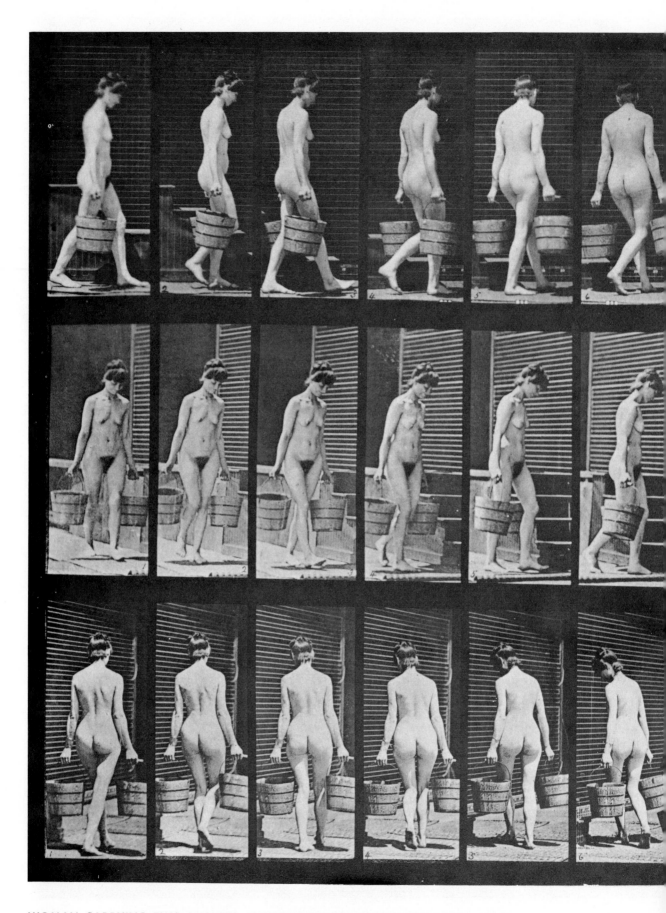

WOMAN CARRYING TWO BUCKETS, TURNING, WALKING UPSTAIRS (.266 second)

PLATE 119

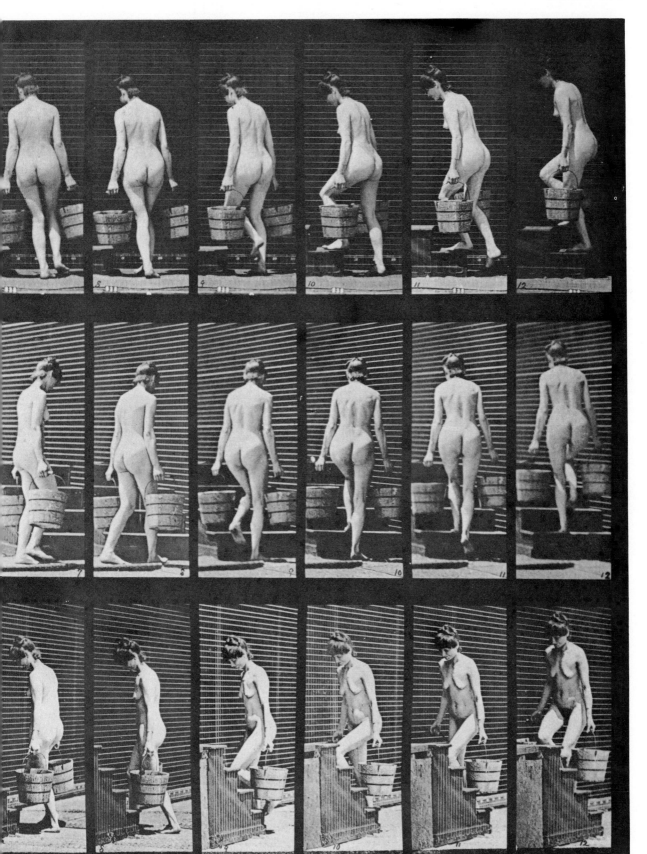

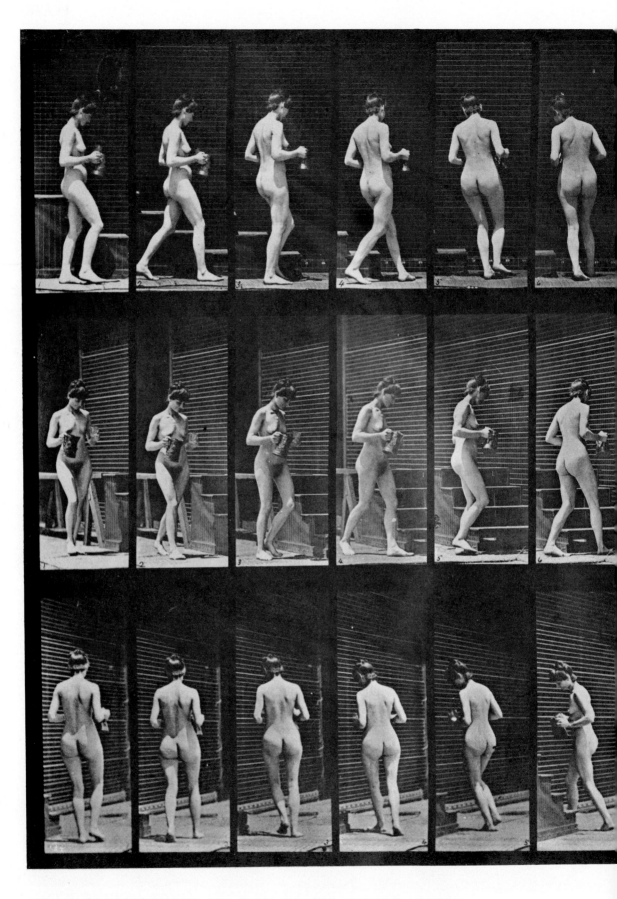

WOMAN CARRYING PITCHER AND GLASS, TURNING, WALKING UPSTAIRS

PLATE 120

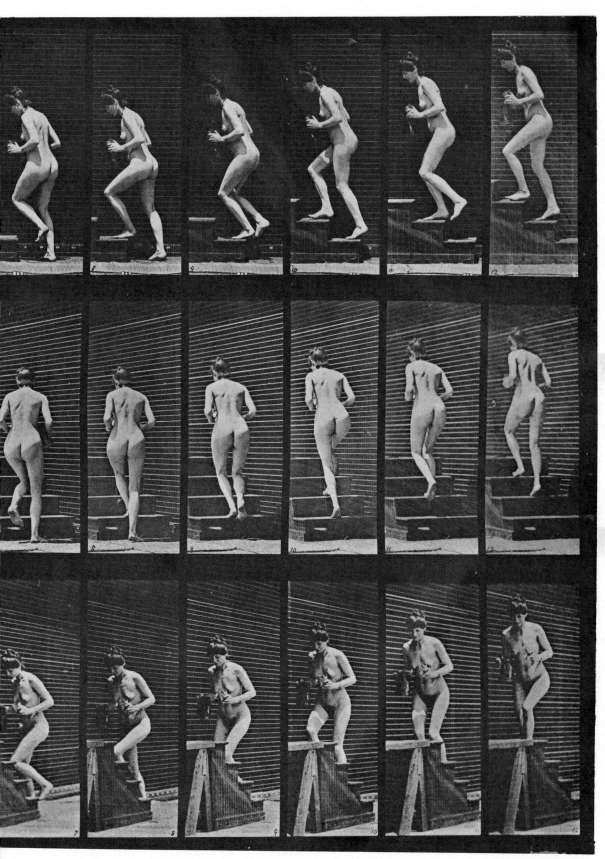

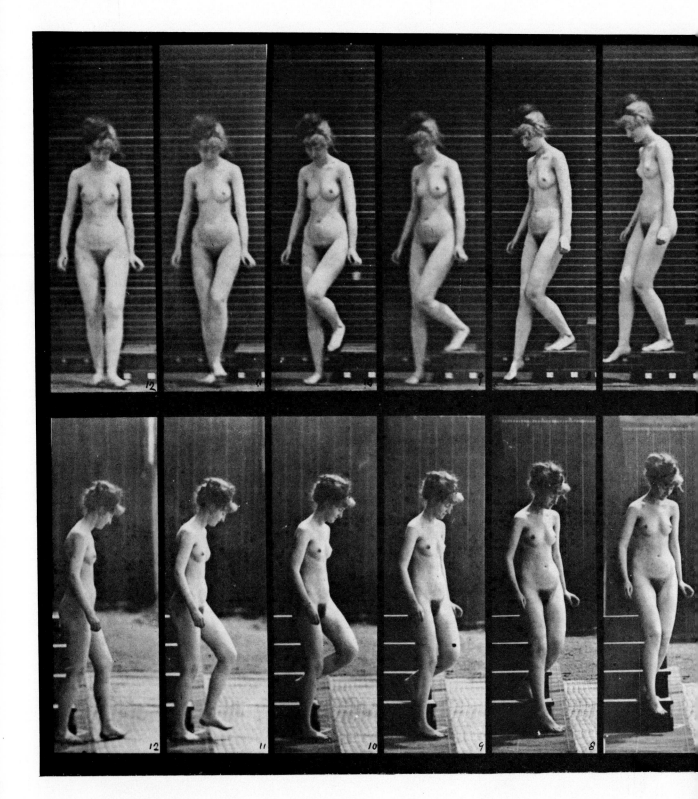

WOMAN WALKING DOWNSTAIRS

PLATE 121

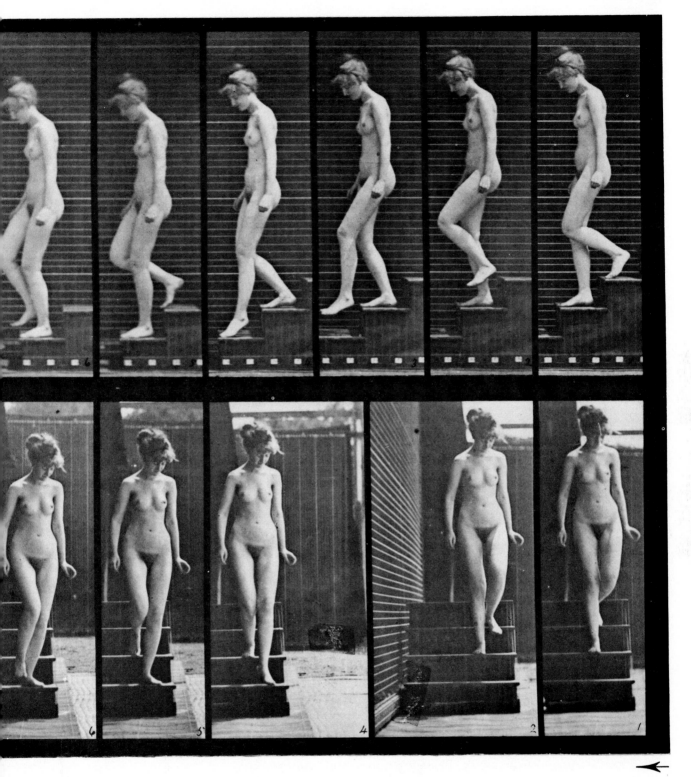

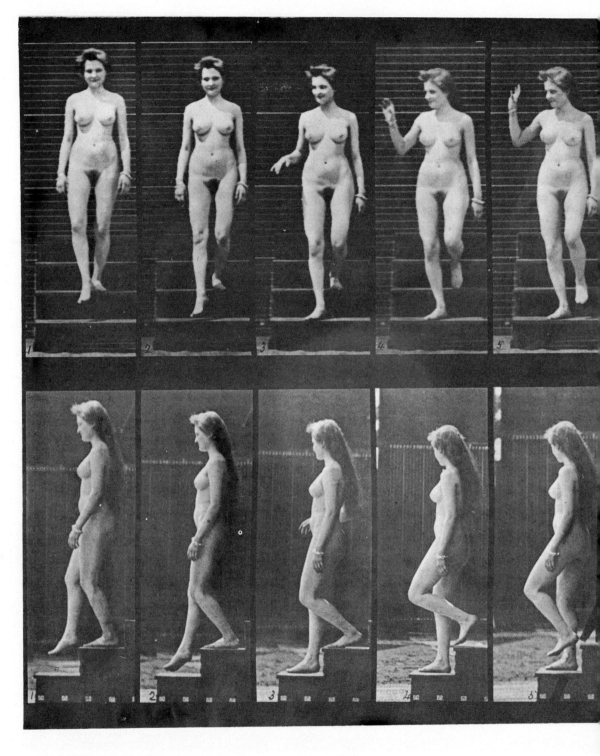

WOMAN WALKING SLOWLY DOWNSTAIRS AND WAVING

PLATE 122

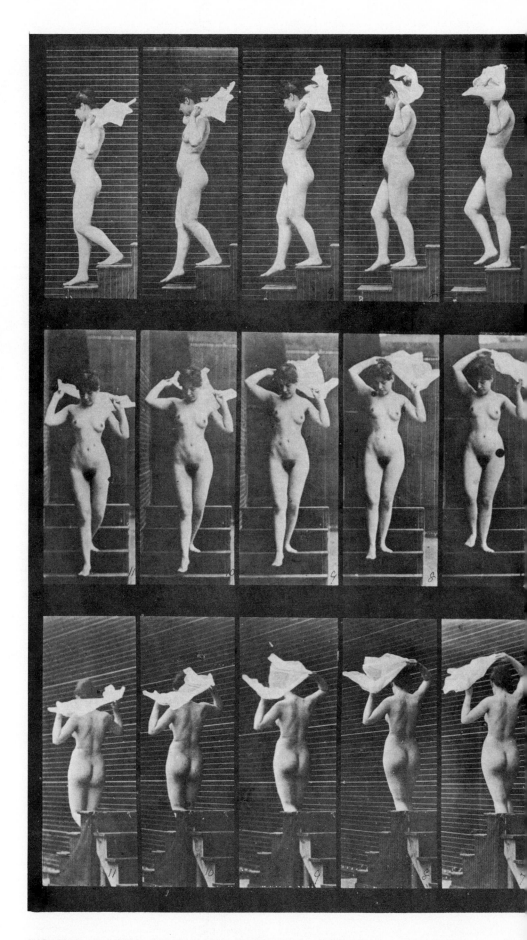

WOMAN WALKING DOWNSTAIRS, THROWING SCARF OVER SHOULDERS (.101

PLATE 123

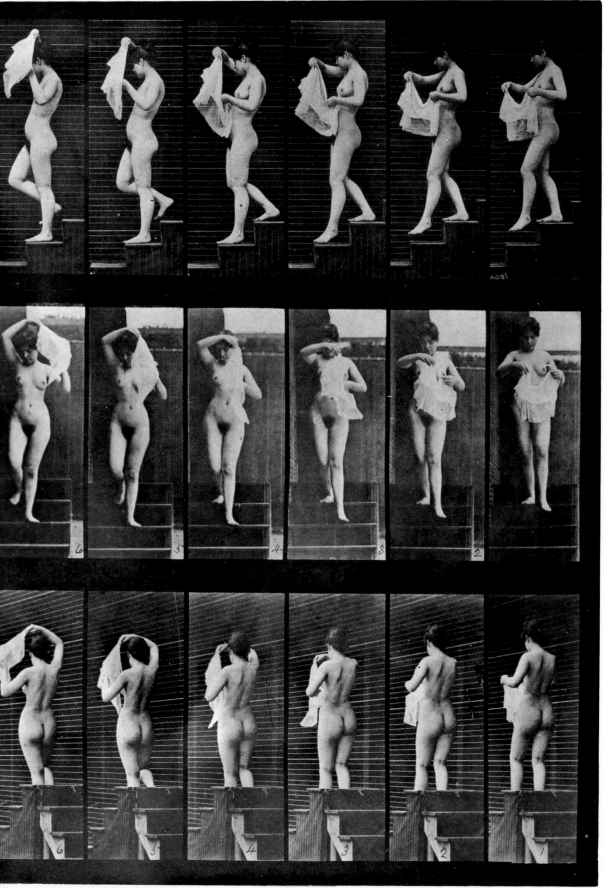

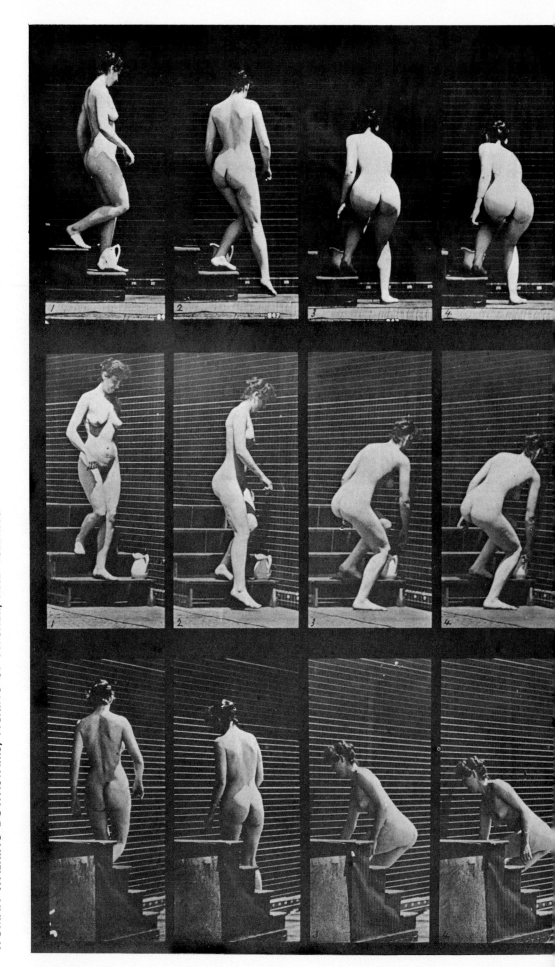

PLATE 124

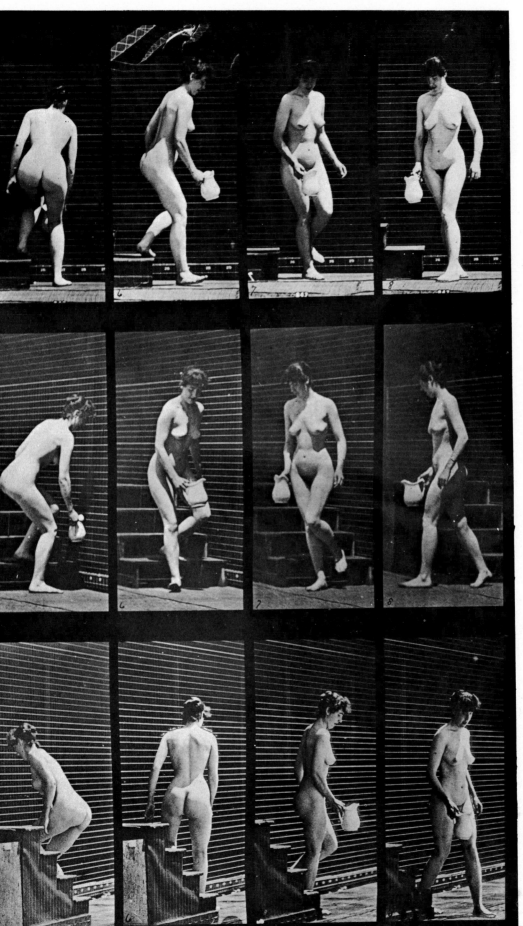

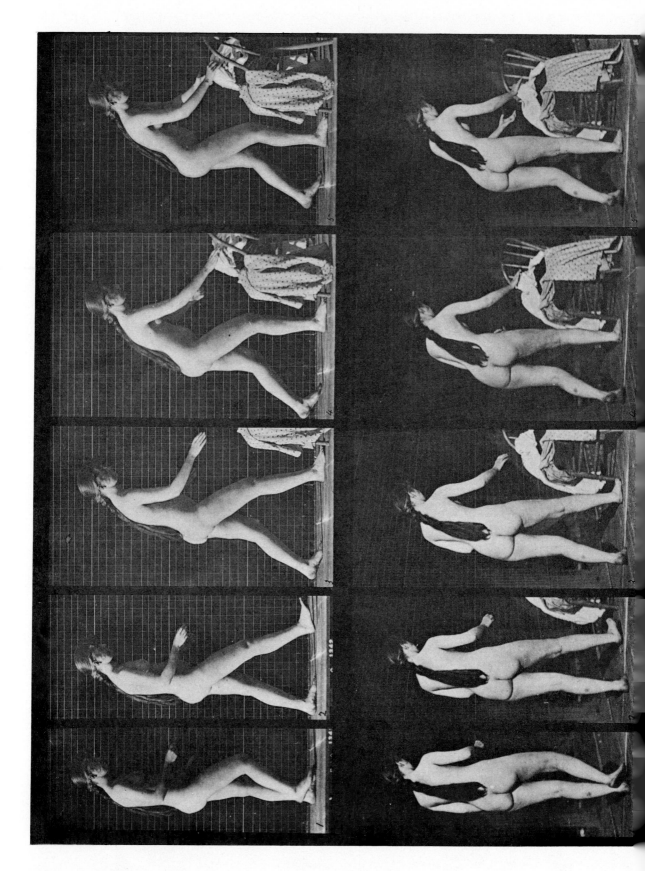

WOMAN PICKING UP CLOTHES

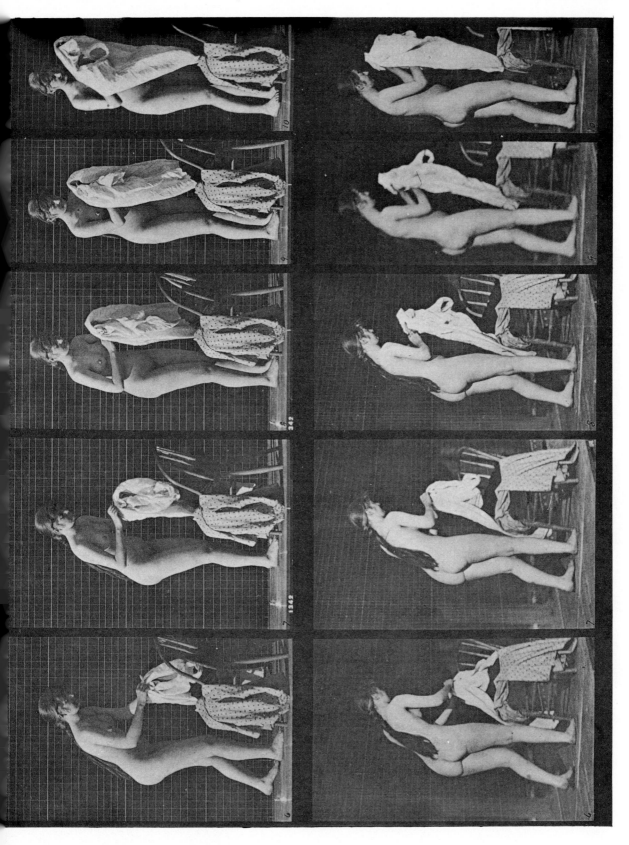

PLATE 125

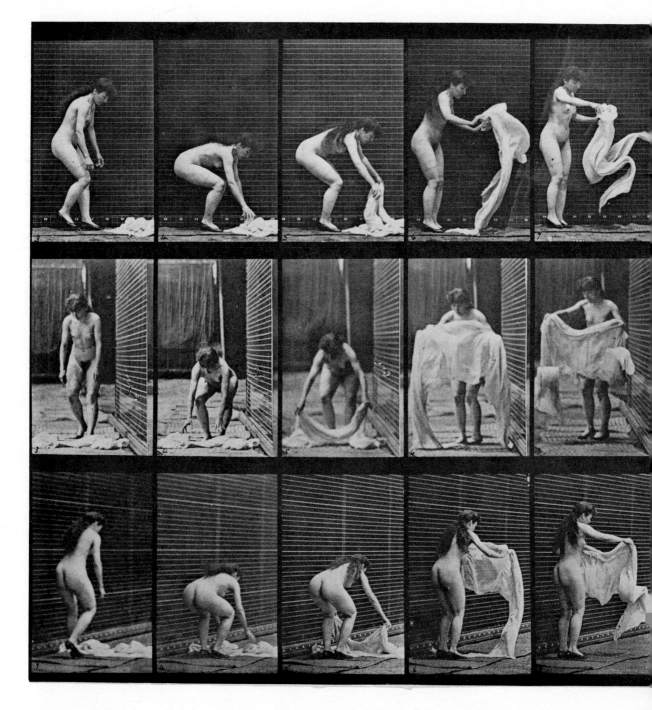

WOMAN PICKING UP SCARF, THROWING IT OVER SHOULDERS WHILE WALKING

PLATE 126

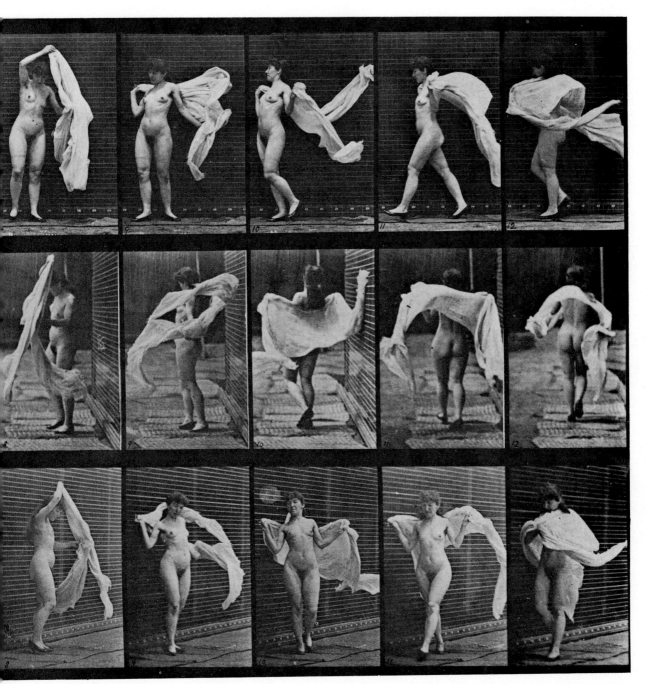

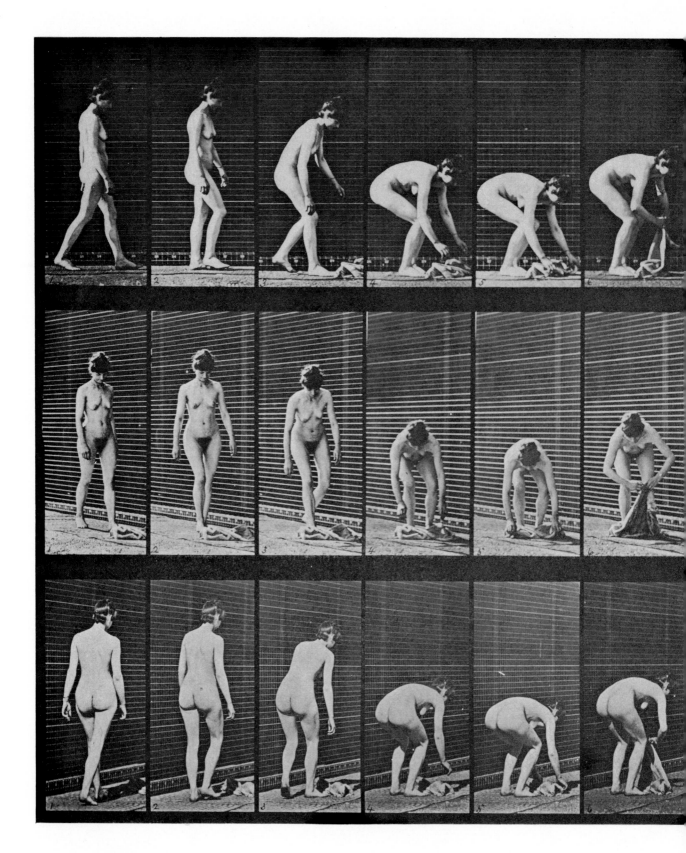

WOMAN PICKING UP TOWEL

PLATE 127

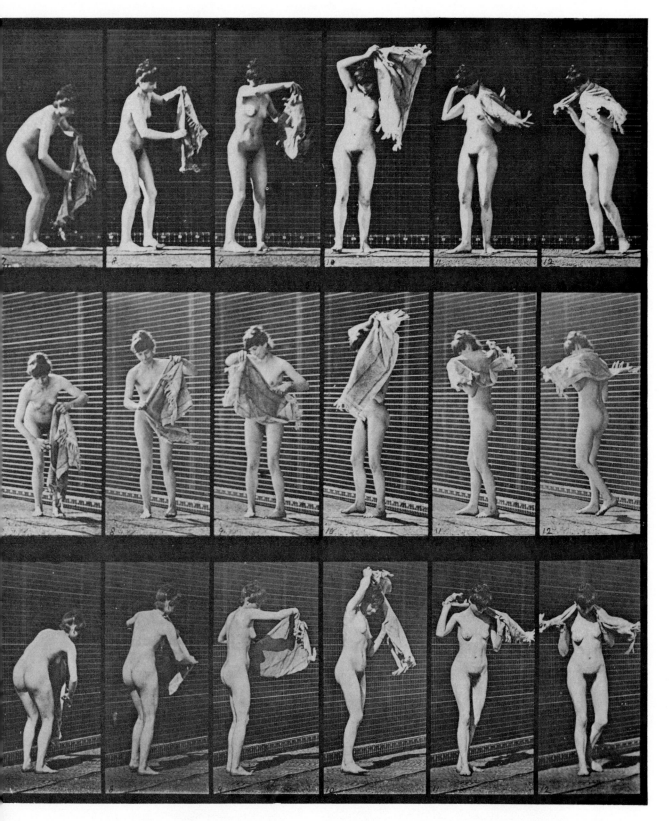

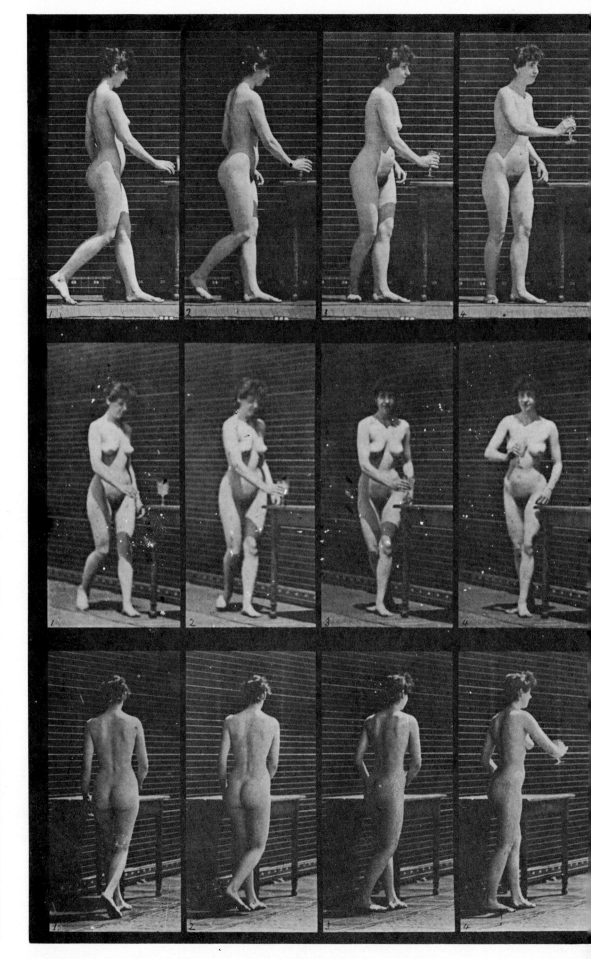

PLATE 128

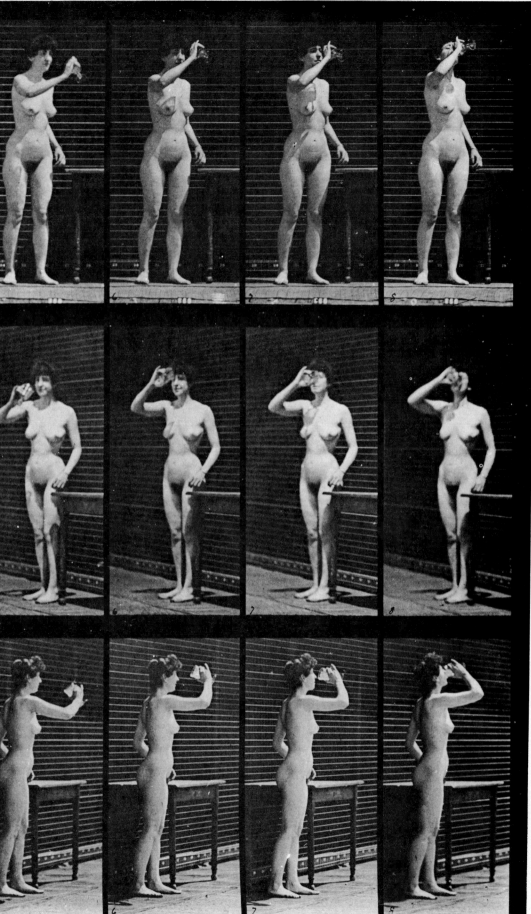

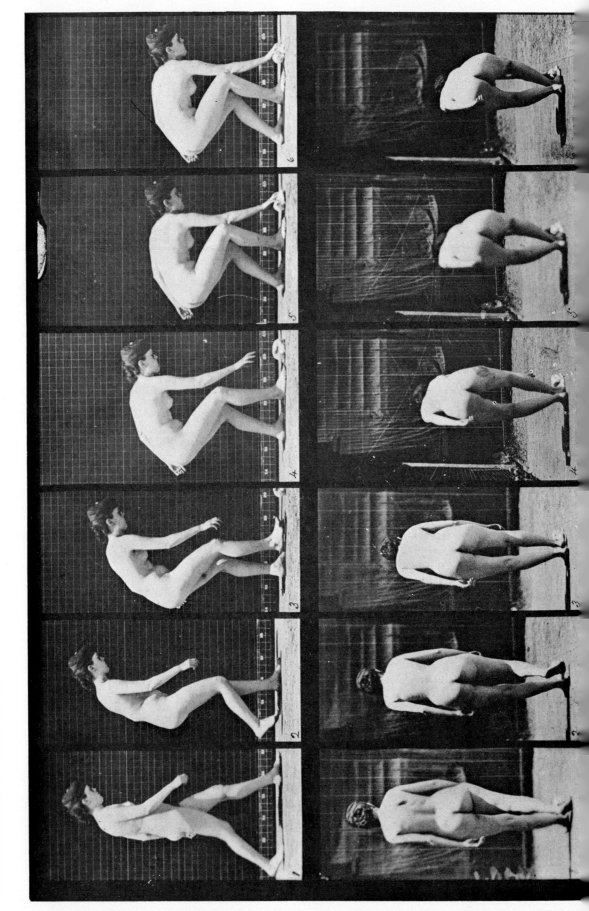

PLATE 129

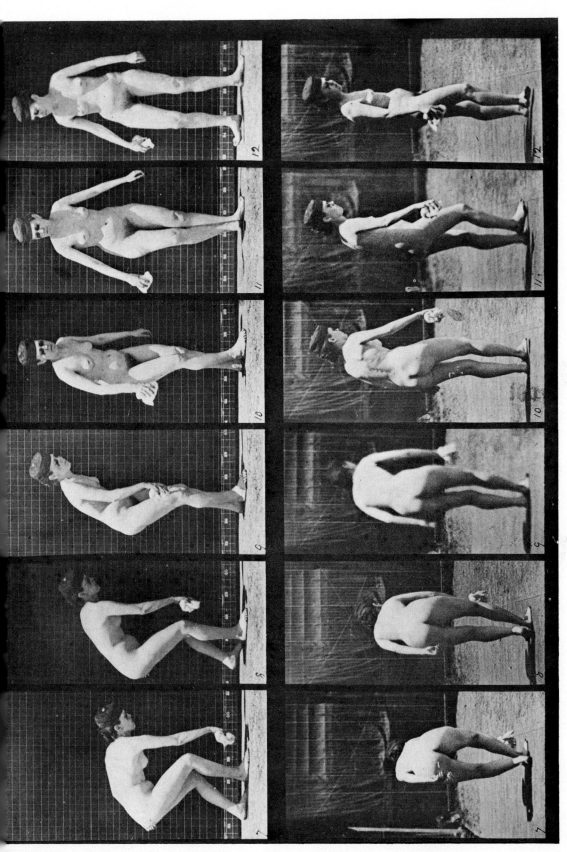

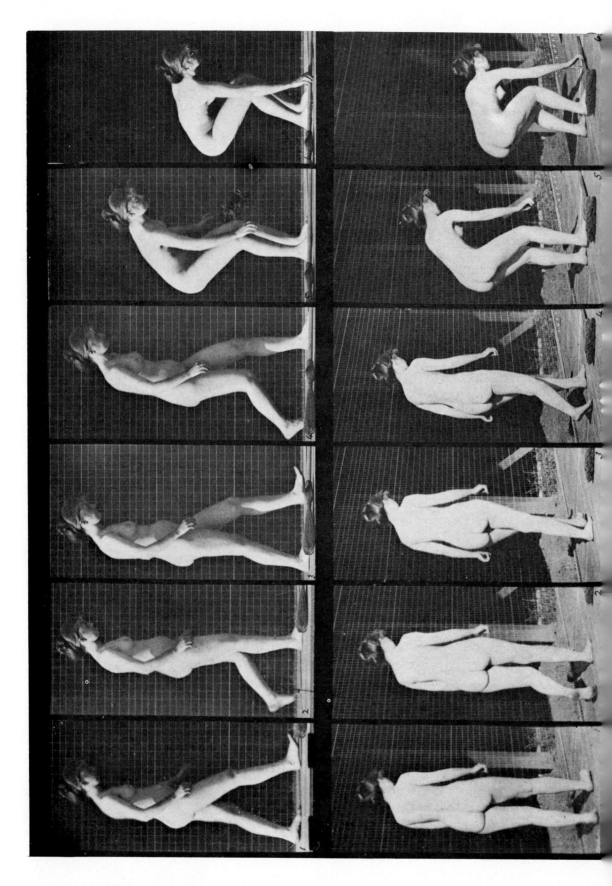

WOMAN PICKING UP BROOM

PLATE 130

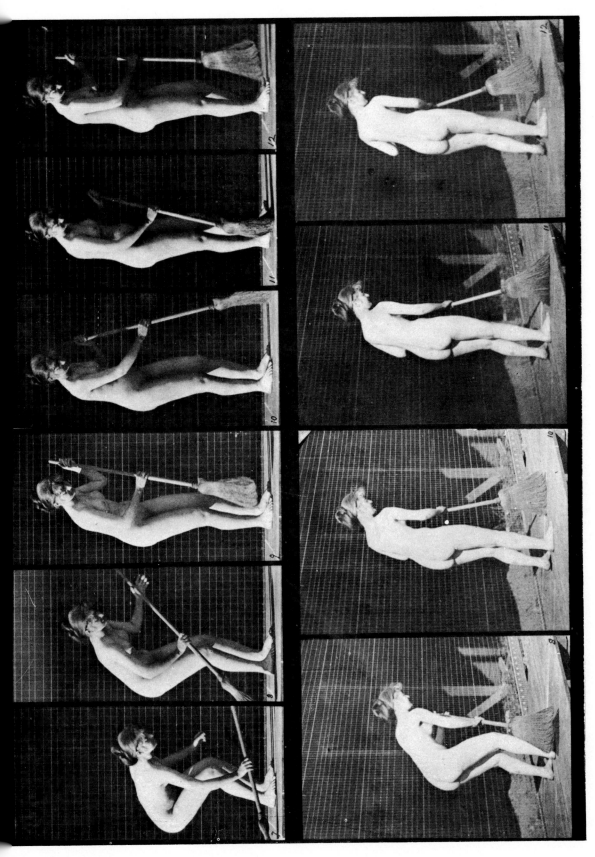

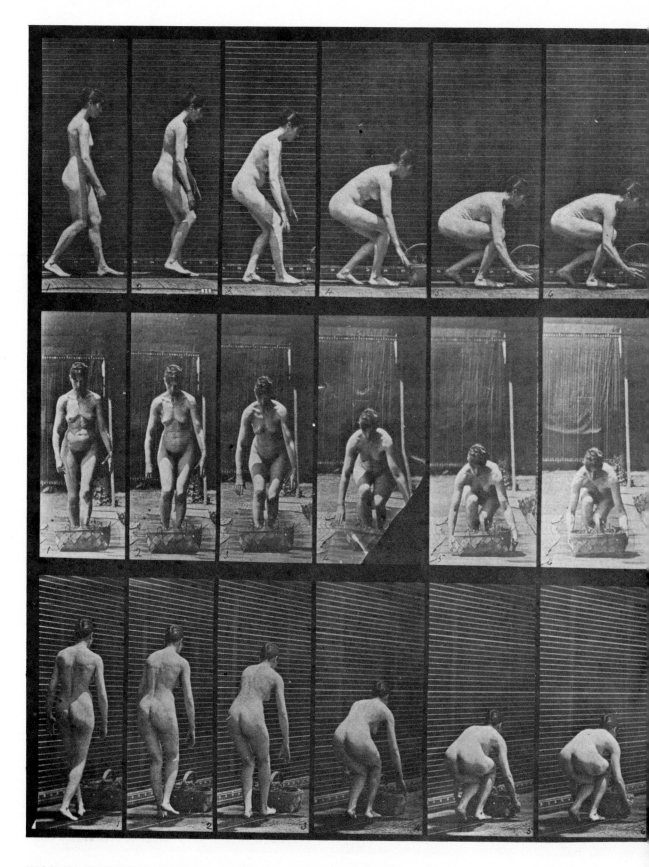

WOMAN PICKING UP BASKET, HOLDING IT ABOVE HER HEAD

PLATE 131

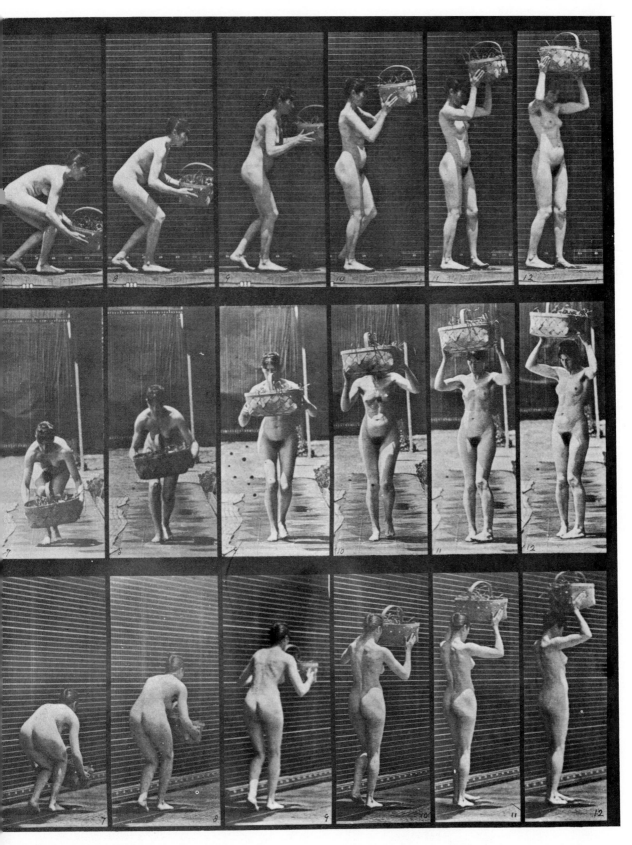

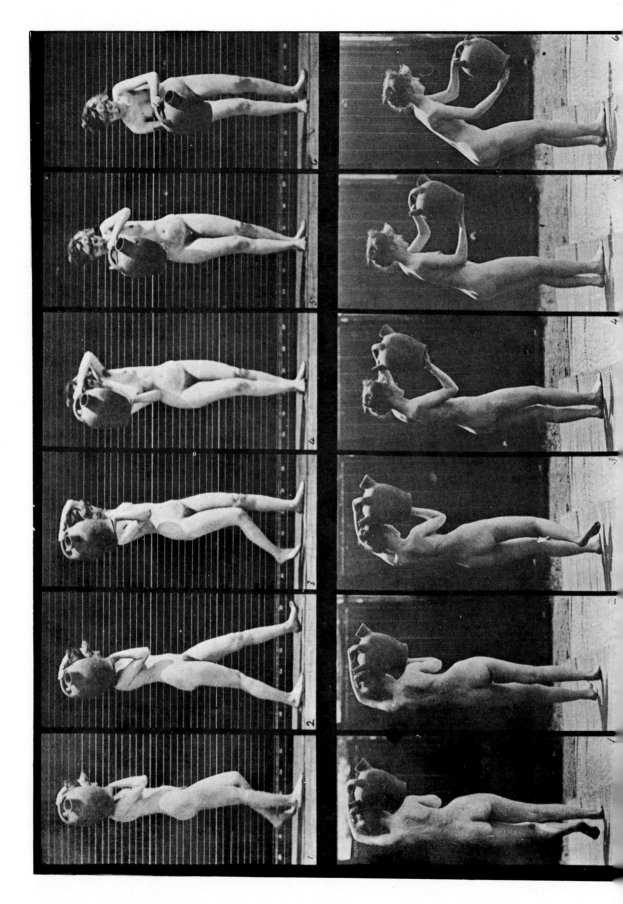

WOMAN PUTTING DOWN JUG FROM HER SHOULDER

PLATE 132

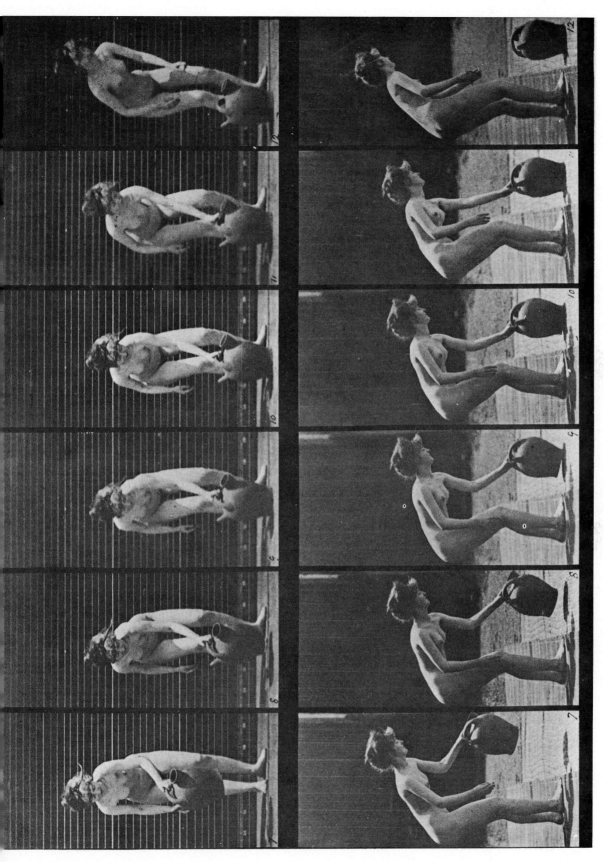

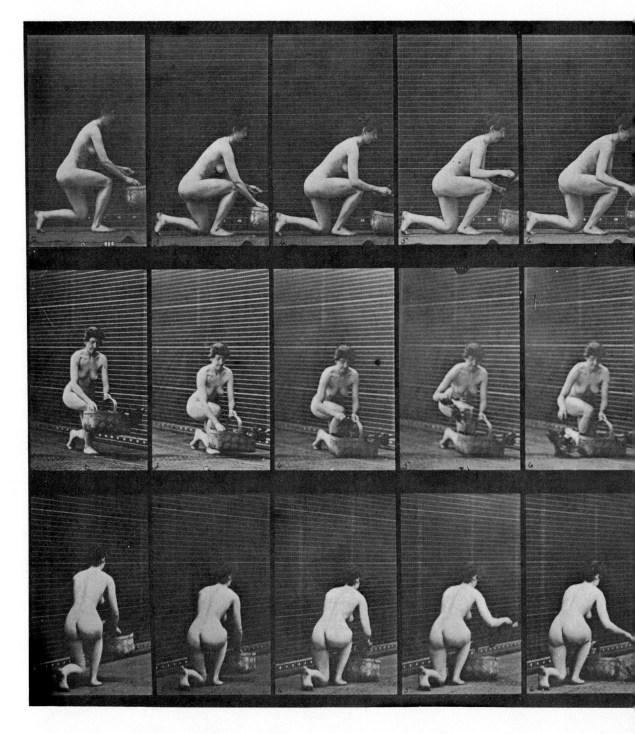

WOMAN PUTTING DOWN BASKET AND PICKING IT UP

PLATE 133

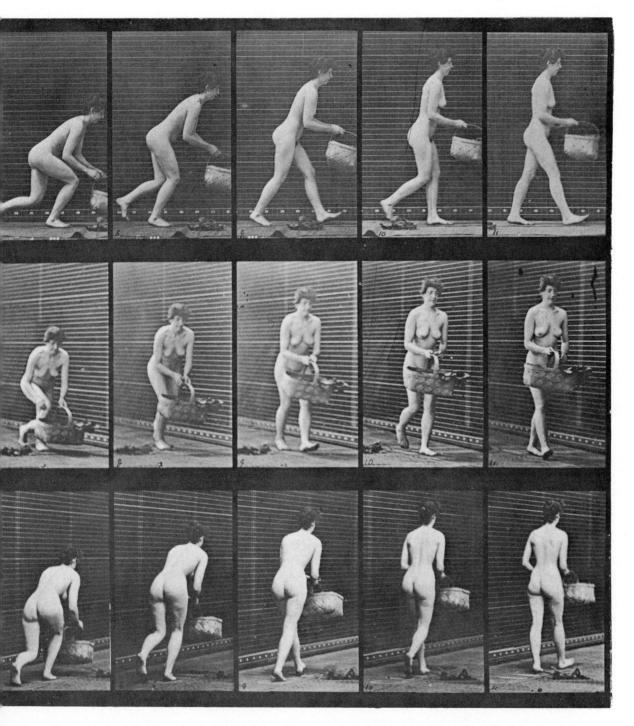

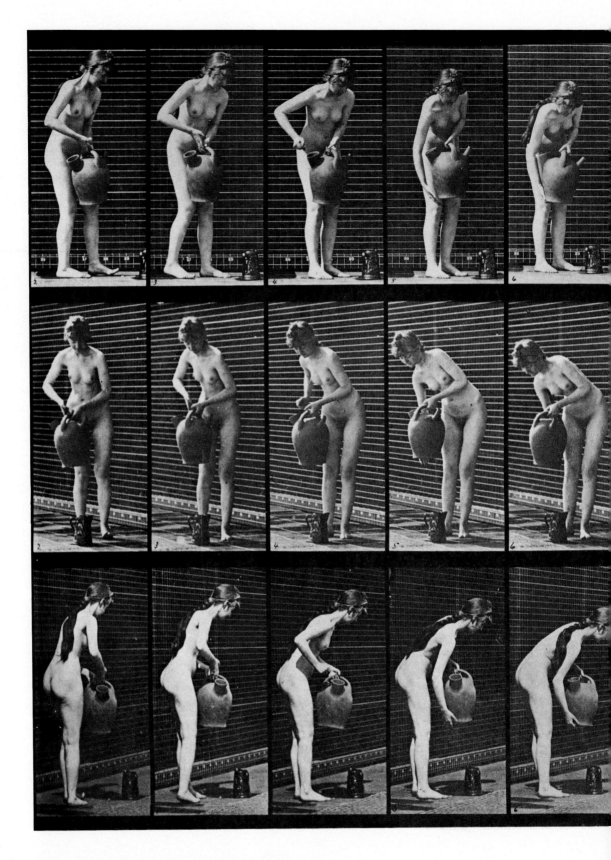

WOMAN LOWERING JUG, POURING WATER FROM IT

PLATE 134

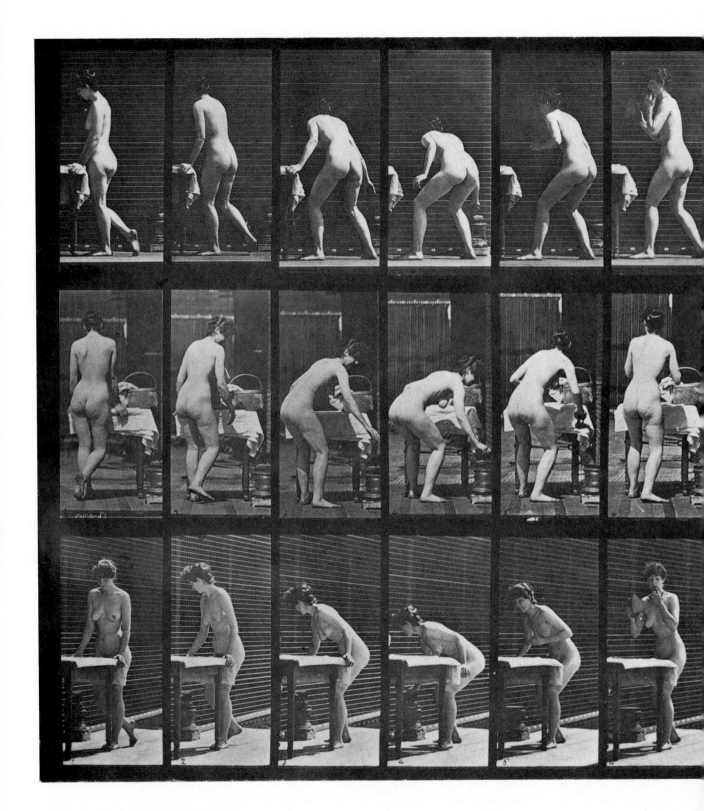

WOMAN STANDING AND IRONING

PLATE 135

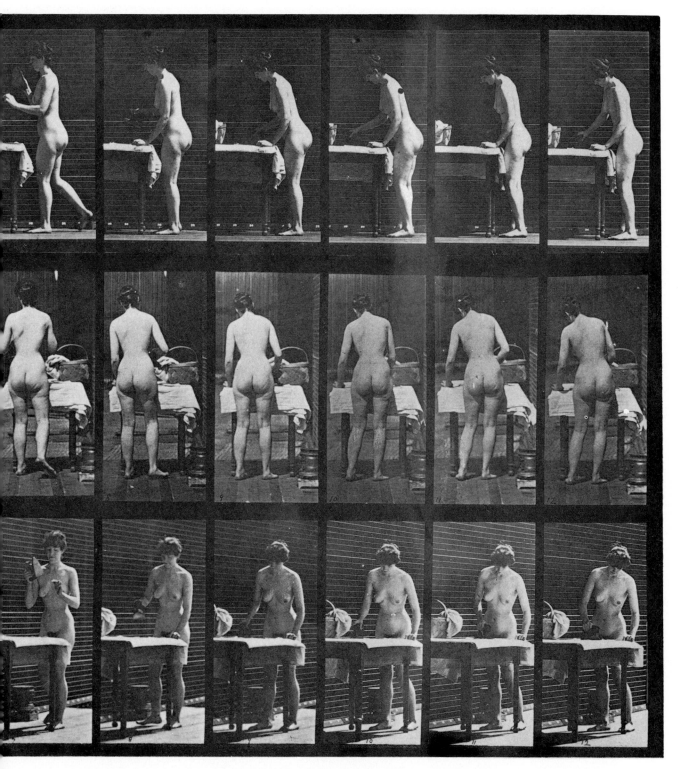

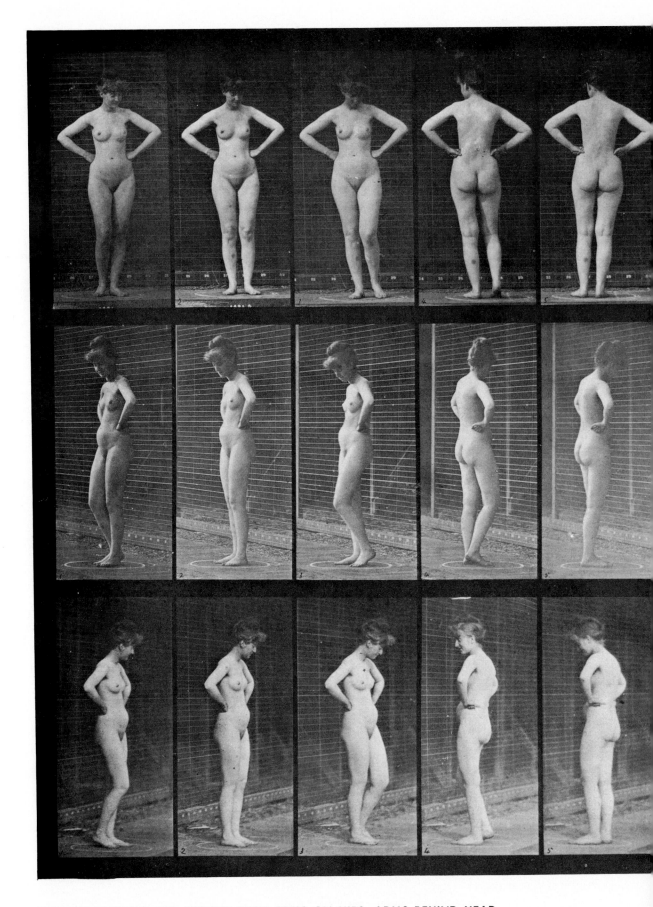

WOMAN SHIFTING HER WEIGHT WITH ARMS ON HIPS; ARMS BEHIND HEAD

PLATE 136

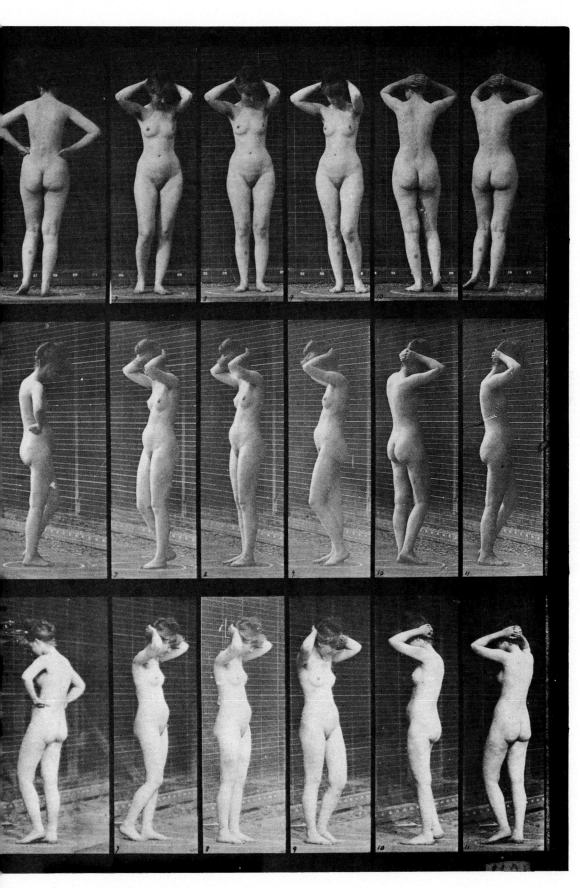

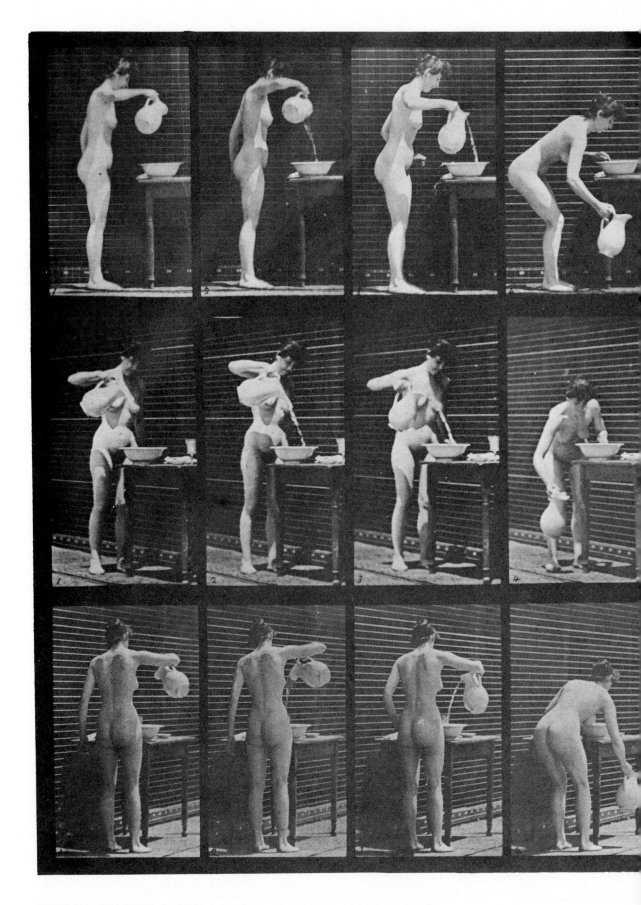

WOMAN STANDING POURING WATER, BENDING OVER WASH BASIN

PLATE 137

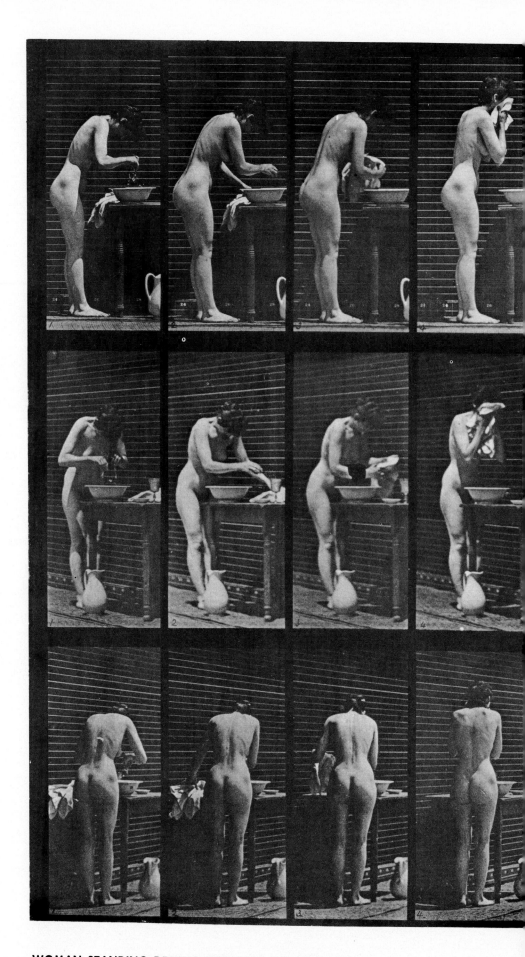

WOMAN STANDING DRYING HER FACE AND BREASTS

PLATE 138

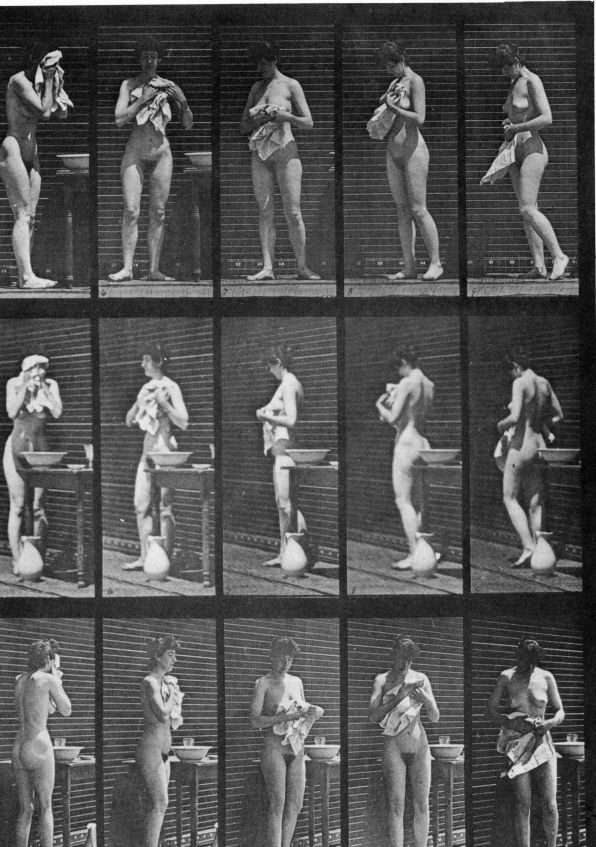

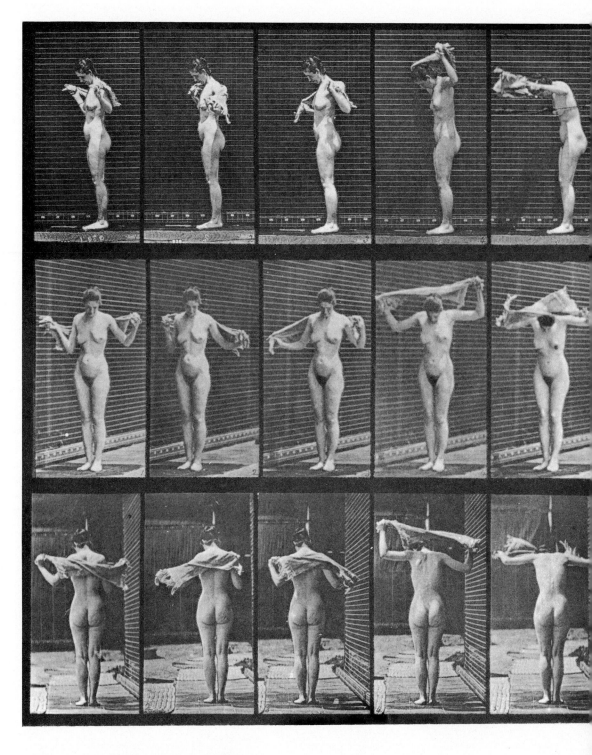

WOMAN STANDING DRYING HER BODY

PLATE 139

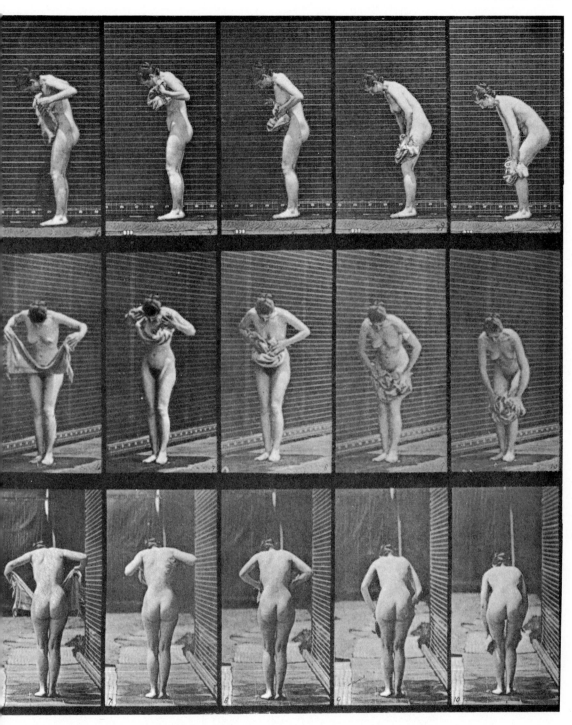

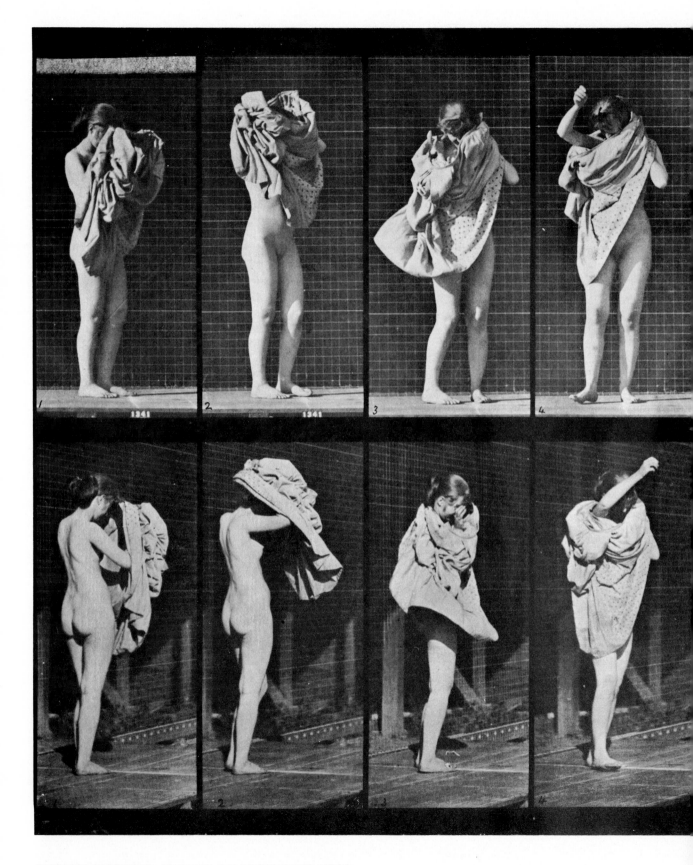

WOMAN STANDING, PUTTING ON DRESS OVER HEAD

PLATE 140

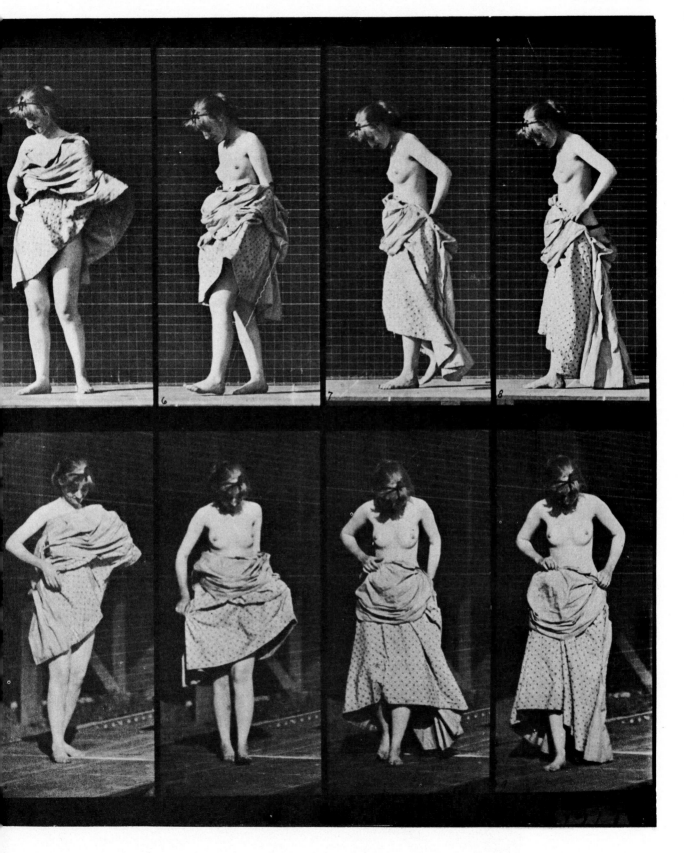

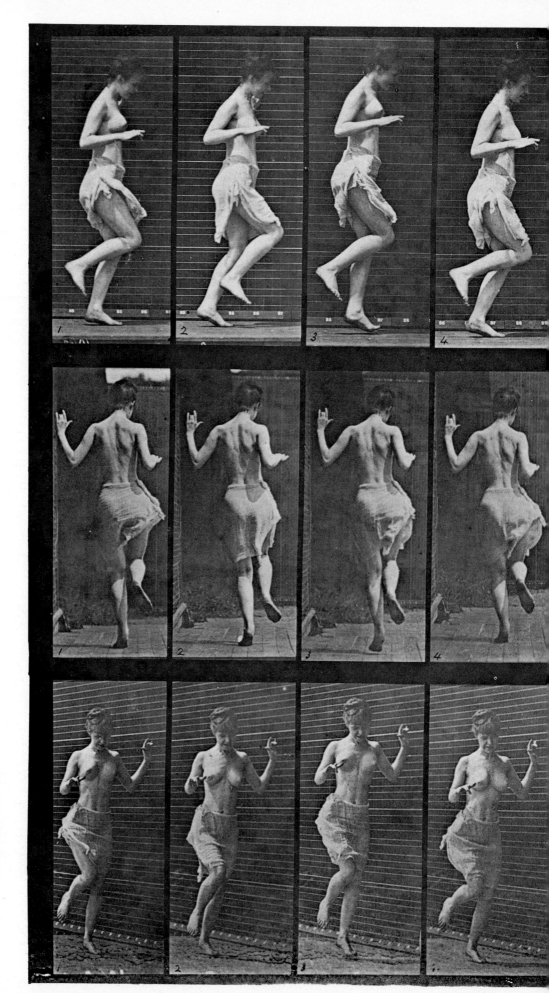

PLATE 141

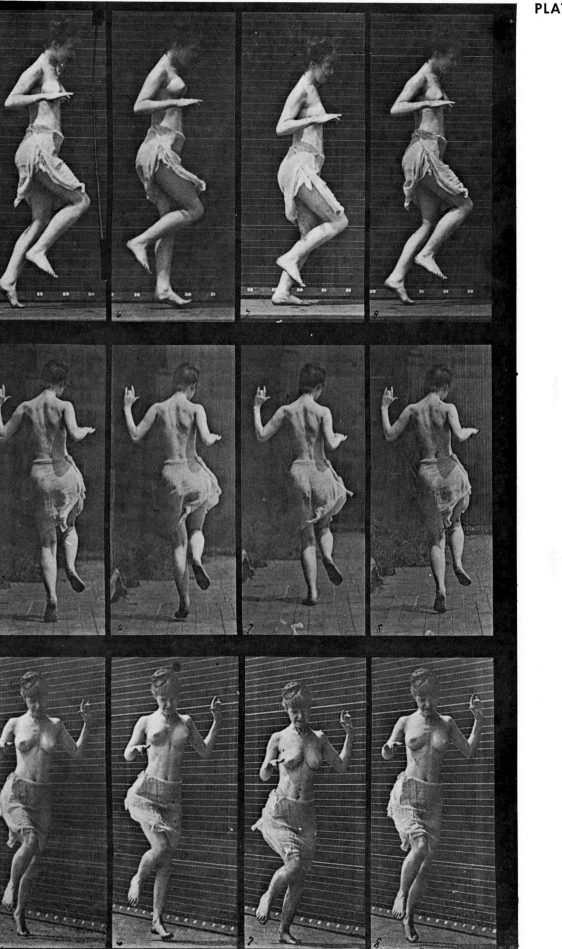

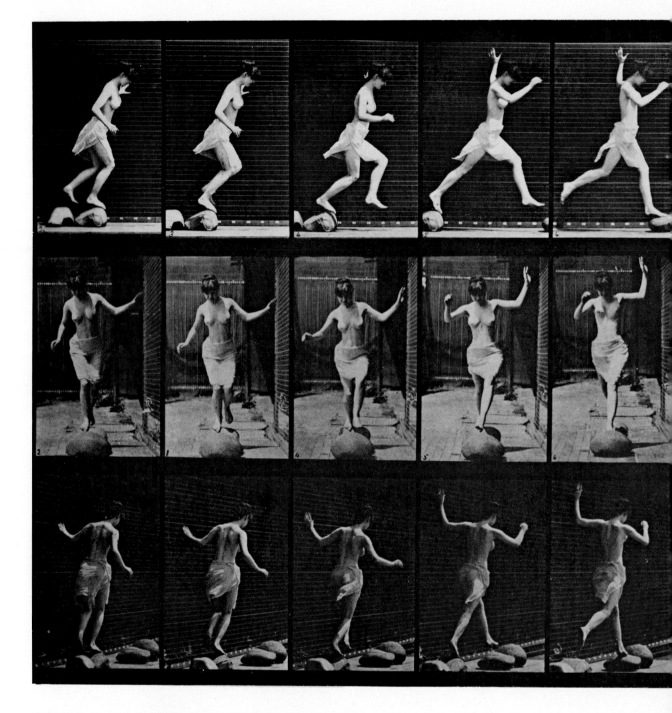

WOMAN JUMPING FROM ROCK TO ROCK (.119 second)

PLATE 142

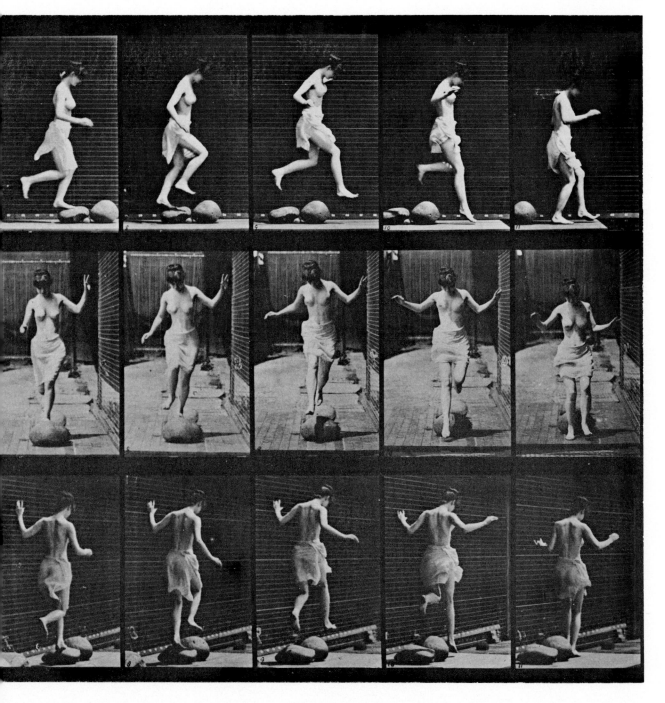

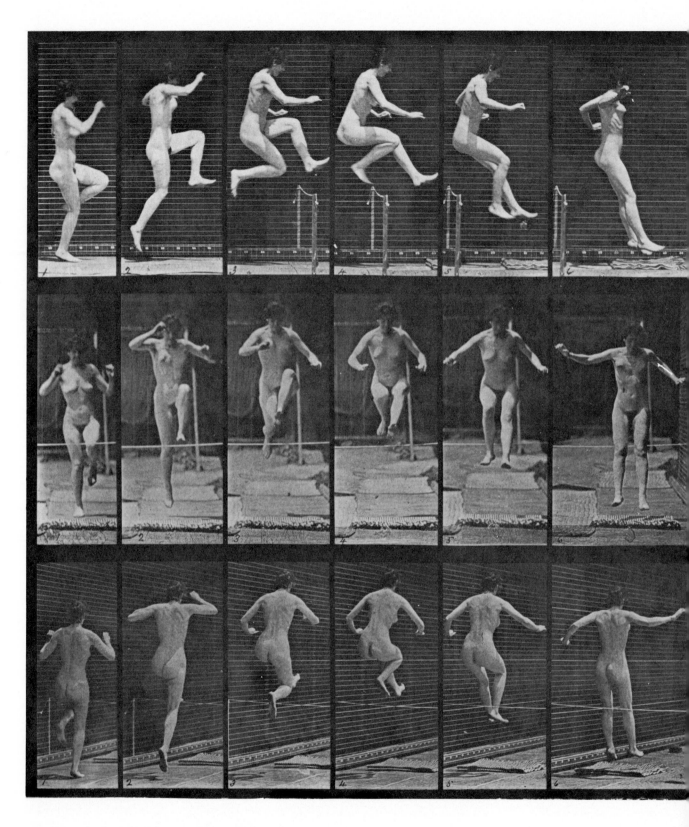

WOMAN JUMPING OVER LOW HURDLE

PLATE 143

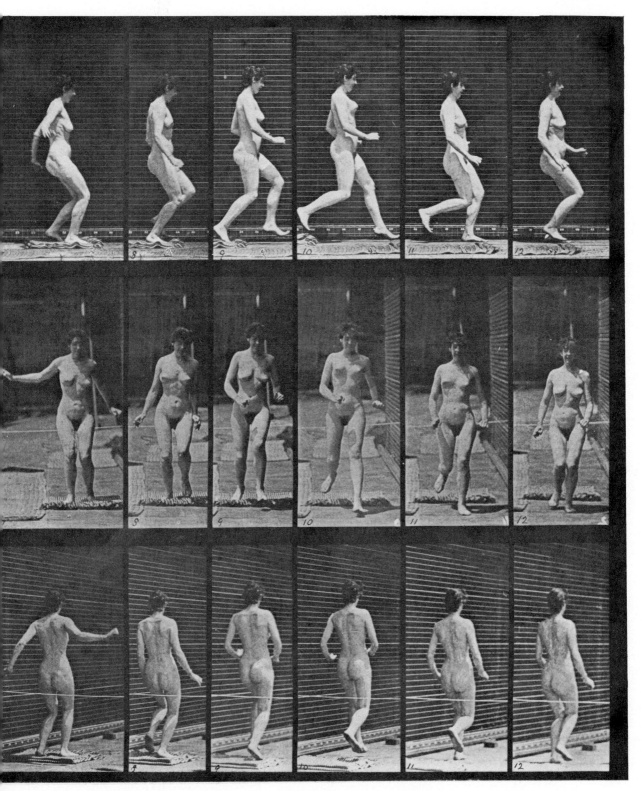

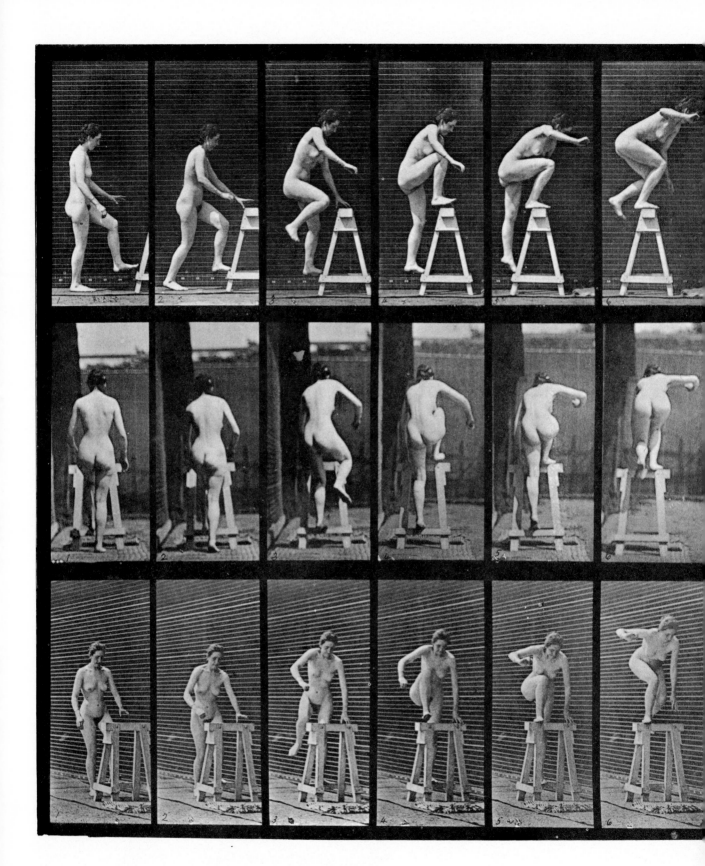

WOMAN CLIMBING UP AND JUMPING FROM SAW HORSE

PLATE 144

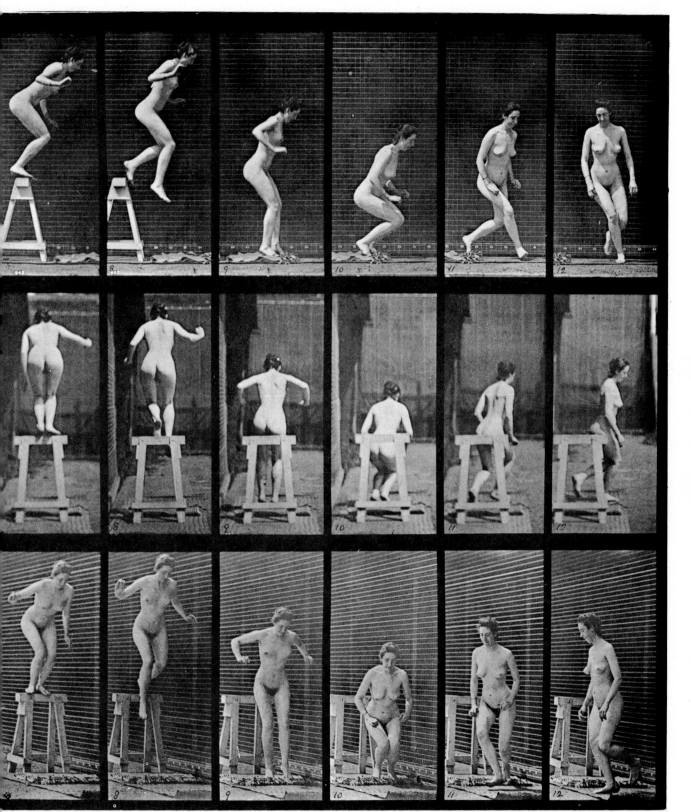

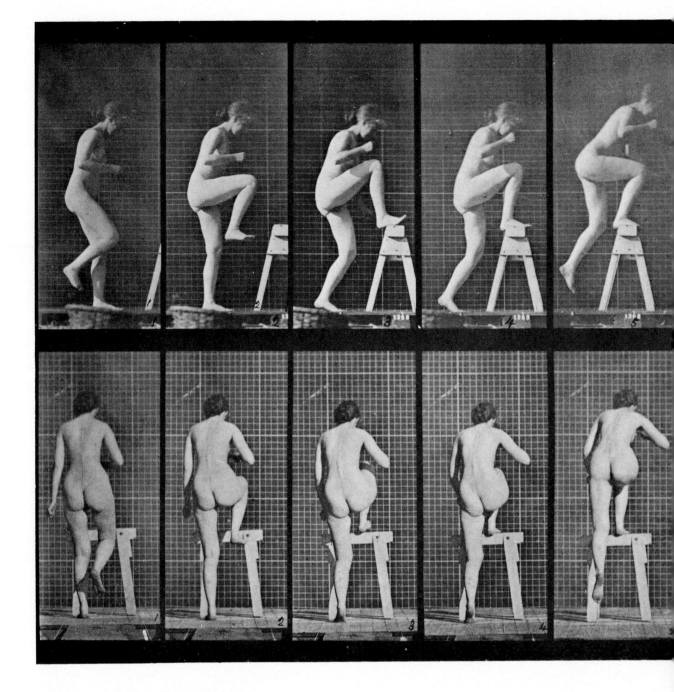

WOMAN CLIMBING OVER SAW HORSE

PLATE 145

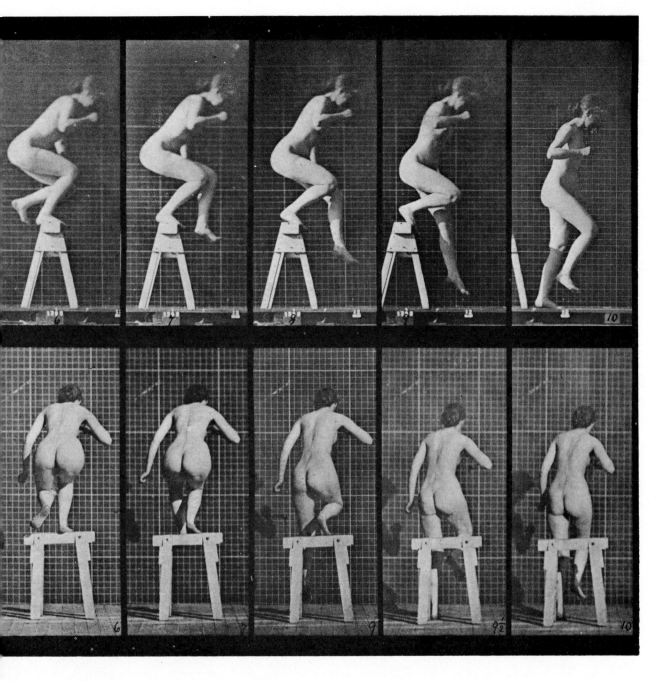

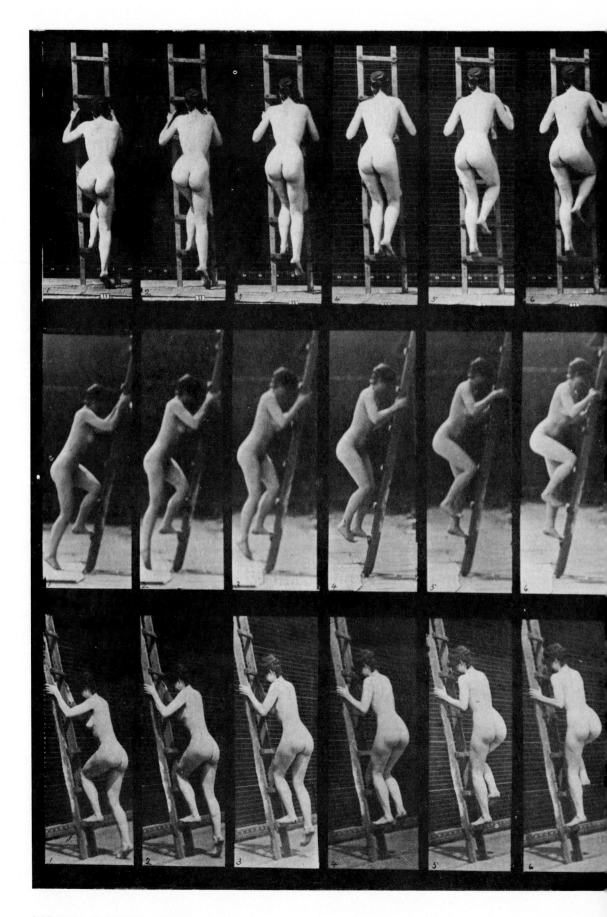

WOMAN CLIMBING LADDER

PLATE 146

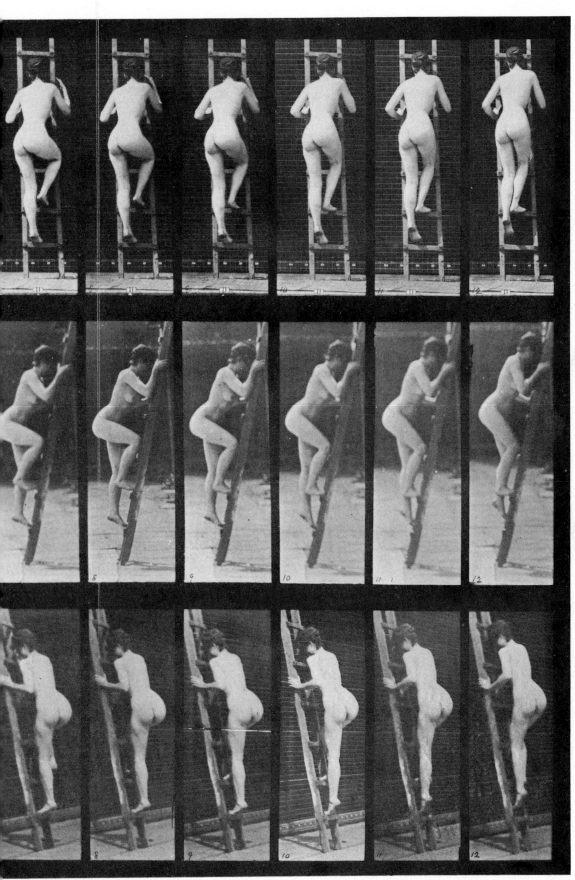

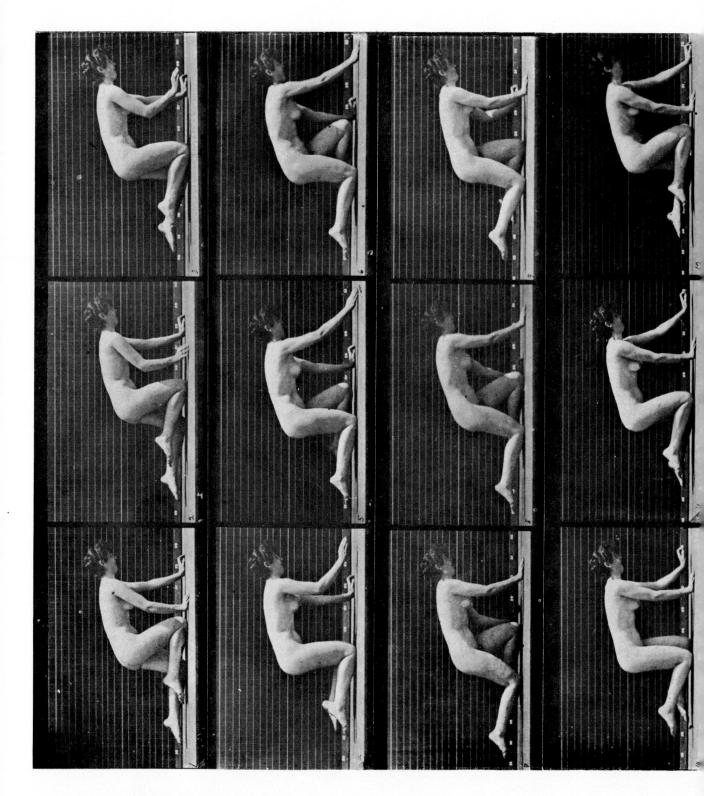

WOMAN CRAWLING ON HANDS AND KNEES

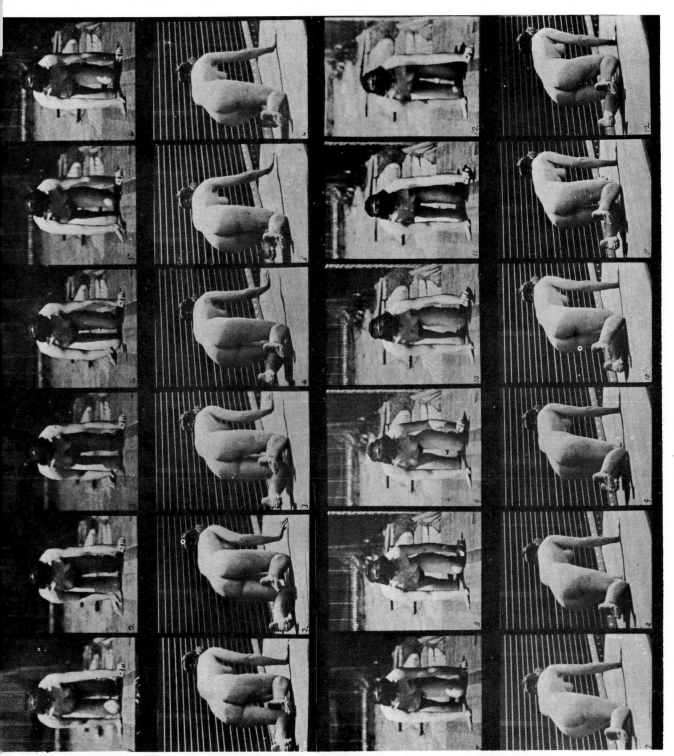

PLATE 147

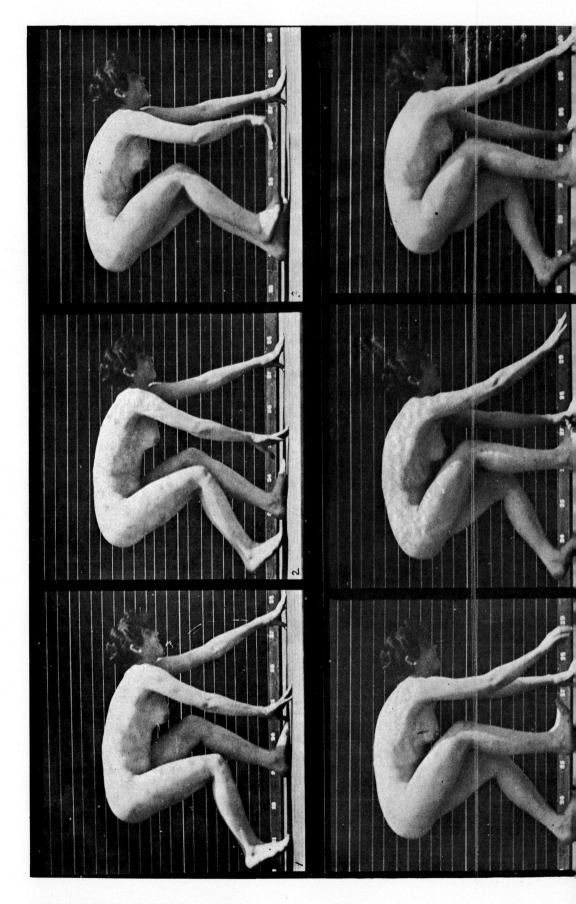

WOMAN WALKING ON ALL FOURS

PLATE 148

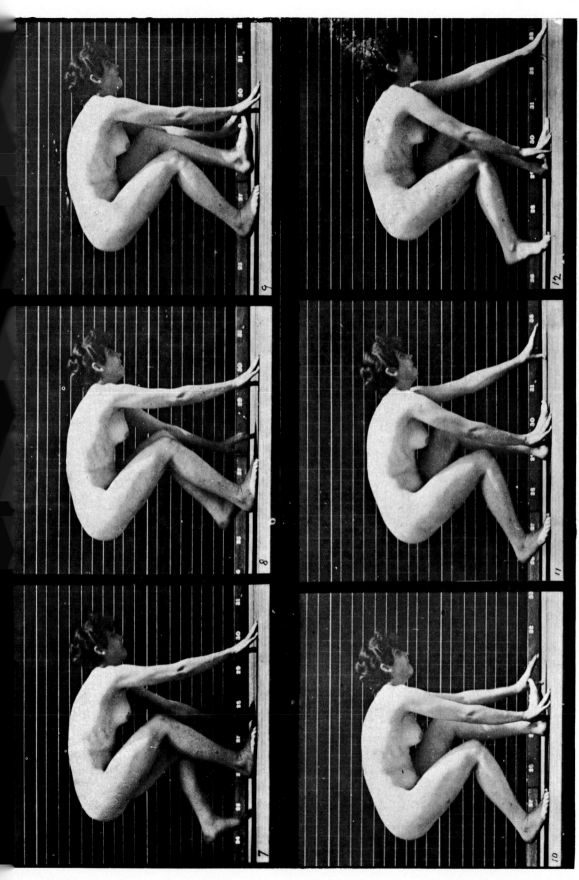

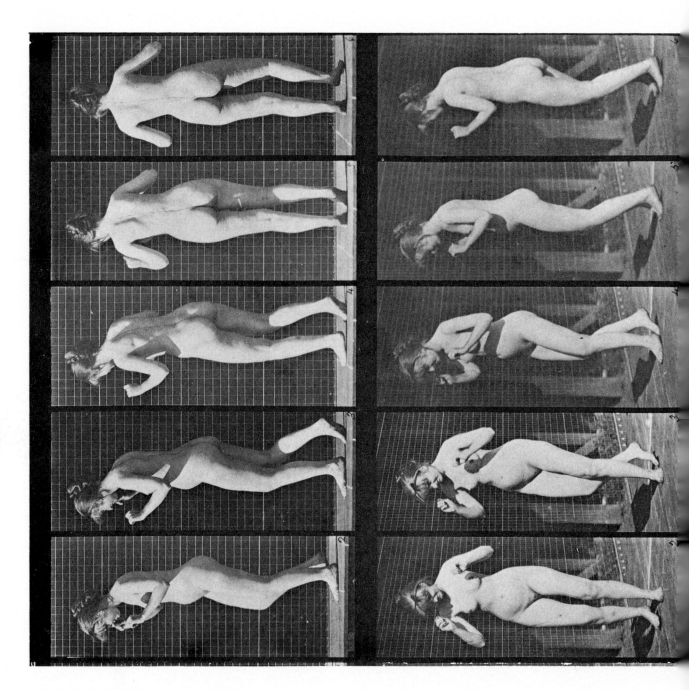

WOMAN DANCING

PLATE 149

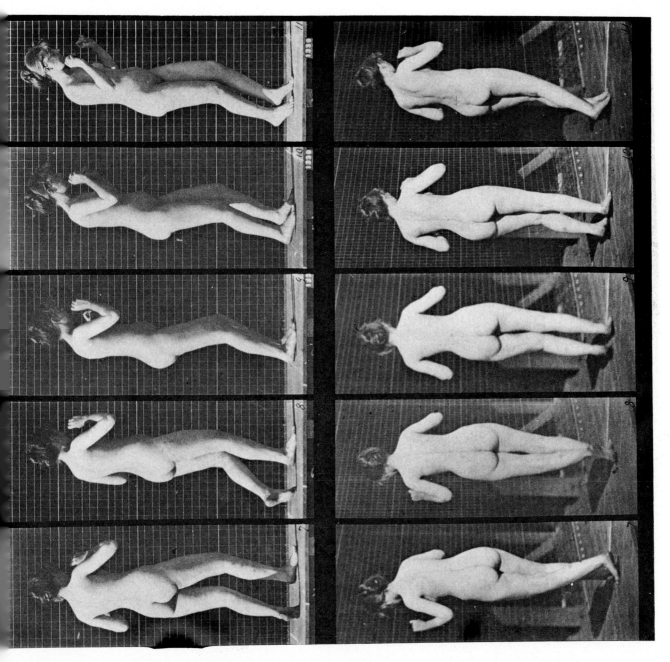

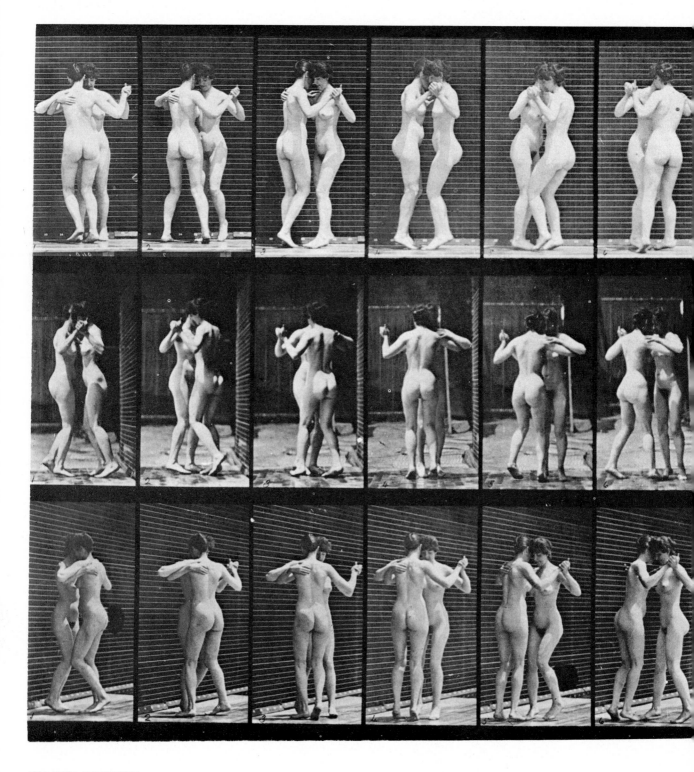

WOMEN DANCING

PLATE 150

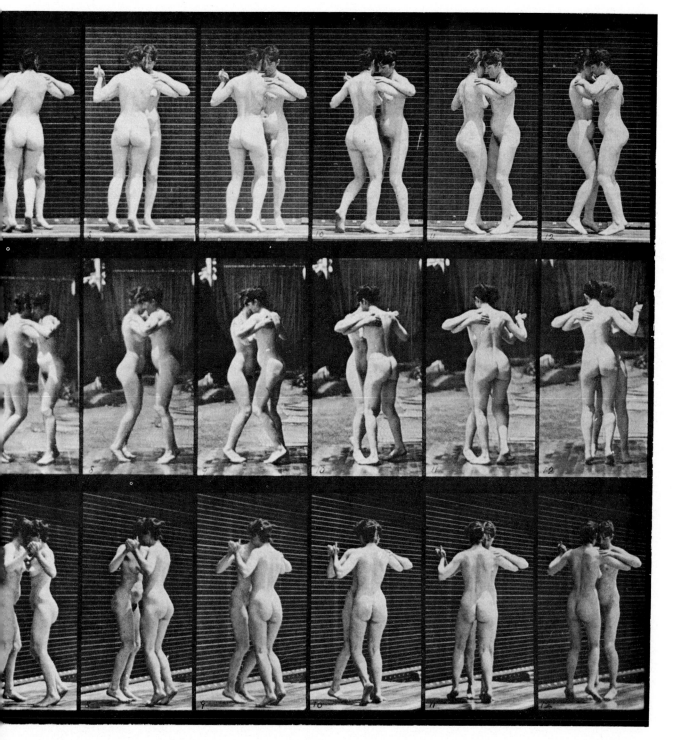

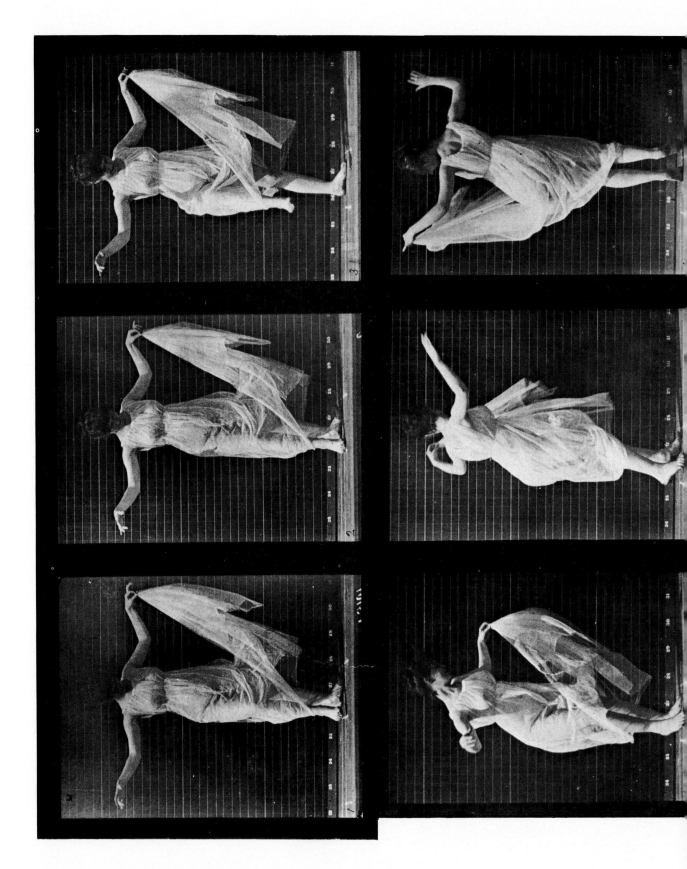

WOMAN PIROUETTING (.277 second)

PLATE 151

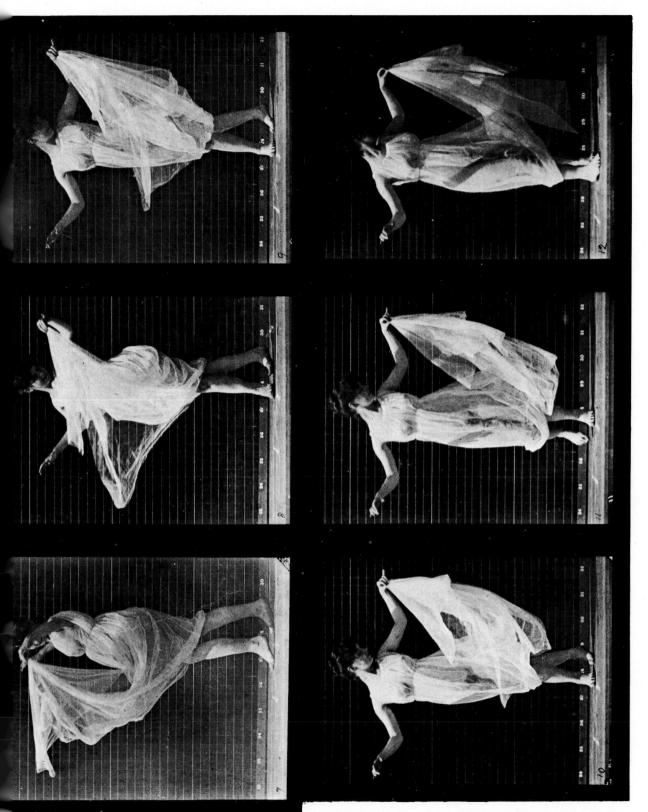

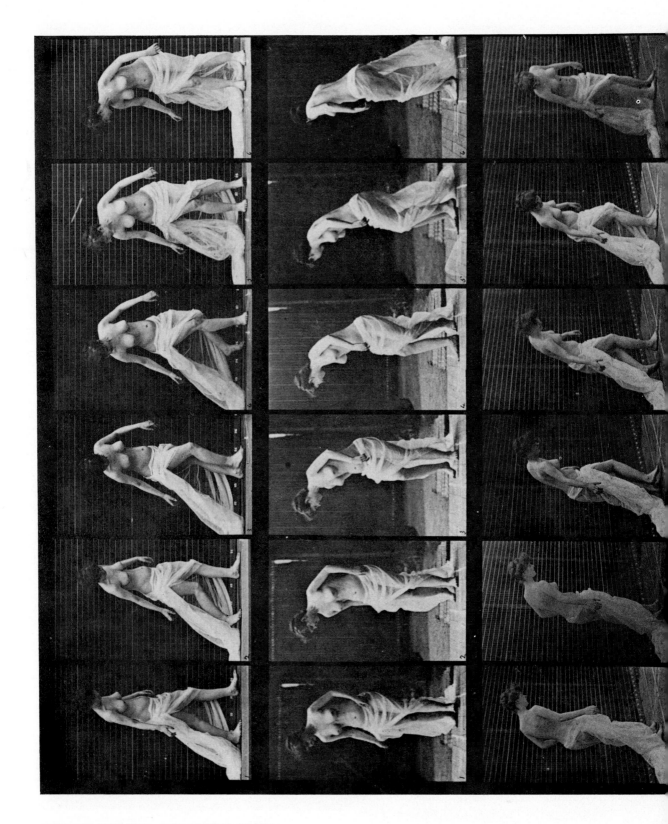

WOMAN TURNING AND LIFTING TRAIN

PLATE 152

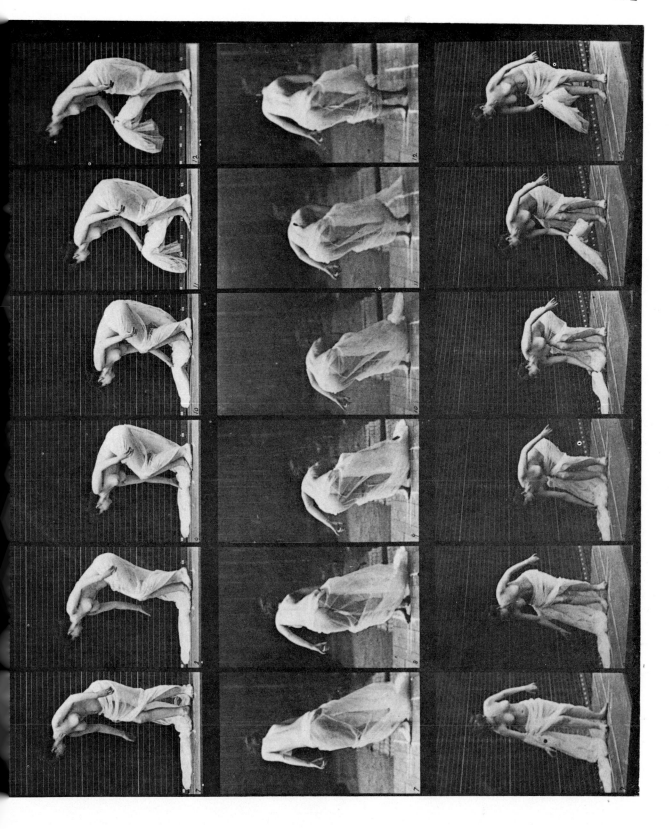

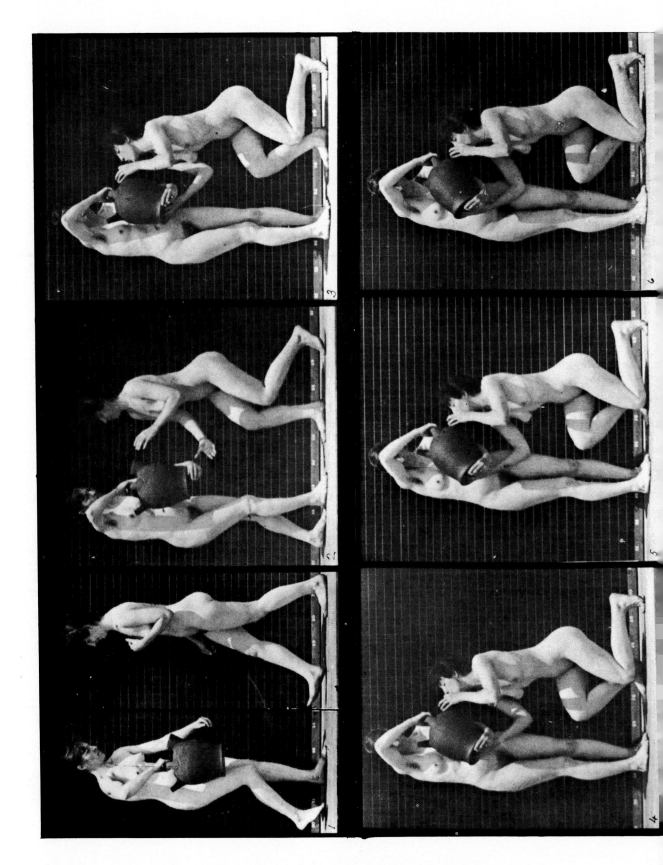

WOMAN TURNING AND HOLDING WATER JUG FOR KNEELING COMPANION

PLATE 153

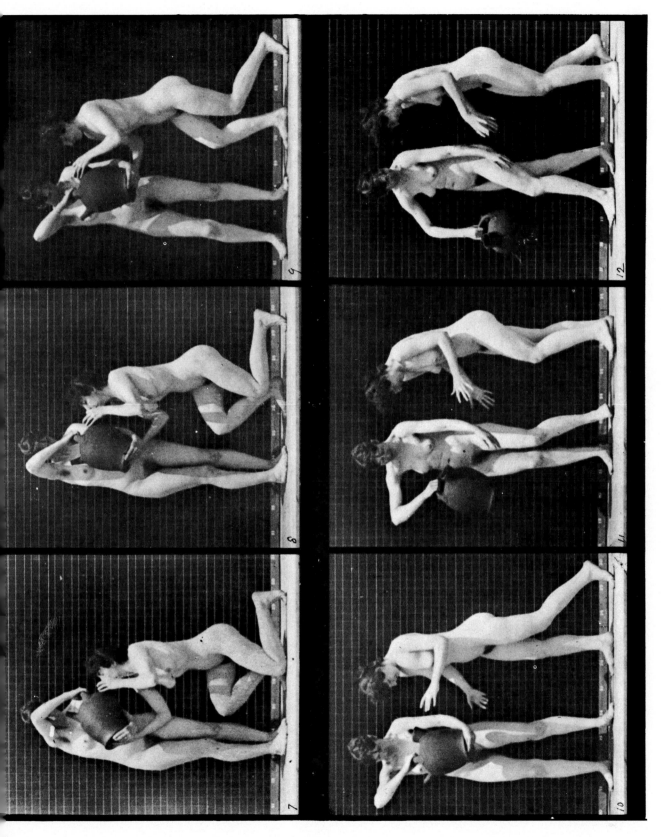

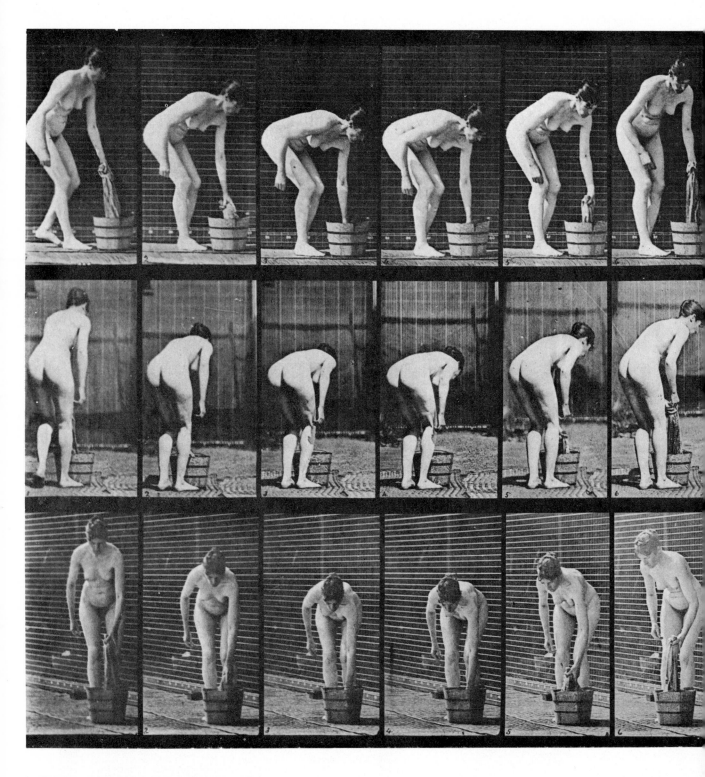

WOMAN TURNING TO WRING OUT RAG

PLATE 154

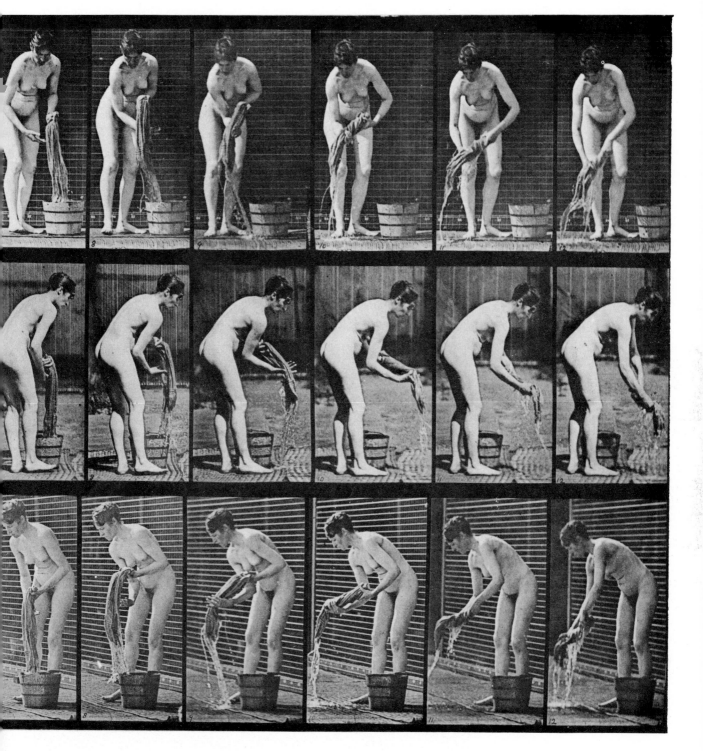

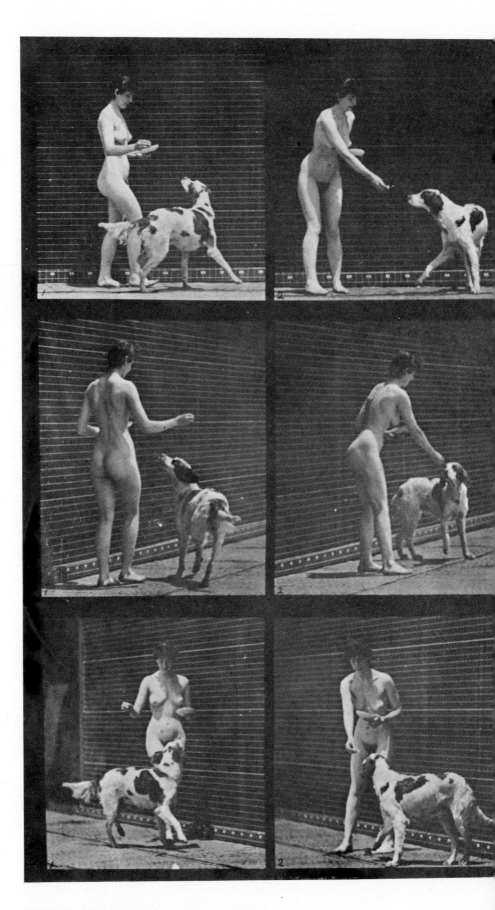

WOMAN TURNING AND FEEDING DOG

PLATE 155

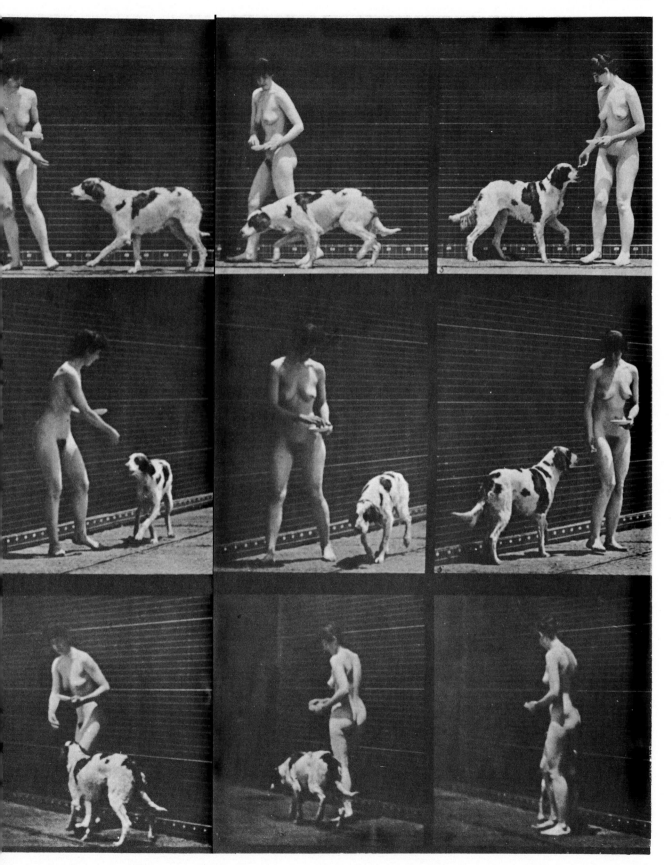

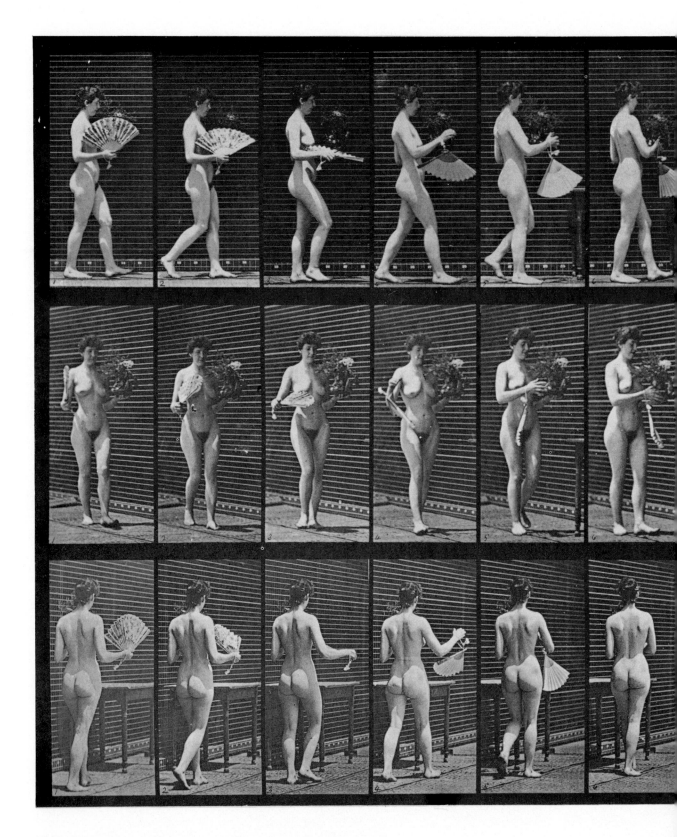

WOMAN TURNING WHILE CARRYING FAN AND FLOWERS

PLATE 156

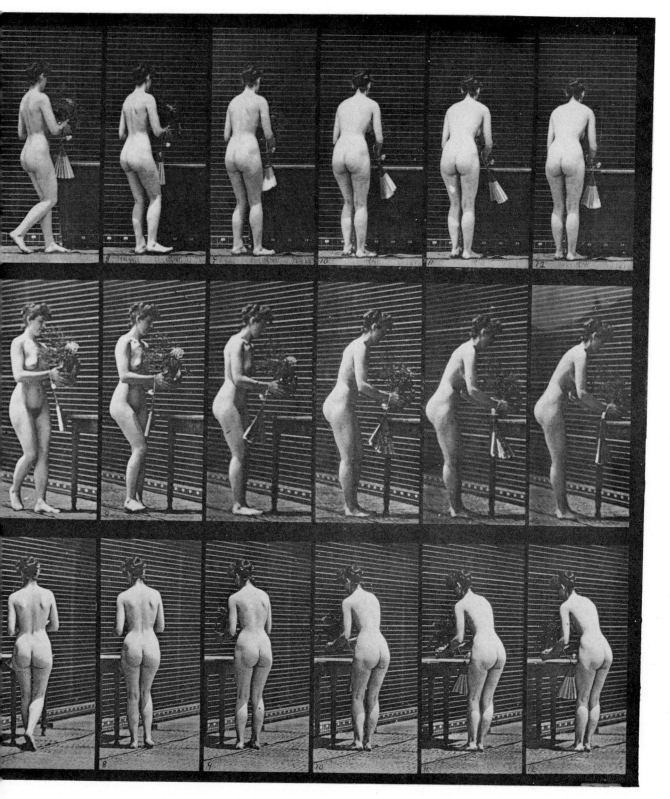

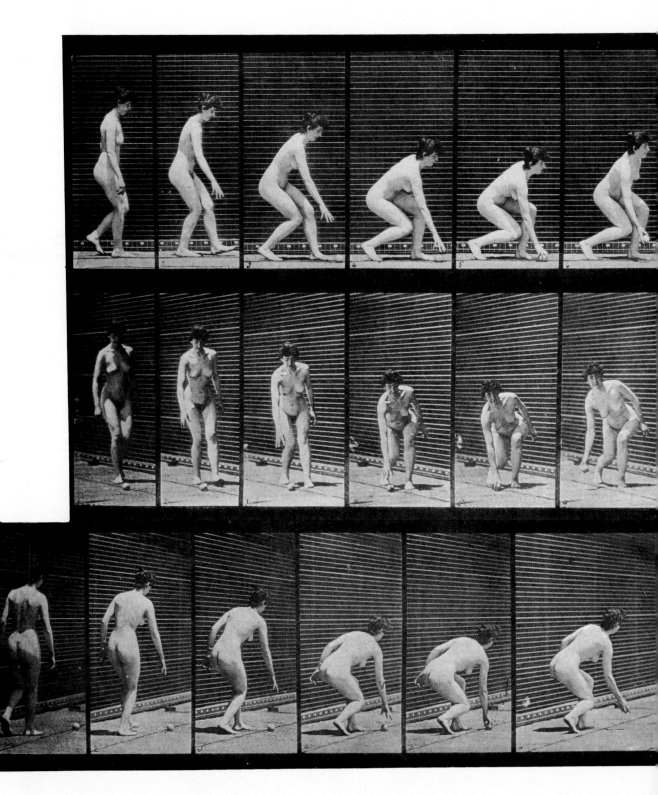

WOMAN PICKING UP AND THROWING BASEBALL

PLATE 157

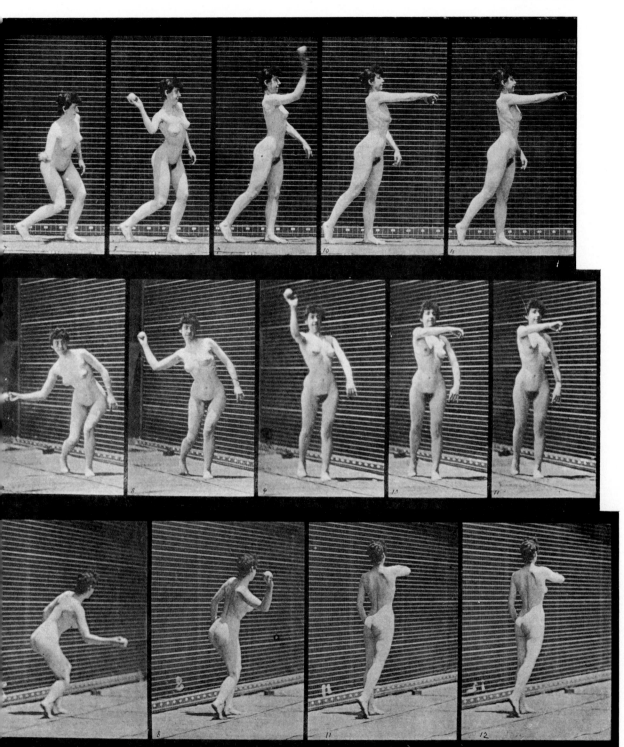

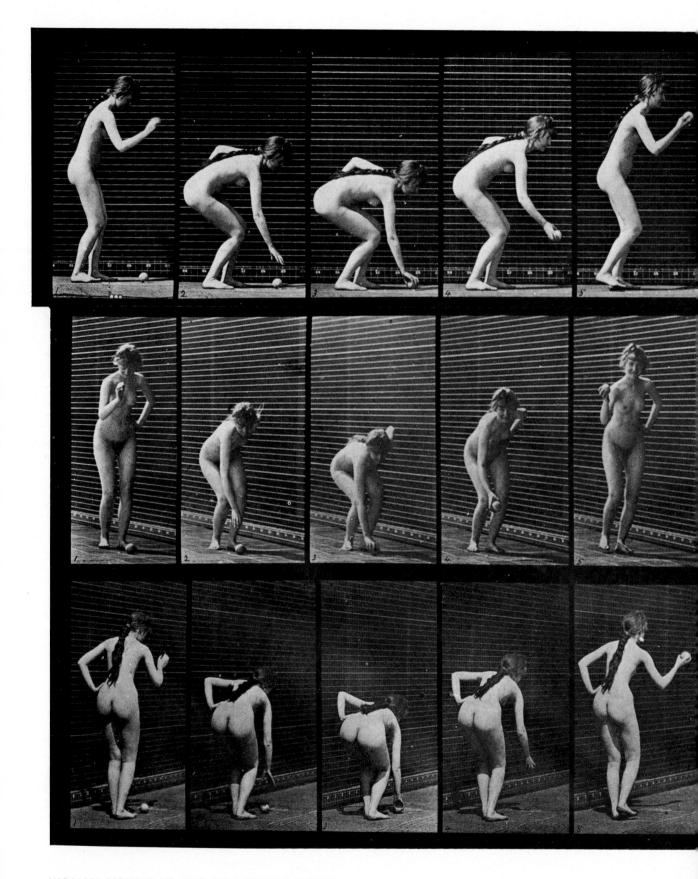

WOMAN PICKING UP AND THROWING BASEBALL

PLATE 158

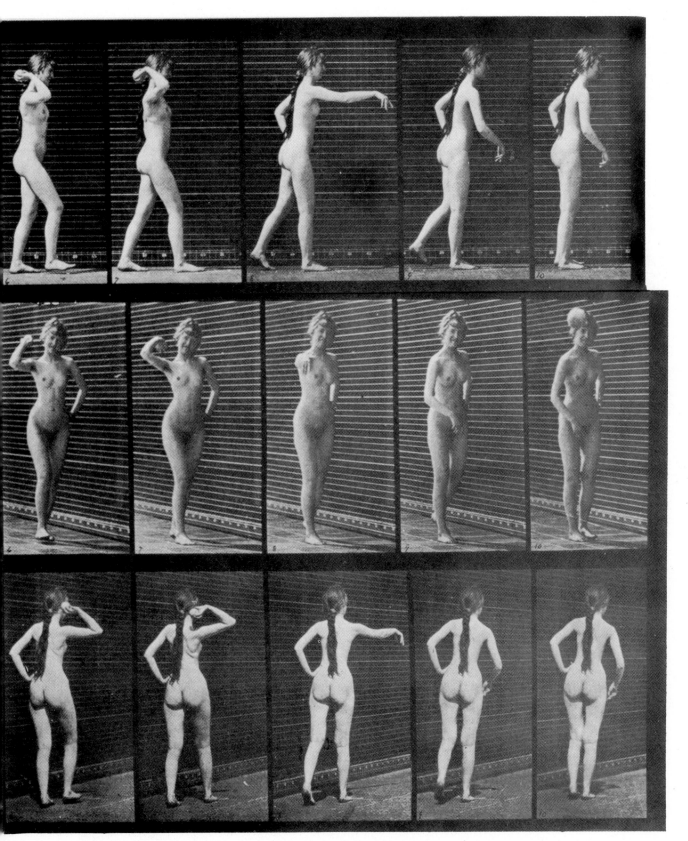

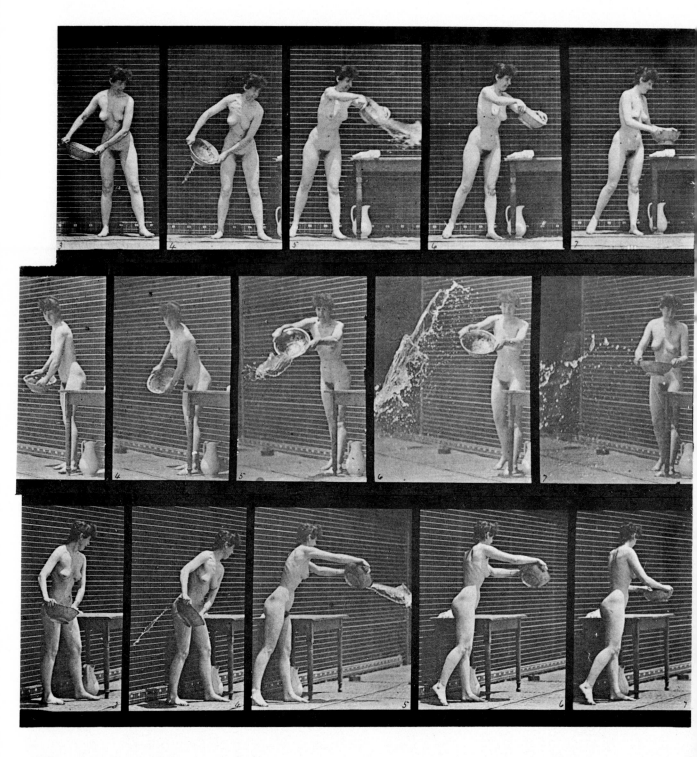

WOMAN THROWING BASIN OF WATER

PLATE 159

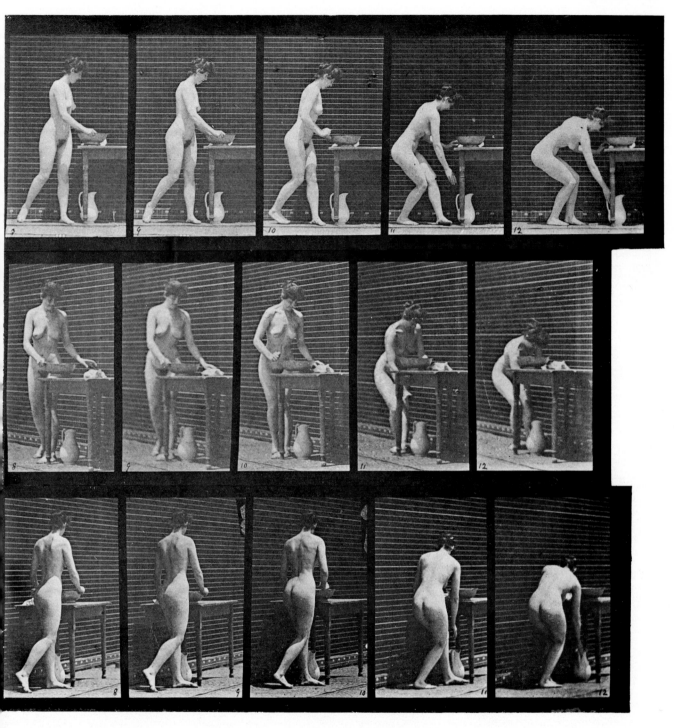

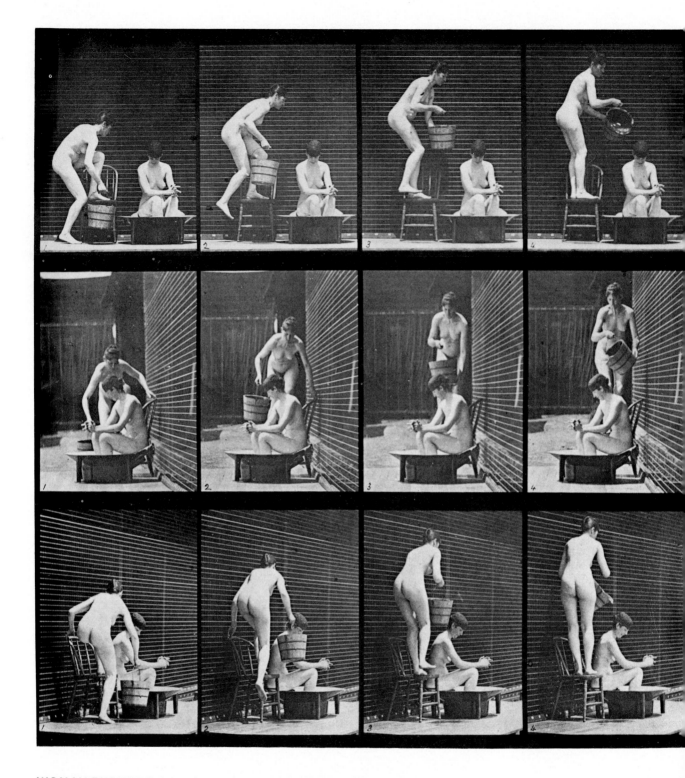

WOMAN EMPTYING BUCKET OF WATER ON SEATED COMPANION (.437 second)

PLATE 160

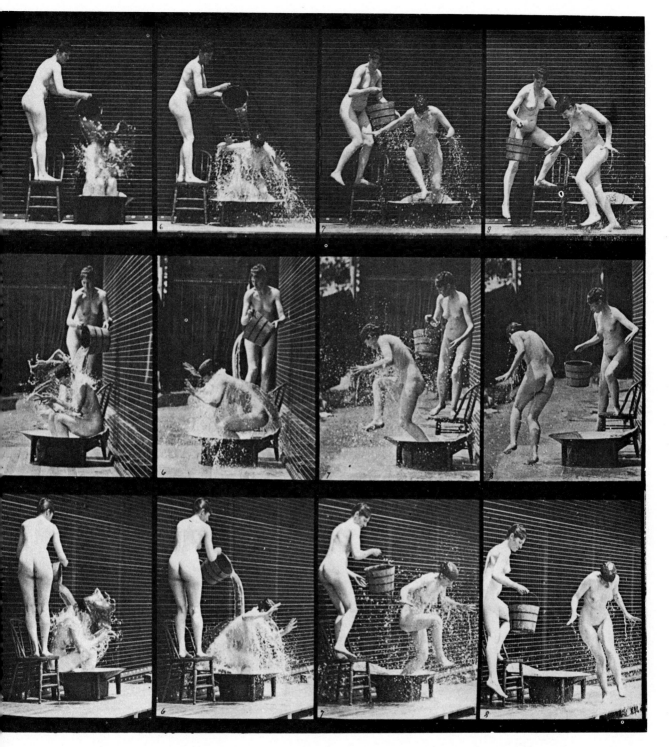

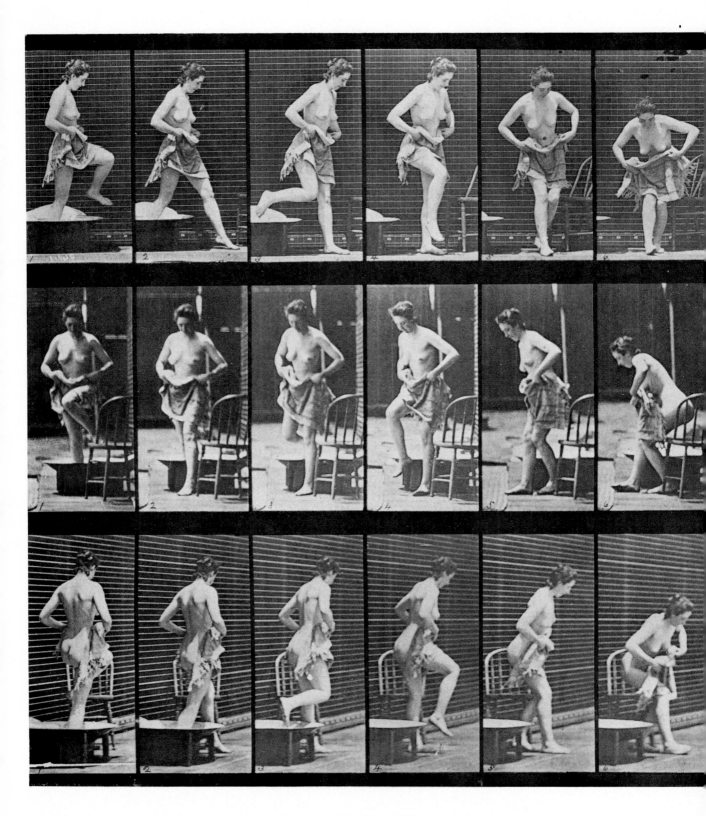

WOMAN STEPPING FROM TUB, SITTING DOWN IN CHAIR, DRYING HER FEET

PLATE 161

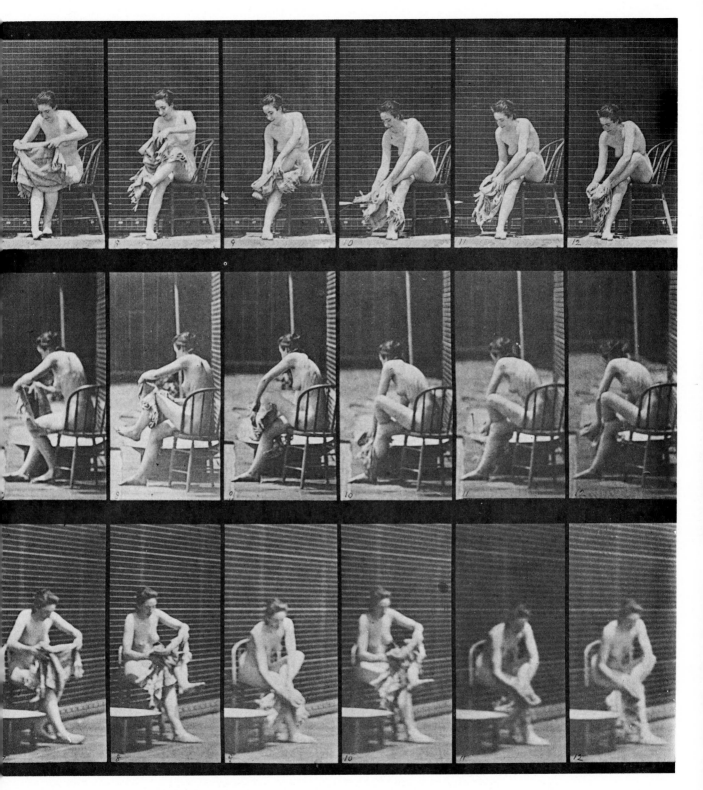

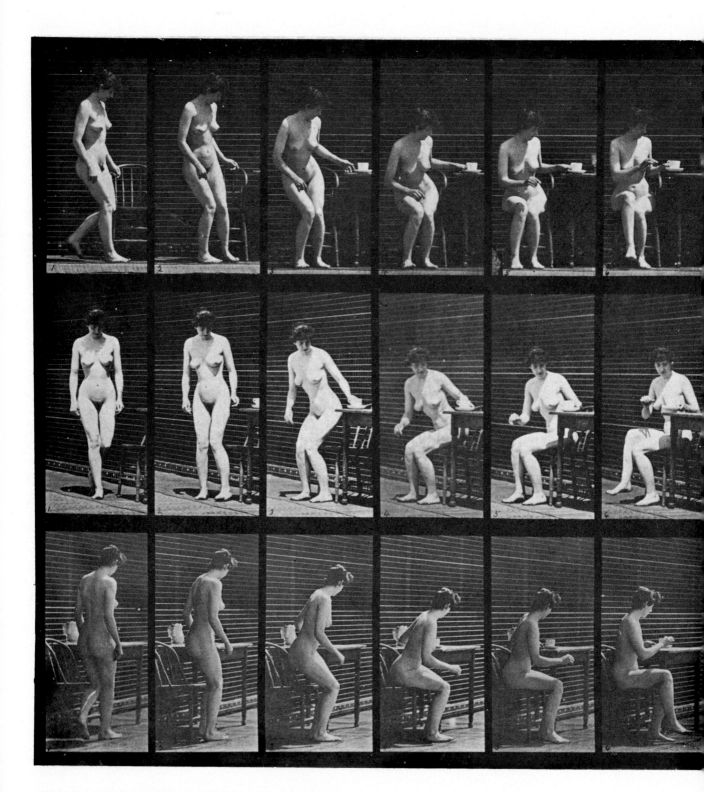

WOMAN SITTING DOWN IN CHAIR AND DRINKING TEA

PLATE 162

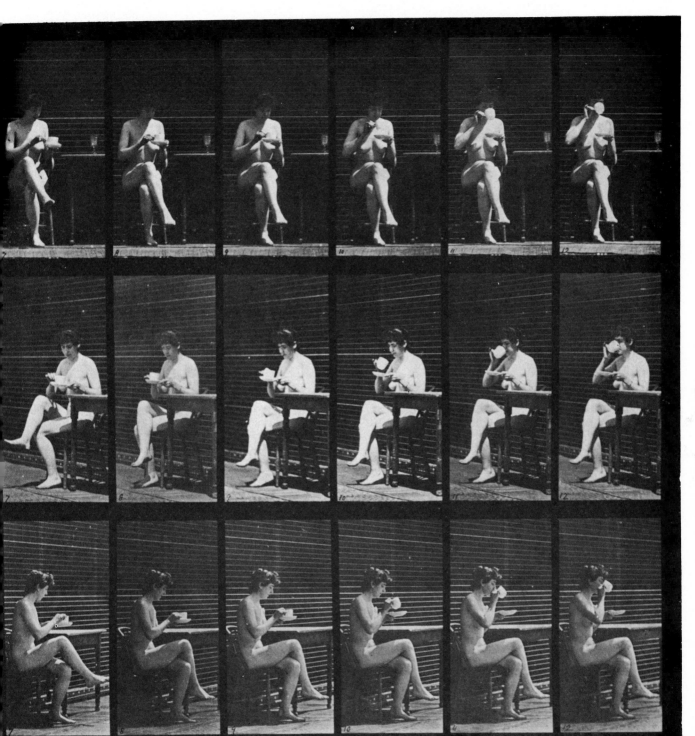

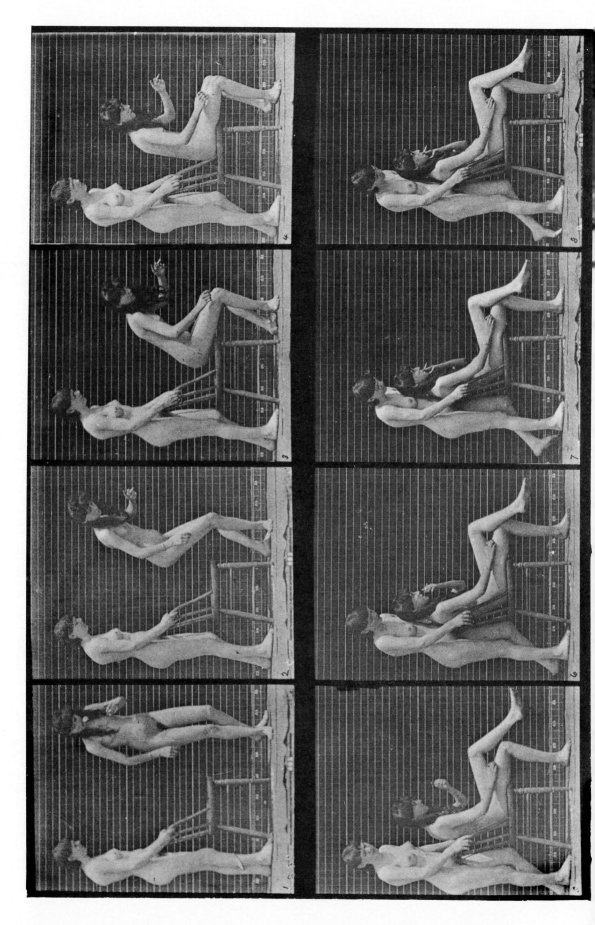

WOMAN SITTING DOWN IN CHAIR HELD BY COMPANION, SMOKING CIGARETTE

PLATE 163

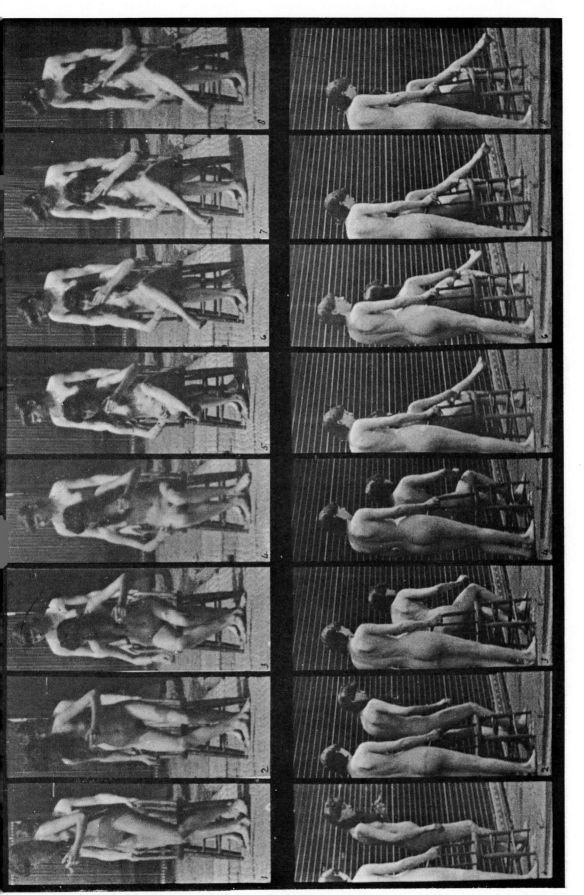

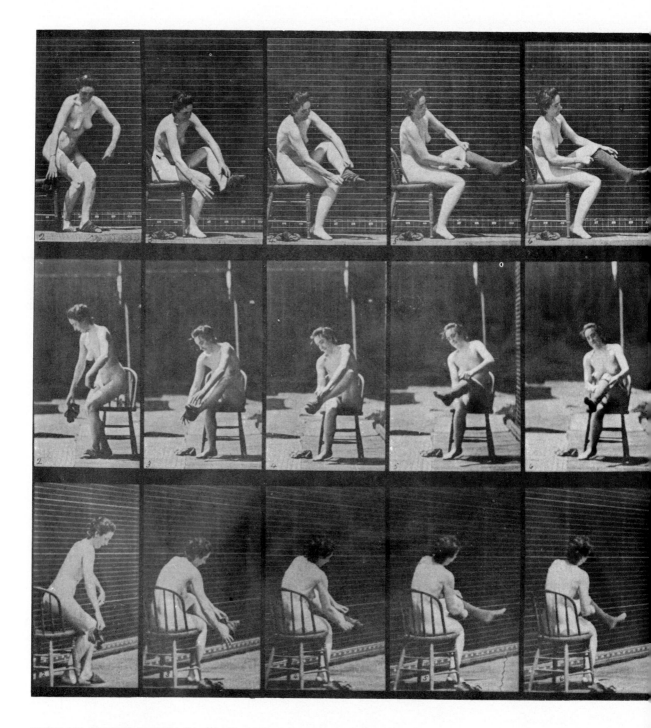

WOMAN SITTING DOWN IN CHAIR AND PULLING ON STOCKING

PLATE 164

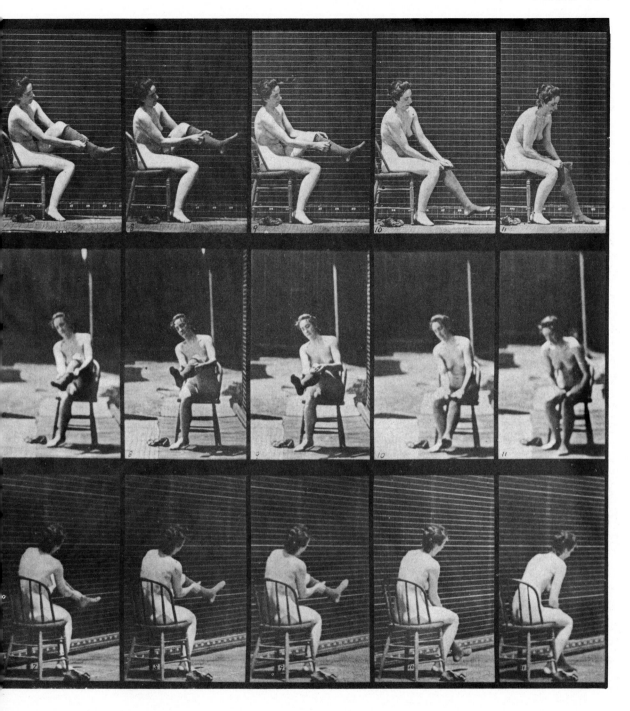

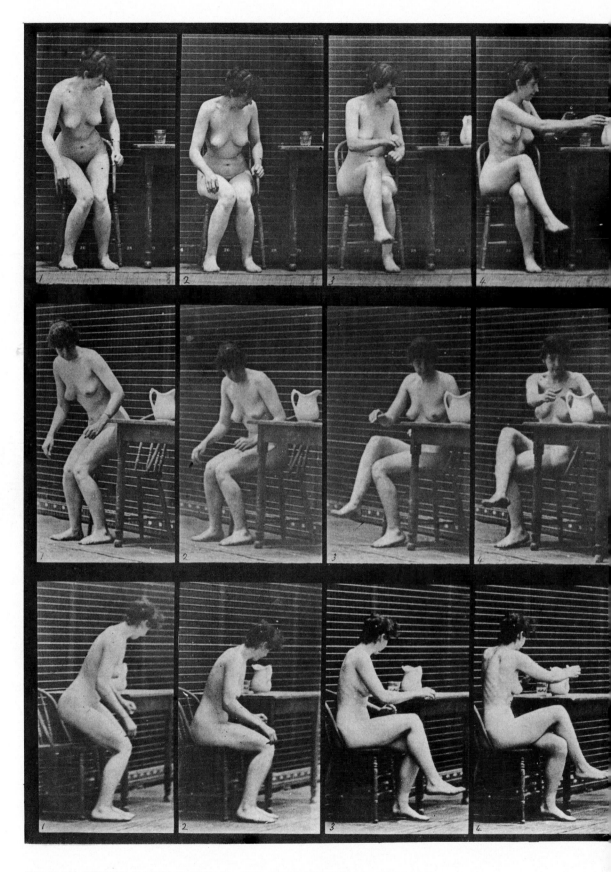

WOMAN SITTING DOWN IN CHAIR AND POURING GLASS OF WATER

PLATE 165

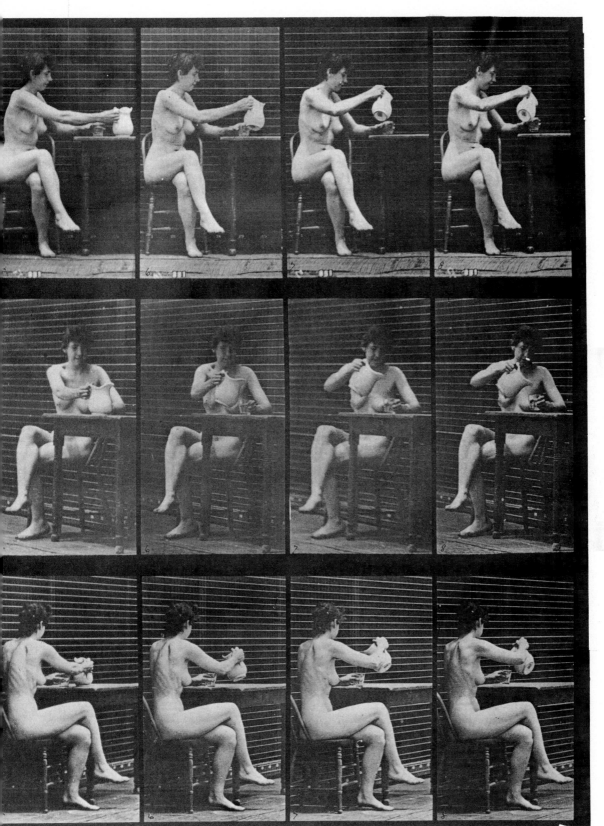

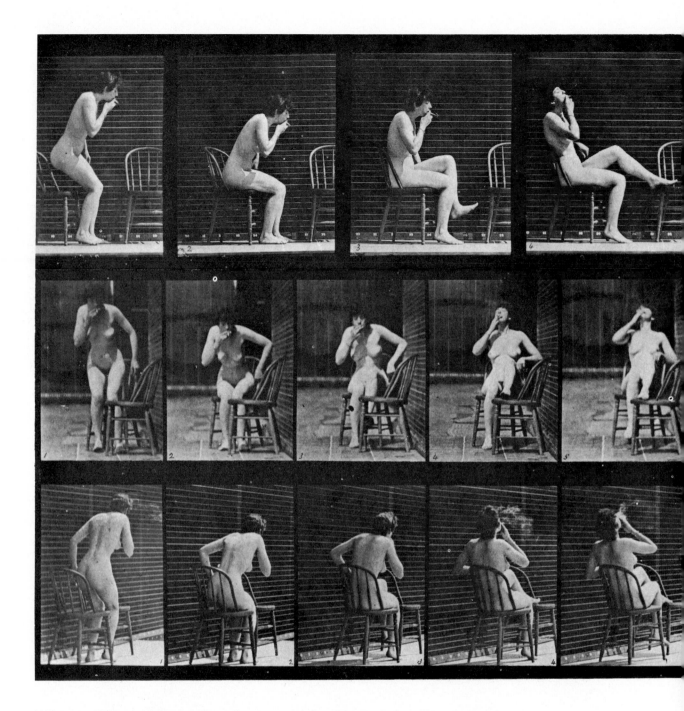

WOMAN SITTING DOWN AND LEANING BACK IN CHAIR, SMOKING CIGARETTE

PLATE 166

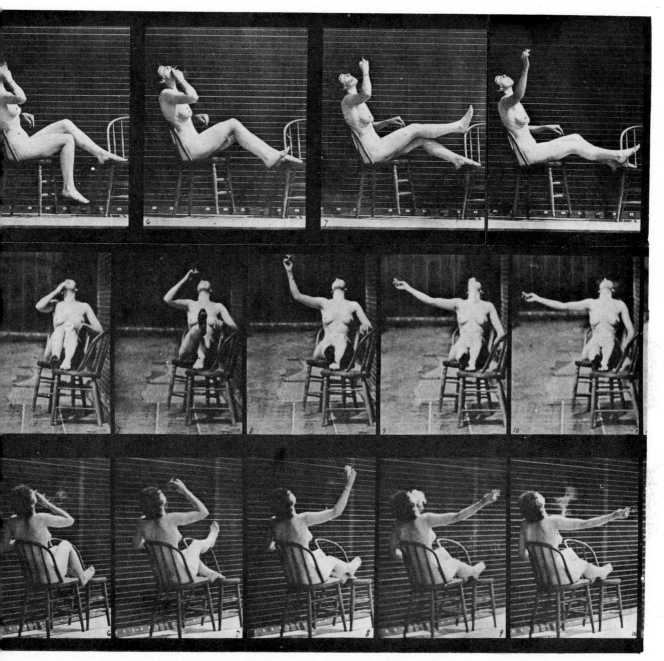

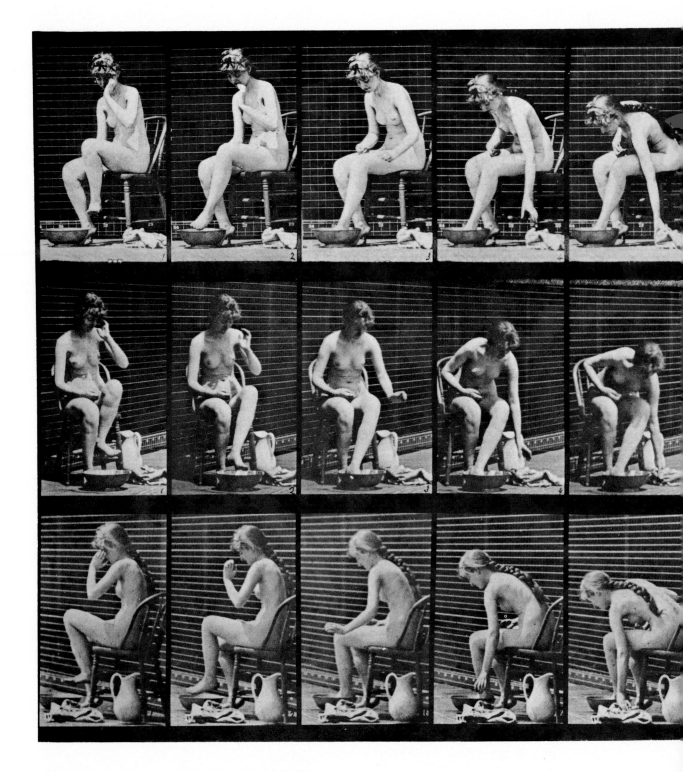

WOMAN SITTING IN CHAIR, DRYING HER FEET

PLATE 167

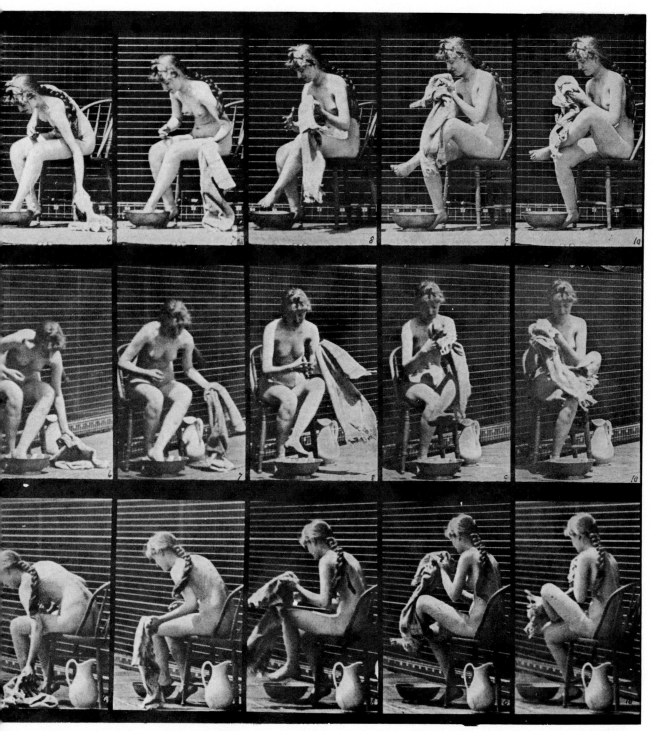

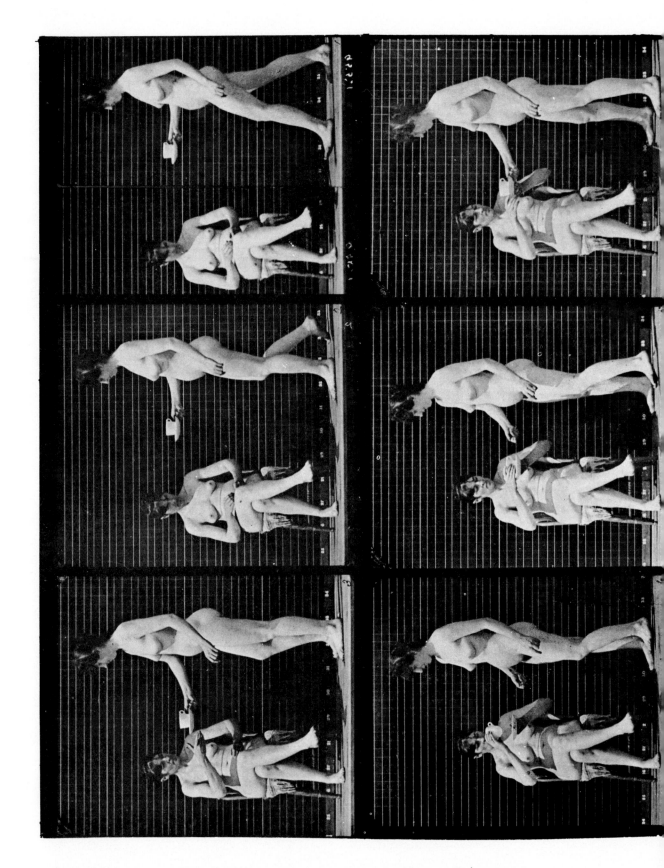

WOMAN SITTING IN CHAIR, DRINKING TEA, SERVED BY STANDING COMPANION

PLATE 168

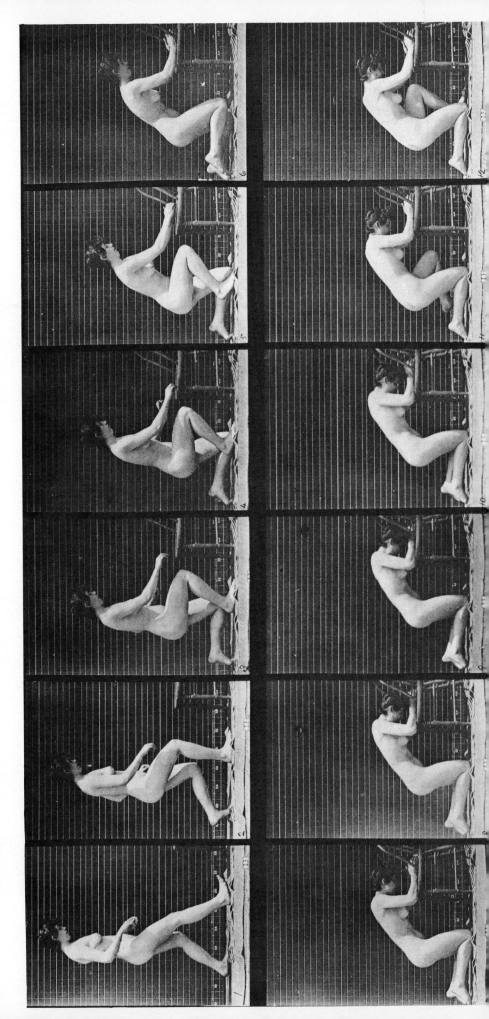

PLATE 169

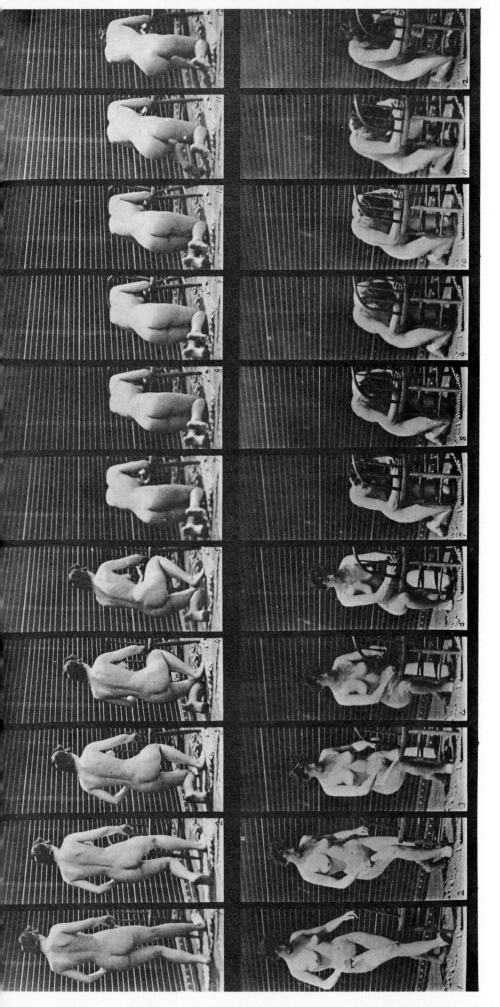

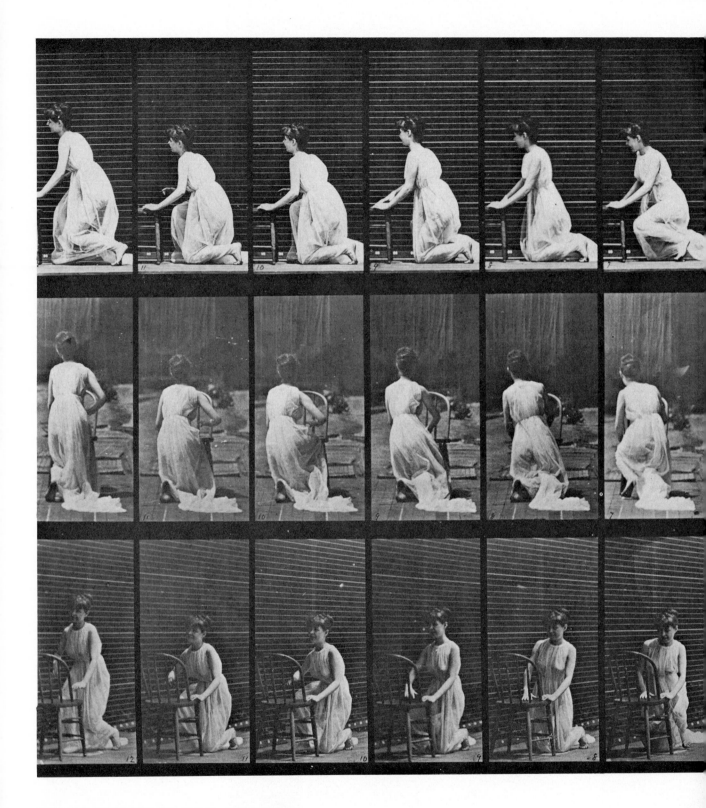

WOMAN KNEELING AT CHAIR, THEN RISING

PLATE 170

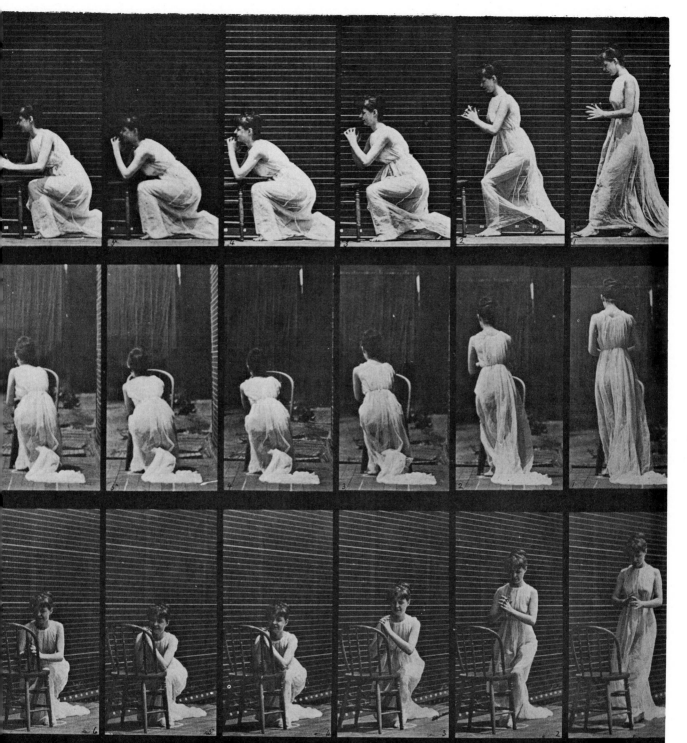

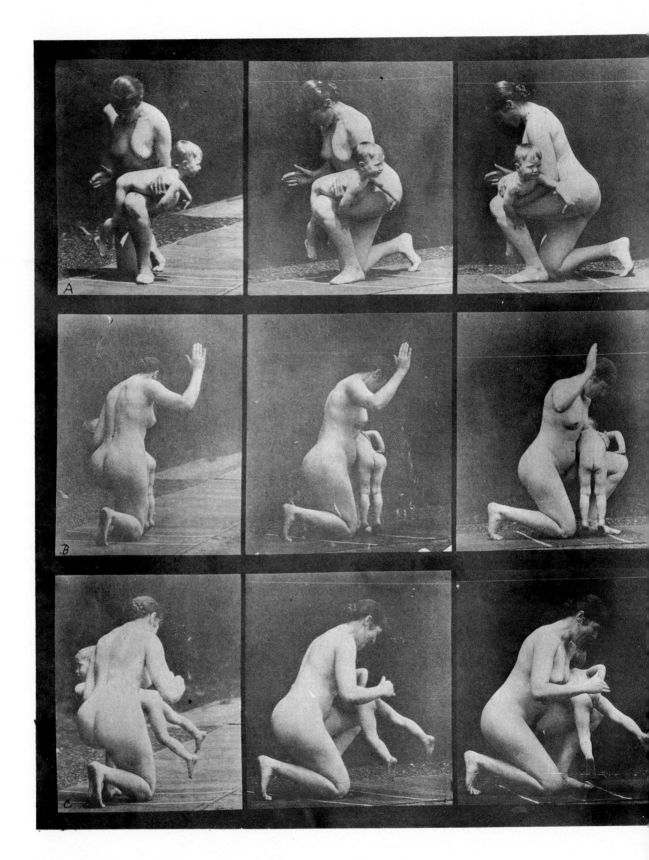

WOMAN ON ONE KNEE, SPANKING CHILD

PLATE 171

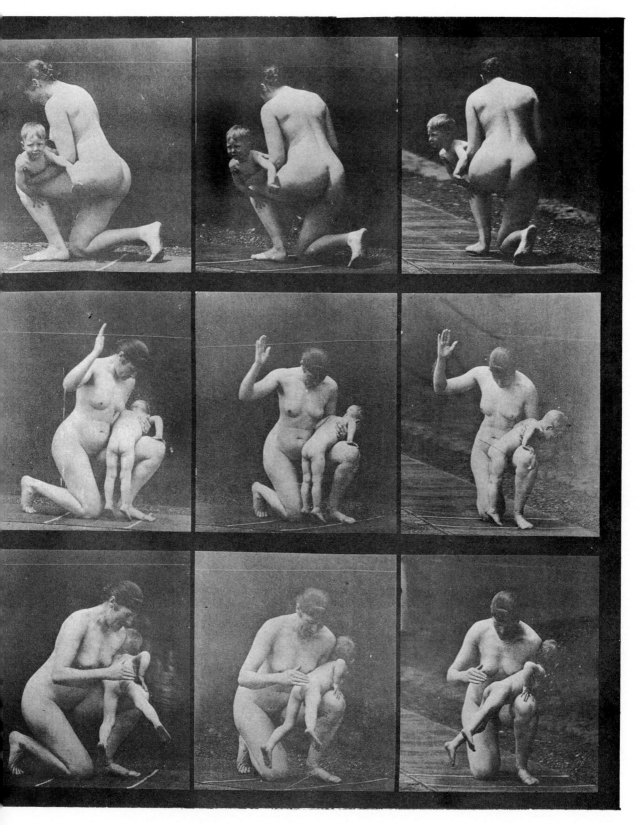

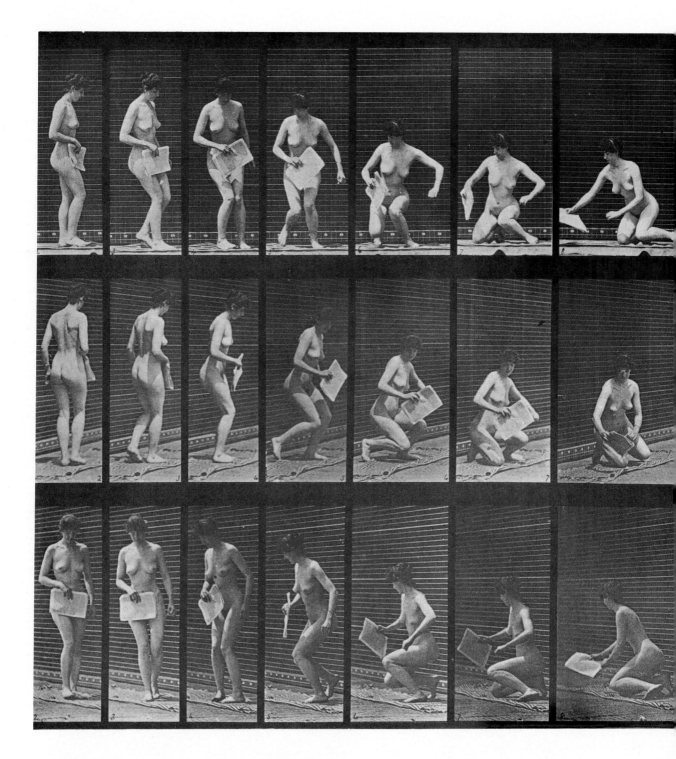

WOMAN WITH NEWSPAPER, LYING DOWN, READING

PLATE 172

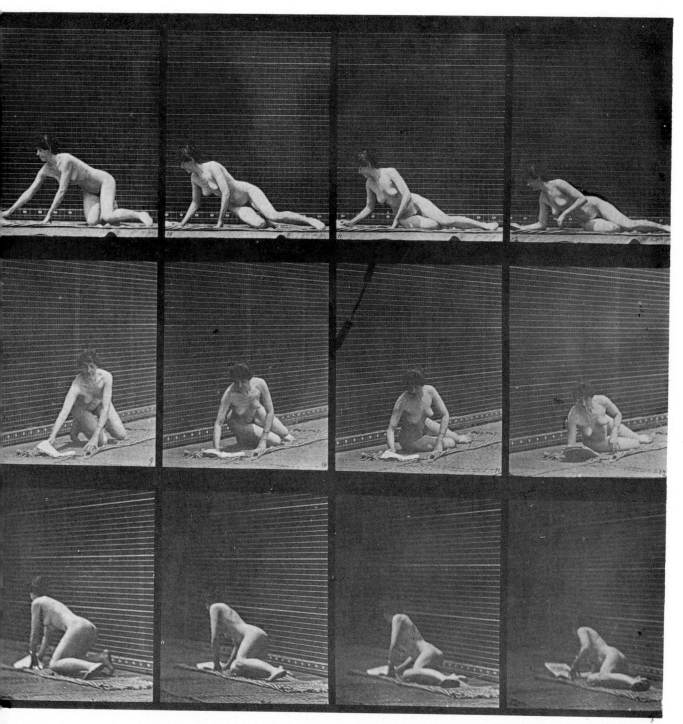

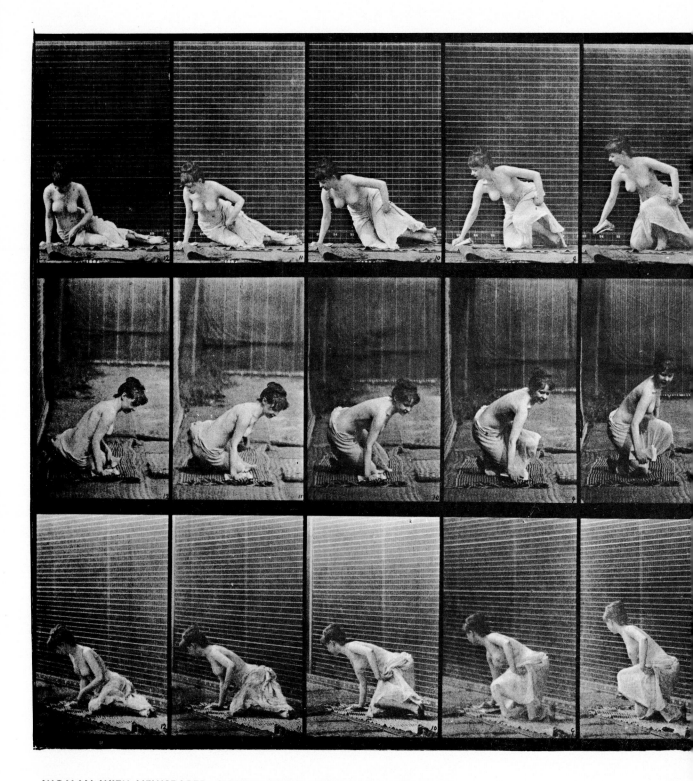

WOMAN WITH NEWSPAPER, SITTING DOWN ON FLOOR (.232 second)

PLATE 173

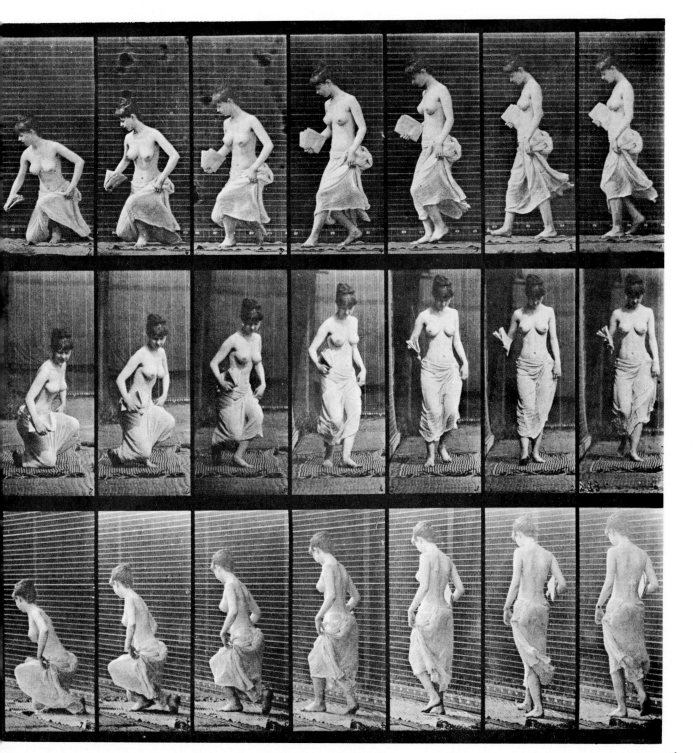

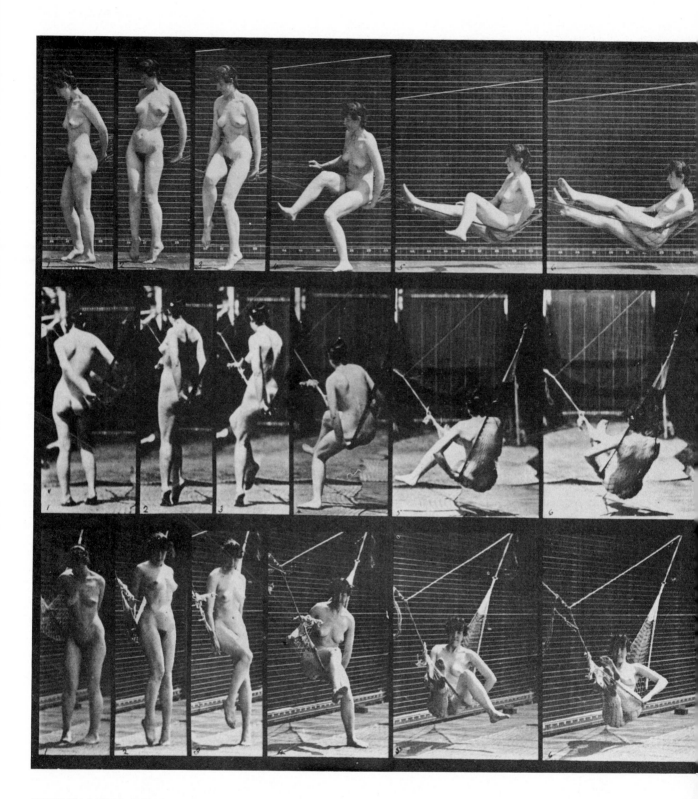

WOMAN LYING DOWN IN HAMMOCK

PLATE 174

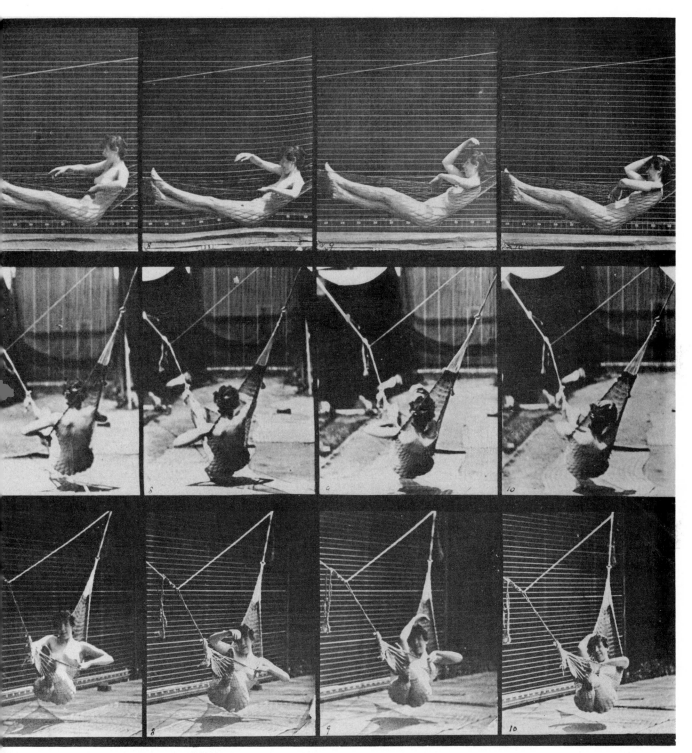

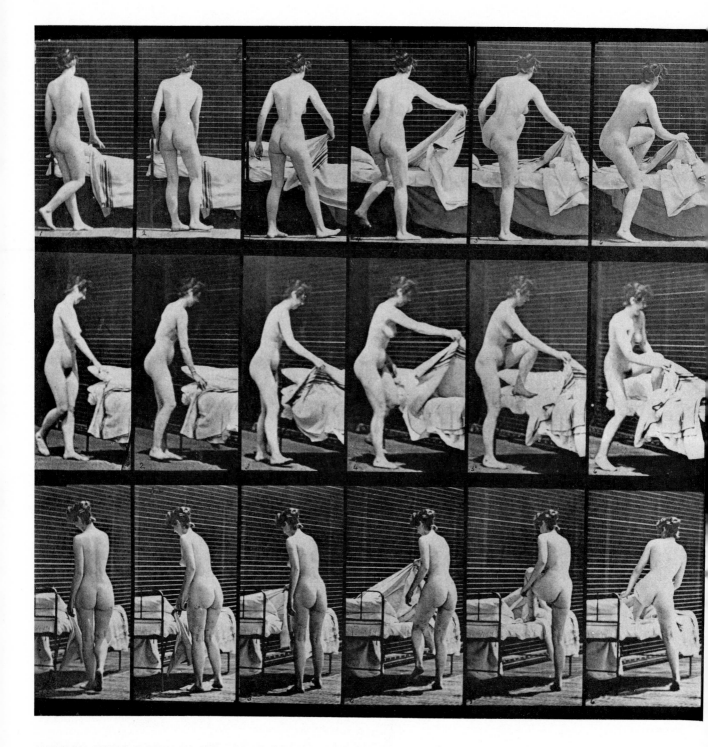

WOMAN LYING DOWN IN BED, COVERING UP WITH BLANKET

PLATE 175

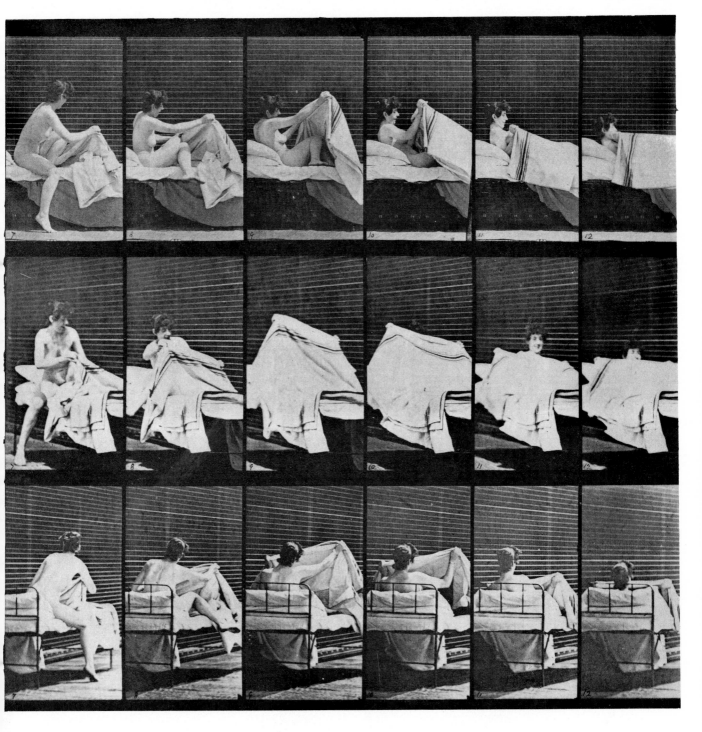

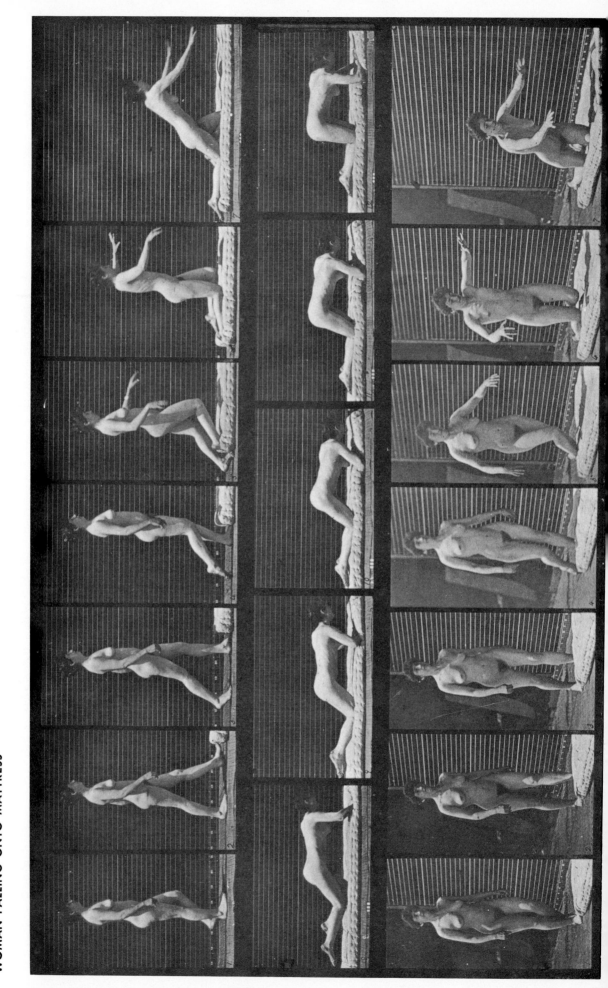

PLATE 176

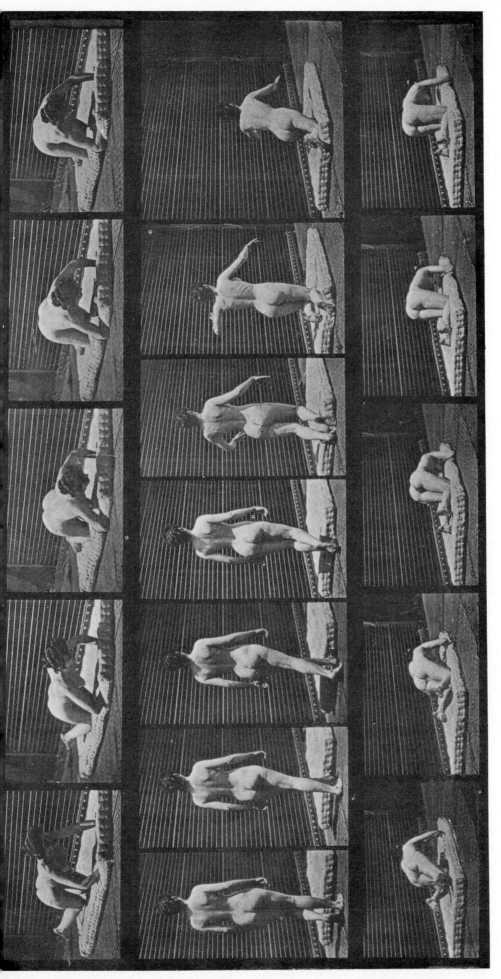

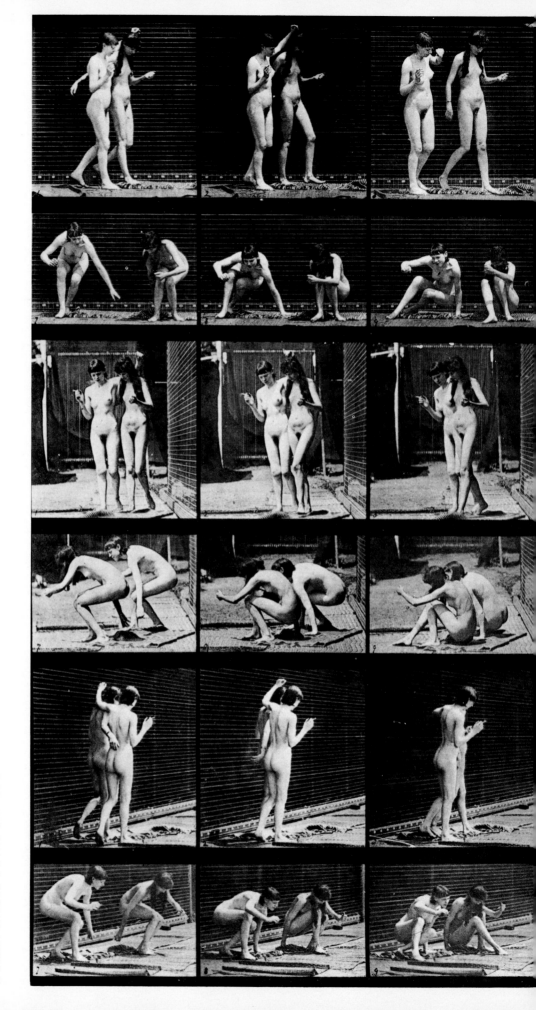

PLATE 177

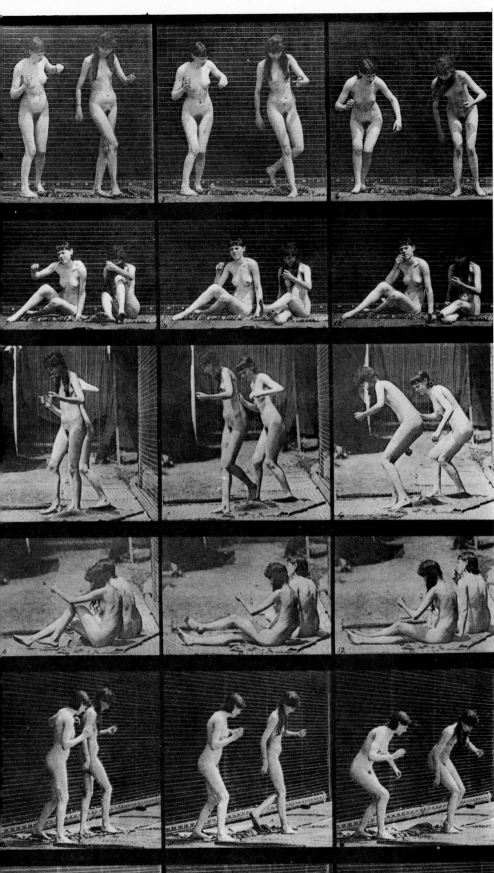
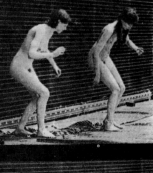
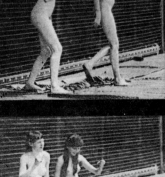
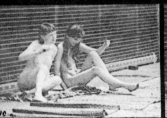
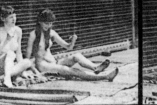
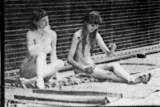

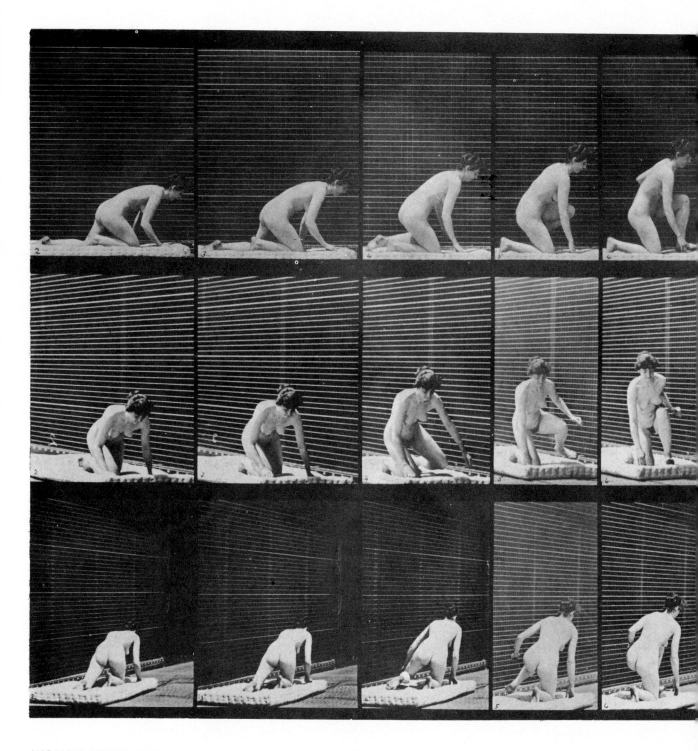

WOMAN RISING FROM KNEES

PLATE 178

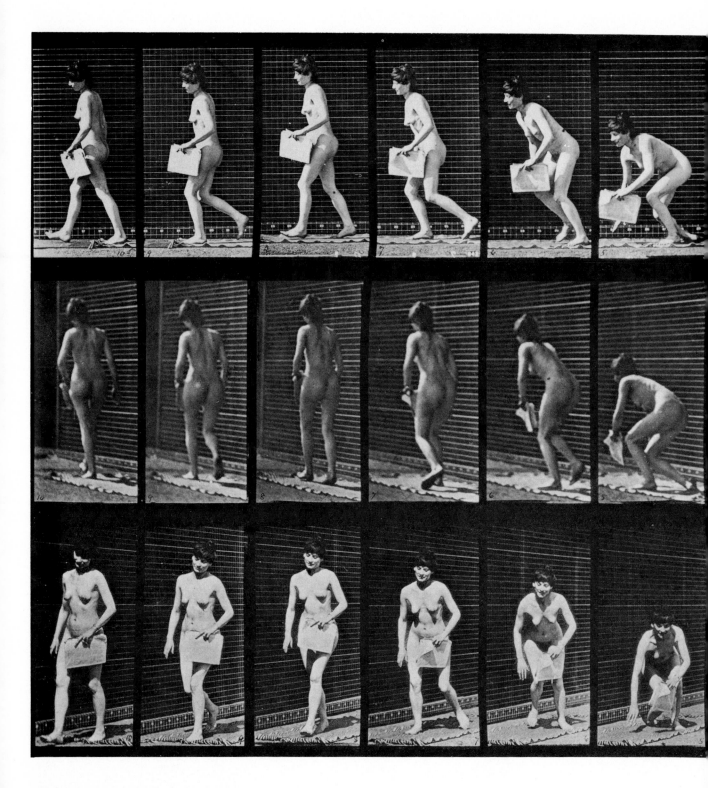

WOMAN WITH NEWSPAPER, RISING

PLATE 179

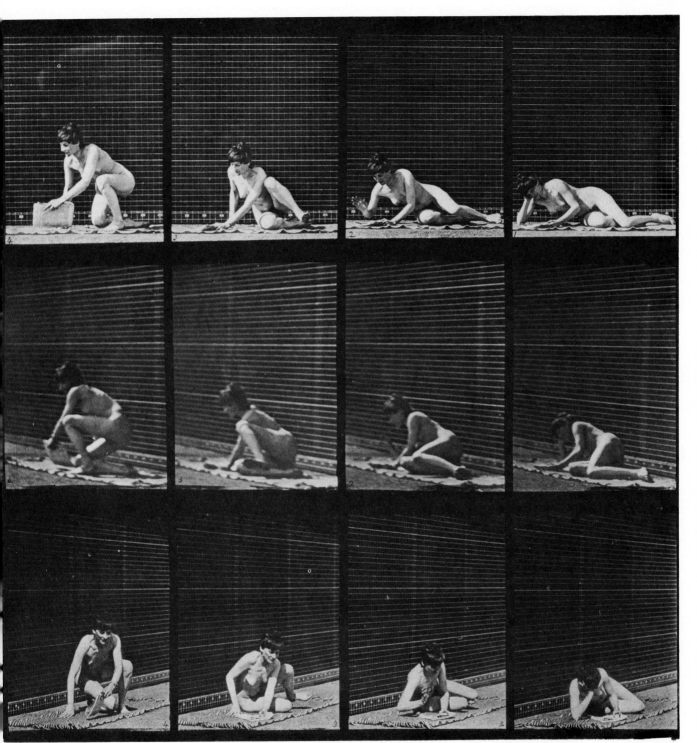

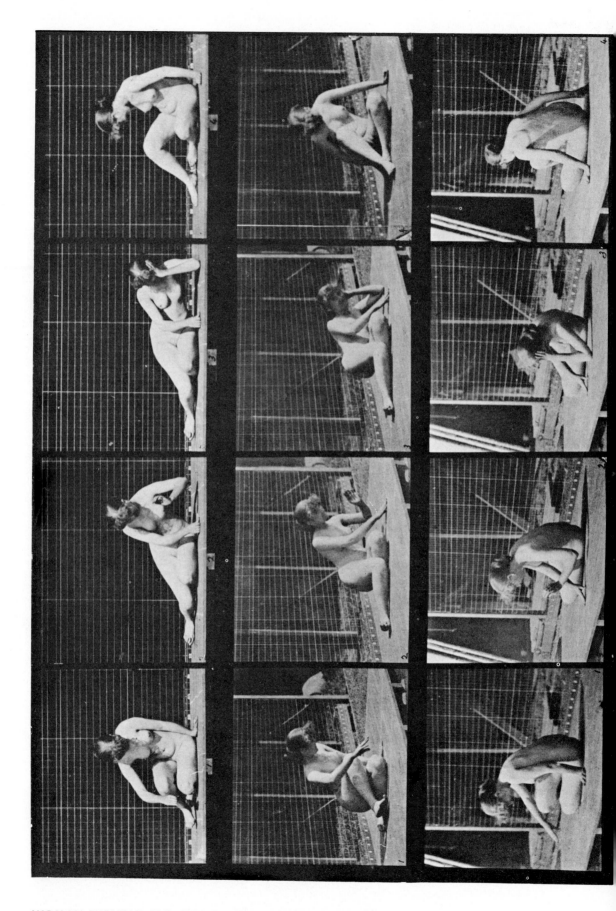

WOMAN TURNING AND RISING FROM SITTING ON FLOOR

PLATE 180

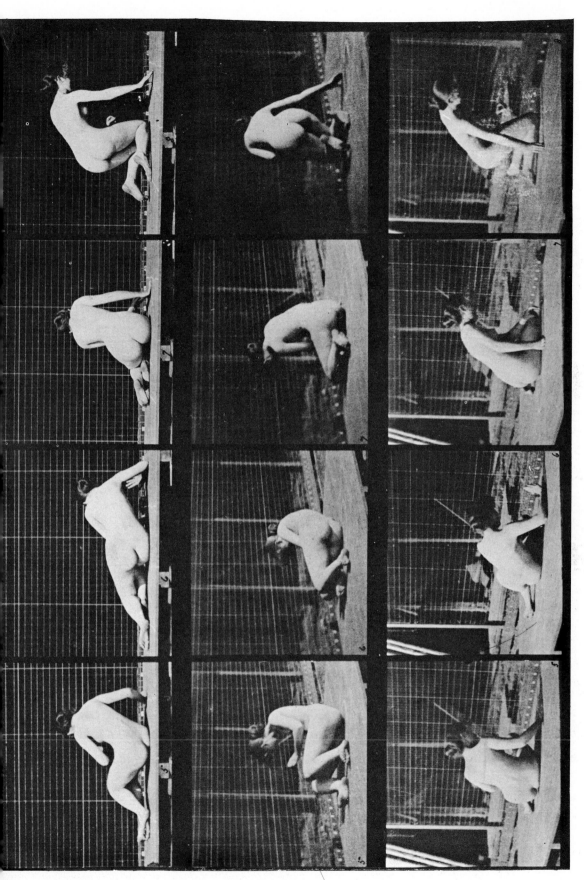

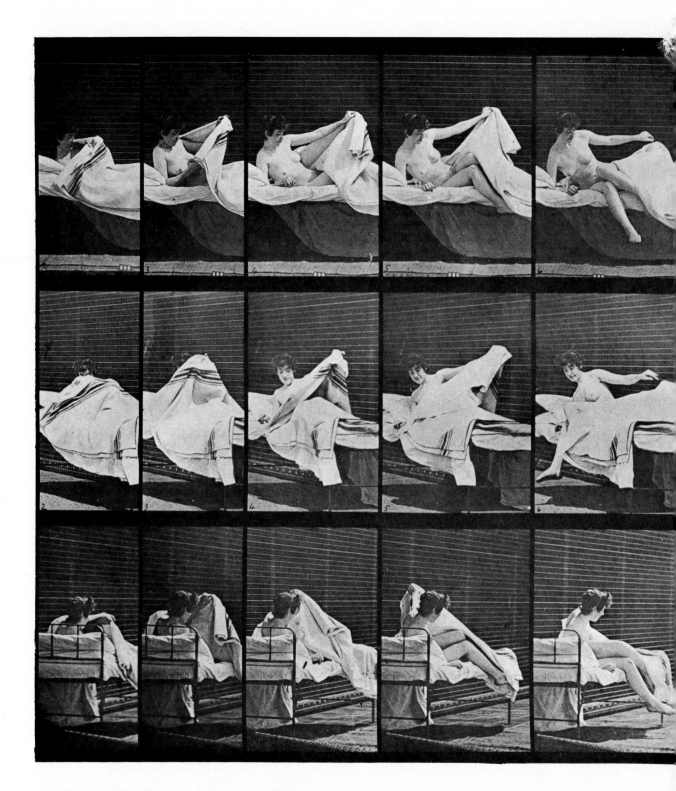

WOMAN UNCOVERING HERSELF AND RISING FROM BED

PLATE 181

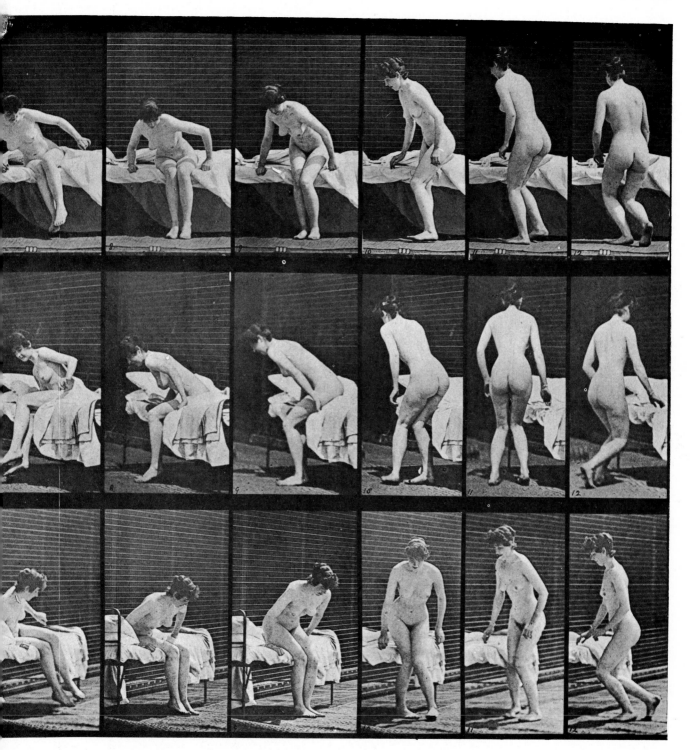

CHILDREN

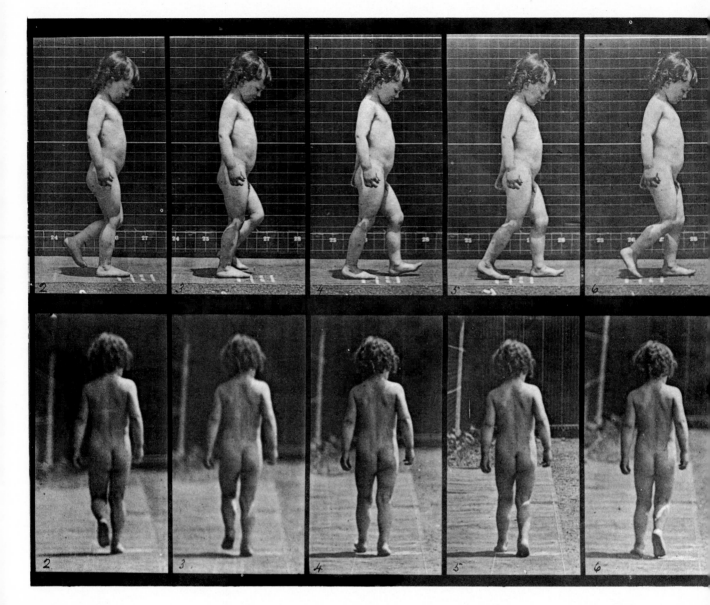

BOY WALKING

PLATE 182

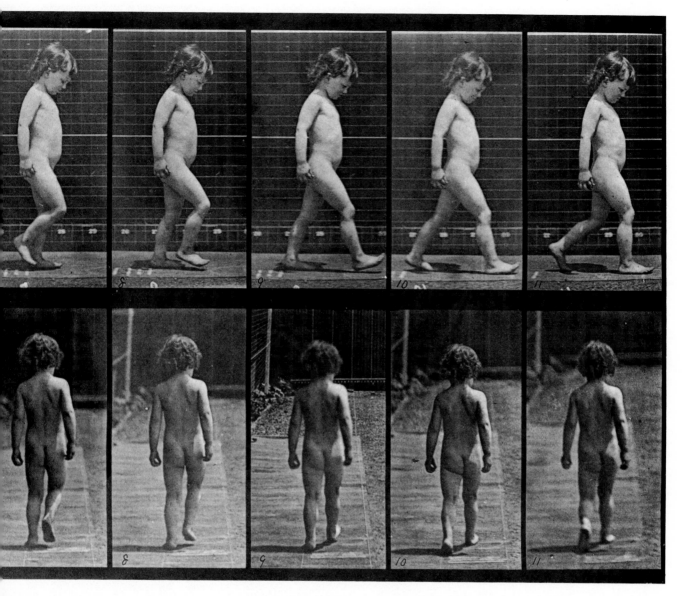

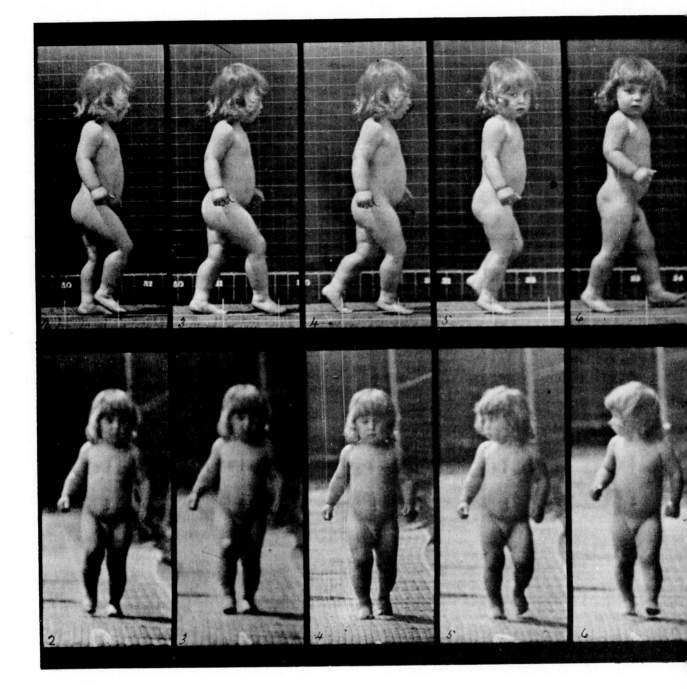

BOY WALKING

PLATE 183

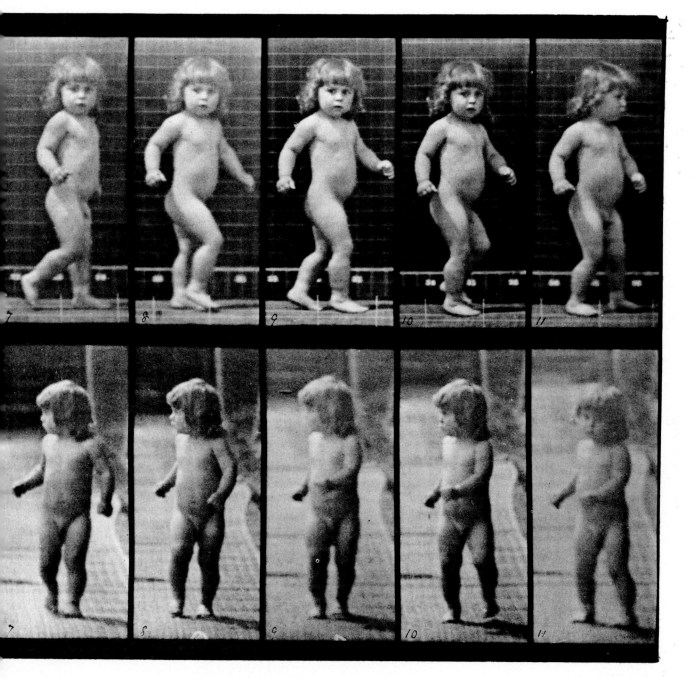

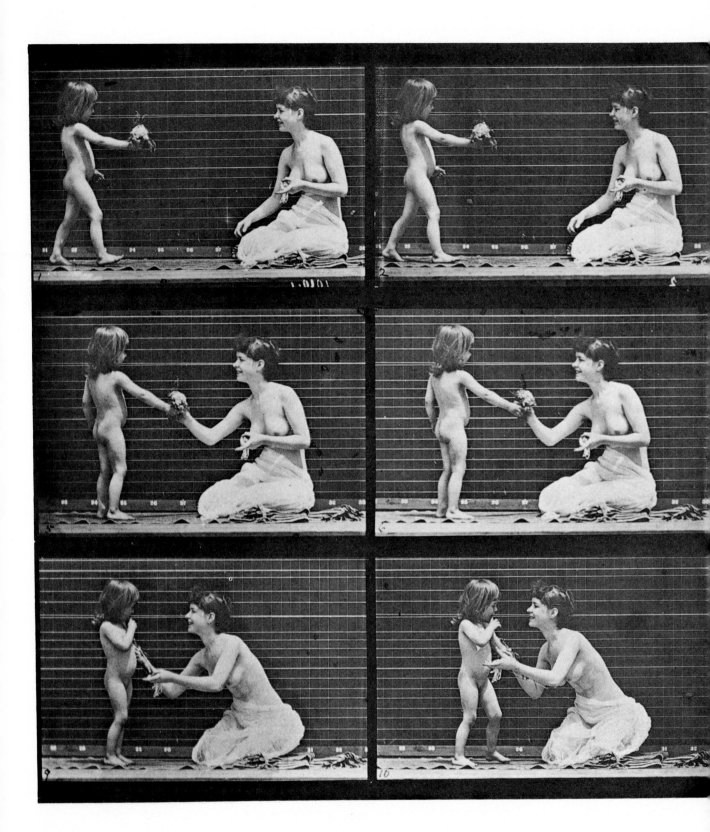

GIRL WALKING TOWARDS WOMAN, CARRYING FLOWER

PLATE 184

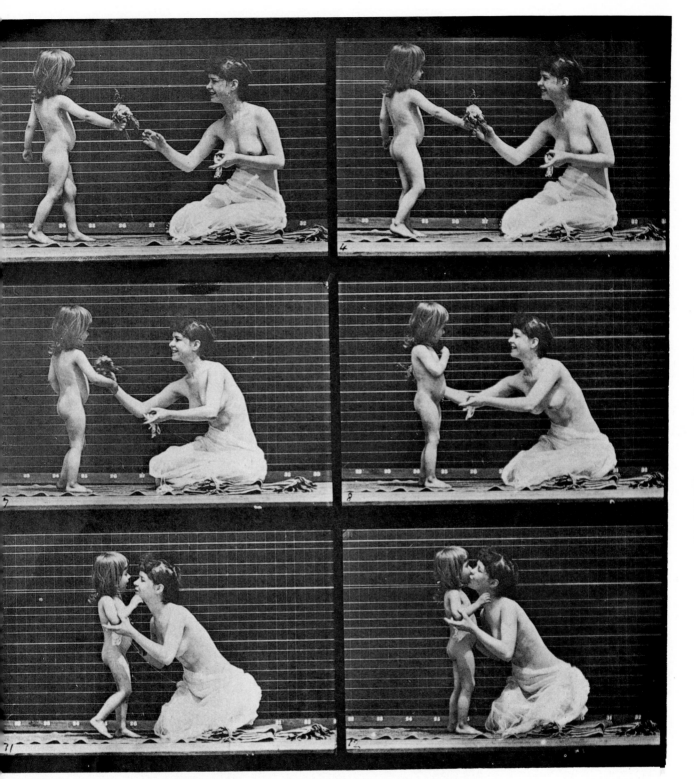

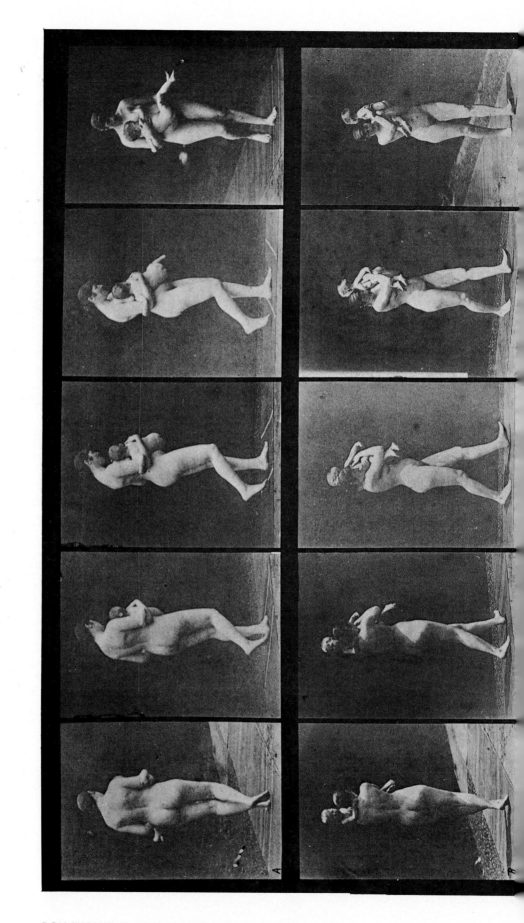

BOY WALKING WHILE HOLDING MOTHER'S HAND

PLATE 185

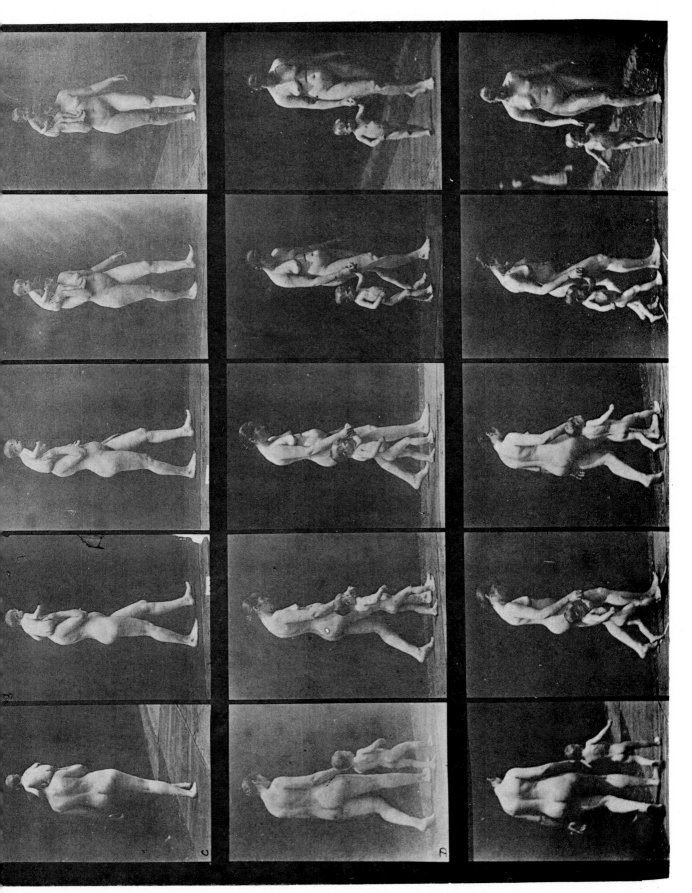

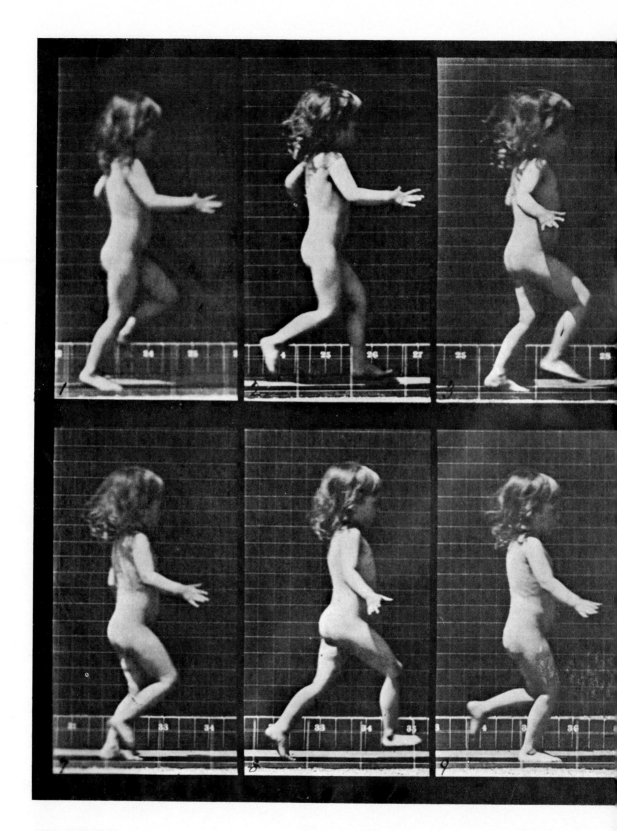

GIRL RUNNING

PLATE 186

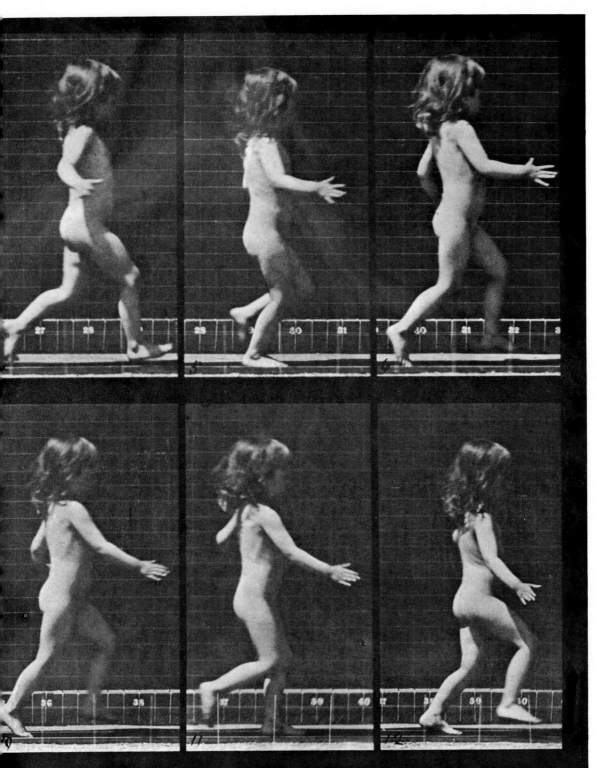

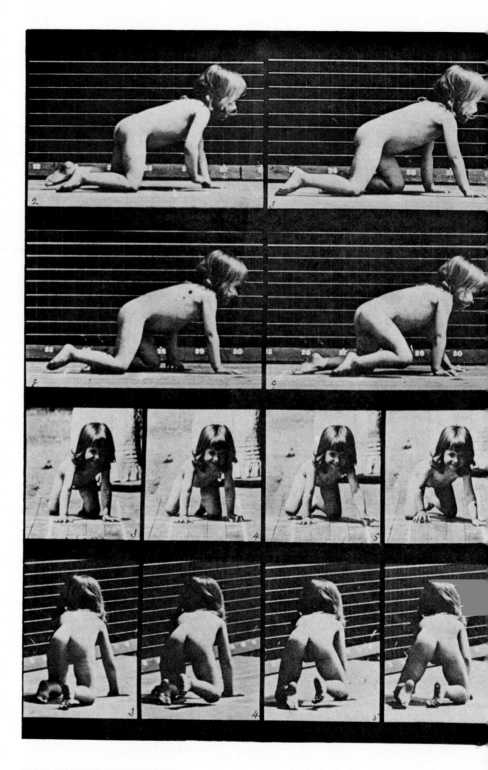

GIRL CRAWLING ON FLOOR

PLATE 187

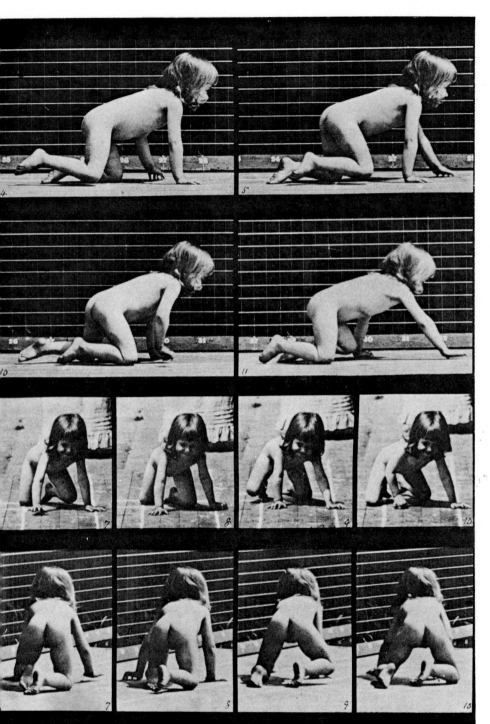

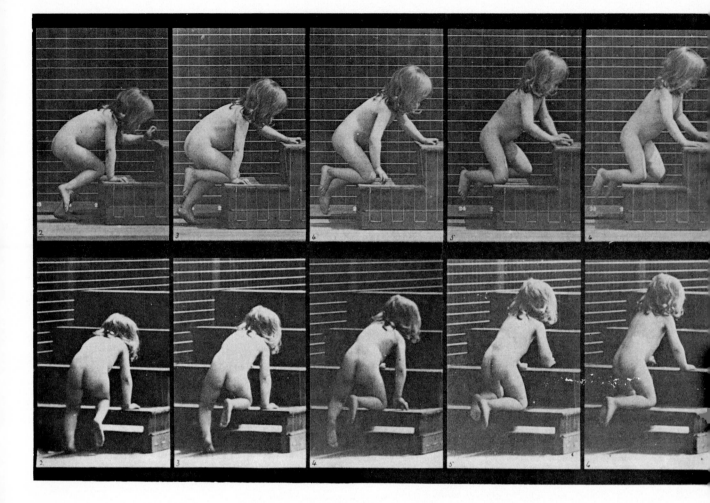

GIRL CRAWLING UPSTAIRS (.206 second)

PLATE 188

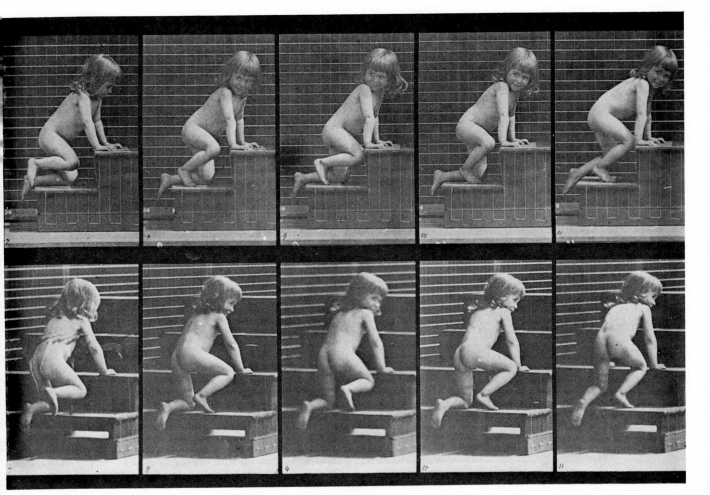

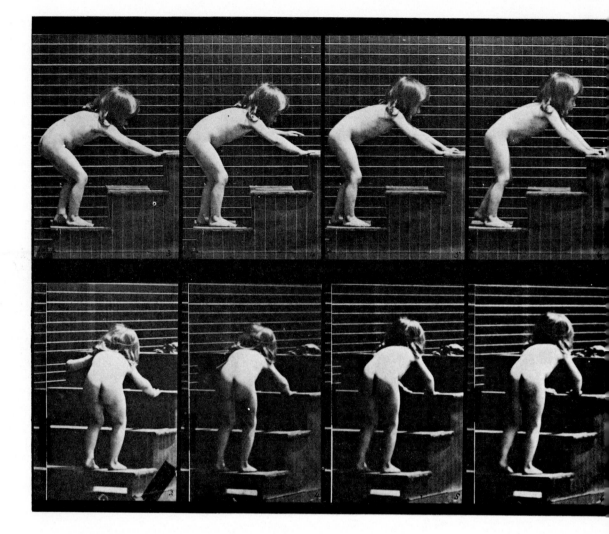

GIRL CRAWLING UPSTAIRS

PLATE 189

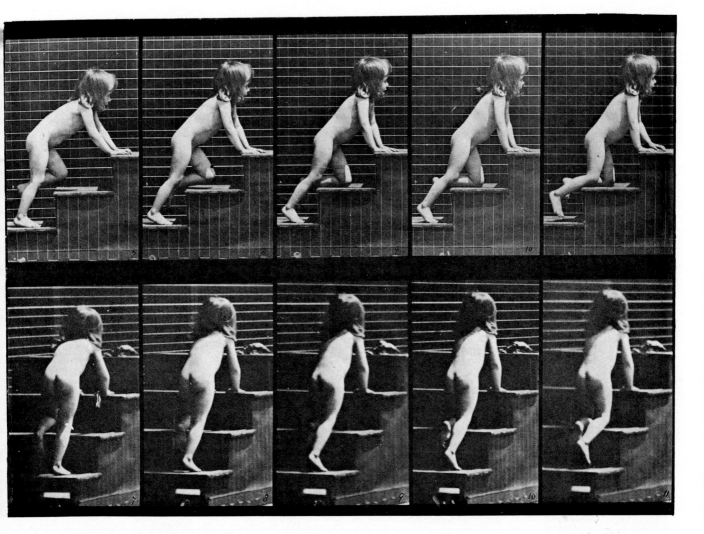

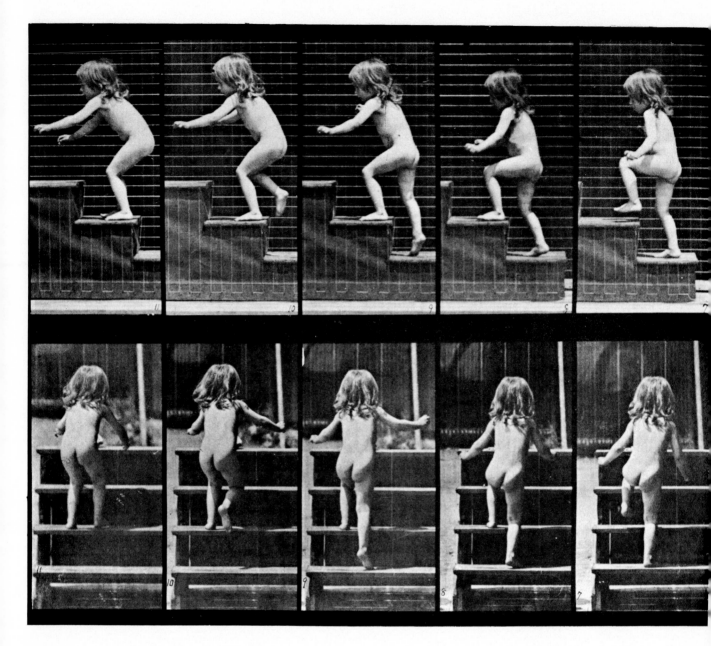

GIRL WALKING UPSTAIRS (.161 second)

PLATE 190

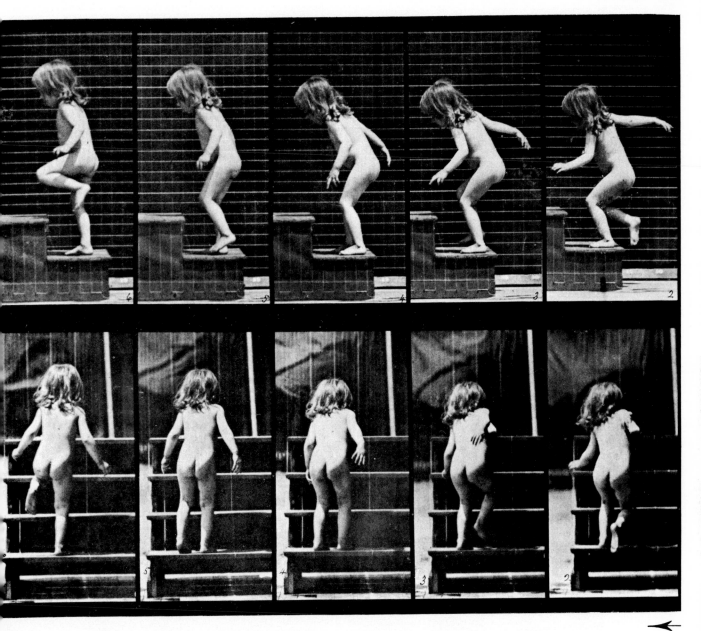

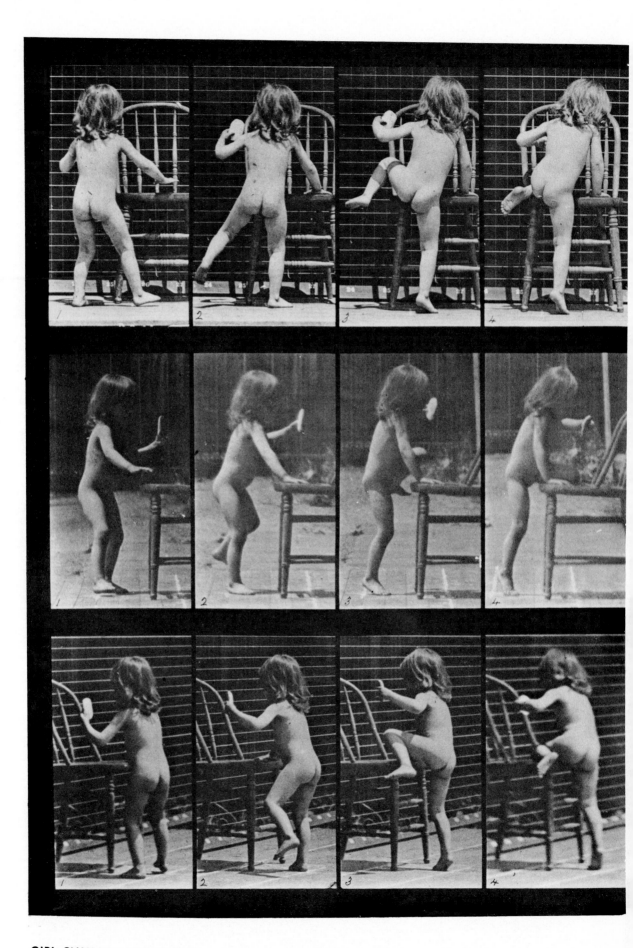

GIRL CLIMBING INTO CHAIR

PLATE 191

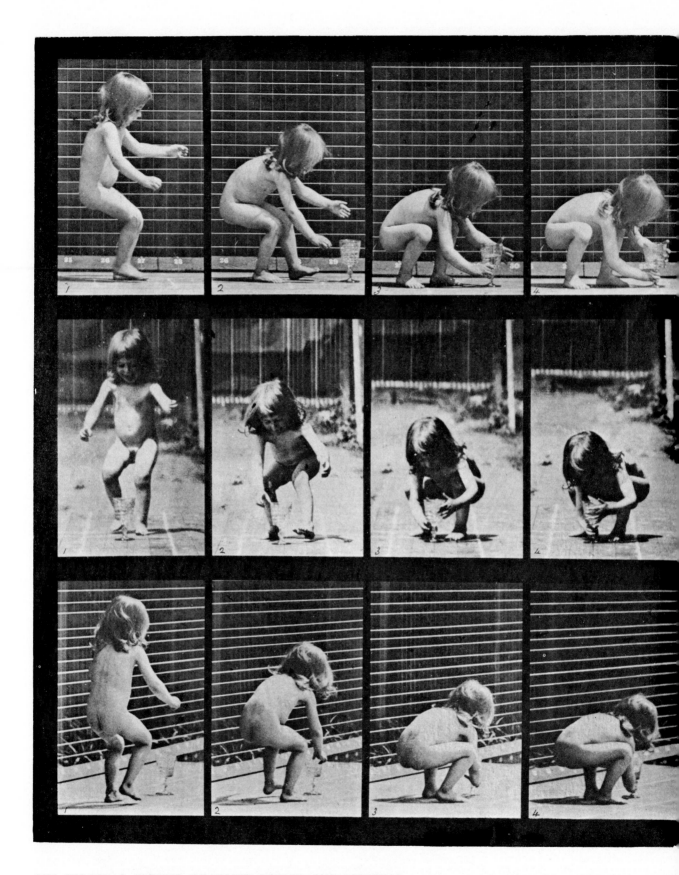

GIRL STOOPING, PICKING UP WATER GOBLET, AND DRINKING

PLATE 192

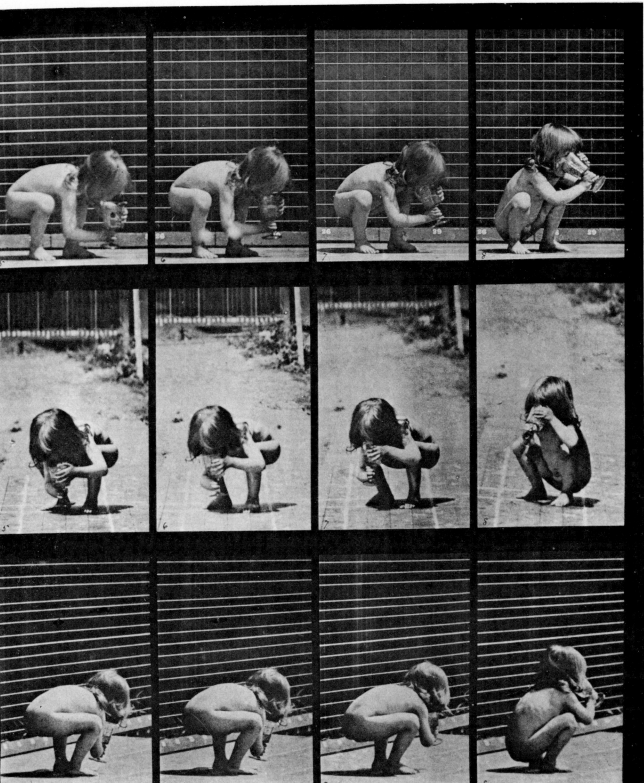

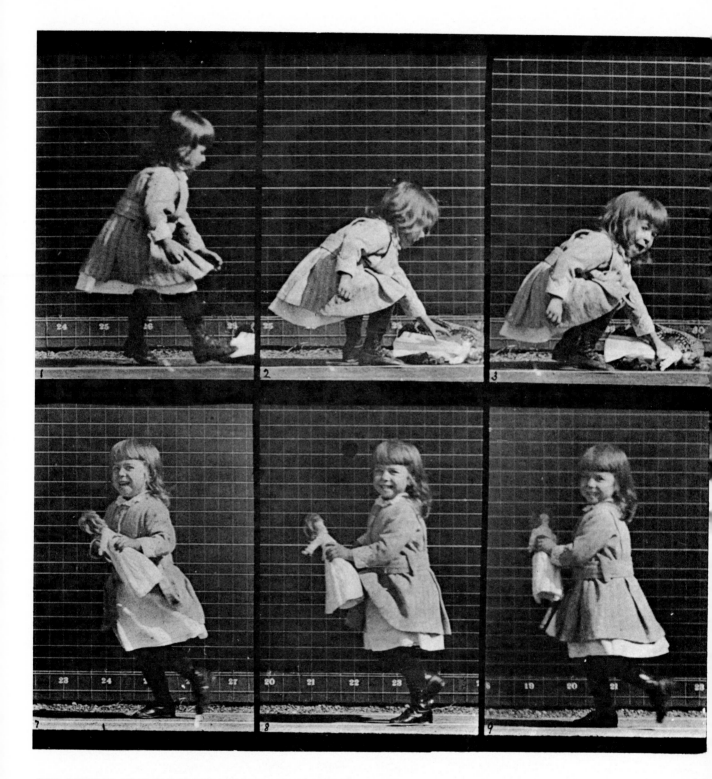

GIRL PICKING UP DOLL FROM FLOOR AND CARRYING IT AWAY

PLATE 193

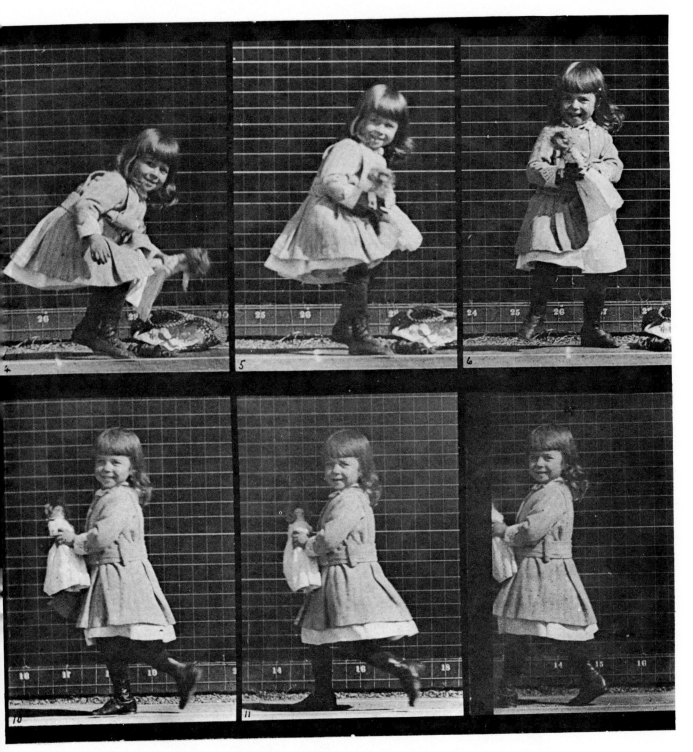

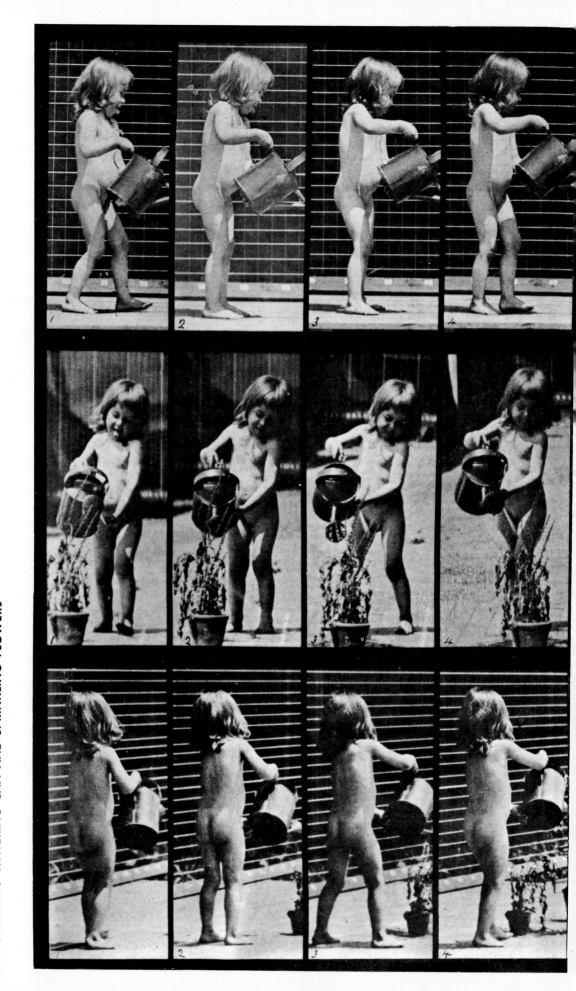

PLATE 194

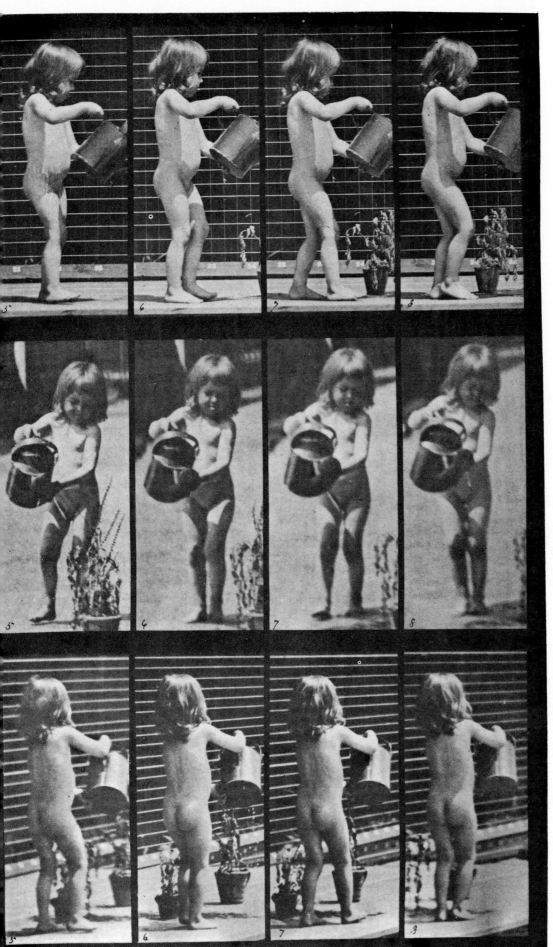

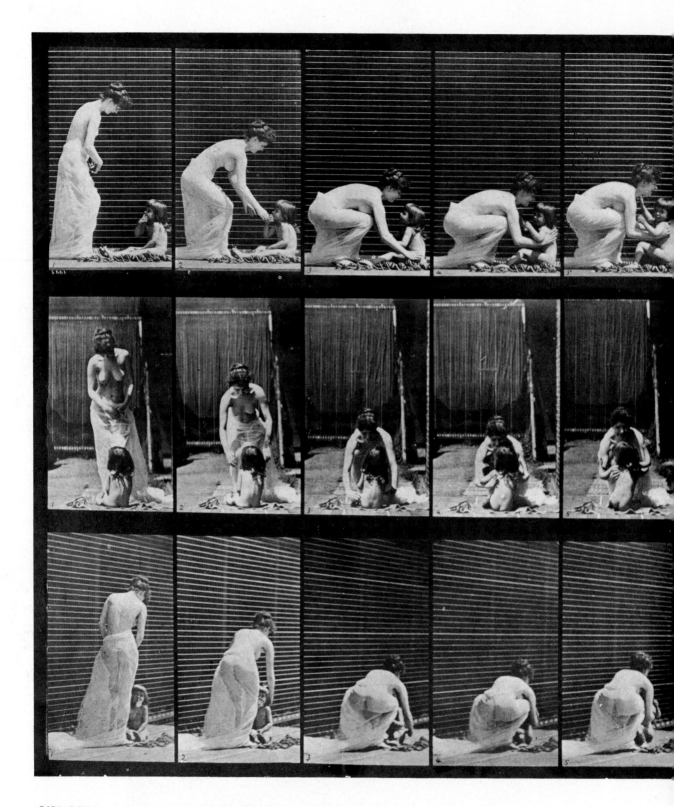

GIRL BEING PICKED UP AND HELD BY WOMAN

PLATE 195

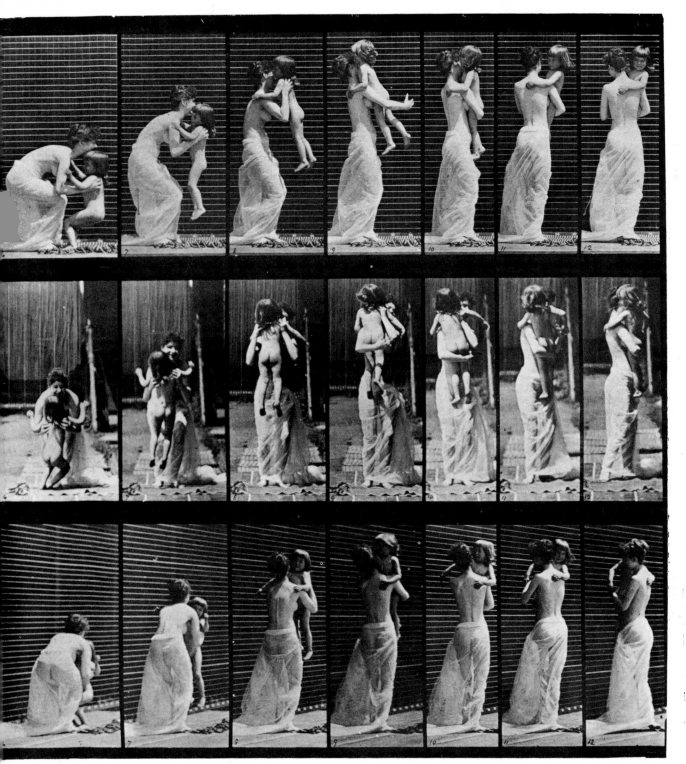